European Art of the
Fifteenth Century

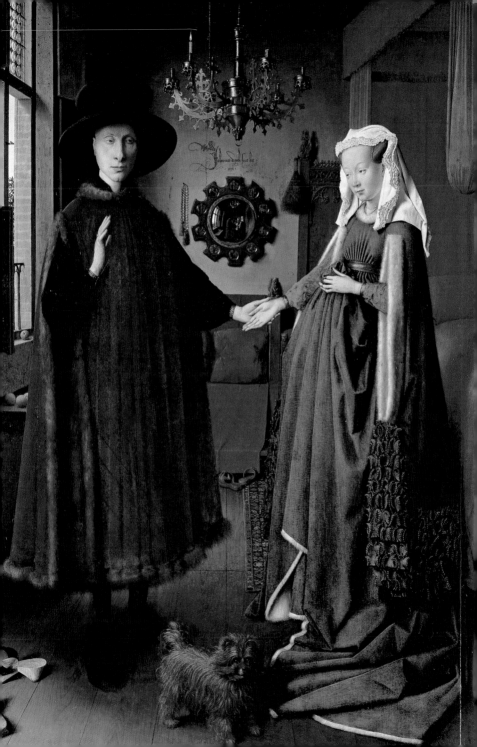

Stefano Zuffi

European Art of the Fifteenth Century

Translated by Brian D. Phillips

The J. Paul Getty Museum
Los Angeles

Art through the Centuries

Italian edition © 2004 Mondadori Electa S.p.A., Milan
All rights reserved. www.electaweb.it

Series Editor: Stefano Zuffi
Original Design Coordinator: Dario Tagliabue
Original Graphic Design: Anna Piccarreta
Original Layout: Sara De Michele
Original Editorial Coordinator: Caterina Giavotto
Original Editing: Antonella Gallino
Original Photo Research: Cristina Proserpio
Original Technical Coordinator: Andrea Panozzo
Original Quality Control: Giancarlo Berti

English translation © 2005 J. Paul Getty Trust

First published in the United States of America in 2005 by
Getty Publications
1200 Getty Center Drive, Suite 500
Los Angeles, California 90049-1682
www.getty.edu

Christopher Hudson, *Publisher*
Mark Greenberg, *Editor in Chief*

Ann Lucke, *Managing Editor*
Robin Ray, *Copy Editor*
Mollie Holtman, *Editor*
Pamela Heath, *Production Coordinator*
Hespenheide Design, *Designer and Typesetter*

Printed in Spain

Library of Congress Cataloging-in-Publication Data
Zuffi, Stefano, 1961–
[Quattrocento. English]
European art of the fifteenth century / Stefano Zuffi ;
translated by Brian D. Phillips.
 p. cm. — (Art through the centuries)
Includes bibliographical references and index.
ISBN-13: 978-0-89236-831-0 (pbk.)
ISBN-10: 0-89236-831-4 (pbk.)
1. Art, Renaissance. 2. Art, European—15th century. I. Title. II. Series.
N6371.Z8413 2005
709'.02'4—dc22
 2005008652

Contents

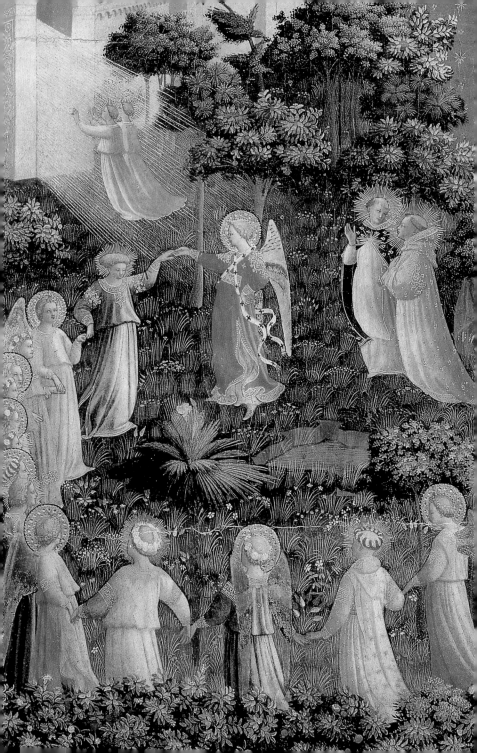

KEY WORDS

Courtly Art

International Gothic

Humanism

Renaissance

Perspective

The Ideal City

Divine Proportion

Portraiture

Anonymous Masters

The Workshop

Fresco

Winged Altar

Wood Sculpture

Polyptych and Altarpiece

Oil Painting

Miniature

Intarsia

Tapestry

Stained Glass

Equestrian Monument

◄ Fra Angelico, *The Last Judgment*, detail, 1431. Florence, Museo di San Marco.

In the fifteenth century, the power of local lordships reaches its peak. Art expresses this power system in a sumptuous and refined way that reflects the chivalrous models underlying court life.

Courtly Art

Related entries
Aragon and Castile, Burgundy, Milan, Paris

Fouquet, Gentile da Fabriano, the Limbourg brothers, Pisanello

The demands and tastes of courts played a fundamental role in art commissions and style choices in fifteenth-century Europe. Each court employed its own specialists in various kinds of artistic, literary, and musical production. Official court painters were responsible for maintaining and disseminating the image of their lord and of the refined aristocratic world that surrounded him. Among their duties were painting portraits of the lord and his courtiers, decorating the most important residences with fresco cycles, and producing altarpieces or other paintings of specific dynastic significance. But in the intervals the artist also had more ephemeral duties to perform: creating stage scenery; making banners and ornamental hangings; designing furniture, costumes, and gowns; illustrating manuscripts; and making shields, armor, heraldic banners, playing cards, and a variety of other objects, including valuable gifts to be sent to other courts with the aim of arousing admiration, emulation, or simply envy. Artists were also required to organize official occasions, such as formal banquets, receptions, tournaments, and official welcomes for noble guests. The fifteenth-century court artist was a designer, graphic publicity artist, copywriter, and stylist. He was a creative artist but also a manager: his sphere of activity was so vast that group work was essential, involving a multitalented workshop able to cope with all sorts of techniques and materials.

▼ The Zavattari brothers, *Scenes from the Life of Queen Theodolinda*, 1444. Monza cathedral, chapel of Queen Theodolinda.

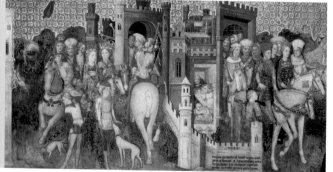

The artist responsible for this refined portrait is not known. He is now generally thought to belong to the Franco-Flemish school, and the fact that in the past the painting has also been attributed to Pisanello or a Bohemian artist is an indication of the substantial stylistic homogeneity of courtly Gothic art across Europe.

The brightly lit and sharp features are characteristic of late-Gothic portraiture, as is the perfect profile. In accordance with the fashion of the time, the lady's hair has been shaved at the top of her forehead.

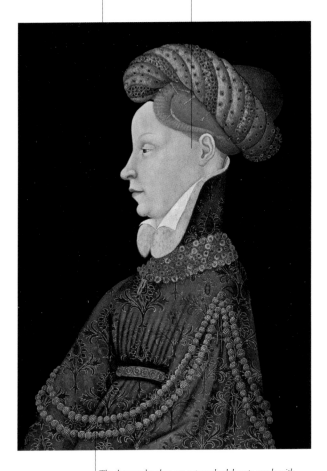

▲ Franco-Flemish master, *Portrait of a Lady*, ca. 1415. Washington, National Gallery.

The dress and turban are extremely elaborate, made with abundant use of gold thread. The whole costume faithfully reflects early-fifteenth-century luxury in aristocratic women's clothing, which was often designed by court painters. Because of their costliness, such clothes often provoked inheritance disputes.

The shrewd, somewhat wily expression, the bristly chin, and the
deep wrinkles make this character unforgettable. In life he was a
jester called Gonnella, who lived at the Este court in Ferrara.
However, the portrait was probably painted after his death—
in 1441, apparently as the result of a practical joke—which
would explain the underlying sadness of his expression.

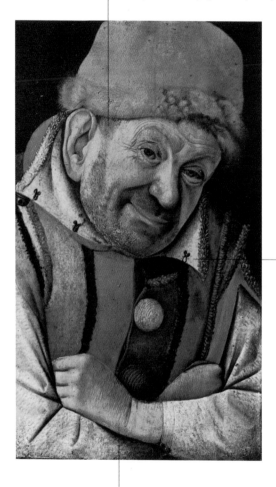

The refined execution of this
portrait and its strong graphic
qualities, together with the
unusual subject, have led to a
wide variety of attributions over
the centuries, from Giovanni
Bellini to Jan van Eyck, via a
number of quite unacceptable
suggestions. The portrait is now
generally recognized as the work
of the French artist Jean Fouquet.

▲ Attributed to Jean Fouquet, *Portrait
of the Jester Gonnella*, ca. 1450. Vienna,
Kunsthistorisches Museum.

The subject's casual pose, with
arms crossed, and his proximity to
the observer, are quite unusual in
early-fifteenth-century portraits: his
low social status allows the artist
freedom from the strict rules of
aristocratic portraiture.

The decoration of the chapel with veined marble wall panels and gilded ceiling coffers reflects the revival of ancient architecture and its embellishments in fifteenth-century Italy. Such small, richly decorated chapels were often built into residences of Renaissance rulers.

Saint Bellinus, a twelfth-century bishop of Padua, was especially venerated by the owners of this book of hours, who hailed from that region. They chose to have themselves immortalized in this miniature attending a mass celebrated by Saint Bellinus.

Andrea Gualengo was a high-ranking courtier and ambassador at the Este court. As a reward for his service, he was allowed to marry Orsina, a member of the Este family that ruled Ferrara. This book was likely produced in honor of their marriage in 1469.

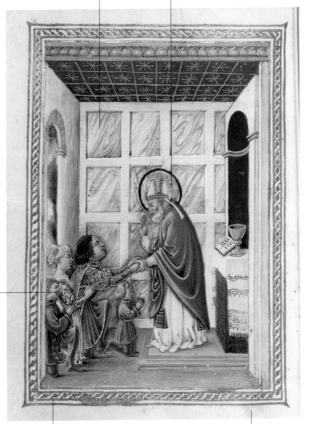

▲ Taddeo Crivelli, *Saint Bellinus Celebrating Mass*, ca. 1469, miniature from the *Gualenghi-d'Este Hours*. Los Angeles, J. Paul Getty Museum.

Books of hours, which contained collections of prayers to be recited at specific times of the day, week, and year, were popular devotional aids in this period. Richly embellished volumes were luxury objects reflecting the social position of their owners.

Devotion to the saints was a vital aspect of Christian piety in this period. Saints served as intermediaries between heaven and earth and were regularly petitioned by the faithful. Books of hours contained prayers to numerous saints, who were often illustrated in accompanying miniatures.

The Wheel of Fortune is one of the tarot cards used in fortune-telling. It shows the continual change of good and bad fortune around a wheel held up by an allegorical image of Fortune, who is blindfolded.

The Emperor is one of the Major Arcana, one of the two types of cards in the tarot deck. He is richly dressed in a gold robe, and prominent on his headdress is the black eagle, symbol of the Holy Roman Empire.

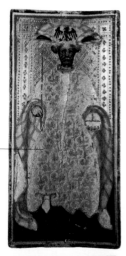

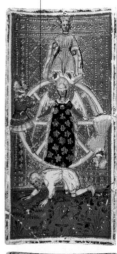

The Knave of Coins is an elegant page at a late-Gothic court. These playing cards are exquisitely crafted using a technique that combines skilled goldwork and miniature painting. These are typical examples of the sort of refined, precious objects constantly demanded in courtly commissions.

The Queen of Swords is one of the court cards (king, queen, knight, knave) in the four traditional suits that make up the Minor Arcana: swords, wands, cups, and coins. These delightful little figures stand out against a rich gold background closely ornamented with stamped patterns.

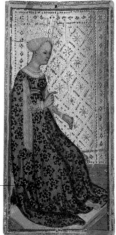

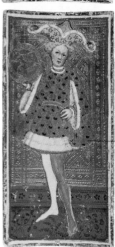

▲ Bonifacio Bembo, *Tarot Cards from the Court of Milan*, ca. 1440. Milan, Pinacoteca di Brera.

Musicians invite the ladies and knights to dance. The scene has the appearance and rhythm of a ballet.

The country banquet was a typical aristocratic leisure activity in fine weather. Here it is transformed into an allegorical apotheosis of the refinement and beauty that reigned at the court of the dukes of Burgundy.

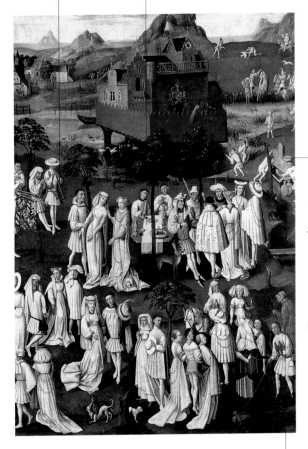

One valet is drinking from the fountain, while another is polishing valuable crockery. Seen in conjunction with the many figures of young people enjoying the warmth of spring, the flowing water here alludes to the iconography of the fountain of youth.

▲ Burgundian master, *A Garden of Love at the Court of Philip the Good* (detail), ca. 1460. Versailles, Musée de Versailles.

One figure, standing to the side, seems decidedly out of place. Among all these heedless youths in gold and white, an ungainly man dressed in red brandishes a stick. He is the popular figure of the "fool," whose complete incongruity within this scene serves as a sharp reminder of the vanity of beauty and the brevity of youth.

There is no clear dividing line between the closing stages of the Gothic and the earliest manifestations of the Renaissance. For much of the fifteenth century, the late Gothic and humanism overlap.

International Gothic

▼ Master of the House-book, *Gotha Lovers* (detail), 1480–85. Gotha, Schlossmuseum.

International Gothic arose in southern Europe, starting at the Palace of the Popes at Avignon. It spread rapidly, assuming substantially similar forms in various countries, thanks to artists' travels, cultural exchanges, and especially the close political, dynastic, and cultural links among the ambitious aristocratic courts across Europe. One of the characteristics of this style is the combination of different arts: the continuous exchange of techniques, problem solving, and subject matter among masters of painting, miniatures, goldwork, fabrics, tapestries, and furniture that affected every aspect of aristocratic life. But there is an important linguistic distinction: in the history of Italian art, the term *tardogotico* refers to the art of the opening decades of the fifteenth century, whereas the corresponding German term *Spätgotik*—apparently a literal translation of the Italian—is applied to very late examples of this style in the waning decades of the century. For European courts, the commissioning and production of works of great refinement became a fundamental part of "image politics," a crucial means of achieving prominence and prestige within a fluid and complex political scene. Catalonia, Burgundy, Lombardy, and Bohemia were the most active regions, and they dictated taste at other courts. From the earliest decades of the fifteenth century, moreover, the late-Gothic culture of chivalry began to converse with the intellectual movement of humanism: the sweet, melancholy, sanguinary tales so dear to courtly taste encountered university studies and investigations into the classical world. This commingling of ideas gave rise to some fascinating artistic phenomena.

The devotional features of the work, such as the angels holding up the crown, are almost completely effaced by the wonderful vivacity of the statuettes, created using the refined technique of enameling en ronde bosse ("in the round"). The entire object is enriched with pearls, rubies, and sapphires, while gold fleurs-de-lis on a blue ground, the heraldic emblem of the French Crown, can be seen in various places.

In front of the Virgin are two angels dressed as altar boys, and behind her is a traditional rose trellis. The rose is one of her symbols.

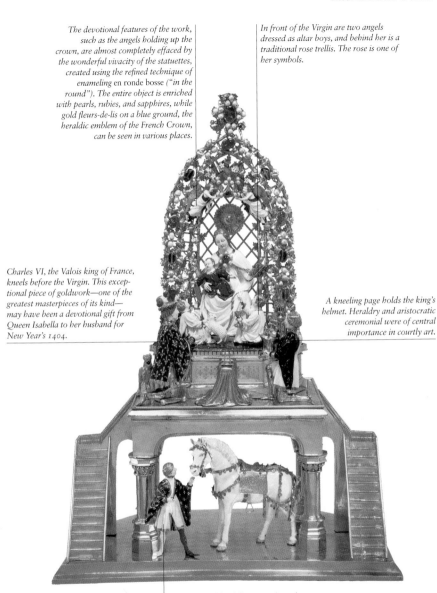

Charles VI, the Valois king of France, kneels before the Virgin. This exceptional piece of goldwork—one of the greatest masterpieces of its kind—may have been a devotional gift from Queen Isabella to her husband for New Year's 1404.

A kneeling page holds the king's helmet. Heraldry and aristocratic ceremonial were of central importance in courtly art.

▲ Parisian or Milanese goldsmith's workshop, *Goldenes Rössl*, 1404, ex voto belonging to King Charles VI of France. Altötting (Germany), treasury of the parish church.

At the foot of the elaborate podium that supports the throne is a page leading a white horse. Due to the realism and immediacy of the horse, the whole ex voto has become popularly known as the Goldenes (or Weisses) Rössl ("the gold [or white] horse").

The mandorla of this meticulously rendered perpetual calendar is elegantly decorated with the signs of the zodiac. It is yet another example of precise detail combined with a taste for the fanciful.

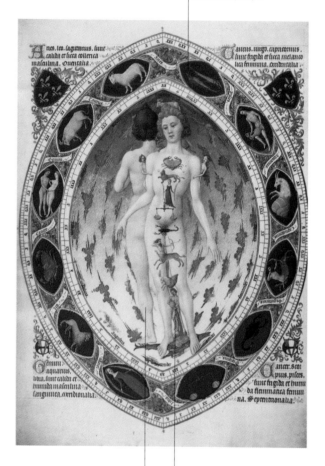

In spite of the element of fantasy in the image, the two nude figures standing back to back have a solid physical structure, thus lending the miniature a magical ambiguity. This combination of the fabulous and the real plays an essential part in the International Gothic style.

The signs of the zodiac are placed on the parts of the body that were thought to be influenced by the stars concerned.

▲ The Limbourg brothers, *Astrological Man*, 1413–16, miniature from the *Très Riches Heures du duc de Berry*. Chantilly, Musée Condé.

This scene is part of a large fresco in which Pisanello represents Saint George preparing to confront the dragon and free the princess. It has very little of the devotional about it, but it reflects the aristocratic and chivalrous ideals of the period.

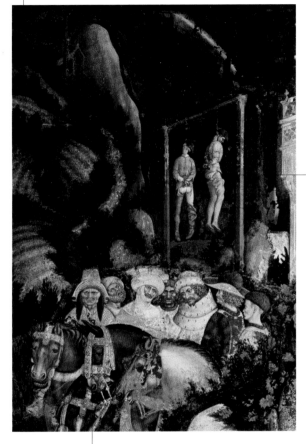

The macabre detail of the two hanged men clearly derives from careful observation. Because of the similar subject matter, it has often been compared to François Villon's Ballade des pendus, one of the most intense, dramatic poems in fifteenth-century European literature.

▲ Pisanello, *Saint George and the Princess of Trebizond* (detail), 1434–36. Verona, Sant'Anastasia.

The exotic figures, depicted with careful anthropological detail, are imaginary dignitaries from the city of Trebizond. Curiosity about distant lands and peoples was on the increase throughout the fifteenth century, eventually leading to the age of discovery.

17

This tapestry is from a famous group commissioned by the Le Viste family of merchants from Lyon.

In characteristic tapestry fashion, the background decoration makes no attempt to provide a sense of depth in perspective but simply places one object above another, as though against a vertical wall.

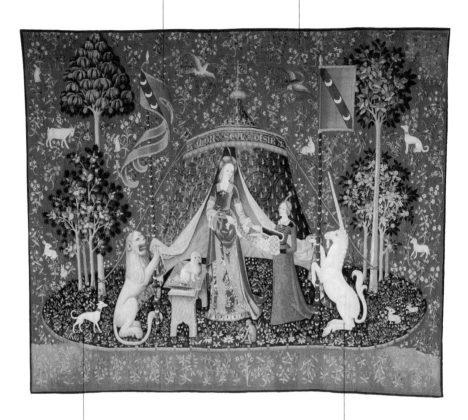

At the center of the composition is a kind of flower bed in which plants and herbs are represented with affectionate care.

The symbolic beasts (lion, unicorn, and monkey) take their places among an attractive assortment of real animals and birds.

▲ French manufactory, *Allegory of Vision*, ca. 1495, from the tapestry series Lady with a Unicorn. Paris, Musée National du Moyen Âge.

The detail of the angels bearing a ducal crown points out the political significance of the painting. It was commissioned by the duke of Milan, Ludovico il Moro, who wished to emphasize the legitimacy of his political ascent at the expense of his nephew Gian Galeazzo.

The duke, kneeling piously on the left, is the painting's real protagonist: the Christ child turns to bless him, the flying angels direct their gaze at him, and Saint Ambrose, the patron saint of Milan, places a protective hand on his shoulder. Although the altarpiece dates to the last decade of the fifteenth century, it belongs to the courtly art tradition.

This very elegant figure is Ludovico il Moro's wife, Beatrice, sister of Alfonso d'Este, the future duke of Ferrara, and of Isabella d'Este Gonzaga, marchioness of Mantua.

▲ Master of the Sforza Altarpiece, *Virgin and Child with the Family of Ludovico il Moro*, 1492–95. Milan, Pinacoteca di Brera.

The face of the Virgin and the figure of the Child clearly reveal the influence of Leonardo da Vinci, whose presence in Milan made it one of the earliest and most lively centers of Renaissance culture. Nevertheless, the painting as a whole, with its abundance of gilding and refined details, still owes much to late-Gothic taste.

Taking the revival of Greek and Roman culture as their point of departure, the humanists rediscover the values of moderation, reason, and a sense of proportion.

Humanism

The aphorism "man is the measure of all things" was taken from classical antiquity and came to typify Florentine humanism. Life in the Middle Ages was characterized by a mystical yearning for God. In humanism, however, men, building on premises established by Dante and Giotto a century earlier, began assuming greater responsibility for themselves; taking on a new, more active role in history and society; and seeking a comprehensive understanding of the natural world. Developments in the figurative arts reflect a more general shift in thinking, which ultimately affected every sphere of civilization. In the calm of their studies, in the lecture halls of universities, and also in court salons, artists and men of letters were setting in motion a profound and lasting cultural transformation. Starting in the towns—places like Florence and Bruges, where there was an active merchant and banking class—the movement spread to university towns, bishoprics, market towns and abbeys, castles and ports. And humanism was not just an elite movement: through devotional images and a broader dissemination of learning, the rules of perspective, symmetry, and proportion became increasingly accessible to every level of society.

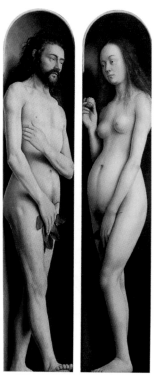

▶ Jan van Eyck, *Adam and Eve*, 1426–32, inner side panels of *The Adoration of the Lamb Altarpiece*. Ghent, cathedral of Saint-Bavon.

The scene has a grand architectural setting. Behind the triumphal arch is a barrel-vaulted ceiling, perhaps to a Brunelleschi design.

The characters are arranged in depth according to their status: the two donors kneel outside the niche, whereas Mary and John stand beside the cross; still farther back, and higher up, is the podium with God the Father. Nevertheless, the figures are all in correct and natural proportion.

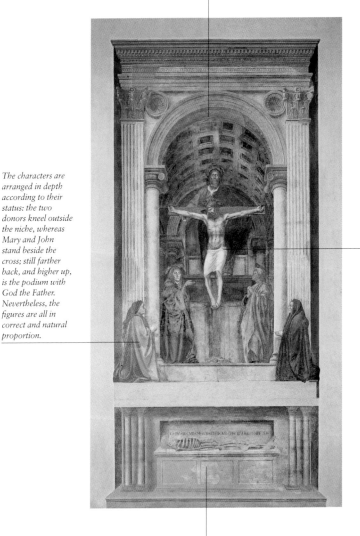

The center of the composition is occupied by God the Father holding up the cross of Christ. This is a common subject in northern Europe, but comparatively rare in Italian art.

▲ Masaccio, *The Trinity*, 1425–26. Florence, Santa Maria Novella.

At the bottom of the fresco is a sarcophagus on which a skeleton and a warning inscription remind us of the brevity of life and inevitability of death.

Light flows down toward the scholar's desk, and the artist uses this natural light from the window with great subtlety to convey the "illuminating" effect of culture.

Saint Jerome is the archetype of the learned scholar-prelate. The attribution of this fascinating little Flemish painting is uncertain, but experts are increasingly inclined to attribute it to Van Eyck.

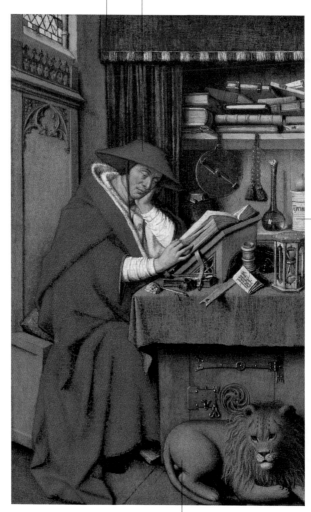

Books, scientific and precision instruments, and other refined objects are piled on the desk. It was such humanists' studies that formed the nuclei of later scientific collections and libraries.

▲ Attributed to Jan van Eyck, *Saint Jerome in His Study*, 1442. Detroit, Institute of Arts.

The inclusion of a lion, the traditional attribute of Saint Jerome, tells us who is seated at the desk. As a doctor of the Church, man of letters, translator, and bibliophile, he was a favorite subject in humanist art.

The man of letters at his desk.

Watchmakers and makers of precision instruments.

In late medieval times, human activity was thought to be influenced by the planets. In this scene, artists and intellectuals work under the lively, active sign of Mercury, though there was a contrary tradition that saw them as sons of Saturn.

A painter busy on a triptych.

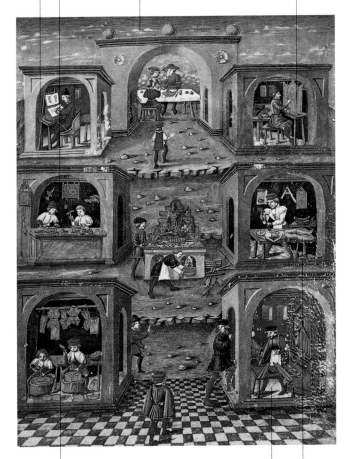

A sculptor putting the finishing touches to a large, fully modeled statue.

Armorers and makers of cuirasses. This was a very prestigious artistic and technical skill.

▲ Cristoforo de Predis, *The Sons of Mercury*, ca. 1460, miniature from the *De Sphaera* codex. Modena, Biblioteca Estense Universitaria.

A maker of organs and other musical instruments.

The references to classical archaeology, such as the heads set in ornamental medallions, establish this as a very noble building—an example of ideal architecture in the age of humanism.

Saint Augustine is wearing the typical dress of a university teacher and sits in a high-backed professorial chair.

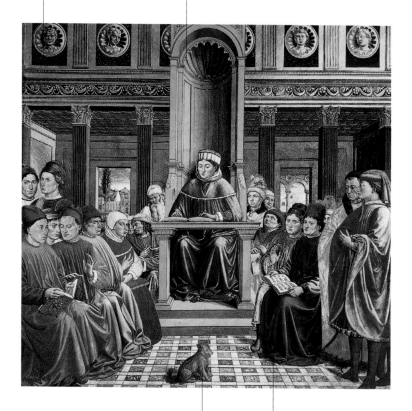

An unexpected but attractive detail is the puppy in the foreground, which adds a touch of liveliness to this solemn gathering.

The audience consists not only of students but also of more senior figures, all involved in an intellectual debate.

▲ Benozzo Gozzoli, *Saint Augustine Teaching Philosophy in Rome*, 1464–66. San Gimignano, Sant'Agostino.

Heraclitus is always depicted frowning deeply or even in tears, to convey his pessimistic view of man and the world.

At the center of the composition is a globe that accurately conveys the geographical knowledge of humanist times: note the uncertain shape of Africa, which had not then been circumnavigated and thus continues on to the South Pole.

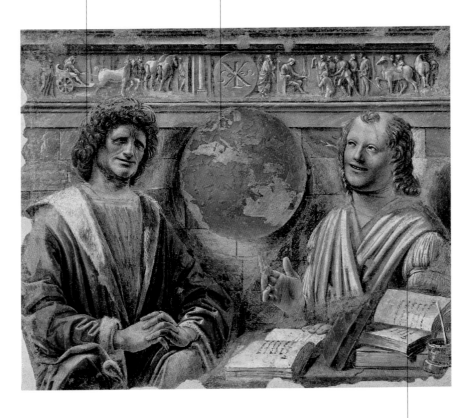

▲ Donato Bramante, *Heraclitus and Democritus Discuss the World*, 1481. Milan, Pinacoteca di Brera.

Democritus, smiling and optimistic, stands for the positive aspects of philosophy. These symbolic images naturally involve a gross simplification of philosophic thought, but it is important to note how their characteristic facial expressions become a means of disseminating the basic elements of philosophy beyond limited university circles.

Florence is the first city to promote the movement that comes to be called the Renaissance, which subsequently spreads throughout Europe.

Renaissance

▼ Vincenzo Foppa,
The Boy Cicero Reading
(detail), 1468. London,
Wallace Collection.

The term *Renaissance* conveys the desire to revive the ancient culture of an idealized Graeco-Roman world, boasting a well-ordered civil society, serene harmony, and progress for the whole community. The rediscovery of ancient literature, together with the study of fragments of ancient sculpture and architecture, produced the image of a "golden age," which contemporaries hoped to revive. In a typical example, the Florence of Lorenzo the Magnificent was compared to the Athens of Pericles. Over the course of the fifteenth century, the early, brilliant achievements in architecture and sculpture by Brunelleschi and Donatello were echoed in Florentine painting. In his treatise of 1436, Leon Battista Alberti declared that "painting has within it a divine power . . . , which not only makes absent men present, for truly it makes the dead seem to live again after many centuries." The ideal of a return to the cultural, ethical, and political values attributed to antiquity gradually spread from Italy to the whole of central and western Europe, from the Baltic to the Mediterranean, and from Poland to Portugal. The voyages of Christopher Columbus in 1492 concluded a century that did not fear the unknown and saw discovery as an exciting adventure. In that same year, other significant events occurred: the Moors were finally expelled from Spain by King Ferdinand, Lorenzo the Magnificent met an early death, a period of religious turbulence began, and, thanks to printing, culture and information became widely disseminated. These were disparate events, but they led to the breakdown of fifteenth-century equilibrium. Even the voyages of discovery can be interpreted as an expression of the urge to break traditional molds, remove barriers, and establish a relationship not with the ancient world, but with nature and the mysteries of our earthly sphere.

Leon Battista Alberti's aim in designing the Tempio Malatestiano was to encase the preexisting church of San Francesco in a marble envelope that would clearly echo classical architectural forms: thus the series of arches in the side wall echoes those of Roman aqueducts.

This miniature shows even more clearly than the final result how the temple facade takes its inspiration from Roman triumphal arches.

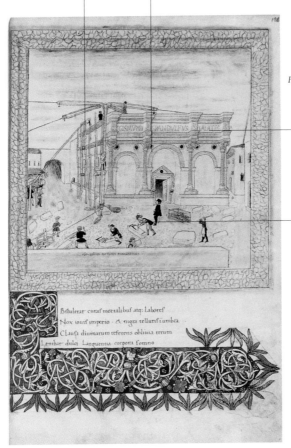

The name of the man who commissioned the work, Sigismondo Pandolfo Malatesta, lord of Rimini, appears in large letters on the pediment.

There is a striking contrast between the classical grandeur of the building under construction and the simple, almost medieval techniques of the masons and stonecutters.

▲ Giovanni da Fano, *The Building of the Tempio Malatestiano at Rimini*, 1462, miniature in the *Codex Hesperis*. Paris, Bibliothèque de l'Arsenal.

The magnificent architecture, rendered in perspective, is an idealized representation of the actual appearance of the Vatican palaces: it may even be seen as an ideal model for a new architectural culture.

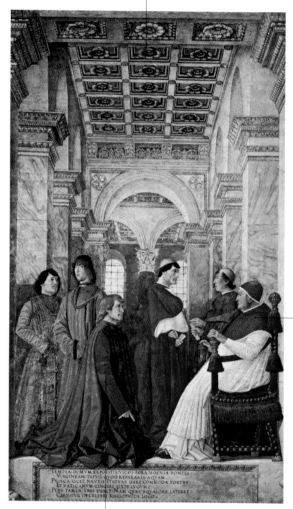

Pope Sixtus IV, a member of the Della Rovere family, played an important part in reestablishing the prestige of Rome in the later fifteenth century: he was responsible for the construction of the Sistine Chapel and the decoration of its walls.

▲ Melozzo da Forlì, *Sixtus IV Appointing Platina as Director of the Vatican Library*, 1477. Vatican City, Pinacoteca Vaticana.

Bartolomeo Sacchi, a humanist known as Platina, is being placed in charge of the new Vatican library by the pope. His most important literary work is a history of the papacy.

This painting is traditionally thought to portray the musical contest between Apollo and the satyr Marsyas, but since the person playing the flute is not a satyr, he is better identified as the mythical shepherd Daphnis, the inventor of bagpipes and bucolic songs. The figure is based on a classical model by Lysippus.

The birds coupling in flight are an allusion to the harmony of nature.

The figure of Apollo is based on a Hermes by Praxiteles. Perugino is openly paying homage to humanist culture, not only in the subject matter but also in the clear reference to classical statues.

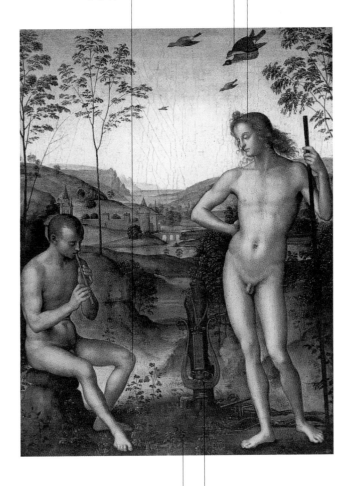

▲ Perugino, *Apollo and Marsyas* (or *Apollo and Daphnis*), 1483. Paris, Louvre.

The painting is a refined mythological allegory, intended to celebrate the peace that Florence enjoyed in the time of Lorenzo the Magnificent.

The elaborate, elegant lyre is the instrument of Apollo.

In the background of
the composition is a
monumental building
of classical design,
partly in ruins.

The shepherds' dark skin stands in striking
contrast to the delicate complexion of the
angels on the opposite side.

The ruined condition of the ancient
building is intended to emphasize its
nobility rather to demean it.

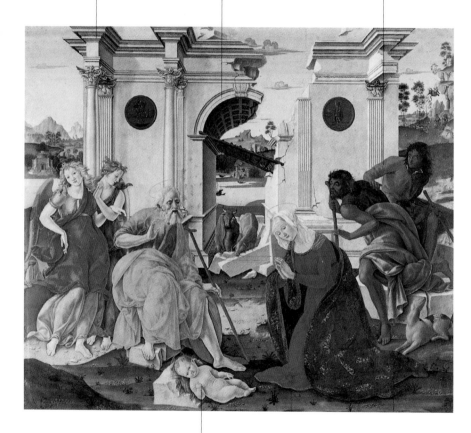

The baby Jesus reclines against a piece of
marble, thereby symbolizing the birth of
Christian culture from the ruins (but also
on the foundations) of classical culture.

▲ Francesco di Giorgio Martini, *The
Nativity*, 1485–90. Siena, San
Domenico.

In this painting Mantegna uses a sophisticated monochrome technique in order to mimic a bas relief carved into precious variegated marble. Delilah is shown cutting the hair off the sleeping Samson.

The imitation marble background lends the scene a strange but intense atmosphere of classical tragedy.

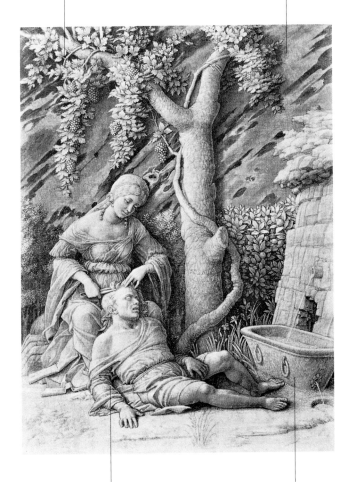

▲ Andrea Mantegna, *Samson and Delilah*, 1491. London, National Gallery.

The biblical subject is interpreted as though it appeared on a classical stele. Nevertheless, the details are rendered with a precision typical of painting, suggesting a kind of contest between painting and sculpture.

Even the flowing fountain on the right echoes the antique: the basin is clearly inspired by Roman models.

The engraving emphasizes the three-dimensionality of the figures. Pollaiolo does not use a background in perspective but depicts an overall pattern of vegetation, as in a tapestry.

Anatomy is here based partly on nature but more particularly on the close observation of classical bas-reliefs. This creates a strange impression of harsh realism combined with intellectual idealization.

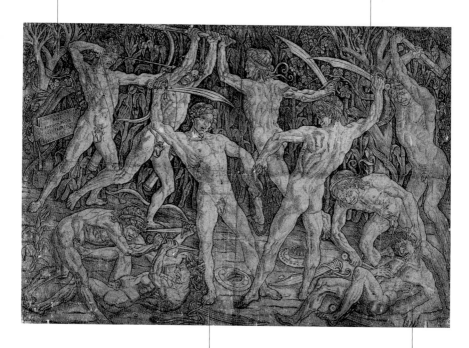

The sinewy male nudes are given sharp outlines.

If we observe the individual figures, we find that they derive from iconographic sources used by other artists. Two figures in this group, for example, are very like those in Mantegna's painting on page 31, but reversed.

▲ Antonio del Pollaiolo, *The Battle of Ten Nude Men*, 1471–72. Florence, Uffizi, Gabinetto Disegni e Stampe.

The central figure is the fulcrum of all the action. His gesture recalls that used by Michelangelo more than forty years later in the figure of Christ in the Last Judgment *in the Sistine Chapel.*

This relief appears to be unfinished; perhaps Michelangelo abandoned the work after the death in 1492 of Lorenzo the Magnificent, who had commissioned the sculpture. Lorenzo intended to place it in the Medici gardens at San Marco.

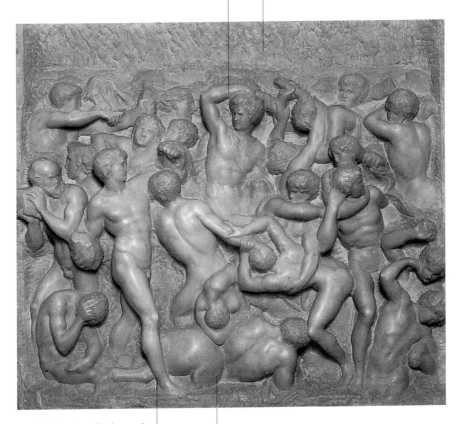

Michelangelo—still only a youth— seems to have Pollaiolo's engraving in mind (see page 32), but the overall simplification of the composition and the fluidity of the individual gestures make this work much more successful.

▲ Michelangelo, *The Battle of the Centaurs and Lapiths*, 1490–92. Florence, Casa Buonarroti.

The subject of the relief is mythological, but there are only a few details—such as the horse's hindquarters in the foreground—to identify the figures of centaurs, whose bodies are part man and part horse.

The Latin word prospicere *means "to look into the distance."*
The concept is simple, but it brings about a real revolution in
the figurative arts.

Perspective

▼ Piero della Francesca,
The Annunciation, ca.
1465, gable of the *Saint
Anthony Polyptych*.
Perugia, Galleria
Nazionale dell'Umbria.

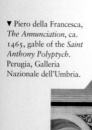

Briefly, the technique of perspective is a graphic device for representing a solid, three-dimensional body on a flat surface, as happens, for example, when a cube is represented geometrically. It is a way of more effectively representing the real world, which is made up not of flat outlines but of volumes defined by light within recognizable natural or architectural spaces. During the medieval centuries, art had been primarily concerned with presenting linear, two-dimensional images. Figures were placed frontally, and only limited background elements were included. The desire to give the human figure substance and volume within a definable space was given expression by Giotto at the beginning of the fourteenth century, coinciding with a newfound understanding that man had an active role to play in the world. This cultural development halted abruptly during the Black Death in the mid-fourteenth century but was set in motion again at the beginning of the fifteenth century. In Flanders, this passionate love of the real world led to the meticulous depiction of richly detailed microcosms in luminous and carefully constructed oil paintings, whereas in Tuscany, the emphasis was on grandiose, monumental architectural forms governed by mathematical rules. The painstaking, empirical Flemish vision and the geometric, classical Italian approach were the two main lines of development in fifteenth-century perspectival realism. The diffusion of these models was also effected by theoretical treatises, such as the *De prospectiva pingendi* of Piero della Francesca.

The pavilion on the left, with its portico, architrave, and arched loggia, is an example of the idealized architecture of the age of humanism. It has a specific compositional purpose, defining the space within which Herod's banquet is taking place.

The story of John the Baptist's death ends with his body being buried by faithful followers in a rocky landscape.

The decorative frieze with putti holding festoons is a direct quotation from classical reliefs. In the wake of humanism, architectural decoration of this kind was widespread.

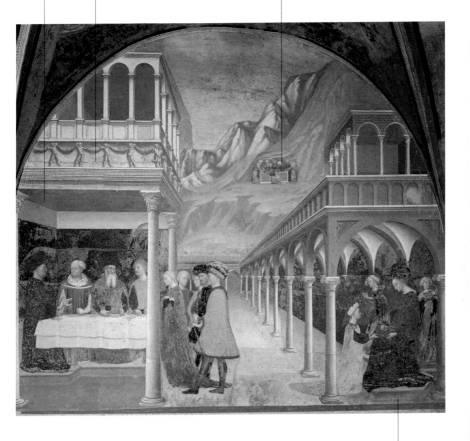

▲ Masolino, *Scenes from the Life of Saint John the Baptist*, 1435. Olona (Varese), baptistery.

The long portico in perspective on the right closes off the scene with its large, serene, Renaissance forms. It is important to remember that Masolino's frescoes are located in a small town in northern Lombardy, where the characteristic architecture is Gothic and in brick—quite different from what we see in this painting.

Perspective

The scene is illuminated by light slanting in from the windows on the left, and every reflection is studied with a poetic, passionate concern for the observation of reality.

While Italian painters who use perspective depict classical porticoes and rectangular buildings, Van Eyck describes the ornate interior of a Gothic cathedral.

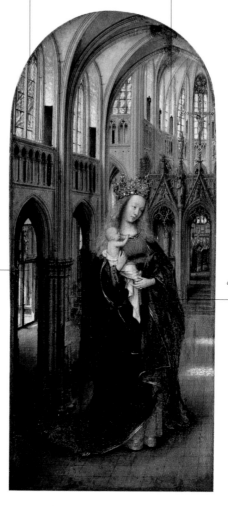

The lateral perspective is unusual but convincing— and very different from the central, symmetrical perspective preferred by Italian artists.

The Virgin is far out of proportion to the architecture, but the difference in scale does not produce an unpleasant or unnatural effect.

▲ Jan van Eyck, *Virgin and Child in a Gothic Church*, ca. 1430. Berlin, Gemäldegalerie.

Virtuosity and optical illusion: using the delicate technique of intarsia with a variety of natural woods, the artist creates an illusion of half-open doors.

In order to accentuate the work's experimentation with perspective, the artist juxtaposes the organic shapes in the vase of flowers with the sharp indentations of the geometrical solid in the cupboard.

Since intarsia was mostly used in a religious context, works often display liturgical objects.

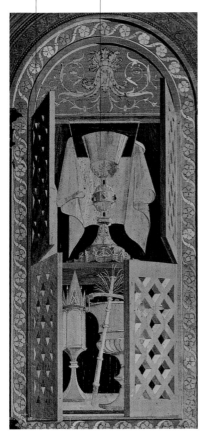

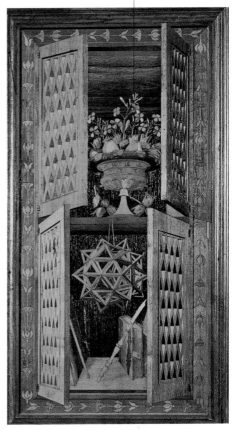

▲ Fra Giovanni da Verona, intarsia in perspective with liturgical objects, ca. 1490. Verona, Santa Maria in Organo.

▲ Fra Giovanni da Verona, intarsia in perspective with geometrical objects, ca. 1495, Monte Oliveto Maggiore (province of Siena), abbey church.

Humanism develops as a prevalently urban culture: humanists, painters, architects, and town planners become passionately interested in the city as a place of civilized, harmonious, and active community life.

The Ideal City

Related entries
Ferrara, Florence,
Milan, Urbino

Brunelleschi, Leonardo,
Mantegna, Piero della
Francesca

A realistic study of the Piazza del Duomo in Florence by Brunelleschi, now lost, is recorded in the early sources as one of the very first attempts at painting in perspective. It was not only an extraordinary effort but also a clear demonstration of the importance of the idea of "city" in the fifteenth century. In the exciting but disciplined atmosphere of humanism, in which the urge to discover was counterbalanced by the need to establish verifiable rules, foundations in geometry, and stylistic analyses, town-planning studies are at the center of the intellectual debate. The rediscovery of classical motifs and the clever modernization of building techniques produce clear-cut and progressive results, with harmonious proportions and dimensions commensurate with those of the human body. The concept that "man is the measure of all things" is taken as the point of departure in new thinking about the city. It leads not only to utopian and futuristic projects, but also to actual work on the ground, especially in Italy, whose importance lies not only in its architectural achievements but in the new social and ethical considerations behind them. Among the best examples are the Addizione Erculea (by Biagio Rossetti) in Ferrara; the little town of Pienza (by Rossellino); the design of the Palazzo Ducale at Urbino "in the form of a city" (by Laurana and Francesco di Giorgio Martini); and finally the extraordinary ideas first articulated by Filarete and later taken up by Leonardo for a new city dedicated to the Sforzas in the duchy of Milan, which never went beyond the planning stage.

The sea horizon is high in order to emphasize the extraordinary nature of the site, which is entirely surrounded by water at high tide.

The unmistakable outline of the abbey of Mont-Saint-Michel is shown with remarkable accuracy in this miniature. It is seen as an impregnable divine fortress, above which Saint Michael fights the devil.

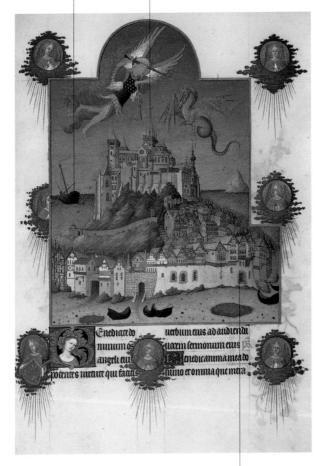

The little town is spread across the lower part of the rock and seems to be protected not only by its own walls but also by the bulk of the abbey.

◀ *Building Site for a Church*, ca. 1470, Parisian miniature from the *Roman de Giron de Roussillon*. Vienna, National Bibliothek.

▲ The Limbourg brothers, *The Mass of Saint Michael*, 1413–16, miniature from the *Très Riches Heures du duc de Berry*. Chantilly, Musée Condé.

The Ideal City

Using a strange and original compositional device, Memling situates a large number of episodes from the Passion within a single urban setting.

This idealized view of Jerusalem has a skyline of towers, spires, and other tall buildings, such as one might have found in commercial towns in Flanders.

For iconographical reasons, Memling has created a number of open spaces, into which he has inserted the scenes of the Passion. The realistic setting follows the common doctrinal advice that one should imagine the Gospel episodes taking place in one's own city.

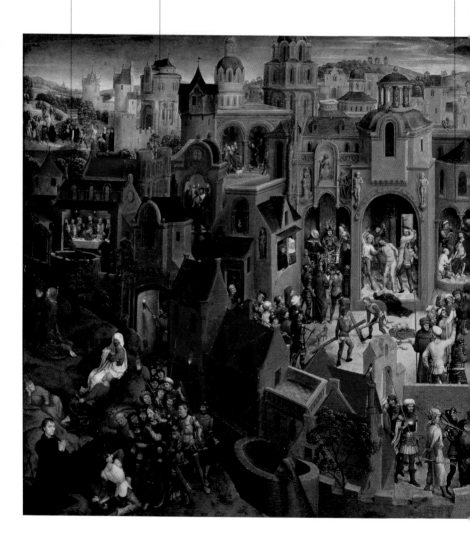

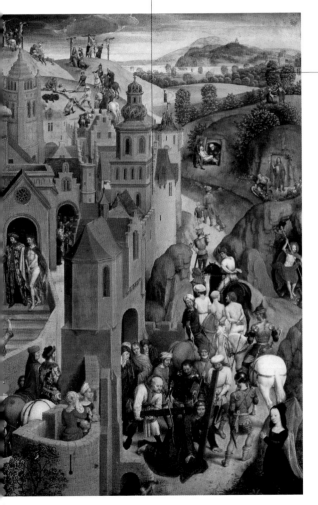

The detail of the walls illuminated by the sun allows us to note how Memling has rendered light and atmospheric effects with great precision.

Memling uses all the available space, not just within the city itself, but also in the background landscape. Nevertheless, the painting remains cohesive and easy to read.

◄ Hans Memling, *The Passion of Christ*, 1470–71. Turin, Galleria Sabauda.

The Ideal City

At the center of this painting is a large, round public building, though it may not be a religious one. The temple with a central plan was soon to become one of the most common subjects in experimental perspective painting in central Italy.

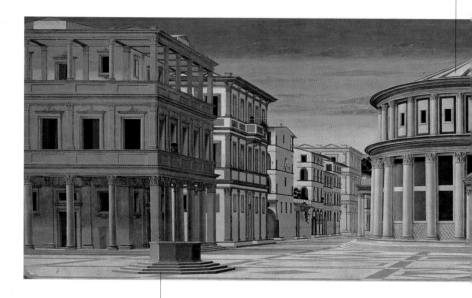

The vast urban space paved in marble is geometrically defined by two octagonal well-heads placed in perfect symmetry.

▲ Attributed to Francesco di Giorgio Martini or Francesco Laurana, *An Ideal City*, 1480–90. Urbino, Galleria Nazionale delle Marche.

The regular sequence of secular buildings is interrupted by a church facade at the back of the square.

The ideal city presented here follows a rigorous and closely worked-out architectural plan, which makes no allowance for green spaces; but nature peeks out from the hills glimpsed in the background.

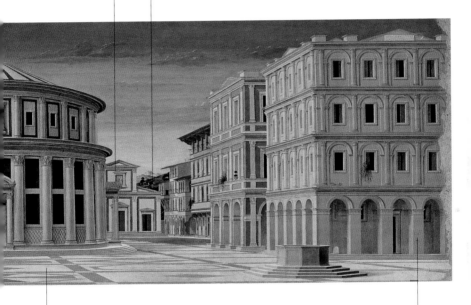

Scholars have put forward various suggestions as to the artist responsible for this extraordinary painting, but there is no certain attribution. However, it is certainly a product typical of the intellectual and artistic circles at the court of Urbino.

Although the city is arranged in a regular and symmetrical manner, the porticoed buildings along the sides, while similar in volume, are architecturally distinct.

The Ideal City

Pacher was a Tyrolean painter who kept abreast of the latest developments in humanist culture and the use of perspective. He sets this scene in the main street of a typical alpine town with sloping roofs and characteristic projecting balconies.

The arches at the back give rhythm and depth to the perspective while depicting a pleasant urban space for strolling, meeting other people, and resting.

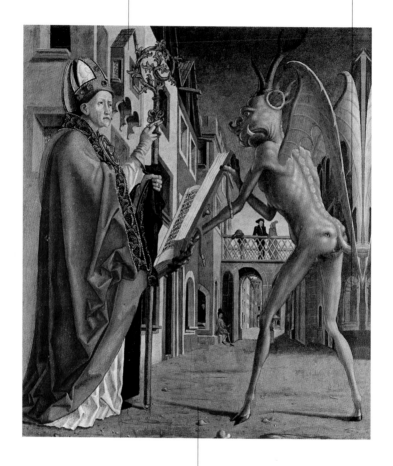

▲ Michael Pacher, *Saint Augustine Makes the Devil Hold Up the Missal*, ca. 1480. Munich, Alte Pinakothek.

The road surface is unpaved. Pacher's ideal city has all the serene simplicity of a Tyrolean market town on a sunny afternoon.

In the late fifteenth century, Venice was called "the most triumphant city in the universe," and its incomparable townscape became an increasingly popular subject for painters.

The three-arched bridge, the palaces with their characteristic chimneys, and the copious architectural detail in the Gothic windows and wooden shutters correspond exactly to the architecture of the real Venice.

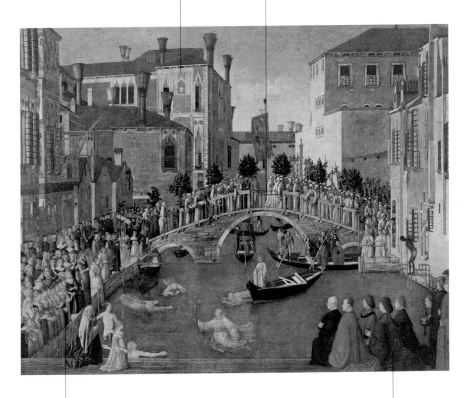

The throngs along the canal banks are watching the miraculous recovery of a reliquary that had fallen into the water. The scene is indicative of the mounting congestion in Venetian housing: the city had one of the highest population densities in Europe.

In the foreground, Gentile Bellini has painted himself and his family, including his father, Jacopo, and his brother Giovanni, both of whom were famous painters.

▲ Gentile Bellini, *Miracle of the Cross at Ponte di Lorenzo*, 1496–1500, from the cycle *Scenes from the Legend of the True Cross* for the Scuola Grande di San Giovanni Evangelista. Venice, Gallerie dell'Accademia.

The search for a golden rule that will provide a mathematical definition of beauty and a measure of harmony becomes an obsession for many Italian humanist artists.

Divine Proportion

During the humanist period, classical treatises on the theory of architecture were revived in an attempt to discover a practical system that would help artists in their work. At the center of the debate was the method proposed by Vitruvius, a scholar from the first century B.C. who drew an analogy between architectural structures and the human body. According to Vitruvius, if a man lies down flat with arms and legs outstretched, he fits exactly into a square and a circle whose center is his navel. This theory was based on the symmetry between the various parts of the "structure," whether architectural or anatomical, and was to become an essential point of reference in the Renaissance. Cennino Cennini suggested that the face, which could be divided into three parts, should be used as the basic unit of measurement. Lorenzo Ghiberti maintained in his *Commentari* that the Vitruvian system was inconsistent, and in order to fit the body within a circle, he offered an extremely elongated figure in which the proportion of head to body was as much as 1:9.5. Leon Battista Alberti suggested placing the human figure inside a complicated geometrical grid, consisting of six

▼ Jacopo de' Barbari, *Portrait of Luca Pacioli*, ca. 1495. Naples, Capodimonte.

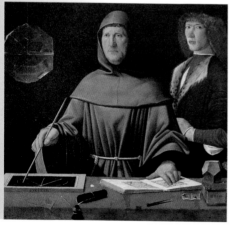

"feet" divided into ten "nails," which were then divided into ten "minutes." Luca Pacioli, inspired by both the treatises and works of Piero della Francesca, suggested dividing the human body into volumes taken from solid geometry, thereby arriving at a "divine proportion." Leonardo finally placed the human body within the circle and square in a coherent manner: in various drawings he suggested deconstructing the face within a regular grid, but he repeatedly pointed out the immense variety of physical types, facial expressions, and features.

Taking the navel as the center, Leonardo traces a circle around the naked man. The figure is also inscribed within a square. The combination of the two geometrical figures is by definition an expression of perfection ("squaring the circle").

As is often the case with Leonardo's papers and codices, the drawing is accompanied by written observations.

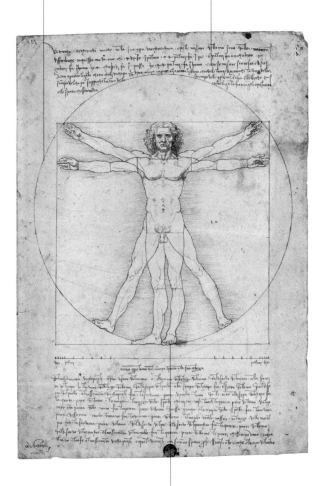

▲ Leonardo da Vinci, *The Proportions of Man According to Vitruvius*, ca. 1500. Venice, Gallerie dell'Accademia.

The arms and legs are drawn in two different positions so that they touch the edges of the circle and square. Underneath, Leonardo has also drawn a scale of measurement, so that his data can be checked geometrically.

The gradual change from the aristocratic profile to the frontal or three-quarters view is a reflection of the development of art toward the imitation of nature and the self-awareness of man.

Portraiture

Related entries
Aragon and Castile,
Bruges, Brussels, Burgundy,
Ferrara, Florence, Mantua,
Paris, the Tirol, Urbino

Antonello, Campin,
Christus, Fouquet,
Leonardo, Memling,
Pisanello, Van der Weyden,
Van Eyck

▼ Pisanello, *Portrait Medal of the Emperor John VIII Palaeologus*, 1438. Brescia, Museo della Città.

Fifteenth-century portraiture took its first step forward under the influence of Jan van Eyck, Petrus Christus, and Rogier van der Weyden. In their paintings the subjects were seen in three-quarters view and stand out from the background in such a way as to appear credible and alive. At first, the subjects were placed against neutral backgrounds and appear thoughtful or engaged in prayer. Increasingly, however, the artists utilized the space around them, depicting a room or a landscape. Humanist investigations and the increasing interest in collecting Roman antiquities (including coins) reinforced this tendency, with the result that the subjects assume the calm, self-confident attitude of Roman emperors. Closely linked to the collection of ancient coins was the production of portrait medals for the courts, a genre in which Pisanello takes pride of place. Meanwhile, portraits in sculpture took a sudden leap forward when some Florentine workshops began to transfer to marble the traditional wax votive portrait busts, whose verisimilitude was very striking. Various sculptors succeeded in obtaining similar results in marble or terra-cotta, producing portrait busts in full relief, which have greater immediacy and likeness than profile portraits in bas relief or even in painting. It was Leonardo, a pupil in the workshop of Verrocchio, who would be responsible for developing the portrait in three-quarters view. Shortly before that, a similar approach was adopted by Antonello da Messina, whose portraits have links with Van Eyck. His figures are half-bust, in three-quarters view, and stand out against a neutral background. Unlike most of the portraits painted by Flemish masters, however, the unknown men painted by Antonello look toward us, thereby initiating an original and captivating dialogue.

In the first half of the fifteenth century, Flemish portraits usually have a dark background, but architectural or landscape backgrounds become increasingly common later on.

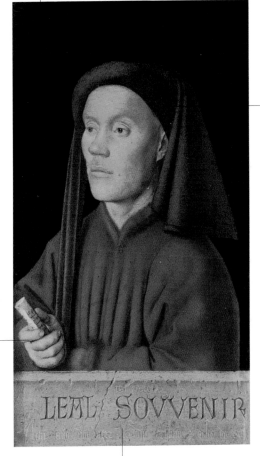

The young man's bust and head are in three-quarters view, but instead of looking at the spectator, he gazes into the distance.

Van Eyck makes a clear break with the courtly Gothic tradition of profile portraits: the hand resting on the ledge emphasizes the artist's intention to break through the surface that separates the painting from the natural world of the spectator.

▲ Jan van Eyck, *Portrait of a Young Man ("Timotheos")*, 1432. London, National Gallery.

The most important element in the painting is the trompe l'oeil inscription on the marble ledge: the portrait is thus presented as a "leal souvenir," a faithful record of the subject's true appearance, not an idealization or symbolic expression of a particular social rank.

Portraiture

Throughout Europe, the dark background remains the preferred setting for fifteenth-century aristocratic portraits.

The clear, sharp profile suggests a perfectly motionless pose, and it is achieved using a preparatory cartoon. Piero della Francesca also used his preliminary drawing of Sigismondo's head for a fresco in the Tempio Malatestiano.

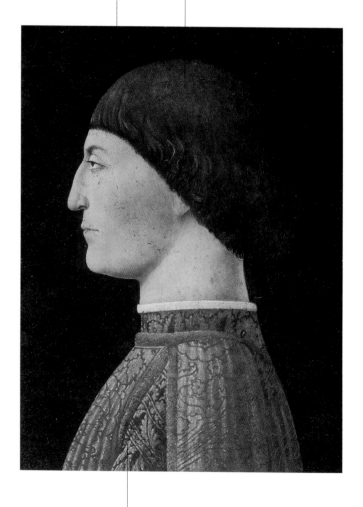

▲ Piero della Francesca, *Portrait of Sigismondo Pandolfo Malatesta*, 1451. Paris, Louvre.

The bust is also in profile. Sigismondo Pandolfo Malatesta, lord of Rimini, who also commissioned works from Leon Battista Alberti, wanted a perfectly classical image. He is thus portrayed using the style of a Roman coin.

The sitter, possibly a Florentine merchant who moved to Bruges, turns toward the spectator but does not look directly at him.

Memling was one of the first portrait painters to consistently paint rooms or landscapes in the background, rather than using a uniform dark backdrop.

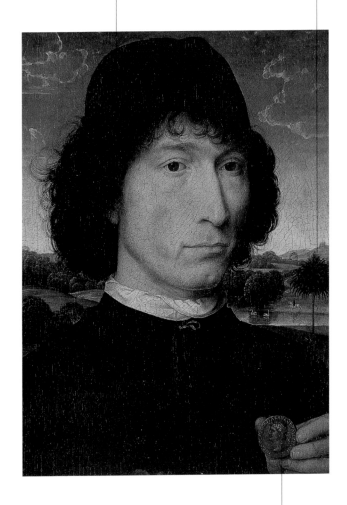

▲ Hans Memling, *Portrait of a Man with a Coin of the Emperor Nero*, ca. 1480. Antwerp, Musée Royaux des Beaux-Arts.

A coin with a Roman emperor in profile is shown in the foreground, emphasizing the new concept of the portrait.

As the king's chancellor, Jouvenel des Ursins was the highest dignitary at the court of France. Before painting this portrait, Fouquet made a careful preparatory drawing, now in Berlin.

The background is a wall decoration that combines humanist motifs (the small flat pilasters, marble paneling, and classical trabeation) with bright gilding and late-Gothic ornamental motifs.

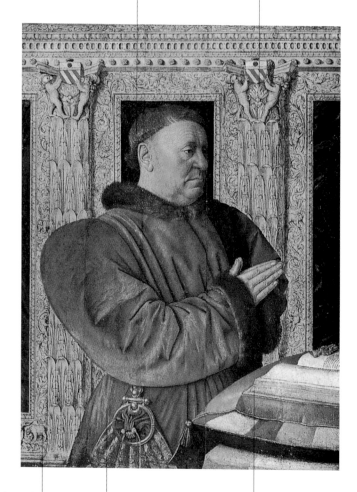

The bear is the heraldic emblem of the Ursins family.

▲ Jean Fouquet, *Portrait of Guillaume Jouvenel des Ursins*, ca. 1460. Paris, Louvre.

Jouvenel's broad body is placed diagonally, thereby occupying depth in space.

Jouvenel seems to be kneeling in prayer at a combined prie-dieu and lectern on which a holy book lies open. The pose is pious, but Fouquet lends it grandeur by extending Jouvenel's considerable bulk.

Antonello's male portraits rely on his knowledge of Flemish portraiture, but the liveliness of expression and the direct relationship with the spectator strike a new note.

The smile of the so-called unknown sailor has become proverbial. This is the only portrait by Antonello that still remains in Sicily, and the features and shrewd expression of the subject clearly portray a perceived Mediterranean "type."

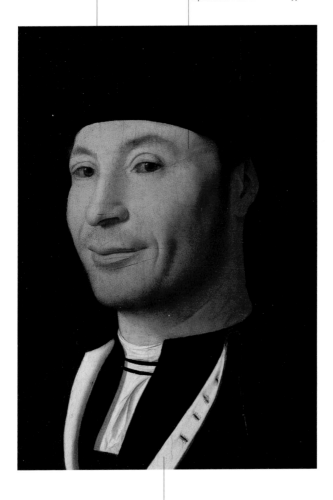

▲ Antonello da Messina, *Portrait of a Man*, 1476. Cefalù (Sicily), Museo Mandralisca.

The portrait has a dark background and uses a very restricted range of blacks and whites, thereby concentrating attention on the subject's face.

Particular care has been taken in rendering the fabric. Florentine workshops also had sculptors who produced busts in wax; the sculptors in marble or bronze had to emulate the realism achieved by these low-cost competitors.

The face is framed in a perfect hair arrangement and closely resembles the early female portraits by Leonardo, who was a pupil of Verrocchio.

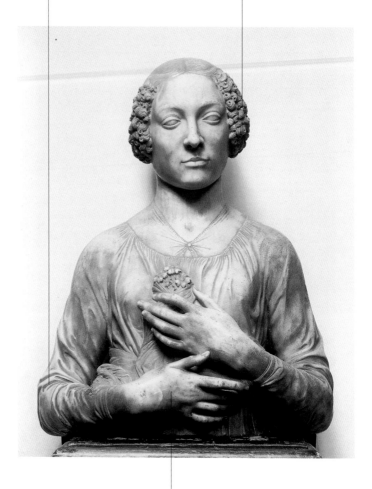

▲ Andrea del Verrocchio, *Portrait Bust of a Lady with a Posy of Flowers*, ca. 1480. Florence, Museo Nazionale del Bargello.

The inclusion of the hands in portrait busts is a significant innovation in the second half of the fifteenth century. Although arms and hands enhanced the vivacity and realism of the figure, they were often omitted because they substantially increased the price.

The young woman's fascinating and intelligent face (she is very probably Cecilia Gallerani, mistress of Ludovico il Moro, duke of Milan) reflects Leonardo's interest in observing geometrical rules. Her hair arrangement complements and emphasizes the oval shape of her face.

Her left shoulder is brightly lit from the side, accentuating the rotation of her body.

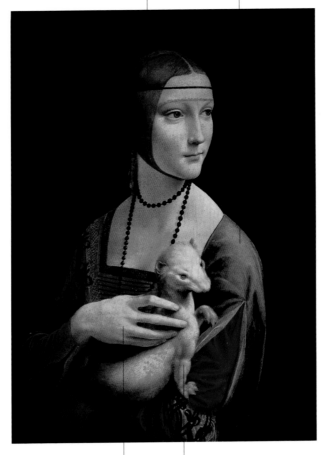

While her body leans backward, her right hand is brought toward the foreground and may at first seem out of proportion. The body is strikingly similar to the one on page 54, made by Verrocchio.

The rotation of the ermine runs opposite to that of the woman. Its presence adds something lively and fierce to the painting.

▲ Leonardo da Vinci, *Lady with an Ermine (Cecilia Gallerani)*, 1494. Krakow, Czartoryski Museum.

A considerable proportion of fifteenth-century artists remain anonymous. Many works are attributed to nameless artists whom critics identify by their most famous or characteristic work.

Anonymous Masters

Painters and sculptors in the fifteenth century rarely signed their works. The idea that art has a history that is linked to the works of individual great artists was beginning to take hold in Italy. Still, in terms of social status, sculptors and painters were regarded as skilled craftsmen, like tailors or armorers: valued for their manual and technical skills rather than for the poetic or conceptual content of their work. That explains why they were paid by the hour or the working day, and also why many works remain anonymous. In the second half of the century, however, the artist's self-image began to change. He started to feel that he was not just part of a local tradition or just another member of a craft guild. In order to satisfy the increasing demands of his patrons, he tried to develop a personal, independent style, so that his work could be distinguished from that of his competitors. Humanist thinkers began to compare the work of the artist to that of the poet, and fine art was promoted from the mechanical to the liberal arts. This new awareness was most strongly felt in select parts of Europe, such as Italy, Flanders, and, to some extent, Burgundy and Provence. Throughout northern Europe, however, even in advanced cities like Cologne and Nuremburg, artists remained within the ranks of skilled craftsmen. It was only after the mid-fifteenth century that German artists began to free themselves from their status as craftsmen. The vibrant and glorious career of Dürer brought the age of anonymity to an end and opened that of the humanist artist, who occupied a privileged position as a witness to history and society.

▼ Master of Saint Veronica,
Madonna and Child, 1410–15,
central panel of a triptych.
Cologne, Wallraf-Richartz
Museum.

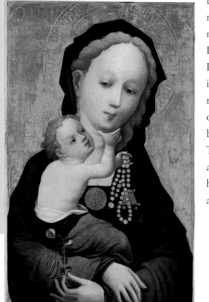

More Italian painters are known by name than are those from elsewhere, due to the greater availability of documentary sources and the new social status of artists. But many remain anonymous, both within and outside Italy.

The large arch, decorated with bas-relief scenes from the life of the Virgin (the Annunciation and the Visitation), is an eloquent demonstration of contemporary classical culture.

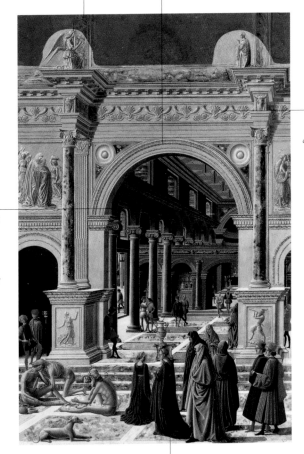

After much research and discussion, scholars have been able to identify the artist as Bartolomeo di Giovanni Corradini, also called Fra Carnevale.

The keen interest in perspective suggests a connection to the court of Urbino: the work was originally part of an altarpiece for a church there.

▲ Fra Carnevalel (Bartolomeo di Giovanni Corradini), *The Presentation of the Virgin in the Temple (?)*, 1467. Boston, Museum of Fine Arts.

As the child Mary makes her way toward the Temple, she is followed by the principal figures in the painting. Their stylistic cadence echoes the qualities of very late-Gothic art, but at the same time the artist reveals his familiarity with contemporary Florentine painting.

The fact that the figure of the Madonna is arranged according to strict geometrical rules reveals that the artist is familiar with the work of Jean Fouquet and shares the taste of the French court.

The serious, dignified angels echo the late work of Hugo van der Goes. Such stylistic qualities have led some critics to attribute the group of works in the Moulins Triptych *to the Flemish painter Jean Hey.*

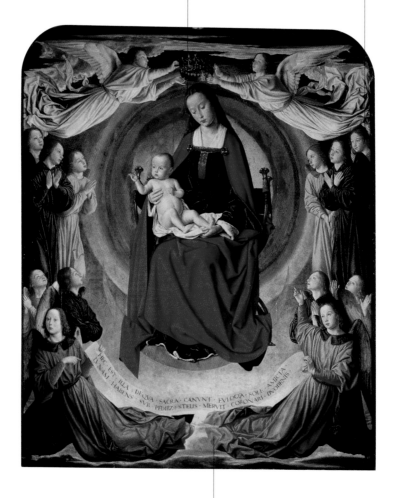

▲ Master of Moulins (identified as Jean Hey or Jean Prévost), *Madonna and Child*, 1498, central panel of the *Moulins Triptych*. Moulins, cathedral.

This panel is the central part of a triptych and has been used as a "name piece," that is, as a reference point to which other works by the same hand can be compared, hence the name given to the artist.

This panel was originally part of a polyptych, which is now divided among several museums. Taken as a whole, it provides the name conventionally given to the artist.

The anonymous artist was almost certainly of Flemish origin, but he worked in the heart of France in the closing years of the fifteenth century. He seems to delight in thoroughly investigating the tiniest details.

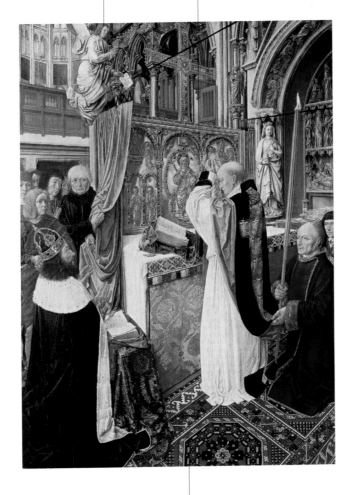

Perspective is not always rendered correctly. In order to convey the rich design of the carpet, for example, the artist does not hesitate to tip the viewpoint toward the spectator.

▲ Master of Saint Giles, *The Mass of Saint Giles*, 1490–1500. London, National Gallery.

Anonymous Masters

Here and in the many other works by this anonymous German artist, the female figures with their faces framed by veils are an unmistakable signature.

The painter uses either gold or brocade backgrounds in his works, with imaginary landscapes of water and rocks that are somewhat reminiscent of contemporary Flemish painting.

The Master of the Saint Bartholomew Altar worked principally in Cologne, and the stylistic qualities of his work are easily recognizable. The list of his works is substantial, and many consider him the greatest anonymous artist in fifteenth-century Europe.

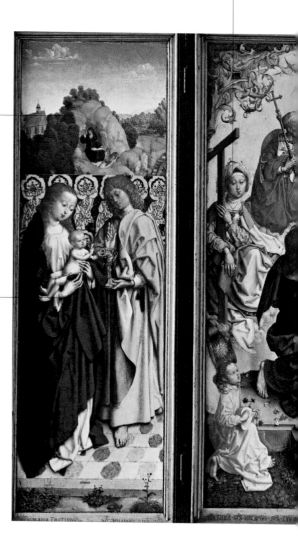

▲ Master of the Saint Bartholomew Altar, *The Incredulity of Saint Thomas Altarpiece*, ca. 1490. Cologne, Wallraf-Richartz Museum.

While the overall context of the painting is fully humanistic, this Rhenish artist uses elaborate late-Gothic decorative features.

German sacred art often evinces a desire to explain and teach. Thus the saints in the side panels are set out in rows and are immediately identifiable from numerous explicit attributes. Their names are written underneath as well.

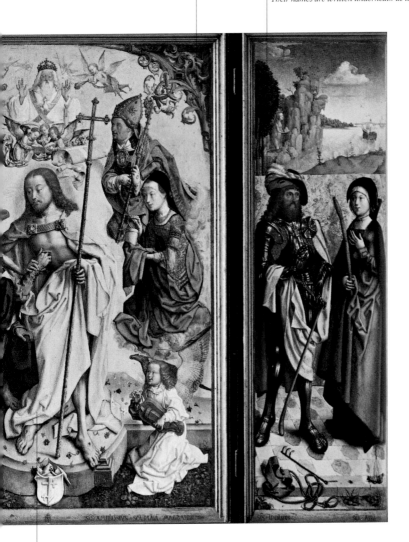

The striking plasticity of the principal figures standing on a sort of podium is very reminiscent of the groups of carved figures on late-Gothic wooden altars.

The fifteenth-century artist is not an isolated creator. The figurative arts are group activities in which a master always has a substantial number of assistants.

The Workshop

A Florentine chronicle from the year 1472 helps give us some idea of the comparative incidence of the various craft activities: according to this account, there were forty active workshops of painters in Florence, forty-four of goldsmiths, more than fifty of high- and bas-relief engravers, and more than eighty of wood inlayers and engravers. The basic workshop tool was the drawing. In art workshops in late-Gothic times, it was customary to make notebooks of drawings: drawings of individual figures, animals, plants, heraldic emblems, and decorative details were used as a catalogue of iconographic formulae. These elements, established by tradition, were easily adapted to the most diverse techniques and applications, from painting to goldwork, textiles to miniatures, and furniture decoration to clothes—all to satisfy court tastes. At the end of the fifteenth century, the late-Gothic notebooks were augmented and gradually replaced by "model books," whose new purpose was to disseminate knowledge of ancient works, and by collected studies of posed figures, anatomy, and drapery. Especially in Tuscany, the latter were used to train pupils and to bring their style into line with that of their master. In some cases the stock drawings were used in combination with posed models, usually workshop boys.

Related entries
Similar workshop practices were used throughout fifteenth-century Europe

For family links within a single workshop, see especially the entries for Erhart, the Limbourg brothers, Filippino and Filippo Lippi, Pollaiolo and Van Eyck; and for formative master–pupil relationships, see Fra Angelico–Gozzoli, Campin–Van der Weyden, and Verrocchio–Leonardo–Perugino

▶ Masolino and Masaccio, *Madonna and Child with Saint Anne*, 1424. Florence, Uffizi.

A direct comparison can be made between Verrocchio and Leonardo in the execution of the two angels: the angel facing forward is the work of Verrocchio, while the one in profile was painted by Leonardo, who was barely twenty at the time.

The work of a third painter—anonymous and unskilled—can be seen in the mediocre, stiff hands of God the Father at the top.

The part of the landscape that is painted in more delicate, sfumato tones betrays the hand of the young Leonardo, while the palm tree and the sharper natural background on the right are the work of Verrocchio.

This painting was executed in Andrea Verrocchio's workshop in Florence, and it is a typical product of several hands.

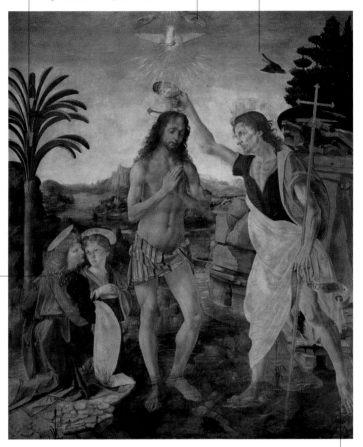

▲ Verrocchio and Leonardo, *The Baptism of Christ*, 1474. Florence, Uffizi.

The graphic, sinewy figure of Saint John the Baptist is the work of Verrocchio, the "owner" of the workshop, whereas the figure of Christ (at least the face, trunk, and feet) was entrusted to Leonardo, the most brilliant artist in the workshop.

Of all painting techniques, fresco demands the quickest work. Because the pigment must be applied while the plaster is damp, the artist must calculate how much he can paint in a day.

Fresco

▼ Unknown Sicilian artist, *Pietà with the Symbols of the Passion*, ca. 1470. Piazza Armerina (Sicily), Gran Priorato di Sant'Andrea.

The fresco dominated much of the history of Italian painting. To make a fresco, the wall surface is first smoothed with a layer of fresh plaster. The artist then sketches a preliminary drawing, either transferring a pre-made cartoon by means of powdered charcoal or sketching directly on the wall using a technique called sinopia. Then a second, very thin layer of plaster is applied, allowing the drawing underneath to show through. While this plaster is fresh, the paint is laid on, and the pigments are bound up in a tough crystalline structure as the plaster dries. The gradual mastery of perspective in fresco commenced with the Brancacci Chapel (Santa Maria del Carmine) in Florence, decorated by Masolino and Masaccio (begun in 1424), and then *The Trinity* by Masaccio alone in Santa Maria Novella (1426). It continued in the frescoes of Paolo Uccello and Fra Angelico, and finally in the *Life of Saint John* frescoes by Filippo Lippi at Prato, just outside Florence. Meanwhile, Pisanello represents the twilight of the Gothic: its courtly gilded works and its fascination with the antique. After the

mid-fifteenth century, Italian painting began to acquire a common means of expression, with fresco as its principal form. In 1481, Pope Sixtus IV summoned the best painters working in Florence to fresco the chapel he had just built in the Vatican. These artists included not only Perugino and Botticelli but also Ghirlandaio, Cosimo Rosselli, and Luca Signorelli. The Sistine Chapel frescoes represent the collective triumph of the Florentine school.

Strange, unrealistic rocks emerging from distant landscapes are frequently seen in Ferrarese painting. They are in fact unmistakable signs of Ferrara artists' eccentricity and originality.

The figures of the three Graces, inspired by a Hellenistic group of statuary, add a classical element to the scene: the world of humanism is gradually supplanting the romantic atmosphere found in late-Gothic courtly frescoes.

▲ Francesco del Cossa, *The Triumph of Venus* (detail), 1469–70. Ferrara, Palazzo Schifanoia, Salone dei Mesi.

The realistic portrayal of the young people meeting, embracing, and kissing blends successfully with the allegorical and humanist elements. Fresco technique favors bright colors and strong, clear light.

Fresco

Above the Madonna is a Resurrection of Christ in a space painted to look like an apse. It is intended to create a time and space different from those of the scene below.

The shallow chapel (scarcely more than a niche) is completely covered in fresco painting, with the clear aim of increasing the sense of space.

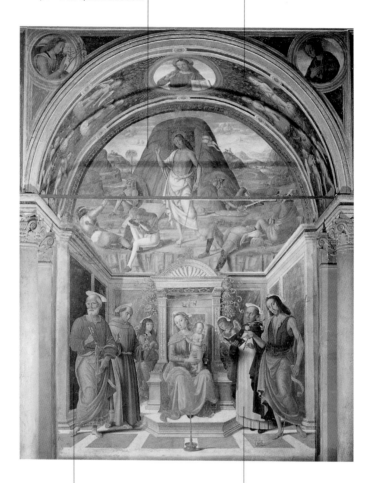

The marble panels on the walls and the Madonna's elegant throne are in a style suited to the Montefeltro court at Urbino, where Giovanni Santi was an authoritative figure: not just as a painter, but also as an intellectual and a writer.

This fresco, by Raphael's father, simulates an altarpiece, depicting a "Sacra Conversazione" (Mary with attending saints) and using perspective to give an illusion of depth.

▲ Giovanni Santi, *Sacra Conversazione*,
ca. 1480. Cagli, San Domenico.

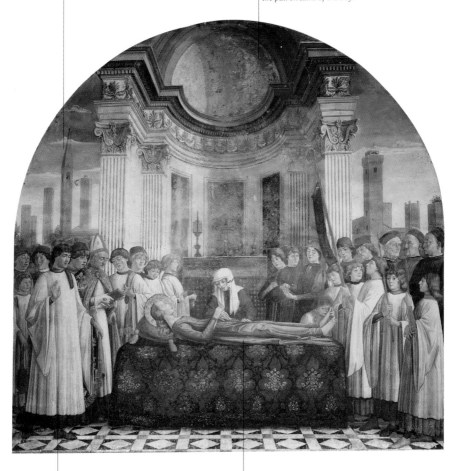

In the background, on both sides, are the unmistakable towers of San Gimignano.

The space is organized around a large, open, architectural structure consisting of a thoroughly humanist apse, with marble panels, classical pilasters, and a bas-relief frieze. In front of the altar stands the funeral catafalque of Saint Fina, the patron saint of the city.

The foreground figures are dressed in white, which increases the diffused luminosity of the whole fresco.

The stiff, supine corpse of the saint makes an obvious contrast with the stark verticality of the towers. Every year, according to legend, clusters of violets appear on the towers of San Gimignano on the day of her death.

▲ Domenico Ghirlandaio, *The Funeral of Saint Fina*, 1475. San Gimignano, collegiate church, chapel of Santa Fina.

Altars with folding panels are a combination of painting and sculpture, and they mark the transition from Gothic to full Renaissance in Germany right up to the Reformation.

Winged Altar

Winged altars are characteristic devotional works of art in German-speaking countries in the fifteenth and early sixteenth centuries. They have two basic components: a shrine that is always in relief, and two or more hinged panels, decorated on both sides, which can be opened or closed in accordance with the requirements of the liturgical year. The panels may be painted or carved, but panel carving is always shallower than the carving on the altar shrine. In addition, Gothic altars in northern Europe often have a painted or carved predella as well as a virtuoso superstructure with an open-work spire. Few of these altars have survived in sound condition. As a result of Protestant iconoclasm, the fragility of the materials used, changes in taste, and the unjustified preeminence given to painting over sculpture in a theoretical hierarchy of the arts, they have been almost entirely lost. In the commissioning of large, complex altars involving a number of artists, extremely detailed contracts were drawn up, assigning specific responsibilities to sculptors versus painters. In most cases, however, commissions were given directly to the very well-equipped wood-carvers' workshops, which usually had their own gilders and decorators. The altars developed rapidly. Thanks to a trio of great specialists (Michael Pacher, Veit Stoss, and Tilman Riemenschneider), the carving on the central shrine developed from an initial stage of static, frontal figures to compositions with complex dynamic scenes.

▼ Michael Pacher, altar at
Sankt Wolfgang with the
outer wings closed, 1471–80.
Sankt Wolfgang (Austria),
parish church.

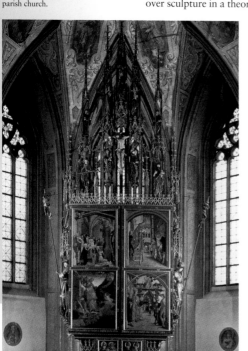

A comparison with the illustration on the previous page shows that the altar is now half open. The outer panels swing out, and the central part of the altar appears as a kind of eight-panel polyptych.

The masterly, complex open-work superstructure is always visible, however many panels are open or shut.

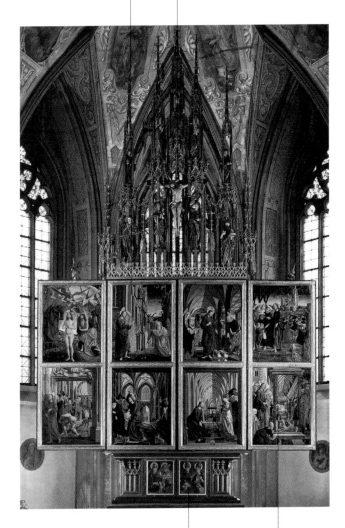

▲ Michael Pacher, altar of Sankt Wolfgang with the inner panels closed, 1471–80. Sankt Wolfgang (Austria), parish church.

The predella panels are closed.

The eight painted panels depict scenes from the life of Christ.

Winged Altar

Four scenes from the life of the Virgin are painted on the inside of the inner panels.

When the panels are fully open, a richly carved and gilded scene of the Coronation of the Virgin is revealed.

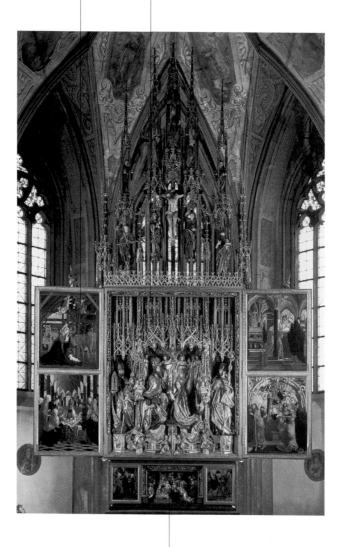

▲ Michael Pacher, altar of Sankt Wolfgang with the inner panels open, 1471–80. Sankt Wolfgang (Austria), parish church.

The predella panels are now open and reveal a bas-relief of the Adoration of the Magi, flanked by two painted scenes (on the inside of the panels) of the childhood of Christ.

In fifteenth-century Europe, wood is the material most readily available and most frequently used. The sculptural styles found in the various countries have many common elements.

Wood Sculpture

Fifteenth-century wood sculpture produced a number of devotional figures that were destined to enjoy extremely wide diffusion, becoming almost a mark of Christian identity among the various nations and languages. Among the most common figures are the "Beautiful Madonna," derived from French Gothic models but acquiring a fresh, smiling sweetness; Christ riding a donkey, used in processions on Palm Sunday; Christ crucified, often with strong overtones of pathos; and the Pietà—the Madonna holding the dead Christ on her lap. Limewood altars came into widespread use in central Europe. They are indicative of the triumph of wood sculpture and enjoyed increasing success, particularly in the 1470s, in parallel with the development of other items of church furniture: pulpits, tabernacles, portals, sculpted tombs, and especially the grand and complex choir stalls. However, a kind of inferiority complex regarding wood persisted for a long time; it was considered poor and common by comparison with noble materials such as marble and bronze. Wood sculpture was consequently nearly always anonymous, and most of it was gilded or painted. For a long time it was the rule that German sculpture, whether in wood or stone, had to be polychromed. It was only at the end of the fifteenth century, thanks to the striking figures that Jörg Syrlin included in the choir of Ulm cathedral, and the arrival on the scene of the great Riemenschneider, that the natural color and grain of the limewood were allowed to remain in view.

Related entries
Wood sculpture is found throughout Europe in the fifteenth century, though less often in Italy

Della Quercia, Donatello, Erhart, Multscher, Pacher, Stoss

◄ Master of the Kruzlowa Madonna, *The "Beautiful Madonna" of Kruzlowa*, ca. 1410. Krakow, National Museum.

The Madonna weeps as she gazes at the body of Christ. Such intense expressions of emotion may be linked to mystery plays, which dramatized the life and death of Christ.

Christ's wounds are dramatically displayed in order to arouse strong emotions in the viewer.

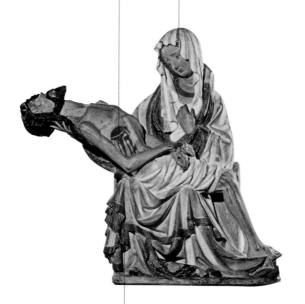

The Pietà sculptural group is called Vesperbild *in German. With few variations (e.g., in the Madonna's veil, which has numerous folds at her forehead in the earliest examples, as in this one), it is found countless times throughout central and northern Europe in the fifteenth century.*

▲ Salzburg master, *Pietà*, ca. 1400.
Munich, Bayerisches Nationalmuseum.

In all wooden choirs, the stalls themselves consist of a row of fold-up seats with high engraved backs, beneath a Gothic open-work canopy.

The ornamentation is extraordinarily varied and imaginative, providing in effect an anthology of late-Gothic decoration.

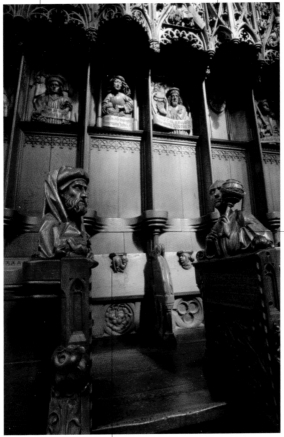

The entrances to the stalls are flanked by realistic life-size sculptures of prophets, scholars, and thinkers from antiquity. Their unusual and evocative presence makes these Ulm choir stalls unique.

Since church services were very long and it was necessary to remain standing for protracted periods, small projections called misericords were provided for participants to lean against. In nearly all fifteenth-century wooden choirs, the reliefs on these projections have a lively comic flavor.

▲ Jörg Syrlin, choir stalls, 1469–74. Ulm, cathedral.

The Gothic polyptych tradition gradually gives way to unitary altarpieces, with the result that the regular but rather monotonous sequence of figures is transformed into an animated narrative scene.

Polyptych and Altarpiece

Composition is of fundamental importance in the arrangement of fresco cycles or large, complex narratives, and it became particularly important in altar painting from the 1430s onward, when artists started to use a single square or rectangular panel instead of a triptych or polyptych. When a painting consists of a series of adjacent panels within a single frame, the composition has to be simplified, demanding a simple sequence of scenes or figures. But in the case of a unitary altarpiece, the figures enter into direct reciprocal relationships within an architectural or natural setting that both accommodates them and suggests how they should be arranged in space. This reciprocity was achieved gradually, rising both in the Flanders of Van Eyck and Van der Weyden and, contemporaneously, in Florence, where artists such as Fra Angelico and Domenico Veneziano were willing to experiment.

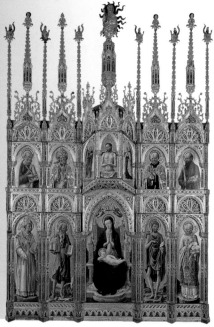

An eloquent example—and one that was to become a model for unitary altarpieces depicting architecture—is Piero della Francesca's *Brera Altarpiece*, in which a group of thirteen perfectly stationary figures is placed within a Renaissance church setting. The church is of moderate size but painted with great care: the proportions are measured against those of the human body, and the accuracy of the perspective, bathed in light, makes it possible to work out the actual measurements of the church. Quite apart from its symbolic significance, the famous detail of the ostrich egg hanging near the back is an excellent demonstration of Piero's total control over the representation of depth in space.

As often happens in religious paintings, the Virgin is larger than the other figures. Masaccio arranges the central group as a powerful geometrical block in an attempt to achieve a simple, unitary image.

This first work by Masaccio (he was barely twenty-one at the time) is a small triptych with a traditional composition, including a medieval-style gold background.

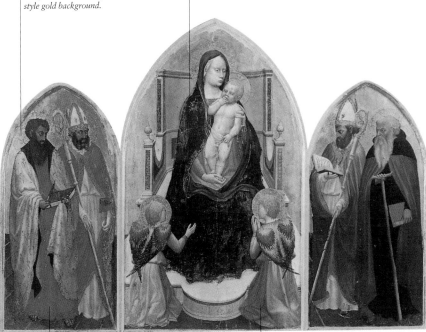

The crosiers of the two bishop-saints in the side panels are symmetrical and convergent, drawing the spectator's gaze toward the middle.

The angels with their backs turned and the semicircular step reveal Masaccio's interest in conveying depth.

◄ Antonio Vivarini, *The Certosa di Bologna Polyptych*, 1450–60. Bologna, Pinacoteca Nazionale.

▲ Masaccio, *The San Giovenale Triptych*, 1422. Cascia di Reggello, San Giovenale.

Polyptych and Altarpiece

The hinges joining the various panels are easy to see, because the polyptych has been dismantled, dispersed, moved, and reassembled more than once in its long history.

This great Flemish masterpiece is arranged on two levels. The four main panels are painted on the front only, whereas the eight side panels are painted on both sides.

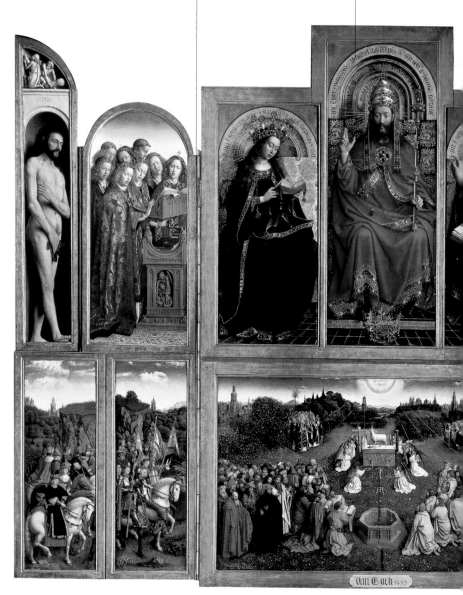

The difference of scale used on the two levels of the polyptych is very evident: the figures in the upper tier are fewer in number and much larger than the figures in the crowds below.

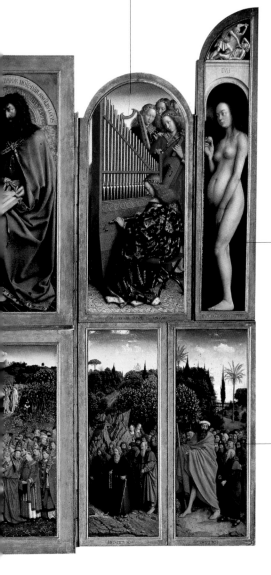

The figures of Adam and Eve at the outer edges of the upper tier emerge from dark niches in a strikingly realistic way.

The lower panels depict a long procession of saints moving toward a paradise garden, where they will join in the worship of the Mystic Lamb—a symbol of Christ's sacrifice for the redemption of sins.

◄ Hubert and Jan van Eyck, *The Adoration of the Lamb Altarpiece*, 1426–32. Ghent, Saint-Bavon cathedral.

Although the central part is taller than the rest of the painting, as often happens in polyptychs, the compositional space here is unitary, and at the center, by the cross, the figures are arranged in depth.

The scene is arranged within a strangely cramped room whose side walls can be discerned near the corners.

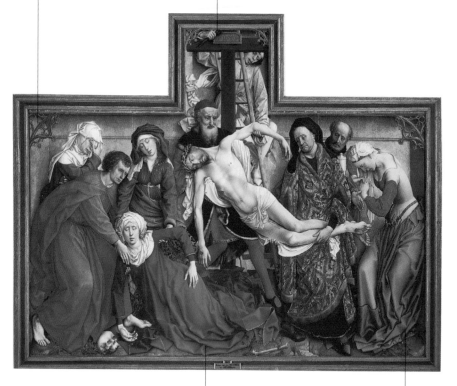

Van der Weyden does not simply abolish the division into compartments; he consciously takes advantage of the possibilities offered by a unitary altarpiece: the bodies of Christ and the fainting Virgin are arranged horizontally in a way that would not have been possible in a polyptych.

The pose of Mary Magdalene on the extreme right seems to stress the rounded, fluid line, as does the gesture of Saint John on the left.

▲ Rogier van der Weyden, *The Deposition of Christ*, 1430–35. Madrid, Prado.

*Among the earliest and best-organized
unitary altarpieces in Florence is* The
Saint Lucy Altarpiece. *The figures here
are arranged in relation to a large, well-lit
architectural structure.*

*The lines of the architecture and the
diagonal arrangement of the figures
at the sides emphasize the central
position of the Madonna.*

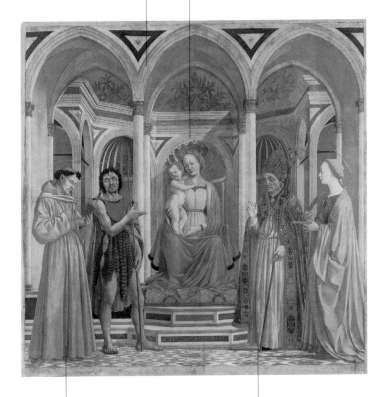

*On the left are Saint Francis and Saint
John the Baptist, and on the right are
Saint Zenobius and Saint Lucy. The
altarpiece originally hung in a church
dedicated to Saint Lucy, hence its name.*

*Although a unitary perspective is
adopted, the panel still has echoes
of Gothic polyptychs in the three
arches and the symmetrical
arrangement of the static figures.*

▲ Domenico Veneziano, *The Saint Lucy
Altarpiece*, 1445–48. Florence, Uffizi.

Polyptych and Altarpiece

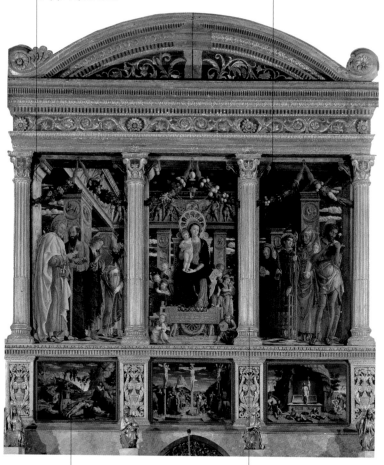

Mantegna has solved the tripart division problem by arranging the whole scene in a single, grandiose architectural space: a large hall supported by pilasters. It is no coincidence that the painting is known in Italian both as the pala (altarpiece) and the trittico (triptych) of San Zeno.

The rich garlands of leaves and fruit that hang in festoons from above are another unifying element in the scene.

The large panels in the predella are copies: Napoleon took the originals to France.

The frame, designed by Mantegna himself, becomes an integral part of the scene: the columns fit the architectural design of the interior.

▲ Andrea Mantegna, *The San Zeno Altarpiece*, 1459. Verona, San Zeno.

Giovanni Bellini and Mantegna were brothers-in-law and the same age. Initially Bellini relied on somewhat conventional models: this richly carved frame surrounds a traditional two-tier polyptych with a predella.

The splendid square panels at the top are smaller than those below.

The narrative scenes in the predella are the work not of Bellini but of a workshop assistant.

The large figures at the lower level are separated by broad columns and have no particular compositional relationship to each other. Each is placed in a different landscape.

▲ Giovanni Bellini, *The Saint Vincent Ferrer Polyptych*, 1464–68. Venice, Santi Giovanni e Paolo.

For visual and compositional reasons, the artist has made the Virgin's body unnaturally long. By doing so, he has situated her head at the top of an ideal triangle formed with the other figures.

The throne is placed within an elegantly humanist pavilion on a square base.

The two lateral saints are placed in front of the pilasters of the building containing the throne. On the far side, beyond the arch, hang some drawn curtains.

▲ Ercole de' Roberti, *The Santa Maria in Porto Altarpiece*, 1480. Milan, Pinacoteca di Brera.

The tall, elaborate podium supporting the Virgin's throne has an octagonal base. The inclusion of the pilasters made it possible to add a small marine landscape, suggestive of the coast of Romagna. The altarpiece was originally intended for the church of Santa Maria in Porto Fuori, near Ravenna.

This polyptych is fortunately complete. Rows of small figures of saints can be seen in the predella and along the pilasters at the sides.

In some parts of central Italy one finds fascinating hybrids combining perspectival innovation and surviving late-medieval models.

The four-lobed pinnacle contains a bust of Christ Pantocrator.

The jagged, carved edges of the frame and crown, together with the rich, uniform gold ground, keep the altarpiece within the stylistic sphere of the very late Gothic.

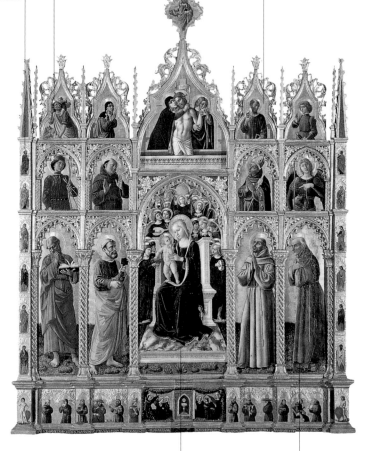

The central figure of the Virgin, enthroned and worshipped by angels, is conceived as a self-contained devotional panel. Like the Pietà above it, this scene is effectively independent of the other figures in the polyptych.

The painter has included a unifying element: the rough ground in perspective glimpsed below and behind the lateral saints.

▲ Niccolò da Foligno (known as "l'Alunno"), polyptych, 1471. Gualdo Tadino (Perugia), Museo Civico.

*The Flemish technique of soaking pigments in various oils—
linseed, walnut, poppy—leads to one of the most significant
innovations in the history of painting.*

Oil Painting

For almost the whole of the fifteenth century Flemish painters held sway in the European art market and influenced stylistic trends in a number of countries. Their success owed much to the dazzling luminosity of their pictures, which teemed with fascinating, minute, descriptive details taken from everyday life. The secret behind these panels was eagerly sought by competitors, and it lay in the use of oil as a binding agent. Because of its greater fluidity and transparency, oil paint can be applied in very thin superimposed layers. Until then, artists had used tempera paint, which is less shiny and permits only a certain amount of detail, producing effects that are not dissimilar to those of fresco painting. Now that the Gothic tradition of gold grounds and metal inserts was fading, Flemish artists used oils to apply paint in a succession of subtle, translucent layers, producing transparent effects and an exceptional brilliance of light and atmosphere. As a result, they were able to achieve optical "truth," imitating the effects of light on all kinds of surfaces. Refined and very expensive paints (such as gold, green from malachite, pale blue from lapis lazuli, and red from cochineal) gained in prestige and intrinsic value as well. Oil paints were adopted in Italy only in the 1470s and were at first used in combination with tempera. Eventually they became the predominant painting medium, and canvas replaced wooden panels as the support of choice.

▶ Robert Campin, *Saint
Veronica*, ca. 1410.
Frankfurt, Städelsches
Kunstinstitut.

The background is not uniformly dark. Although he employs only dark colors and very few details, Petrus Christus manages to create an atmospheric background.

The luminosity of oil paint enables the painter to create subtle effects of light, as well as changes of tone that were impossible with the thicker tempera and fresco paints.

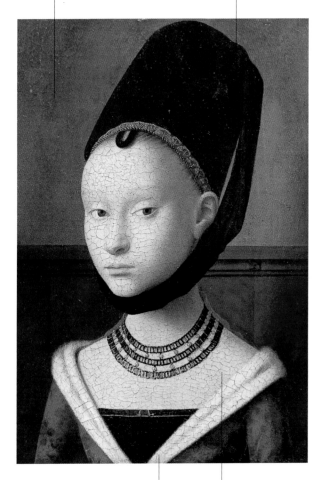

Especially where the colors are paler, one can clearly see a typical side effect of using oil paints: craquelure, the fine cracks that appear when the oil dries. They are particularly evident in panel painting.

▲ Petrus Christus, *Portrait of a Young Woman*, ca. 1470. Berlin, Gemäldegalerie.

The choice of colors is simple and fundamental, producing exquisitely refined harmonies.

Late-Gothic illuminated codices are examples of a particularly private kind of art: they were intended to be handled and examined only by select courtiers.

Miniature

▼ Rogier van der Weyden, *A Book Is Presented to Philip the Good*, ca. 1446, miniature in the *Chroniques de Hainaut*. Brussels, Bibliothèque Royale Albert I.

The heyday of the lordly court spurred considerable development in the art of the miniature. For centuries, books had been almost exclusively for the use of ecclesiastics and were to be found principally in the libraries of the great monasteries. Very few codices were intended for laymen. At the end of the fourteenth and the beginning of the fifteenth century, however, kings, princes, and noblemen began to commission and receive wonderful illuminated codices. Some of these have devotional content—Bibles or the very popular books of hours—while others contain stories of chivalry or treatises on learned topics; but very often the most important aspect of a codex is not the text but the decorative images that accompany it.

Although traditional elements persisted, such as decorated initials or ornamental bands along the edges, other aspects of miniature painting changed noticeably. Increasing importance was given to complex scenes, which were elaborated with imposing display despite the small dimensions of the page, and they might even occupy a whole page. In the vignettes accompanying some of the more precious codices, a lord could enjoy seeing himself posed in everyday situations: at ease or busy with his favorite activities. The court became the ideal (and often idealized) place of delights, leisure activities, and refinement: at its center was the lord, who created, or liked to imagine that he created, a sophisticated world in his own image and likeness.

The scene is centered on the Garden of Eden, enclosed by a polygonal wall, where Adam and Eve are about to commit their original sin. On the left they are expelled from paradise through a towered gate. Above, Adam toils in the fields while Eve tends sheep and spins their wool.

Boccaccio's book Concerning the Fates of Illustrious Men and Women *tells the stories of notables from biblical, classical, and medieval history. This volume was produced in Paris at the time when the art of illumination flourished there, under the patronage of the French kings and their courtiers.*

Boccaccio, dressed in red scholar's garb, is seated at a table on which his book lies propped on a lectern. His finger is raised in a gesture of speaking. He begins his narrative with the lives of Adam and Eve.

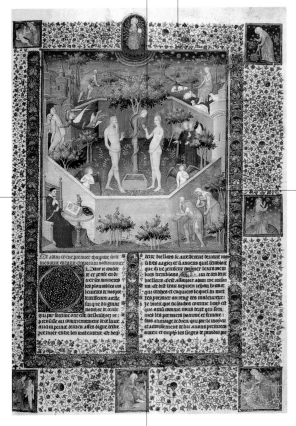

Stooped with age, Adam and Eve approach the author to tell him their story.

Little vignettes in the borders of the page depict the creation of the world, commencing at the upper right and proceeding clockwise.

▲ Boucicaut Master and Workshop, *The Story of Adam and Eve* in Giovanni Boccaccio's *Concerning the Fates of Illustrious Men and Women*, ca. 1415. Los Angeles, J. Paul Getty Museum.

This complicated episode from a chival-rous romance, in which the characters personify the sentiments of honor and love, is little more than a pretext for free and delightful illustrative invention.

The incomparable fascination of the miniatures in this codex lies partly in the extraordinary effects of nocturnal light. The figures glow in the faint illumination and cast long shadows.

The broad decorative bands are neatly separated from the rectangular narrative scenes.

This codex is almost without peer and its attribution is complicated. It is known to be of Flemish-Provençal stylistic background, and scholarly opinion tends to ascribe the painting to Barthélemy d'Eyck. Some, however, suggest it was done by another hand, called the "Master of King René of Anjou" or "Master of the Coeur d'amour épris" after this work.

▲ Master of King René of Anjou or Barthélemy d'Eyck, *The Offering of the Heart*, ca. 1450, from the *Coeur d'amour épris*. Vienna, Österreichische Nationalbibliothek.

The splendid Bible commissioned by Borso d'Este, duke of Ferrara, was a great collective enterprise. In addition to the calligraphers who wrote the text, a number of miniaturists under the direction of Taddeo Crivelli were responsible for the decoration.

Each page is elegantly organized, with two columns of text, broad bands of decorative volutes, and spaces for inserting figurative scenes.

▲ Taddeo Crivelli and other miniaturists, *Incipit of Saint Mark's Gospel*, ca. 1470, from the *Bible of Borso d'Este*. Modena, Biblioteca Estense.

There are two different illustrations on this page: below the incipit panel is a representation of Saint Mark busy writing his Gospel, while at the bottom, below the relevant text, is Saint John the Baptist preaching.

Animals have been introduced among the volutes, as well as references to Este heraldic symbols.

The gold sprinkled over the clothing of the Virgin and the Child is an elegant device that Fouquet often used to create effects of light.

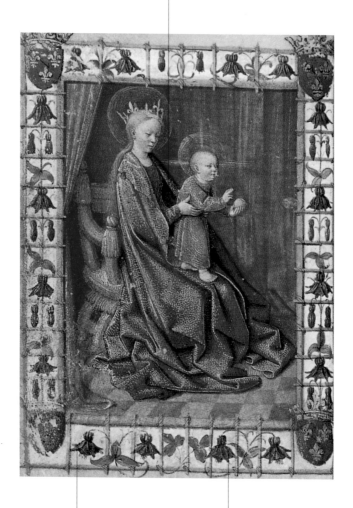

Fouquet has decorated this small book of hours using a refined and restricted palette, in which the principal colors are white, blue, green, and red.

Fouquet's restraint and careful synthesis of elements are emphasized by the borders with blue flowers and white-on-white effects.

One can see how the lapis lazuli blue has worn away in the coats of arms, revealing the red underneath. It is this red pigment, made from red lead (minium *in Latin*), that led to the use of the word miniature *to describe the pictorial decoration of manuscripts.*

Simon de Varie is shown in prayer before the Virgin. This is a common pose for Fouquet's figures: he often painted or illuminated diptychs in which a donor on one page faces the Virgin on the opposite one.

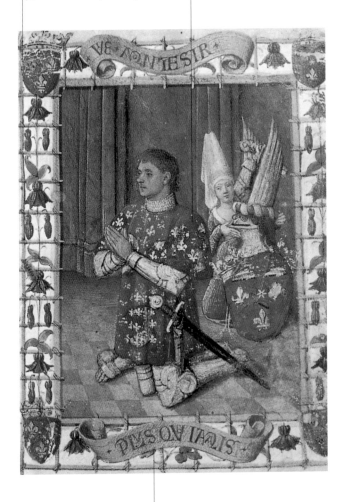

▲▲ Jean Fouquet, *Simon de Varie Kneeling in Prayer*, ca. 1460, two illuminated pages from the *Hours of Simon de Varie*. Los Angeles, J. Paul Getty Museum.

The page bearing the donor's portrait contains many references to his arms and motto.

Italy does not dominate the history of wood carving, but it is there that the technique of intarsia develops. It proves especially fruitful for the ingenious use of perspective.

Intarsia

Great patience and extreme care are required to create inlaid wooden panels using the technique called intarsia: fitting together thin strips of different woods, which are often treated to give them a variety of color tones. They were used in two quite different spheres, one religious and the other secular: intarsia covers the choir stalls and large lecterns in abbeys, and it was also used in noblemen's studies, not only as a pleasant wall covering but also on the doors of cupboards and shelves. Although they were working in such different contexts, the masters of fifteenth-century intarsia always displayed their interest in perspective. Intarsia came to be used for devising and representing complicated perspective devices, and it is no coincidence that great students of perspective, such as Paolo Uccello and Piero della Francesca, produced intarsia designs. Wood intarsia was used to represent half-open doors and shelves with objects of different shapes (such as faceted cups, crosses, musical instruments, pieces of armor, or birdcages), as well as windows opening out onto land-scapes or, better still, onto views of an ideal city. In the fifteenth century the technique of intarsia was used almost exclusively in Italy; only in later centuries did it spread north of the Alps, and even then it was always treated with great caution.

▼ Baccio Pontelli, to designs by Sandro Botticelli and Francesco di Giorgio Martini, *The Duke's Armor*, ca. 1470, intarsia in Federico di Montefeltro's study. Urbino, Ducal Palace.

It was normal practice for intarsia to be made by specialized craftsmen using designs or cartoons by well-known painters.

This intarsia belongs to the genre of figurative panels that are complemented by illusionistic demonstrations of perspective, usually in the background. Here, however, the artist has clearly attempted to render the figure itself three-dimensionally, in details such as the hand and the crook of the crosier.

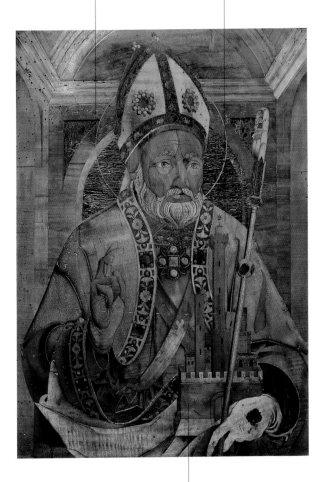

▲ Agostino de' Marchi, to a design by Francesco del Cossa, *Saint Petronius*, ca. 1470, wood intarsia. Bologna, San Petronio.

Saint Petronius, the patron saint of Bologna, holds a small model of the city with its unmistakable towers.

Tapestry involves expert artists, sophisticated looms, highly skilled workers, and very often precious materials such as silk and gold thread.

Tapestry

The French town of Arras was so renowned for its tapestries that its name became synonymous with the art—*arazzo* in Italian, *arras* in English. Despite its early fame, however, the town ceded dominance in the fifteenth century to two centers of production now in Belgium, Tournai and Brussels. These two cities enjoyed historical and cultural conditions that were ideal for the artistic and commercial development of tapestry. Both were well situated within a substantial network of commercial and trading links; both had practical reasons for producing tapestries (protection from cold and damp in winter); and, above all, both had well-equipped factories with numerous looms, as well as skillful and creative master tapestrymakers. Furthermore, some of the great Flemish artists, such as Rogier van der Weyden, took to producing tapestry cartoons. Van der Weyden's life, in fact, coincided with the development of the art of tapestry. Brussels gradually took over from Tournai as the chief center, while toward the mid-fifteenth century entrepreneurs began to set up factories in Italian *signorie*, starting with Ferrara.

▼ Flemish manufactory, *Grape Harvest*, ca. 1500. Paris, Musée National du Moyen Âge.

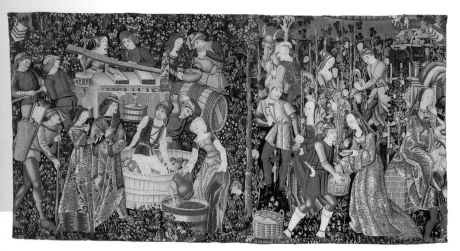

The great skill of the Brussels tapestrymakers is evident in the rendering of subtle tones and bright colors against a background of open sky.

Because this scene derives from a painting, it contains features of perspective and spatial definition that are somewhat unusual in tapestry.

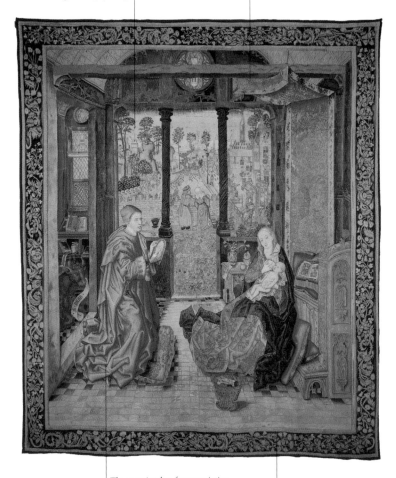

The scene is taken from a painting by Van der Weyden, of which more than one version is known; but the transposition to tapestry did not take place until two or more generations after his time.

▲ Brussels manufactory from a cartoon of a painting by Rogier van der Weyden, *Saint Luke Drawing the Virgin*, ca. 1500. Paris, Louvre.

The painting on which the tapestry is based was so important and so widely known in Europe, through many copies, that in this textile version it was given a narrow, inconspicuous border here—little more than a picture frame around the scene.

The art of polychrome stained glass continues to produce masterpieces, as artists reconcile traditional techniques with compositional innovations involving perspective.

Stained Glass

▼ Unknown German master,
The Virgin and Saint John,
ca. 1420, part of a
Crucifixion. Los Angeles,
J. Paul Getty Museum.

Since stained glass is obviously dependent on the style and dimensions of the windows in which it is placed, its development in the fifteenth century has to be viewed in relation to architectural developments. The building sites of the great Gothic cathedrals, especially in France, were now closing down, and so was the production of polychrome stained-glass windows, using the traditional technique of juxtaposing pieces of glass of different colors and holding them together with strips of lead. The use of rectangular pieces of glass results, for the most part, in their being placed side by side in series, and hence in a sequence of scenes; there are rare but interesting cases of attempts to create scenes that pass from one piece of glass to another within a single context. The most important works of this kind are at Bruges and Nuremburg; glasswork at Strasbourg and Milan is more traditional, though—thanks to the involvement of contemporary painters—it introduces a new proto-Renaissance sensitivity. In any case, the fifteenth century saw the end of the great period of stained glass. Wonderful stained glass was indeed produced in that century, but it marks the transition from an aesthetic of light to an aesthetic of form: a transition from the refined transparency of polychrome glass to monumental painting in the form of altarpieces and fresco cycles.

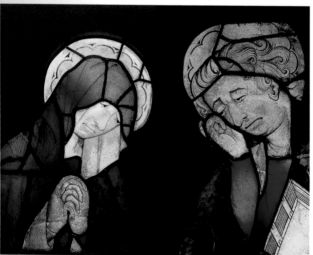

The whole window is a celebration of the
fleur-de-lis—the heraldic flower of the
throne of France—echoed in the very shape
of the upper openings. The artist treats the
theme of the Annunciation, placing the
figures of God the Father and the Holy
Spirit at the very top of the window.

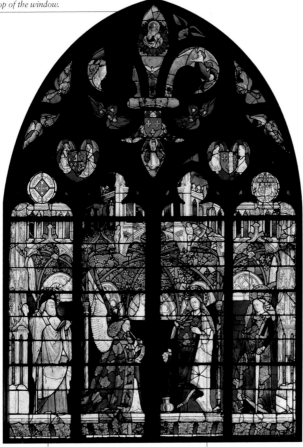

The figures have an imposing
solidity that is quite exceptional in
mid-fifteenth-century French art.

The Gothic vaulting spanning all
four panels shows that the whole
window is being treated as a unit
rather than being broken up in a
succession of isolated scenes.

▲ Based on cartoons attributed to Jacob
de Littemont, *The Annunciation*, 1451.
Bruges, cathedral of Saint-Étienne,
chapel of Jacques Coeur.

The influence of classical culture is very clear in the dramatic and demanding genre of bronze equestrian statues, which take as their model the statue of Marcus Aurelius in Rome.

Equestrian Monument

Even before the impressive revival of equestrian statues in the humanist period, there had been a number of medieval masterpieces in the genre. The pace quickened in late-Gothic times, as noblemen commissioned numerous monuments, some of them spectacular and widely admired. Even if these were no more than tombs, the physical form of the noble subject would be shown in all its imposing vigor. In Milan, Verona, and Naples, and also in Venice, France, and Catalonia, equestrian monuments showed the lord erect in the saddle, in full ceremonial armor and wearing the heraldic emblems of his house. He thus became a symbol of absolute power that passed from generation to generation. During the fifteenth century, however, the antique style of equestrian monument was revived, celebrating the warrior's victory; bronze was chosen as the "glorifying" material par excellence. Following the two trompe l'oeil paintings by Paolo Uccello and Andrea del Castagno in Florence cathedral, which celebrate the military prowess of mercenary leaders, the archetype of Renaissance equestrian sculpture was established in Padua by Donatello with the statue of another mercenary, Gattamelata. The monument to Bartolomeo Colleoni in Venice, to a design by Verrocchio, soon followed. Leonardo devoted considerable time to overcoming the technical difficulties involved in equestrian statues, but his projects for statues to Sforza and Trivulzio in Milan were never realized.

▶ Andrea del Castagno, *Equestrian Monument to Niccolò da Tolentino*, 1456. Florence, Santa Maria del Fiore.

The sturdy horse is observed from life, but it also bears traces of the long classical tradition of representing horses, echoing in particular the four bronze horses on San Marco in Venice.

Gattamelata, in armor, sits upright in the saddle, but his pose and expression suggest relaxed self-confidence.

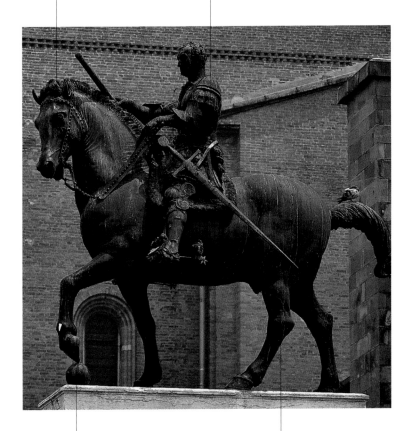

The hoof of the horse's left foreleg is the only one to be raised, and even so it rests on a ball. One of the chief technical problems in designing an equestrian statue, top-heavy by nature, was how to make it stay up.

▲ Donatello, *Equestrian Statue of Gattamelata* (*Erasmo da Narni*), 1447–53. Padua.

The sword on the rider's left and his commander's baton on the right create a dynamic diagonal that suggests forward movement, as though in a victory parade.

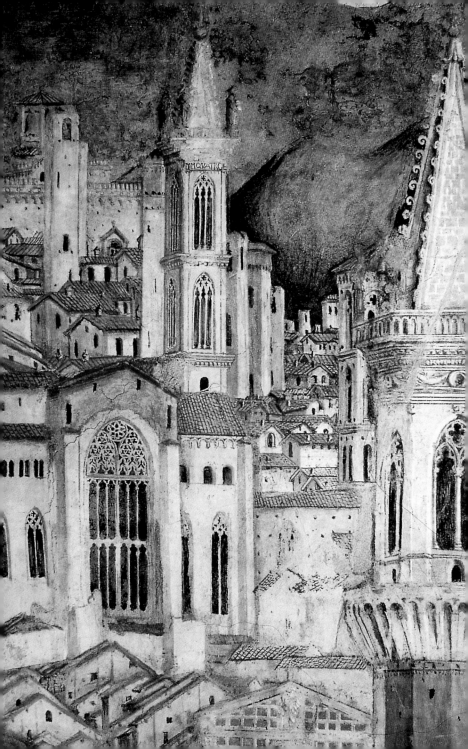

PLACES

Northern and Central Europe
Hanseatic Towns
The Rhine from
Constance to Cologne
Nuremburg
Krakow
Alsace
The Tirol

Flanders and France
Bruges
Brussels
Other Flemish Towns
Burgundy
Paris

The Western Mediterranean
Aragon and Castile
Catalonia and Valencia
Provence

Italy
Milan
Mantua
Padua
Venice
Ferrara
Urbino
Florence
Rome
Naples
Other Italian Towns

◀ Benedetto Bonfigli, *View of Perugia*, 1454,
detail from the Chapel of the Priors frescoes.
Perugia, Galleria Nazionale dell'Umbria.

Northern and Central Europe
Hanseatic Towns
The Rhine from
Constance to Cologne
Nuremburg
Krakow
Alsace
The Tirol

The Hanseatic League was a historical federation of towns on the Baltic Sea. It still colors our image of places like Bremen, Lübeck, Rostock, Stralsund, Danzig (Gdansk), Bergen, Riga, and Tallinn.

Hanseatic Towns

When the house of Luxembourg succeeded that of the Habsburgs in 1437–38, the area of influence of the Austro-German Empire extended eastward to include Bohemia and Hungary. At that time, however, Germany was not yet a great unitary monarchy like France and England. German lands were still split into principalities whose allegiance to the central power was only nominal. In addition, there were the so-called free imperial towns, which benefited from a special statute granting them important commercial privileges and substantial administrative autonomy. The Baltic towns that formed the Hanseatic League left an unmistakable impression. The league was created in the fourteenth century for largely commercial reasons, and in the fifteenth century it became a strong unifying factor in culture and architecture. The heart of a Hanseatic town was the market square, usually with the town hall on one side. The town hall was the proud symbol of the town's autonomy and prosperity and was often a splendid, complex piece of architecture, to be extended and ornamented over the centuries.

There was always a large Gothic church nearby, often with bell towers stretching up to very tall pointed spires. Brickwork was typically left in view, while the interior was usually plastered with lime. The brick facades of houses were sometimes partially enameled in dark glaze and ornamented with stepped pediments.

Related entries
International Gothic,
Anonymous Masters,
Winged Altar, Wood
Sculpture

Memling

▼ Facade of the church of the Trinity, ca. 1450, now the Muzeum Naradowe, Gdansk.

Francke, probably of Flemish origin, became the leading painter in the Baltic region in the first half of the fifteenth century. He displays a keen interest in descriptive detail.

The fair-haired figure of Barbara flees into the forest, pursued by her furious father. Although almost obscured in the background and hidden by the trees, she is easily identified by her shining halo.

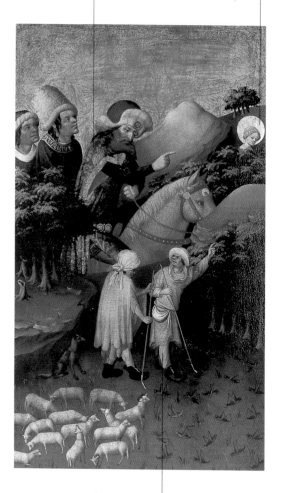

The figures are obviously out of proportion. The painter is much more interested in narrative effects than in correct perspective.

▲ Master Francke, *The Pursuit of Saint Barbara*, 1410–15. Helsinki, National Museum.

Christ's face is full of pathos, and the blood streaming freely from his wounds is intended to arouse pity in the faithful. Such devotional and iconographic features are frequently seen in German sacred art.

A fine brocade curtain, held aloft by angels, closes off the rear of the picture space and projects the figure of Christ toward the spectator.

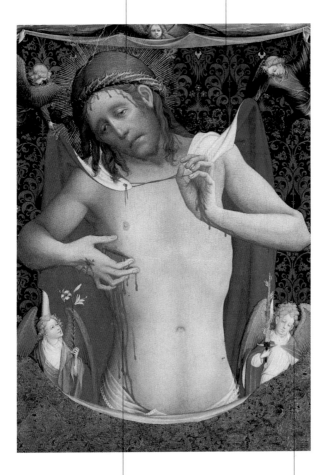

The smooth flesh of Christ's body is inspired by the dramatic monumentality of Burgundian sculpture.

The two angels at the bottom hold lilies and a flaming sword, symbols taken from the book of Revelation. They allude to the Last Judgment.

▲ Master Francke, *Christ as Man of Sorrows*, ca. 1425. Hamburg, Kunsthalle.

With hugely dramatic effect, Saint George stands erect on his white horse as he prepares to strike the dragon with his sword, having already pierced and wounded it with his lance.

Bernt Notke (ca. 1440–1509) came from Ratzeburg, near Lübeck, and worked along the whole Baltic coast from Lübeck to Aarhus and even as far as Tallinn. He was an eclectic artist, and above all a great wood-carver, but he also tackled stone sculpture and painting.

The work is actually composed in two separate parts: off to the side of the main group is the figure of the princess, who is being saved thanks to the heroic intervention of Saint George.

▶ Bernt Notke, *Saint George and the Dragon*, 1489. Stockholm, cathedral.

The fearsome dragon, which became one of the emblems of Stockholm, is an invention of fantastic imagination. This group is not only Notke's greatest masterpiece but one of the most extraordinary fifteenth-century wood sculptures.

The base is richly decorated with bas-reliefs.

This triptych was commissioned by Angelo di Jacopo Tani, a Medici banker, and was painted at Bruges, but the ship that was taking it to Florence was intercepted and sacked by a North Sea pirate named Paul Benecke. The triptych ended up in Danzig, and, despite requests from the pope and Lorenzo the Magnificent, it was never returned. Instead it became a key model for painting in the Baltic and Hanseatic region.

The lower parts of all three panels teem with the naked souls of men and women. The center represents the resurrection of the body and the separation of the blessed from the damned, with angels in battle with devils. The side panels depict the ascent to paradise and the descent into hell.

The left panel is dominated by the gates of paradise, on whose balconies an orchestra of angels plays. The souls of the blessed appear naked before Saint Peter at the foot of a crystal staircase. When they reach the top, angels dress them in wedding clothes and they enter into the light of the Empyrean.

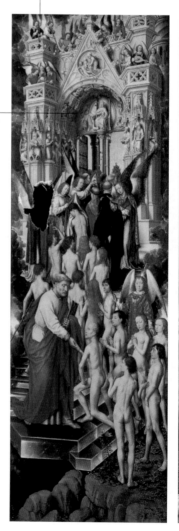
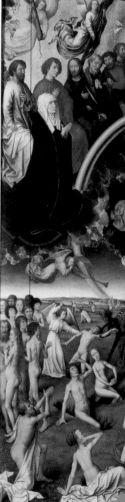

▶ Hans Memling, *The Last Judgment Triptych*, 1478. Gdansk, Muzeum Narodowe.

The vertical axis of the central panel is defined by the figures of Saint Michael, who weighs the souls, and Christ in Judgment, seated on the rainbow.

The angel sounding a trumpet is an essential feature of Last Judgment scenes.

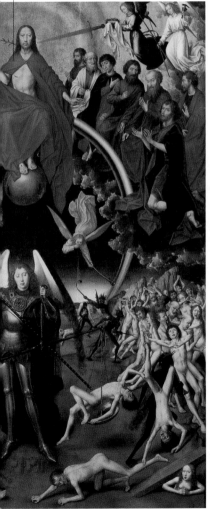

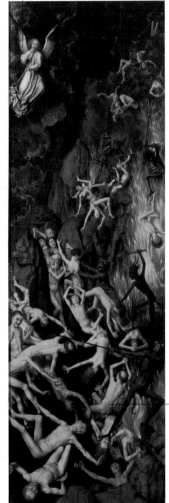

The representation of hell is something that stirs the macabre in the imagination of artists. Memling, however, is a sophisticated, intellectual painter who prefers to concentrate on the figures and the expressions of the damned rather than on the invention of frightening or grotesque devils.

From Lake Constance to Basel and then along the course of the Rhine from northern Switzerland to Alsace and the Black Forest, an enchanted and enchanting style of art develops.

The Rhine from Constance to Cologne

▼ Erhart Küng,
*Saint Michael
Defeating the
Devil*, ca. 1490,
from the *Last Judg-
ment* in the main
portal of Bern
cathedral. Bern,
Historisches
Museum.

During the fifteenth century, many towns along the Rhine enjoyed a period of great prosperity. Constance and Basel became centers of diplomacy at a European level when they hosted two councils (1414–18 and 1431–49), which helped resolve the problematic post-Avignon schism and overcome the deep crisis over the role of the pope. Along the banks of the Rhine, from Lake Constance to the northern frontier of Switzerland and on to Basel, and then along the course of the great river to Alsace and the Black Forest, an enchanted and enchanting style developed: a delightful, delicate, and unusual page in the history of German art, which so often strove for dramatic expressive effects. The most important center of development of this "soft style" was the great city of Cologne. There a vigorous patrician class and dynamic church commissions laid the foundations for the creation of numerous flourishing workshops, which engaged in dialogue with other art centers. In sculpture and painting as well as in miniatures and goldwork, we find delicate, sinuous female figures, immersed in a fabulous ambience of woods and gardens, where an astonishing variety of adventures unfold. This line of development had as its most distinctive feature the production of dreamlike panels in which the Virgin sits in a flower garden. One master of this genre was Stephan Lochner, perhaps the greatest German painter before Dürer. Characters from Bible stories are interpreted as heroes in a poetic and genteel legend, whose final destination is the paradise garden, a choir of angels, and endless sweet smiles.

Saint Anthony lived in the
fourth century. Renouncing
his worldly goods, he retired
to the desert of northern
Egypt to live like a hermit.

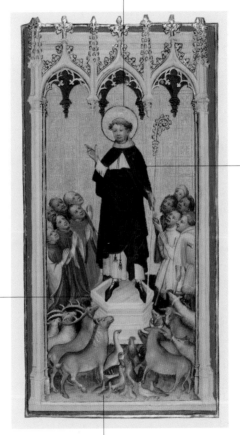

The Order
of Knights
Hospitallers, an
organization
that cared for
the sick across
Europe, adopted
Anthony as its
patron saint;
hence he is
depicted in the
attire of the
Hospitallers and
welcomes a
group of men
with various
ailments.

Saint Anthony Abbot,
standing on a pedestal
beneath three Gothic
arches, looks like a living
statue venerated by his
devotees. His face is
sweet and pensive, as is
common in Cologne
paintings, as he blesses
the men and animals
assembled around him.

The animals and birds gathered at the saint's
feet look up to him with rapt attention.
Apparently, the abbot of the church of Saint
Anthony in Cologne blessed the animals on
the saint's feast day each year. This picture
may therefore have been painted for this
church or a chapel in the adjoining hospital.

▲ Master of Saint Veronica, *Saint
Anthony Abbot Blessing the Animals,
the Poor, and the Sick*, ca. 1400–1410.
Los Angeles, J. Paul Getty Museum.

Lochner, the chief exponent of the Rhenish "soft style," often gives his figures serene and smiling expressions.

The curved outlines of the blue angels stand out against the gold background, as one frequently finds in Lochner's paintings.

The cult of the three Magi is particularly strong in Cologne. Their relics are preserved in the cathedral in a sumptuous reliquary chest by Nicolas de Verdun.

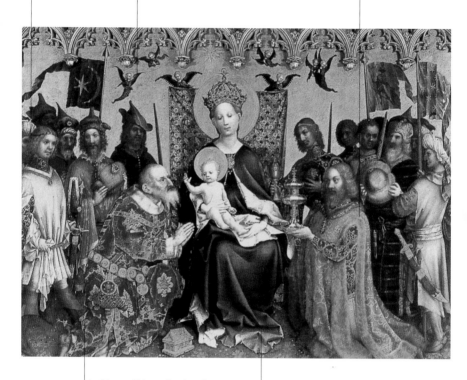

In this great Cologne altarpiece, the taste for descriptive detail, especially in the cloaks and gifts of the Magi, is similar to what one finds in contemporary Flemish or Burgundian art.

The Virgin is slightly out of proportion to the other figures, but without the exaggerated difference of scale that one finds in other northern painters. Her round face with half-closed eyes is very typical of Lochner.

▲ Stephan Lochner, *The Adoration of the Magi*, 1435–40, central panel of *The Patron Saints of Cologne Altarpiece*. Cologne, cathedral.

Although he remains anonymous, the artist responsible for this panel (from a series devoted to the Virgin), was certainly one of the most influential Rhineland masters in the second half of the fifteenth century.

The scene of the midwife handing the newborn Mary to Saint Anne, still in childbed, occupies only the middle ground, but the figures and spaces are distributed in such a way that the spectator's attention is drawn to the principal action.

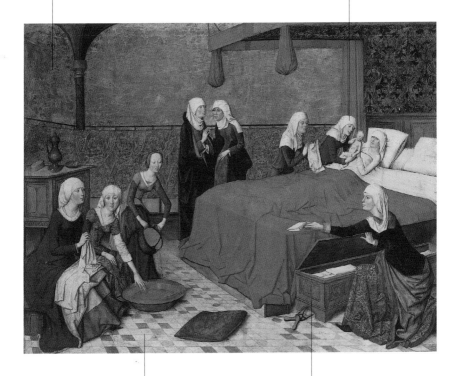

Once again we find a taste for descriptive details from everyday life, within a simple, bright composition with pleasantly animated figures.

Although the artist has not worked out a unitary vanishing point for the whole composition, he gives the figures, objects, and room angled viewpoints so as to emphasize the three-dimensional nature of the scene.

▲ Master of the Life of Mary, *The Birth of the Virgin*, ca. 1475. Munich, Alte Pinakothek.

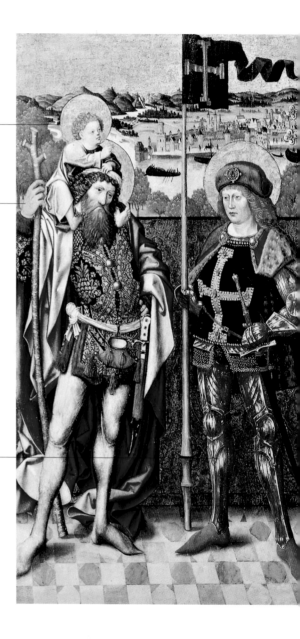

In the background is an extremely faithful representation of the Rhine landscape in the vicinity of Cologne. The anonymous painter seems to enjoy painting the busy river traffic, with large cargo boats.

Merchants were required to stop at Cologne for at least three days if they wished to offer their goods to the local people.

The choice of saints is linked partly to popular cults of a general nature (Saint Christopher is the patron saint of rivers and their fords) and partly to specific local cults, such as that of Saint Gereon, seen here in armor.

▶ Master of the Assumption of the Virgin, *Saint Anne Metterza with Saint Christopher, Saint Gereon, and Saint Peter*, ca. 1493. Cologne, Wallraf-Richartz Museum.

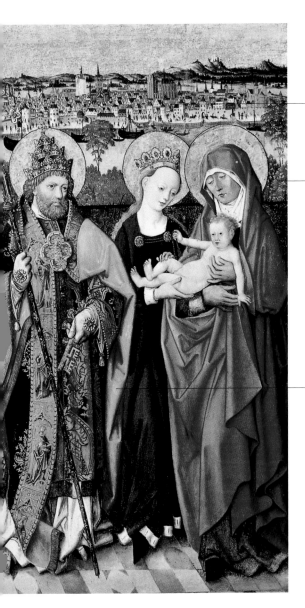

In the late fifteenth century, Cologne was one of the busiest and most densely populated European cities, with forty thousand inhabitants. Here it is depicted in detail: the cluster of fishermen's houses by the riverbank, the spires of the Romanesque churches, the colossal cathedral site, and the turreted city walls stretching for some five miles.

The wooded riverbank (where the Deutz district is situated today) contrasts with the densely built-up urban area.

The garments and attributes of the saints provide a sense of regal splendor: in 1475, the emperor Frederick III had declared Cologne a free imperial city with the right to mint its own coins.

Protected by a splendid ring of walls, Nuremburg had a substantial merchant class—well educated and prosperous—that promoted the city's intensely active cultural and artistic life.

Nuremburg

Imperial privileges and traditional precious-metalworking meant that Nuremburg had the whole of Europe as its market, from Krakow to Lisbon, Venice to Lyon. War damage has partly obliterated the layout of the city, but its principal Gothic monuments and amazingly rich treasure of artworks (some of which display breathtaking virtuosity) give us a sense of its spectacularly vigorous culture, which reached its high point with Albrecht Dürer, the most emblematic representative of the humanist-artist north of the Alps. Nuremburg has every reason to be proud, for example, of its early printing presses and the workshops that produced scientific instruments. Humanist studies were promoted by patrician libraries, some of which contained hundreds of volumes. At the time of Dürer, in other words, Nuremburg was a cosmopolitan city, home to men of letters and mathematicians, geographers and theologians, artists and merchants. It was renowned for its goldsmiths, some of whom, including Dürer's father, were immigrants from Bohemia and Hungary. Gold and silver objects from Nuremburg were highly regarded throughout Europe, both for their artistic qualities and for the technical skill they manifested. Table clocks were much sought after, as were automata, musical instruments, and precision instruments for navigation and astronomy. Over a period of two centuries—from the early fifteenth century to the threshold of the seventeenth century—Nuremburg gradually ceded its primacy to Augsburg, the city of the Fugger bankers, which was destined to become the capital of the silver trade in the sixteenth and seventeenth centuries.

▶ Sebastian Lindenast,
The Castle Cup,
ca. 1495. Nuremburg,
Germanisches
Museum.

The two principal churches in the city, Saint Lawrence and Saint Sebald, both had a pair of towers with spires.

The sturdy, turreted castle was built on the highest part of the city and became a symbol of Nuremburg. Dürer's house is very close by.

The fortified gates, which provided access to the city, also served as a marketplace, customs post, and storage depot for food.

The city had as many as fifty thousand inhabitants and was protected by a double circuit of walls, much of which still stands.

▲ *View of Nuremburg*, colored wood engraving, from Hartmann Schadel, *Liber Chronicarum*, 1494.

During the fifteenth century, the ancient capital of the Jagiellon kingdom was one of the most lively and attractive cities in northern Europe.

Krakow

▼ Inner courtyard of the
Jagiellonian University,
1460, Krakow.

The cathedral and royal palace that rise proudly on Wawel Hill are symbols of the nation, and they contain the historic, artistic, religious, and symbolic relics of many centuries. Other parts of Krakow provide further evidence of the period of splendor it enjoyed during the fifteenth century, when it became established as a place where Western states and the Slav world met. The immense building that housed the cloth market indicates the extent of the city's commercial development, and the foundation of the Jagiellonian University in 1460 gave Krakow an undisputed position of primacy in the humanistic and scientific fields in northeastern Europe. In the second half of the century, furthermore, the traditional late-Gothic style was enriched by new influences, especially from Germany. Of fundamental importance was the presence in the city of Veit Stoss (called Wit Stowsz in Polish), an exile from Nuremburg. He was responsible for the spectacular *Altar of the Death of the Virgin* in the church of

Saint Mary; in 1492, he abandoned wood for red marble when he sculpted the *Tomb of Casimir IV Jagiello* beneath an open-work canopy with bowed arches. This was another masterpiece, and it led to commissions for a whole series of royal tombs in Krakow. In later years, after Stoss had returned to Nuremburg, two Tuscan specialists, Francesco Fiorentino and Bartolomeo Berrecci, were called to Krakow: in the first twenty years of the sixteenth century, they left on Wawel Hill some of the finest examples of Renaissance sculpture outside Italy, thereby initiating a period of great success for the Tuscan style at the courts of sixteenth-century Europe.

The exuberant late-Gothic crown and arches are reminiscent of the lavishness of contemporary wooden altars.

The capitals, decorated with biblical scenes, are signed by Stoss's assistant, Jörg Huber of Passau.

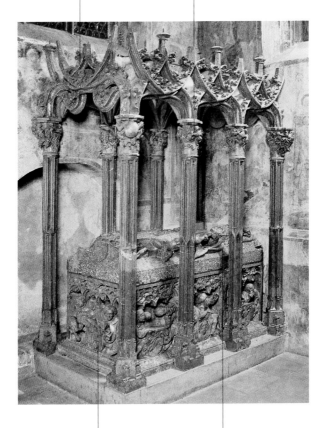

▲ Veit Stoss, *Tomb of Casimir IV Jagiello*, 1492–94. Krakow, cathedral, chapel of the Holy Cross.

The sculpted figures along the sides of the sarcophagus bear the insignia of the kingdoms of Poland, Lithuania, and other royal possessions.

The monument is made of richly veined red Salzburg marble, and Stoss particularly emphasizes the expressive quality of his material in the striking portrait of the king lying on the sarcophagus.

Alsace is a key region in the history of Europe. Thanks to the artists working there and the autonomous styles they developed, it became an international point of reference during the fifteenth century.

Alsace

▶ Niclaus Gerhaert,
Bust of a Man,
1463. Strasbourg,
Musée de l'Oeuvre
de Notre-Dame.

The tall, articulated mass of Strasbourg cathedral is a symbolic central point for the whole region. During the fifteenth century all activities at its construction site were at their peak, as masters from many nations converged on Strasbourg to help with its architecture and engineering, as well as its sculptural decoration and the preparation of polychrome stained glass. Their spectacular achievements made Strasbourg cathedral an object of study and emulation: it became the inspiration for other grandiose international building projects in late-Gothic times. The presence of the Netherlandish sculptor Niclaus Gerhaert of Leiden furthered its success. Although works in stone dominated at Strasbourg, master wood-carvers worked throughout Alsace and maintained direct contact with the German art of the Rhineland. There is clear evidence of this contact in the altar shrine at Isenheim, commissioned by the prior of the Antonite convent, Jean d'Orlier, and carved by a local master, Nicolas d'Hagenau. Painting was at first characterized by the strong influence of Flanders and Burgundy, but in the second half of the fifteenth century, the Alsatian school could boast of its own great master, Martin Schongauer of Colmar. Thanks to his splendid engravings, Schongauer became immensely famous, and he is thought to have been a formative influence on such diverse artists as Michelangelo and Dürer. Schongauer worked mainly at Colmar, Isenheim, and nearby Breisach, just beyond the Rhine.

The richly carved original frame is an integral part of the image: both Virgin and Child turn toward the angels playing musical instruments along the sides.

The hortus conclusus *of the Virgin is enclosed by an espalier of roses, the symbol par excellence of the Virgin Mary.*

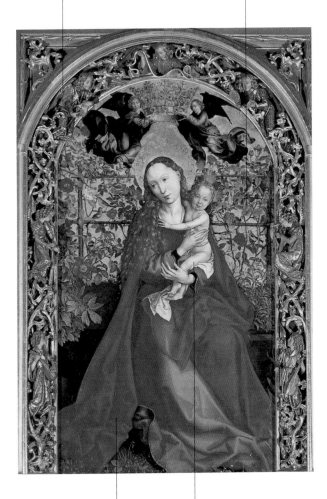

The Virgin's red robe visually dominates the painting and creates a striking and refined contrast with the gold ground.

Schongauer's image is rather static and was intended for sacred purposes. But the artist has offset these qualities with a series of realistic elements, not only in the botanical accuracy of the background, but also in the play of the poses of the two figures, who are turned in opposite directions.

▲ Martin Schongauer, *Madonna of the Rose Bower*, 1473. Colmar, church of Saint Martin.

It was in the Tirol that the power of the Habsburgs arose and spread, thanks to its key position between "Gothic" central Europe and "humanist" Italy.

The Tirol

Related entries
International Gothic,
Humanism, Winged Altar,
Wood Sculpture

Multscher, Pacher

▼ Conrad Laib, *Saint Hermes*,
1449. Salzburg, Museum
Carolino Augusteum.

The complex and varied lands of central Europe were theoretically unified under the Holy Roman Empire, but in fact they were a fragmented series of seigneuries and small states. Imperial power was only truly effective in hereditary dominions, together with those gradually acquired through shrewd and highly advantageous marriages. This process culminated in the marriage of Maximilian of Habsburg and Mary of Burgundy in 1477. Maximilian's program of celebrations was ambitious, and his art commissions often served to generate images for specific propaganda purposes. His taste embraced both the German tradition and Italian humanism, and his court took a particular liking to Innsbruck, with the result that the alpine region of the Tirol became a center for artistic debate. The development, aims, and cultural characteristics of the Tirol at the dawn of the Renaissance perfectly suited the twin activities of Michael Pacher as painter and sculptor. Pacher was born in the Tirol, worked primarily at Bolzano/Bozen, Bressanone/Brixen, Innsbruck, and Salzburg, and was well versed in late-fifteenth-century developments in European art. He seized the opportunity to act as an intelligent mediator between Italian art and the German world, hence the creation of his magnificent altars at Sankt Wolfgang, Novacella/Neustift abbey, and the Franciscan church at Salzburg (these last two have unfortunately been broken up). They are magnificently conceived works in which wood carving and painting are perfectly combined, and at the same time they bring together both compositional perspective and intensely characterized figures, thus becoming models for the next generation of German artists.

The mountain landscape seen through the windows is a direct clue to the Tyrolean origin of this anonymous painter, who worked mostly in the Bressanone/Brixen area.

The pivot of the compositional space is the flagellation column, made of smooth brecciated marble.

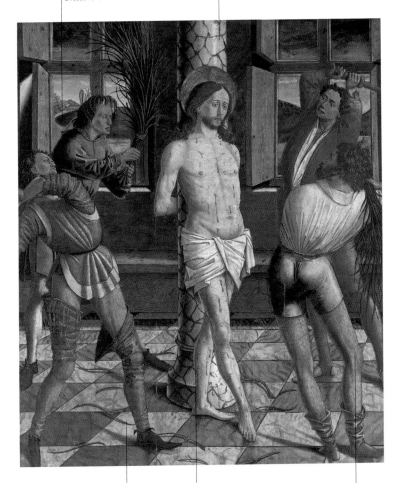

The checkered floor provides an effective way of creating depth in perspective, and the twigs lying on the floor add a lively sense of variety.

The poses of the scourgers combine a northern tendency to exaggerate gestures and expressions with possible classical echoes.

References to the antique can be detected, particularly in the body of Christ. The flowing blood is an appeal to popular piety.

▲ Master of Uttenheim, *The Flagellation*, 1465–75, panel of *The Saint Stephen Altarpiece*. Moulins, Musée Anne de Beaujeu.

The virtuosic intertwining of the extravagantly complex arches at the top are a Gothic feature that is always found in winged altars and in northern wood carving in general.

The regularity of the composition, with three saints standing on pedestals, is characteristic of wooden altars in the German world. Only a few artists (Pacher, Stoss, and Riemenschneider) prefer complex narrative scenes.

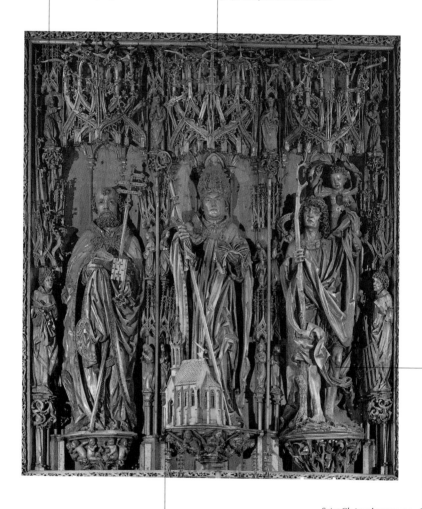

▲ Attributed to Martin Kriechbaum, *Altar with Saint Peter, Saint Wolfgang, and Saint Christopher*, 1491. Kefermarkt (Austria), parish church.

The little church at the feet of Saint Wolfgang appears to be a model of a typical Austrian Gothic parish church with steeply sloping roof and an interior consisting of a nave and two aisles, all of the same height.

Saint Christopher was one of the most popular saints in the fifteenth century, especially in alpine regions and the German world. He is the patron saint of rivers and travelers, and he is also supposed to offer protection from bandits and death by violence.

The steeply sloping roofs of the towers and other buildings are common in alpine architecture because they prevent snow from building up.

Dürer painted this enchanting view on his first journey to Italy. At the time, the emperor Maximilian's residence could not rival the French and Italian courts. Its appearance was dictated by traditional architecture and by its multiple functions as a commercial, administrative, and military center.

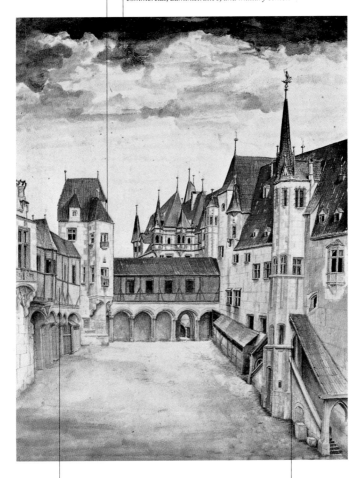

The projecting half-timbered walls are typical of central European secular architecture.

▲ Albrecht Dürer, *The Courtyard of Innsbruck Castle,* watercolor, 1494. Vienna, Albertina.

The octagonal tower with its spire contains a staircase and dominates the inner courtyard space. This castle was the favorite residence of Maximilian I of Habsburg.

Flanders and France

Bruges

Brussels

Other Flemish Towns

Burgundy

Paris

Thanks to its flourishing economy and an outstanding school of painters from Van Eyck to Gerard David, Bruges could rival Florence for cultural primacy in the middle decades of the century.

Bruges

Until 1477, Flanders formed part of the duchy of Burgundy. The capital was Brussels, but there is no doubt that Bruges was the true cultural heart of refined Flemish society. The city's strategic position gave it easy access to the North Sea, and it became the most important commercial and financial center in western Europe, its fine streets with canals boasting splendid Gothic buildings. Furthermore, the Prinsenhof was the favorite residence of the dukes of Burgundy, who spent a good deal of time there with their court. Foreign businessmen and merchants chose the city as their headquarters, and the Hanseatic League opened an important branch there. The closest commercial links, however, were with Spain and Italy. The Medici bank—the powerful financial institution of the lords of Florence—opened an office in Bruges in 1439. These links encouraged artistic as well as commercial exchanges among these countries and laid the foundations for a flourishing art market supported by a cosmopolitan society where, for the first time, the middle classes had as important a role as the aristocracy's. Tuscan bankers and merchants (the Arnolfini, the Tani, and the Portinari) were among those who commissioned works of art from masters like Van Eyck, Memling, and Van der Goes. However, the progressive silting up of the river harbor, together with political events, brought about a decline in the city's economic importance, and it slowly faded from the limelight of history. The painters who were active at Bruges in the second half of the fifteenth century, from Memling onward, seem to reflect in their style a desire to hold on to the memory of a successful period that was now slipping away.

Related entries
International Gothic,
Humanism, Perspective,
Oil Painting, Miniature

Christus, David,
Memling, Van Eyck

▼ Bruges, the cloth
market and Beffroi
tower, begun in 1499.

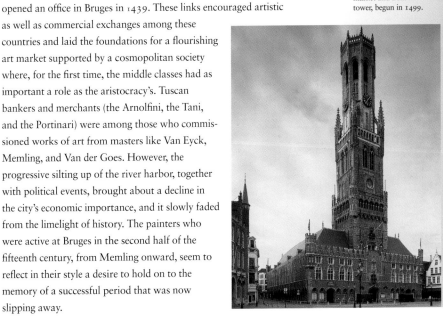

The scene is set in a complex architectural structure: the ambulatory of a large Romanesque church.

A basic feature of this altarpiece is the highly controlled use of light. There are visible light sources that produce vivid reflections on the various luxury fabrics. Such effects were unimaginable before the adoption of oil painting.

The splendid, heavy red robe of the Virgin evokes Bruges's chief source of wealth: the luxury cloth trade.

The geometric pattern on the carpet emphasizes the use of perspective and hence the depth of the image.

▶ Jan van Eyck, *The Van der Paele Altarpiece*, 1436. Bruges, Groeningemuseum.

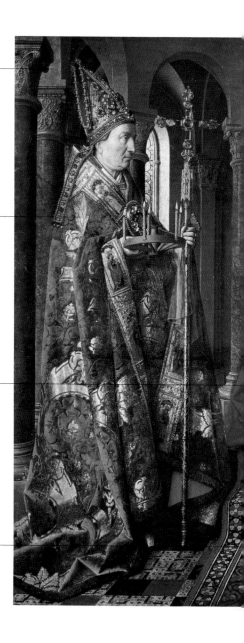

The portrait of the elderly kneeling donor is undoubtedly a most impressive early-fifteenth-century work. Van Eyck's optical realism achieved heights beyond the reach of his contemporaries.

Saint George's gesture of homage in removing his helmet is exactly like that in the ex voto of Charles the Bold, illustrated on page 137.

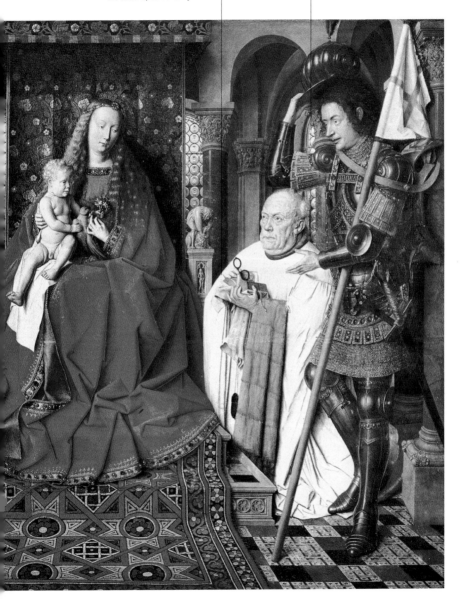

This delightful object is in the typical form of a medieval reliquary shrine, but instead of being made of the usual materials (bronze, or gilt-silver and enamel), it is delicately carved out of wood, parts of which are painted.

Memling's painted tondi on the sloping sides of the cover are directly reminiscent of the similar tondi, usually in polychrome enamel, painted on reliquary shrines from the Meuse Valley.

At the feet of the Virgin on the front of the shrine kneels the donor, the abbess of the convent at Bruges. The shrine was intended to hold the relics of Saint Ursula, who was martyred at Cologne along with eleven (or, according to one legend, eleven thousand!) other virgins.

The bittersweet, romantic story of Ursula is narrated along the sides. Although the sequence is made up of independent episodes, Memling has used a single unifying landscape background.

▲ Hans Memling, *The Shrine of Saint Ursula*, 1489. Bruges, Memlingmuseum.

The exotic tale of the Persian king Cambyses, as related by Herodotus, is brought into the fifteenth-century world and situated in a Flemish city of the time.

The corrupt judge Sisamnes is arrested on the order of King Cambyses. In the next panel he suffers the dreadful punishment of being flayed in the public square.

▲ Gerard David, *The Justice of Cambyses*, 1498. Bruges, Groeningemuseum.

For iconographical reasons, the king has to be included, but the painter hides him in the crowd of citizens. Among them, David has included portraits of actual townspeople. Justice is thus seen to involve the whole population, not just the king.

David's painting was commissioned by the town council of Bruges, much as similar moralizing canvases were painted by Bouts for Brussels. One of the latter is illustrated on page 132.

When Brussels became the capital of the duchy of Burgundy, it also became a cultural center, with important architectural sites and a vibrant commercial life.

Brussels

The Beffroi is a tall tower rising from the middle of the late-Gothic city hall of Brussels. Begun in 1402, it is one of a number of spectacular buildings in the old city, emblems of a rich and proud city that the dukes of Burgundy chose as the political and administrative capital of Flanders because of its strategic position. The strange octagonal crown on the tower, whose first stone was laid by Duke

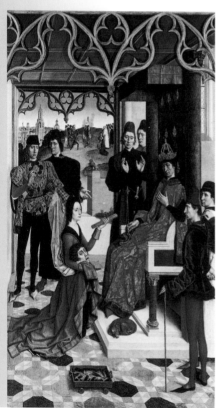

Charles the Bold in 1449, seems to transform the building into a gigantic piece of goldwork. The leading figure in the Brussels art world was a Walloon, Rogelet de la Pasture. He was a pupil of Campin, slightly younger than Van Eyck, and on arrival in the capital he took a Flemish form of his name to become Rogier van der Weyden. He worked for members of the court and for various towns in the duchy of Burgundy (one of his largest and most important works is *The Last Judgment Altarpiece* in Beaune), and he was also responsible for miniatures and cartoons. His art has an international dimension, for he introduced into Flemish art typically Italian sacred scenes with large figures scaled in perspective and exported to southern Europe a taste for refined detail and the technique of oil painting, in which paint is laid on in thin superimposed layers that create subtle, transparent effects. Dirck Bouts, on the other hand, was responsible for the scenes of justice that were used to decorate the city hall (ca. 1470), which inspired similar secular paintings in other Flemish towns.

The representation of depth in space and the organization of the narrative are evidence of the total control over perspective reached by the best Flemish artists as early as the first half of the fifteenth century.

The scene is set in Rome. With naive but effective approximation, Van der Weyden's anonymous assistant tries to supply some Roman landscape details, such as the Tiber River, the Colosseum, and a large basilica with an obelisk in front of it.

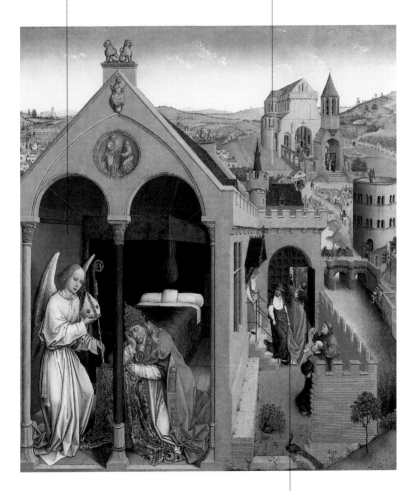

◄ Dirck Bouts, *The Justice of Emperor Otto*, 1470–73. Brussels, Musées Royeaux des Beaux-Arts.

▲ Workshop of Rogier van der Weyden, *The Dream of Pope Sergius*, ca. 1440. Los Angeles, J. Paul Getty Museum.

The scene stretches out into the distance, using deep perspective as though it were seen through a telescope.

Typical of the unique flowering of art in fifteenth-century Flanders is the great variety of forms of expression and architectural ideas.

Other Flemish Towns

▼ Dirck Bouts, *The Last Supper*, 1464–67, central panel of *The Last Supper Altarpiece*. Louvain, church of Saint-Pierre.

The period when the Flemish towns flourished found architectural expression in the style called Brabantine Gothic, after the Brabant region. In the town halls of Brussels and Louvain, in the cathedrals of Antwerp and Ghent, as well is in many buildings in Bruges, builders strove for the spectacular and the unexpected, and immensely tall towers sprang up. Since windows took up so much wall space and the climate was damp, we do not find the frescoes that are so common in Italy. Decoration is instead on panels and in tapestries, stained glass, and complex carved-wood altars. The various towns made use of art to project their own images: Tournai remained the chief center for rich tapestry production; Ghent had not only Van Eyck's peerless *Adoration of the Lamb Altarpiece* but also a brilliant school of miniaturists; and Dirck Bouts was established in the thriving town of Louvain. When Philip the Good died in

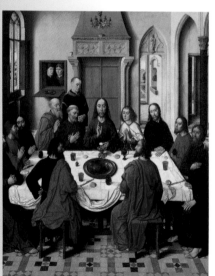

1467, however, the commercial and political fortunes of Flanders became less secure. The new duke of Burgundy, Charles the Bold, tried to extend his dominions and in doing so provoked a disastrous war with France, which cost the duke his life at the siege of Nancy (1477). Charles's daughter, Mary of Burgundy, married Maximilian of Habsburg, the future emperor of Germany, but when she died in 1482, Flanders was being torn apart by competing Habsburg and French ambitions. Maximilian was accepted as regent in most of the duchy, but Flanders allied itself with France and England in a ten-year struggle that weakened the rebel towns of Bruges, Ypres, and Ghent, bringing their development to a final halt.

This miniature displays unrivaled virtuosity in the use of perspective and light. Notice the large wide-open window with characteristic circles of glass.

Beyond the window, a large well-lit view in perspective represents the interior of a Gothic cathedral. Once again we see the symbolic identification of Mary and the Church, as seen on a number of occasions in the works of Van Eyck. It is very likely that this codex was made at Ghent, which had a prestigious school of miniaturists.

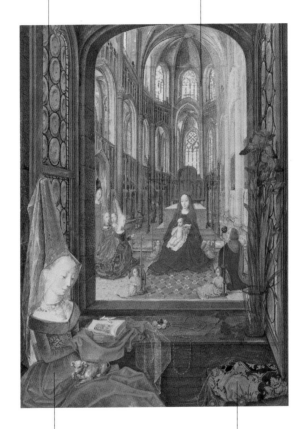

The anonymous miniaturist offers us two spaces: an intimate space in the real world where the duchess is reading, and an image evoked by that reading—the dreamlike, fabulous world of the church beyond the window.

▲ Master of Mary of Burgundy, title page of the *Book of Hours of Mary of Burgundy*, ca. 1470. Vienna, Österreichische Nationalbibliothek.

Books of hours were collections of prayers and sacred readings that were often wonderfully decorated with miniatures. They represent one of the rare cases in which works of art might be commissioned by or made for women.

For much of the fifteenth century, Tournai maintained its supremacy in tapestry production. But Brussels gradually gained the upper hand, thanks not only to its very high technical standards but also because of the refinement of its subject matter, taken from the paintings of great masters.

In accordance with their tradition, Tournai tapestries do not seek to convey perspective: the natural background of bushes, trees, and foliage rises behind the figures like a wall.

▲ Tournai manufactory, *Tapestry of the Rabbit Hunt*, 1460–70. San Francisco, M. H. de Young Memorial Museum.

Tapestry subjects are attractively linked to late-Gothic imagery: farm work, the leisure activities of the nobility, and the gentle cycle of the seasons; touches of acute realism could also be included.

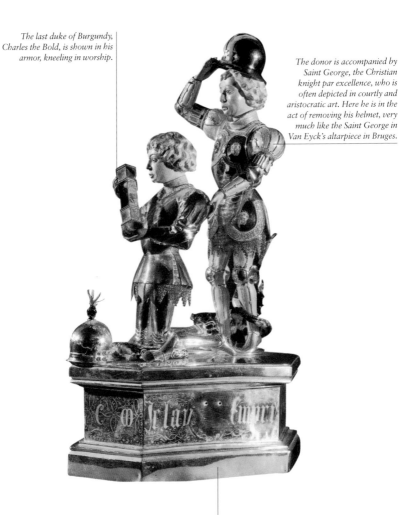

The last duke of Burgundy, Charles the Bold, is shown in his armor, kneeling in worship.

The donor is accompanied by Saint George, the Christian knight par excellence, who is often depicted in courtly and aristocratic art. Here he is in the act of removing his helmet, very much like the Saint George in Van Eyck's altarpiece in Bruges.

The Meuse region, one of whose chief towns is Liège, boasts a long and glorious tradition of master goldsmithing.

▲ Gérard Loyet, ex voto of Charles the Bold, 1467. Liège, treasury of the cathedral of Saint-Paul.

Here once again the precise indication of the light source distinguishes the art of the Flemish masters.

Louvain was a city of learning, becoming the seat of a university in 1425. In its desire to claim prestige among Flemish cities, it relied heavily on the painting skills of Dirck Bouts. In 1468 the city made him its official painter.

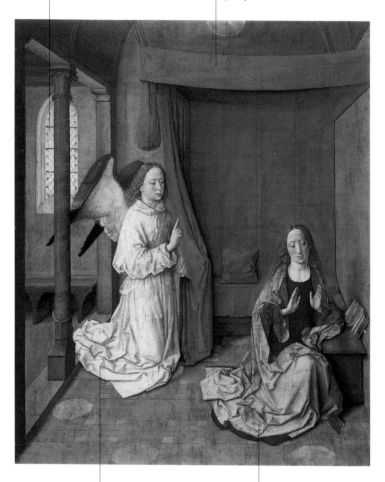

The whiteness of Gabriel's robe stands out in a painting whose colors are generally muted. The reason for the muted tones lies in the fact that the support is not wood but, very unusually for its time, canvas.

The calm, measured gestures of the angel and Mary are typical of Bouts.

▲ Dirck Bouts, *The Annunciation,*
1450–55. Los Angeles,
J. Paul Getty Museum.

The scene is set in the ambulatory of a large Romanesque church. The use of light is striking, but the architecture seems rather flimsy.

A crowd of onlookers gathers behind Saint Peter, who acts as a link between the two groups of figures.

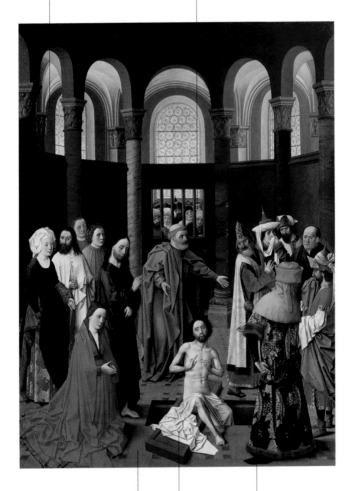

This panel is one of very few known works by Albert van Ouwater, who worked at Haarlem, one of the most active small towns in the northern Low Countries. One of his pupils was Geertgen tot Sint Jans, the best local painter.

The painter's penchant for refined detail is evident in the costumes.

▲ Albert van Ouwater, *The Raising of Lazarus*, 1455–60. Berlin, Gemäldegalerie.

One unusual iconographic detail is that the tomb from which Lazarus emerges is in the floor of a church rather than in an open-air cemetery.

The work was commissioned by the members of the Confraternity of Saint John the Baptist at Haarlem. The painter was himself a member, hence his nickname "tot Sint Jans," which means "of Saint John."

The painting has a very complicated subject: the narrative includes a number of different episodes concerning the burial of Saint John and the discovery of his remains.

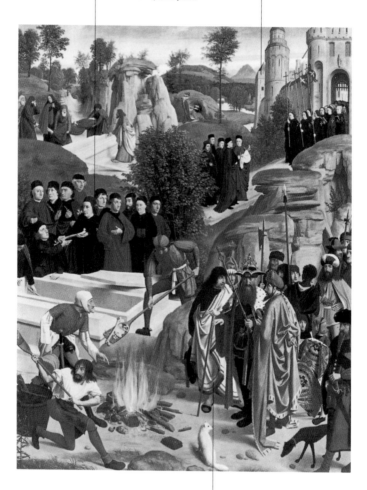

▲ Geertgen tot Sint Jans, *The Burning of the Bones of Saint John the Baptist*, 1480–90. Vienna, Kunsthistorisches Museum.

In spite of its iconographic complexity, the scene unfolds very effectively within a vast landscape, and the painter indulges in pleasing realistic touches in the costumes and facial features of the principal figures.

This is the artist's "name piece," the work by whose Latin name (meaning "Virgin among virgins") the anonymous master is known. He worked mostly at Delft.

The four young female saints surrounding the Virgin can be identified by their jewels, which refer to their specific attributes.

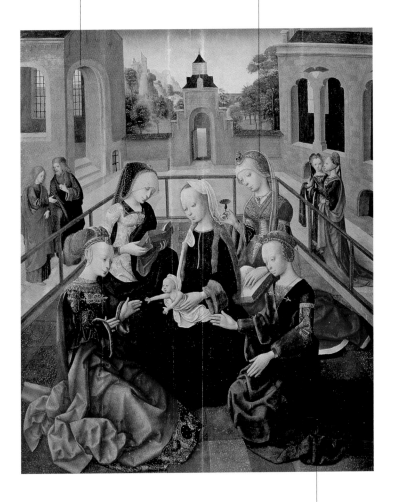

▲ Master of the Virgo inter Virgines, *Virgin and Child with Saint Catherine, Saint Cecilia, Saint Barbara, and Saint Ursula*, ca. 1490. Amsterdam, Rijksmuseum.

The principal scene of the Virgin surrounded by saints is enclosed within a fence. This is a symbolic reference to Mary as an "enclosed garden," but is also a device for solving the problems of the setting and perspective, which seem to cause the Dutch painter some unease.

Thanks to a skillful policy of alliances and territorial expansion, the duchy of Burgundy was the richest state in fifteenth-century Europe. It was therefore able to dictate taste in late-Gothic times.

Burgundy

Related entries
Courtly Art, International
Gothic, Humanism,
Anonymous Masters,
Stained Glass

Campin, the Limbourg
brothers, Van der Weyden,
Van Eyck

▼ Claus Sluter and Claus de
Werve, *Mourners on the
Tomb of Philip the Bold*,
1403. Dijon, Musée des
Beaux-Arts.

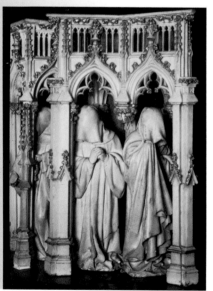

Duke Philip the Bold (d. 1404) and the sculptor Claus Sluter together brought about a substantial change of direction in European art. At the threshold of the fifteenth century, the refined but rather self-absorbed world of the courts, with its taste for precious, exquisitely wrought objects, was shaken by the sudden rise of towering figures in both the artistic and political realms. Among the artists, Sluter seems to have realized that excessive attention to techniques and materials had dangerous limits, and he therefore produced a series of works for the duke that were both monumental and dramatic. During the reign of Philip the Good (1419–67), Burgundy expanded to include the Flemish lands of Flanders, Artois, Brabant, Hainault, Limbourg, and, to the north, Holland and Zeeland, so that the ducal territory covered what is now Belgium, part of southern Holland, and part of France. Burgundian traditions are thus fused with developments in Flemish art, thanks to the equilibrium maintained between the ducal court on the one hand and the autonomous mercantile cities on the other. When Philip the Good died, his son Charles the Bold tried to enlarge the ducal territories even further, but Louis XI of France put an end to his ambitions—and his life—at the siege of Nancy in 1477. In order to maintain the independence of the duchy of Burgundy, Charles's daughter, Mary, married Maximilian of Habsburg, the future emperor, bringing the Dutch part of the ducal holdings as her dowry; but this marriage brought to an end the first splendid period in the art of the Flemish commercial towns, such as Bruges, Ghent, and Louvain. The kingdom of France swallowed up the region of Dijon, ending Burgundy's century of splendor.

Flemish artists often placed figures in extensive and minutely detailed landscapes with winding rivers that pull the eye toward the horizon, trees dotting the hillsides, and towns with tall church spires rising in the distance.

This elegant and costly prayer book was commissioned by the Burgundian duke Charles the Bold and it is richly adorned with highly detailed and lively miniatures. The Burgundian dukes were avid bibliophiles and nurtured the art of book illumination in their domains.

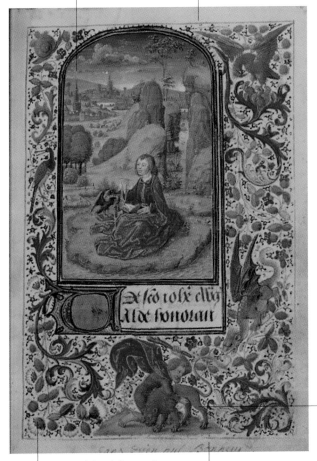

Van Lathem liked to decorate the borders around his miniatures with a variety of creatures. Here we see the pelican feeding its young by plucking its own breast (a symbol of Christ's sacrifice), and a dragon eagerly following the contest between a strongman (Hercules or Samson?) and a lion.

The pages of Flemish illuminated manuscripts are frequently strewn with plant motifs that carefully reproduce individual specimens and give the books a lush effect.

▲ Lieven van Lathem, *Saint John on Patmos,* in the *Prayer Book of Charles the Bold,* 1469. Los Angeles, J. Paul Getty Museum.

Lieven van Lathem worked for a succession of Burgundian rulers, starting with Duke Philip the Good and ending with Maximilian I, who married Charles the Bold's daughter, Mary. He resided primarily in Antwerp, which would become the center of landscape painting in the sixteenth century.

Bellechose was a native of Breda who held the post of official painter at the court of Burgundy for thirty years, from 1415 to 1445; but in spite of such a promising start to his career, he received only a few ducal commissions.

There are two different scenes in the picture: on the left, Saint Denis receives his last communion, in prison, directly from the hands of Christ; and on the right, he is martyred along with his companions Rusticus and Eleutherius.

When he became official court painter at the court of Burgundy in 1415, on the death of Jean Malouel, Bellechose tried to remain faithful to local tradition, using an abundance of gold, fine fabrics, and detail that hearken back to the late-Gothic courtly tradition.

▶ Henri Bellechose, *The Trinity and Scenes from the Life of Saint Denis*, 1416. Paris, Louvre.

At the top of the composition is the monumental figure of God the Father holding up Christ's cross. The symbol of the Holy Spirit, a little dove, can be made out in Jesus' halo. The altarpiece was intended for the Carthusian monastery of Champmol, which was known as the "Maison de la Trinité."

The expressive intensity of the figures is Bellechose's most original contribution to Burgundian painting.

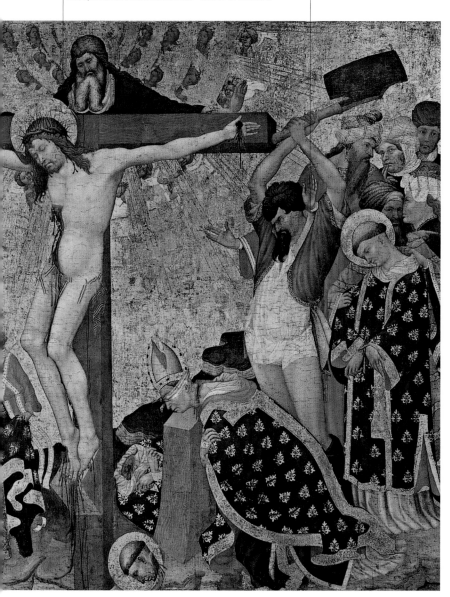

Burgundy

Tapestry was the most expensive kind of decorative art. This example is of a type known as "millefleurs," which was highly esteemed at the Burgundian court.

▲ Brussels workshop, *Millefleurs* tapestry (detail), ca. 1466. Bern, Bernisches Historisches Museum.

This tapestry depicting a profusion of carefully detailed flowers was made for Duke Philip the Good, whose coat of arms and collar of the Order of the Golden Fleece appear at its center. The weaving symbolized the terrestrial paradise flourishing under the rule of the Burgundian dynasty.

A diaphanous veil frames the adolescent face of Mary, daughter of Charles the Bold and wife of Maximilian of Habsburg, to whom she brought the duchy of Burgundy as her dowry.

Marie
de
Bourgogne
1457 · 1482

The jar is an iconographical attribute of Mary Magdalene. It was not unusual for people to be presented in the role of saints or figures from antiquity.

The jewels, the turbanlike hair arrangement, and the splendid clothes are evidence of the refinement attained at the Burgundian court. After her marriage to the emperor, pictures of Mary were to be found throughout Europe, and at least a dozen copies of this portrait are known.

▲ Flemish school, *Portrait of Mary of Burgundy*, ca. 1480. Chantilly, Musée Condé.

In spite of Burgundy's secure place at the center of culture and art, Paris continued to increase its own considerable importance in the art world.

Paris

▼ Jean Fouquet, *The Right Hand of God Protecting the Faithful against the Demons*, 1452–60, from *The Book of Hours of Étienne Chevalier*. New York, Metropolitan Museum.

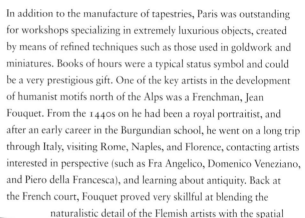

In addition to the manufacture of tapestries, Paris was outstanding for workshops specializing in extremely luxurious objects, created by means of refined techniques such as those used in goldwork and miniatures. Books of hours were a typical status symbol and could be a very prestigious gift. One of the key artists in the development of humanist motifs north of the Alps was a Frenchman, Jean Fouquet. From the 1440s on he had been a royal portraitist, and after an early career in the Burgundian school, he went on a long trip through Italy, visiting Rome, Naples, and Florence, contacting artists interested in perspective (such as Fra Angelico, Domenico Veneziano, and Piero della Francesca), and learning about antiquity. Back at the French court, Fouquet proved very skillful at blending the naturalistic detail of the Flemish artists with the spatial monumentality and clarity of illumination that he had learned in Italy. He was a versatile if rather unusual painter and was responsible for some glorious and inimitable series of miniatures; indeed, he was one of the greatest miniaturists in the history of art. Taking the Gothic tradition as his point of departure, he invented a new figurative language that proved to be the high point of humanist expression in French painting. One characteristic of his art was his skill in bringing different images together in a unified composition, and he was wonderfully gifted in depicting environments, natural details, and costumes. He delicately sprinkled his painted robes with gold dust to give them a special luminosity.

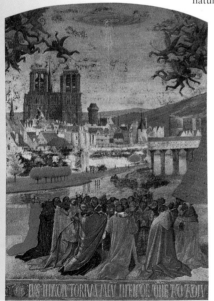

*One can instantly recognize the slim
Gothic outlines of Sainte-Chapelle, the
heart of religious life in the Île de la Cité.*

*The scene is set outside the walls of
Paris: what was then the Palais de la Cité
is now the Conciergerie.*

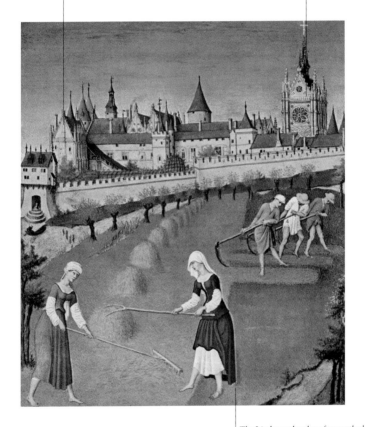

▲ The Limbourg brothers, *June*, ca. 1413–16,
miniature from the *Très Riches Heures du
duc de Berry*. Chantilly, Musée Condé.

*The Limbourg brothers frequently depicted
the Months through the seasonal work
going on in the fields. As always in their
miniatures, accurate representations of
known buildings appear in the same compo-
sition with completely fanciful scenes of
everyday life. Thus peasants are making hay
in hypothetical fields right in the middle of
Paris, along the left bank of the Seine in the
area of the Latin Quarter.*

The French town of Arras continued to produce
tapestries even in the fifteenth century, but the
quality of its products gradually fell behind that
of its Flemish competitors.

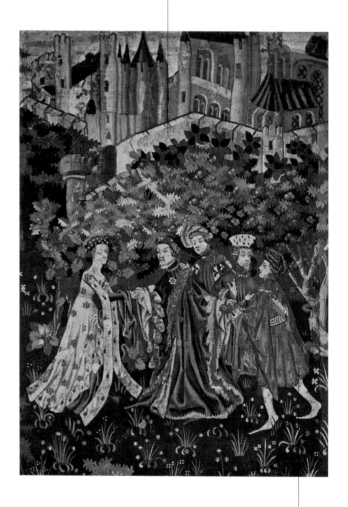

The favorite subject matter remains
that of courtly times: aristocratic games
and leisure pursuits set in luxuriant
landscapes with fairy-tale castles.

▲ Arras manufactory, tapestry with
scenes of courtly love, ca. 1420.
Paris, Musée des Arts Décoratifs.

The drawn curtains give the impression of a sort of royal manifestation.

Fouquet's portrait was painted for the Sainte-Chapelle in Bourges, one of the royal residences. It became a model for royal portraits, one which was taken up in the next century by François Clouet and Hans Holbein.

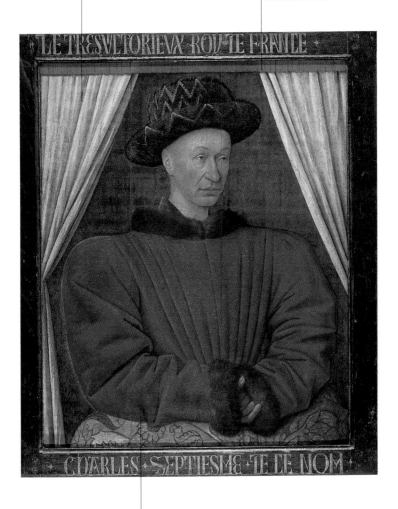

The subject is viewed from the front, but he is not looking toward the spectator. The figure of the king splendidly occupies the whole picture space, but at the same time he keeps his distance, both physically and socially.

▲ Jean Fouquet, *Portrait of King Charles VII*, 1444–50. Paris, Louvre.

The topmost decoration and ogee arch of the central part are suggestive of Gothic models, but the master responsible for this painting is familiar with the latest in contemporary Flemish art. Some have tentatively identified him as André d'Ypres.

This panel was intended for the Grande Chambre in the Paris parliament building. Other Parisian buildings appear in the background, such as the Tour de Nesles, the Louvre, and the Palais de la Cité.

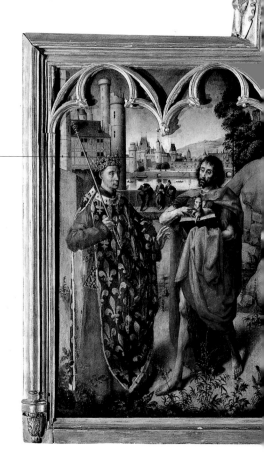

▶ Master of Dreux-Budé (André d'Ypres?), *The Paris Parliament Crucifixion*, ca. 1452. Paris, Louvre.

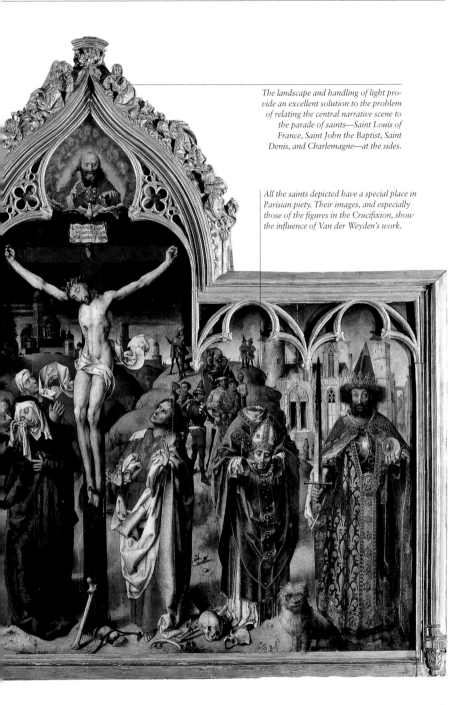

The landscape and handling of light provide an excellent solution to the problem of relating the central narrative scene to the parade of saints—Saint Louis of France, Saint John the Baptist, Saint Denis, and Charlemagne—at the sides.

All the saints depicted have a special place in Parisian piety. Their images, and especially those of the figures in the Crucifixion, show the influence of Van der Weyden's work.

The Western Mediterranean
Aragon and Castile
Catalonia and Valencia
Provence

The singular way that Mediterranean art develops in the fifteenth century results from the quantity and intensity of cultural exchanges.

Aragon and Castile

The fragmentation of Spain, resulting from dynastic divisions and the long Arab domination of Andalusia, accounts for the existence of a variety of art centers, where incoming international currents encountered persistent local trends, which were often sharply defined. The prevalent taste remained tenaciously anchored in the Gothic tradition, which enjoyed a period of great opulence in the fifteenth century, especially as a result of large ecclesiastical commissions. Visitors to Spanish cathedrals mark the colossal works of painting and sculpture there: grandiose and articulated polyptychs on several tiers take up so much space on altars that they obscure the architecture, and Spanish retables are couched in a very local idiom, which often has an attractive originality that derives from the influx of many different artistic styles. That Jan van Eyck was in Spain in 1428 is indicative of an interest in Flemish painting, but there was also an ongoing dialogue with Italian spatial experiments, carried on along the maritime routes to Naples. The unification of Spain began when Ferdinand of Aragon married Isabella of Castile (1469), and it was completed when the Moors of Granada were defeated at the battle of Las Navas in 1492. These events had important consequences for painting. The principal Spanish painters now traveled in order to make contact with the latest developments in art: the Catalan painter Jaime Baço, known as Jacomart, visited Naples and Rome; Bartolomé Bermejo (from Andalusia) learned his art in Flanders and made frequent visits to Aragon and Catalonia; and Pedro Berruguete moved to Urbino in 1474, taking a leading role at the cosmopolitan court of Federico da Montefeltro.

Related entries
Courtly Art, Anonymous
Masters, Wood Sculpture

Bermejo, Berruguete,
Juan de Flandes

▼ *King Solomon Enthroned*, ca. 1430, miniature from the *Bible of the House of Alba*. Madrid, Collections of the Duke of Alba.

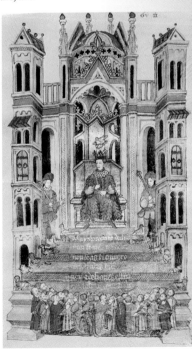

Christ hurls arrows at
humankind as punishment for
indulging in the deadly sins.

The large figure of the Virgin, whose
robe is held up by angels, protects the
just from the wrath of God.

In this expressive masterpiece
of mid-fifteenth-century
Aragonese painting, the
anonymous artist has included
portraits of the pope, the king,
and the queen among those
protected by the Virgin.

The allegorical figures of
the deadly sins in the side
niches are struck by Christ's
arrows. They are conveyed
with considerable symbolic
effect, but a halting use
of perspective.

▲ Anonymous Aragonese master, *Virgin
of Mercy*. Teruel, bishop's palace.

▲ Gil de Siloé, *Tomb of the Infante Alfonso*, 1489–93. Burgos, Carthusian monastery of Miraflores.

Gil de Siloé proved to be one of the most imaginative and original sculptors in southern Europe. He knew how to combine successfully a sense of monumentality in the image, expressed in a broad, calm way, with a virtuoso attention to detail in the ornamentation.

The presence of Dominican friars emphasizes the importance of their order at the Spanish court.

A background landscape can be seen through the windows, but no light from the windows falls on the figures.

The king and queen kneel in prayer: on one side is Ferdinand of Aragon, known as "the Catholic," and on the other is Isabella of Castile. This arrangement of figures was widely used in royal family portraits.

The somewhat tilted perspective shows that the anonymous painter had struggled with it, or at any rate that his chief concern was the portraits rather than their setting.

▲ Unknown Castilian master, *Virgin of the Catholic Monarchs*, ca. 1492. Madrid, Prado.

This panel was once part of a retable dedicated to Saint Dominic for the cathedral at Gerona. It shows sentence being passed by the Inquisition, which was administered by the Dominicans.

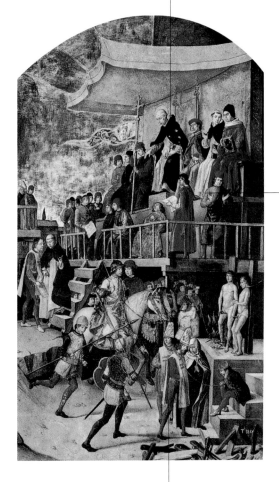

The judges' platform is viewed from below in correct perspective, and the perspective is emphasized by the canopy. It demonstrates how much Berruguete had learned about geometry during his residence at the court of Urbino.

Those under sentence can be identified by their headgear and the robes they are obliged to wear. Two half-naked "heretics" are tied to a stake and are being executed by garroting.

▲ Pedro Berruguete, *Auto-da-fé*, 1495–1500. Madrid, Prado.

Growing in the shadow of austere and imposing Gothic churches, somewhere between late Gothic and humanism, the Catalan school artists are ready to compete in an international field.

Catalonia and Valencia

Related entries
Courtly Art, International
Gothic, Humanism,
Anonymous Masters,
Wood Sculpture

Baço, Bermejo, Huguet

▼ Gonçal Peris (Gonzalo
Pérez), *Portrait of King
Jaime I*, ca. 1420. Barcelona,
Museo Nacional de Arte
de Catalunya.

In the twelfth century, Catalonia was annexed to the kingdom of Aragon. It became part of the new Spanish kingdom created by the marriage of Ferdinand and Isabella in 1469. However, this was not a simple historical transition, for it meant lasting tension between the central authority (which was largely Castilian) and Catalan patriotism. In the Barcelona region, the most significant stylistic influence in painting came from Flemish artists, especially Van Eyck. Alfonso of Aragon owned some of his works, and they were well known in Naples as well. Catalan painters remained substantially faithful to these models, though they made cautious contact with Italian innovations in perspective. Jaime Baço, known as Jacomart, an artist from Valencia, never lost his ties with Flemish painting, even though he resided at the court of Alfonso of Aragon in Naples. Bartolomé Bermejo trained as a painter in the Low Countries but lived for a long time at Valencia, remaining more or less unattached to any school as a result of his wanderings in Aragon, Italy, and Catalonia. In Barcelona, Bermejo came into competition with Jaume Huguet, one of the greatest Catalan artists of the later fifteenth century, in whose work Italian and Flemish motifs blend with elements of International Gothic. Huguet remained faithful to the medieval Catalan tradition in using heavy gold grounds with floral reliefs, before which elegant and graceful figures take their places. Bermejo's presence in Barcelona went some way toward modifying this state of affairs, for he initiated a humanist period. But it was a brief one, coming to an end amid the crisis that struck Catalonia at the beginning of the sixteenth century.

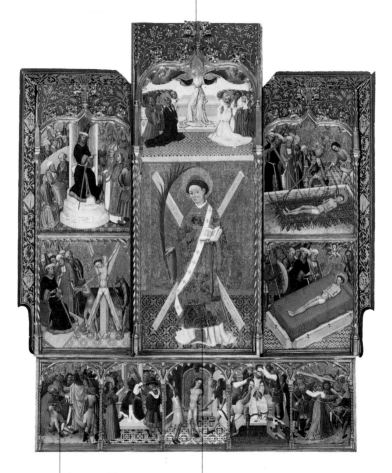

This retable was made for the Cistercian abbey of Santa Maria de Poblet. It is a good example of Martorell's eclectic figurative style, for we see a series of different interpretations in the various panels, involving appreciable changes in style and dimensions.

The scenes of the Passion in the predella display a narrative vivacity that is typical of International Gothic.

▲ Bernat Martorell, *Retable of Saint Vincent Martyr* 1430–40. Barcelona, Museo Nacional de Arte de Catalunya.

The retable is dominated by the figure of Saint Vincent Martyr against a gold ground. Bernat Martorell, who died in 1452, is the outstanding Catalan painter of the first half of the fifteenth century.

The calm monumentality of the archangel is clear evidence of contact with Italy, which Baço visited on a number of occasions.

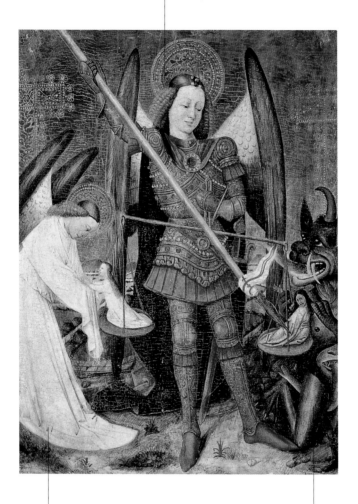

The play of different shades of white in the angel and the blessed soul is an example of the preferred style at Mediterranean courts in the mid-fifteenth century.

▲ Jaime Baço (Jacomart), *Saint Michael Weighing Souls*, ca. 1450. Reggio Emilia, Galleria Parmeggiani.

Some traits of Gothic expressionism are evident, especially in the grimaces of the damned soul and the defeated devil.

The intensity of expression and extreme pathos of the figures are characteristic qualities of Bermejo's art and religious sentiment.

The sharp corner of Christ's tomb emerges with painful immediacy from the foreground space.

Many details of this extraordinary human episode, depicted by Bartolomé de Cárdenas (known as Bermejo, "Red," because of his red hair), remain a mystery. The extreme attention to detail seems to suggest a direct acquaintance with Flemish painting.

▲ Bartolomé Bermejo, *The Dead Christ Supported by Angels*, 1468–74. Peralada (Gerona), Museo del Castillo.

The south of France was now going through a fascinating period in art, during which Flemish attention to detail was blended with the monumentality of Italian art and the use of diffused sunlight.

Provence

▼ Barthélemy d'Eyck
(debated attribution), ca.
1450, miniature from the
Cœur d'amour épris.
Vienna, Österreichische
Nationalbibliothek.

After spending about seventy years in Provence, the papal court returned to Rome in 1379. Left behind in the papal palace at Avignon were frescoes, memories, regrets, and schismatic ambitions: the papal residence there, with its entourage of painters, poets, and other artists, made the area into a cultural hotbed. The kings of France were at the time perpetually at war with the English and repeatedly moved the royal court. Eventually Provence found itself once more an active center for the production of art. The old pilgrim roads had become comfortable trade routes, which, together with commercial and cultural traffic around the Mediterranean, put Avignon at the center of a close-knit cultural network: from the Côte d'Azur to the Rhône Valley, the French Midi enjoyed a period of artistic splendor. The proximity of Burgundy accounts for the prevalent Flemish influence, which revived with the arrival in the region of the Master of the Aix Annunciation—a key to understanding the reciprocal stylistic influences of the Flemish, Provençal, Burgundian, and Italian art centers—now identified as Barthélemy d'Eyck. Compositions grew in size and showed a characteristic blend of courtly splendor and popular feeling. The relationship with Italian painting is clear in the parallels between Piero della Francesca and Enguerrand Charonton. Charonton worked at Avignon and painted vast compositions in which the broad use of gold grounds is accompanied by a clearly humanistic monumentality.

The investigation of light is perhaps the most characteristic and fascinating aspect of Provençal painting. We can see this in the works of Lieferinxe, who was active at Avignon. Although he was inspired by Flemish art, his attention to illumination developed in such a way that it became a signature trait.

This painting is part of a polyptych devoted to Saint Sebastian, the various parts of which are scattered in museums across the world.

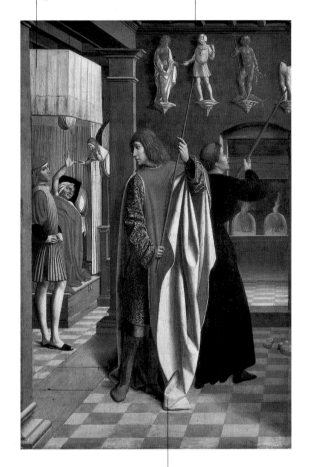

Provençal masters particularly liked bright colors. Lieferinxe may also have had contacts with Lombard painters.

▲ Josse Lieferinxe, *Scene from the Life of Saint Sebastian*, 1497–98. Philadelphia, Museum of Art.

The face of God the Father is seen through a window in the background; the dove is a visible symbol of the relationship between Holy Spirit, Father, and Son.

On the extreme left is a strip of brightly lit landscape, but the background of the rest of the painting is a dark, gloomy wall.

The portrait of the kneeling donor is particularly expressive: his features are deeply incised and tense with emotion, and his prayer, in white letters, rises heavenward.

Christ's tomb in the extreme foreground seems almost to project from the painting toward the spectator.

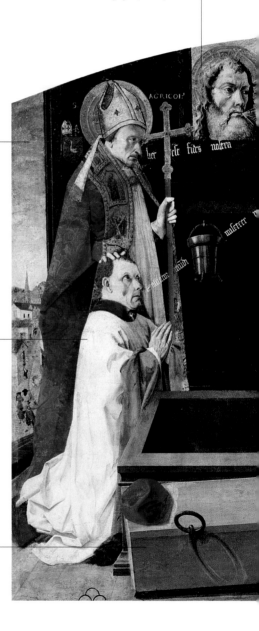

▶ Provençal painter, *The Boulbon Retable*, 1445–50. Paris, Louvre.

The long beam on which the symbols of
the Passion appear is a reference to the
horizontal bar of the cross.

The symmetry of the composition risked
being thrown off by the donor on the
left, but he is cleverly counterbalanced
by the Flagellation column that closes
the scene on the right.

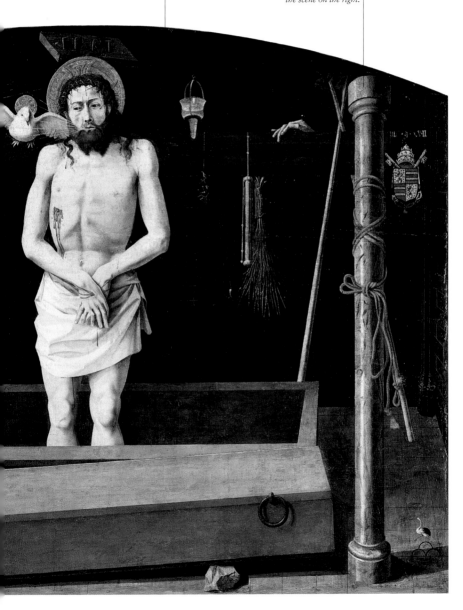

Although there are great differences of scale in the figures, the scene does not seem unpleasant or forced. The effect, rather, is to enable the spectator to read the picture at several levels, in sequence.

The painting was commissioned by the prior of the Carthusian monastery of Val-de-Bénédiction. The composition is extraordinarily complex: we notice, for example, that the margin below the main scene contains a representation of the Last Judgment.

Charonton's extraordinary intuition enables him to give the scene a cosmic dimension by means of a single vast landscape in which both Jerusalem and Rome appear, separated by the cross.

▶ Enguerrand Charonton, *The Coronation of the Virgin*, 1453–54. Villeneuve-lès-Avignon, Musée de la Chartreuse.

At the specific request of the donor, the figures of Christ and God the Father are identical. Mary's robe merges into the robes of the other divine figures, symbolizing the Virgin's involvement in the mystery of the Trinity.

The shift of power from the Visconti to the Sforza family midway through the fifteenth century also signals a transition from late-Gothic refinement to new humanist models.

Milan

Milan and Lombardy have a special place in the history of fifteenth-century European art. In the first half of the century, *ouvrage de Lombardie* meant an object of extremely refined manufacture, an exquisite expression of elitist and rarefied courtly taste, of which miniatures and goldwork are perfect examples. But although the Milanese duchy was considered the quintessential home of the late-Gothic style, it was also in frequent contact with the avant-garde of humanist culture, thanks partly to a network of commercial and dynastic links, especially with Flanders. The cathedral building site was set up in 1386 and drew masters from France, Burgundy, and Germany. This influx contributed to the international flavor of Milanese artistic culture as well as to the development of a local school of sculpture, which aided in the production of the vast number of statues required for the cathedral. After the demise of the principal branch of the Visconti family in 1447 and the brief Ambrosian Republic, power in Milan passed to Francesco Sforza in 1450. This set in motion a spectacular series of architectural projects with contributions from Tuscan masters. Vincenzo Foppa and, immediately after him, Bergognone and Bramantino gave rise to a prestigious Milanese school. Thanks to the patronage of Ludovico il Moro, it came into direct contact with masters from central Italy, such as Bramante and Leonardo, who worked for long periods in Milan and other Italian cities.

Related entries
Courtly Art, International Gothic, Renaissance, Perspective, Fresco, Miniature, Intarsia, Equestrian Monument

Bramante, Foppa, Leonardo

▼ Giovannino de' Grassi, *Funeral Oration for Duke Giangaleazzo Visconti*, 1402. Paris, Bibliothèque Nationale.

The resurrected Christ at the apex is
very reminiscent of the saints sculpted
on top of the cathedral spires.

The architectural design of the mon-
strance almost exactly repeats some of
the motifs of Milan cathedral, such as
the large Gothic windows, the flying
buttresses, and the drainage spouts.

In late-Gothic times and throughout the
Renaissance, Lombard craftsmen were
among the most highly regarded producers
of refined luxury objects in Europe.

▲ Lombard goldsmith,
The Voghera Monstrance,
1456. Milan, Castello Sforzesco,
Civiche Raccolte d'Arte Applicata.

In Bergognone's pictures, everything is calm and controlled. The treatment of drapery and color is reminiscent of contemporary Provençal and Flemish painting.

The rendering of perspective is confident and coherent, as are the realism of individual objects and the almost tactile effect of surfaces.

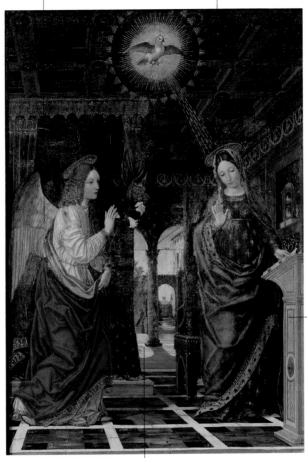

Ambrogio Bergognone and Vincenzo Foppa were the most important Lombard painters during the Sforzas' rule.

This painting is part of a cycle of scenes from the life of the Virgin. This cycle is considered to be Bergognone's greatest achievement, especially for his refined definition of light and his depiction of rooms in series.

▲ Ambrogio Bergognone, *The Annunciation*, ca. 1495. Lodi, church of the Incoronata.

In order to convey the mystery of Mary's virginity and the Immaculate Conception, Leonardo paints a wonderful kind of natural womb: a hollow of filtered light through which we can glimpse a distant landscape of mountains and streams.

This altarpiece is the first work that Leonardo painted in Milan. At the time he was a guest of the De Predis brothers, who had originally been asked to paint it themselves.

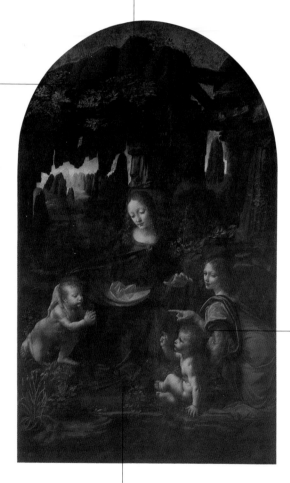

The angel's gesture toward the Virgin's womb was repeated in a later copy by the De Predis brothers, made under the supervision of Leonardo and now in the National Gallery in London.

The painting was intended for the church of San Francesco Grande in Milan. The Franciscans were dedicated to the cult of the Immaculate Conception, which was only recognized as a dogma of the Catholic Church some centuries later.

▲ Leonardo da Vinci, *Virgin of the Rocks*, begun in 1483. Paris, Louvre.

In spite of the small size and marginal nature of their territory, the Gonzaga family gave life to one of the most splendid seigneurial courts in Europe.

Mantua

Once the Gonzaga family came to power in Mantua, they turned the Ducal Palace on the banks of the Mincio into one of the largest, richest palaces in Europe. Almost all the furnishings and works of art have been lost as a result of later historical events, but that in no way lessens their fascination and importance. While the neighboring and related Este family was playing an active part in Ferrara's urban design, the Gonzaga preferred to concentrate on a few grandiose artistic projects, such as that humanist masterpiece of Leon Battista Alberti, the great church of Sant'Andrea. The post of court painter was occupied by a succession of important figures, a sign of the sophisticated taste of the Gonzagas. Thanks to Andrea Mantegna, who was appointed court painter after Pisanello in 1460, the little court became a breeding ground for Renaissance artistic ideas, including the striking and innovative use of perspective. An outstanding example of this experimentation is the fresco cycle in the Camera degli Sposi. There Mantegna portrayed the Gonzaga court and, by means of a courageous perspectival device, "broke through" the ceiling of the room, simulating a circular opening with a balcony, from which various figures look down. The Camera degli Sposi was an epoch-making development in the Italian courtly style, marking the transition from lavish late-Gothic ornamentation to more sober humanistic and intellectual images. An outstanding figure toward the end of the century was Isabella Gonzaga, an intelligent and generous patron of the arts.

Related entries
Courtly Art, Humanism, Renaissance, Perspective, Fresco, Intarsia

Alberti, Mantegna, Pisanello

▼ The expulsion of the Bonacolsi from Mantua in 1328 allowed the Gonzaga family to gain control of the city. Domenico Morone, *The Expulsion of the Bonacolsi*, 1494. Mantua, Ducal Palace

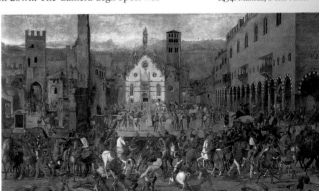

Mantegna ingeniously makes use of the
architectural structure of the room, which
is in the massive late-fourteenth-century
castle of San Giorgio.

The lunettes are used
for rich festoons of
leaves and fruit above
patches of cloudy sky.

The wall on the left shows
the marquis meeting his
cardinal son at the gates of
Rome. Since it is situated
by the window, the scene
seems to echo the natural
open landscape.

The lower part of
the wall is decorated
with a geometrical
pattern that simulates
precious marble.

► Andrea Mantegna, frescoes in the
Camera degli Sposi, 1465–74. Mantua,
Ducal Palace, castle of San Giorgio.

The principal scene is arranged along the fireplace wall. Mantegna has painted a curtain drawn back to reveal the Mantuan court, consisting of the Gonzaga family surrounded by dignitaries.

By a very skillful use of chiaroscuro, Mantegna has made the ceiling appear to have rich, classical decorations in stucco, with friezes, garlands, and busts of Roman emperors.

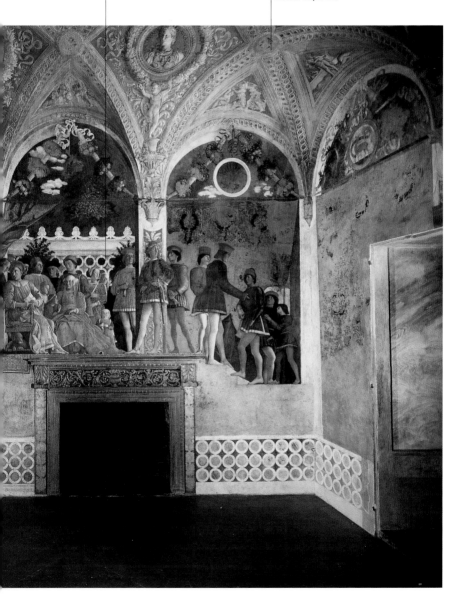

Italian fifteenth-century art is not solely the preserve of the courts and chief cities. This is clear from the case of Padua, a university town that is near Venice but independent of it.

Padua

▼ Donatello, *Saint Louis of Toulouse and Saint Justina*, ca. 1453. Padua, basilica of Il Santo, high altar.

Since Padua was only about twelve miles from Venetian territory, it was one of the first towns in the Veneto to come within the orbit of the Republic of San Marco. It lost its court but was amply compensated by the extraordinary artistic tradition inaugurated by the arrival of Giotto, the development of the university, and the enduring cult of Saint Anthony, whose church became the nucleus of a whole series of architectural and artistic projects. Links with Tuscan humanism were an important factor: Donatello worked at Padua for a long time, leaving behind memorable works such as the equestrian statue of Gattamelata and the bronze statues of the *Altar of Saint Anthony*. These masterpieces led, soon after midcentury, to an extremely fruitful artistic school, and Padua became a place where Tuscan masters, with their original use of perspective, met painters working in northern Italy. It was certainly no coincidence that many of the masters who shared a youthful sojourn in Padua took to fresco painting in the 1450s. In Ferrara, Cosmè Tura organized work at Palazzo Schifanoia, the Lombard painter Vincenzo Foppa left an unsurpassed masterpiece in the Portinari chapel in Milan, and the Tyrolean painter Michael Pacher used humanist perspective in works found as far away as the remote Val Pusteria in the Dolomites. The most important case, however, is that of Mantegna, whose career from the early scenes in the Eremitani church to his triumphant masterpiece in the Camera degli Sposi in Mantua revitalized the visual language of sacred and secular fresco painting in northern Italy.

A famous detail is the pergola in perfect perspective. Mantegna was one of the first painters in northern Italy to display a systematic interest in the representation of depth, and he was encouraged by the presence of great Tuscan masters in Padua.

The deep townscape is also memorable. In creating it, Mantegna took part in the passionate search for the "ideal city" modeled on the aspirations of the humanists.

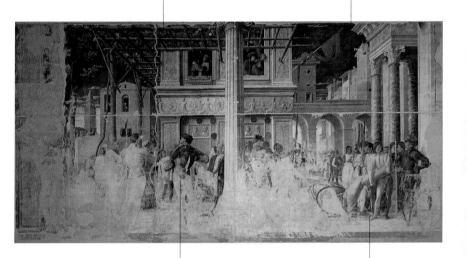

The fresco cycle suffered irreparable damage during the Second World War. However, the parts that survived allow us to appreciate how keenly interested the young Mantegna, the son of peasants, was in classical antiquity. He has even included a correct representation of two Roman funerary stelai in the central building.

On the right we see the giant body of Saint Christopher being taken away after his martyrdom.

▲ Andrea Mantegna, *The Execution and Burial of Saint Christopher*, 1453. Padua, church of the Eremitani, Ovetari chapel.

The religious power of the patriarchate and the administrative power of the senate are reflected in the unique image of the city called Serenissima—the Most Serene.

Venice

▼ Vittore Carpaccio, *The Miracle of the Reliquary of the True Cross* (set on the banks of the Grand Canal near the old Rialto Bridge), 1494. Venice, Gallerie dell'Accademia.

Tradition and innovation: the mosaics at the basilica of San Marco still follow the rules of Byzantine art, but the Ducal Palace displays refined late-Gothic ornamentation. The arrival of Florentine masters around 1450 (Andrea del Castagno, Paolo Uccello, and Donatello) had no effect on local painting, whose outstanding workshops were those run by Jacopo Bellini, where his sons Gentile and Giovanni learned their art, and by the Vivarini family on the island of Murano. When Antonello da Messina arrived in 1475, Giovanni Bellini acquired a new understanding of space, constructed using light and the regular arrangement of colored geometrical shapes, and it was he who now assumed leadership of the Venetian school. Meanwhile, the city's appearance was transformed by a whole repertoire of classical ornamentation with a cool, balanced rhythm. This style was introduced by the architect Mario Codussi and members of the Lombardo family, and it was applied to many public and private buildings. The city's renewed splendor was described in tones of awe in diplomatic

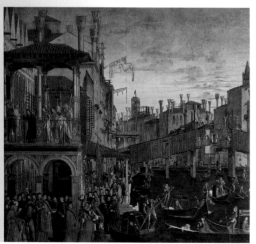

reports and gained an international reputation. After emerging in the thirteenth century, the Venetian "empire" reached its greatest extent at the end of the fifteenth century. In Italy, its territories reached beyond what is now the Veneto, to include Romagna and the provinces of Brescia and Bergamo as far as the river Adda. Along the Adriatic, Venice's dominions stretched down the coast from Friuli to Dalmatia. Trading stations were scattered across the *stato da mar* or "sea state"—the term used for Venice's possessions in the Aegean and eastern Mediterranean, including Crete and Cyprus.

This elongated architectural structure is a strange pastiche of different elements. It closely follows a drawing found in an album of Jacopo Bellini's, in which he had gathered a large number of sample architectural and theatrical drawings.

A gold ground is the basic unit of color and light throughout the decoration of the basilica of San Marco. It has an iridescent effect, which Venetian painters have consistently used to their advantage.

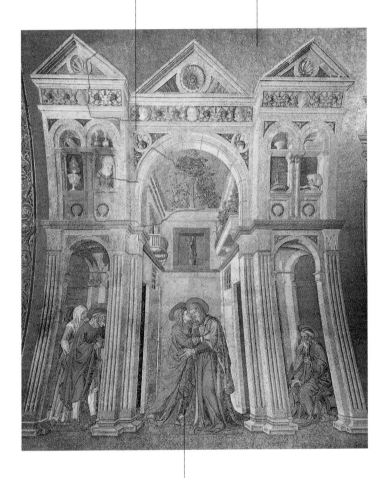

The pronounced plasticity of the figures contrasts with the traditional linearity of Byzantine painting. It shows the influence of Andrea del Castagno's 1452 frescoes in the Venetian church of San Zaccaria.

▲ Based on drawings by Andrea del Castagno, Michele Giambono, and Jacopo Bellini, *Mosaic of the Visitation*, 1453. Venice, basilica of San Marco, Mascoli chapel.

Giovanni Bellini has painted panels of variegated marble behind the group of figures.

The vast, noble architectural setting brings together some clearly humanist barrel-vaulting in perspective and an apse decorated with Byzantine mosaics with a gold ground, in homage to the medieval Venetian tradition.

This painting is a milestone in the history of Venetian art, for it brought about a revolution in painted altarpieces. Even the individual figures were copied and imitated for decades: an almost identical Saint Francis appears in an altarpiece painted by Giorgione in Castelfranco cathedral at the beginning of the sixteenth century.

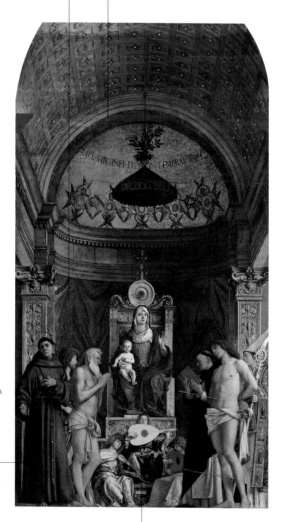

▲ Giovanni Bellini, *The San Giobbe Altarpiece*, 1487. Venice, Gallerie dell'Accademia.

The large musical instruments held by angels emphasize the rays of light that flow over the scene from right to left.

Carpaccio specialized in detailing everyday life in his paintings. In this panel he depicts cormorant hunters on the Venetian lagoon. The hunters shoot pellets of dried clay that stun the birds but leave their flesh and feathers undamaged.

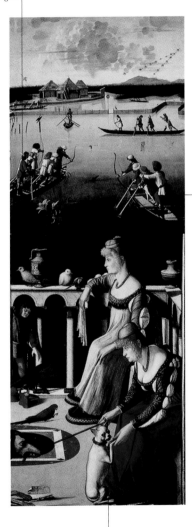

The panel is two-sided (the reverse shows a bunch of letters tucked behind a red rope) and has hinges and a latch, which suggest that it was used as a decorative window shutter or the door to a cabinet.

▲ Vittore Carpaccio, *Hunting on the Lagoon* and *Two Courtesans*, 1490–95. Top, Los Angeles, J. Paul Getty Museum; bottom, Venice, Museo Correr.

Two luxuriously dressed women sit on the balcony overlooking the lagoon. Their fancy attire, ornate hairstyles, and low necklines suggest that they may be courtesans. Venetian courtesans were famous for their luxurious lifestyles and immodest fashions.

Displaying great sensitivity, Gentile Bellini goes beyond depicting famous buildings: he also makes room for the densely packed Venetian townscape.

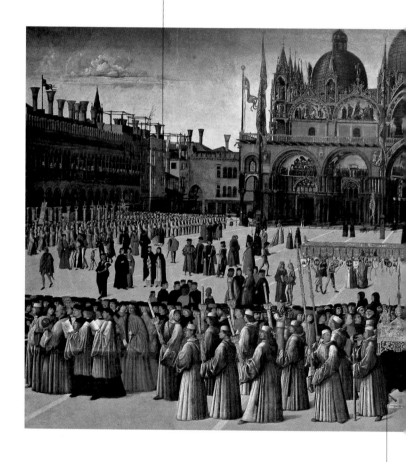

▲ Gentile Bellini, *Procession in St. Mark's Square*, 1496. Venice, Gallerie dell'Accademia.

Members of the procession carry the reliquary of the True Cross, a precious object of veneration, under a canopy.

The background to the scene is the unmistakable broad facade of the basilica of San Marco. It is faithfully represented in exact detail, including, of course, the four bronze horses on the balcony.

The Ducal Palace is the revered civil and administrative counterpart of the massive holy shrine of San Marco.

Bellini has distorted topographical reality in only one detail, and that one deliberately. He has moved the bell tower to the right, placing it beside the Procuratie in order to avoid obscuring the Ducal Palace.

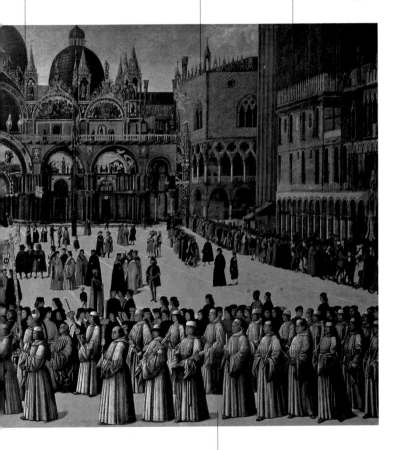

Leading the procession are the members of the Scuola Grande di San Giovanni Evangelista, who commissioned the painting, but a great many other citizens are also included. This painting illustrates the nature of Venetian public ceremonies, which tended to include every level of society.

Bold commissions from the Este dukes were responsible for the birth of the most fantastical school of painting in Italy and for the construction of monumental buildings in the urban center.

Ferrara

Until the Este family became its lords, Ferrara had been an old medieval town near the river Po; but when, at the end of the fourteenth century, Niccolò d'Este established the first political and cultural institutions of his *signoria*, such as the castle and the university, "the first modern city in Europe" rose and developed around them. This included the Addizione Erculea, an extraordinary planned quarter ordered by Ercole d'Este and created by Biagio Rossetti, with broad, straight streets flanked by famous palaces. Painting played a fundamental role in the Renaissance culture of Ferrara. The dukes brought to their court distinguished artists such as Rogier van der Weyden and Piero della Francesca, as well as others from farther afield. Lionello d'Este sat as a model in a painting contest between Jacopo Bellini and Pisanello, and the best local talent, namely Cosmè Tura, the son of a shoemaker, was sent to study, at Este expense, in the nearby hotbed of humanism, Padua. This extremely rich mixture gave rise to the highly original Ferrarese school, which included Francesco del Cossa and Ercole de' Roberti as well as Cosmè Tura. It was a unique period of artistic skill and invention, giving rise to wonderful refined paintings, as one can tell just by looking at the fresco cycle in the Salone dei Mesi in Palazzo Schifanoia. It is a collective work by Ferrarese masters (ca. 1470), and provides one of the best illustrations of life and art at a fifteenth-century court: a perfect blend of everyday subjects enjoying health and life in the Venetian territories among the islands of the Aegean and eastern Mediterranean, including Crete and Cyprus.

▼ Cosmè Tura, *The Martyrdom of Saint Maurelius*, 1474. Ferrara, Palazzo dei Diamanti, Pinacoteca Nazionale.

The Schifanoia frescoes are one of the greatest masterpieces of fifteenth-century secular painting. They are arranged in three tiers, one above the other. The top tier depicts the triumph of a god or a goddess (Venus in this case) with scenes relevant to the season of the year.

The middle tier has a dark background and shows the sign of the zodiac for the month in question (Taurus in this case), together with other astrological and allegorical references.

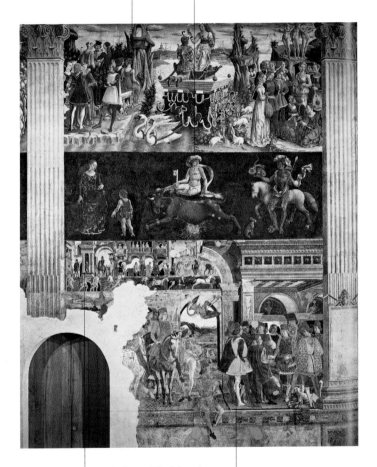

In the background, the duke and his court watch a donkey race through the city streets.

▲ Francesco del Cossa, *April*, 1469–70. Ferrara, Palazzo Schifanoia, Salone dei Mesi.

The bottom tier shows episodes in the life of the Este court. On the right, the smiling figure of Duke Borso offers a reward to a jester.

How could a small frontier duchy perched in the hills of the Marches make a name for itself? Federico da Montefeltro's answer to that question was to create a "palace in the form of a city."

Urbino

▼ Piero della Francesca, *The Urbino Diptych* (*Portraits of the Duchess and Duke of Urbino, Battista Sforza and Federico da Montefeltro*). ca. 1460, Florence, Uffizi.

The most complete and fascinating example of an Italian humanist court is that of Urbino, where Duke Federico da Montefeltro created a city of great artistic splendor. From the mid-century onward, he brought painters, architects, men of letters, and mathematicians to Urbino. The family palace was substantially renovated and enlarged in Renaissance style by Francesco Laurana and Francesco di Giorgio Martini, and discussions went on in palace rooms about the form an "ideal city" should take, about perspective, and about the historical and moral responsibilities of "illustrious men." Outstanding among the painters at Urbino were the Florentine Paolo Uccello, the Flemish artist Justus of Ghent, and the Spaniard Pedro Berruguete. They transformed the court into a key meeting place for new ideas in various artistic spheres, among them sculptural decoration (coordinated by Agostino di Duccio) and the wonderful inlaid wood panels in perspective in the duke's study. The painting of Piero della Francesca there achieved a perfect balance between strict geometrical rules and the serene, broadly conceived monumentality. The atmosphere at the Montefeltro court was to prove ideal for further developments: two of the principal interpreters of the High Renaissance, Bramante and Raphael, were born and learned their art in Urbino. When the Montefeltro rule came to an end, Urbino was to remain a brilliant Renaissance court, thanks to the Della Rovere family.

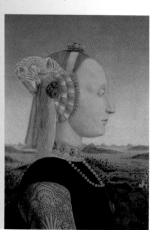

Along the upper part of the walls, above
the intarsia, is a row of portraits depicting
ancient poets, thinkers, and scholars.
They are the work of Justus of Ghent and
Pedro Berruguete: fourteen of them are
still in place, and another fourteen are in
the Louvre.

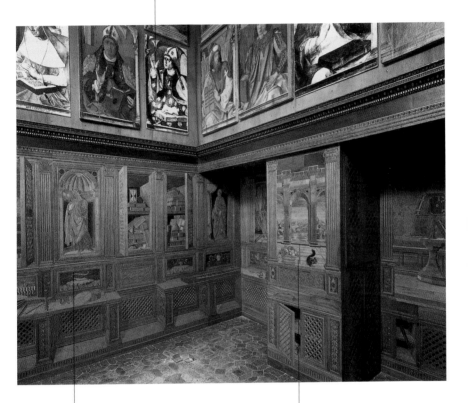

The central section of the intarsia
contains a number of simulated niches
with statues, shelves, and doors. They
treat the viewer to a succession of
symbolic references that celebrate the arts.

The entirety of the small room is
covered with intarsia, which masks,
or at least attenuates, the unevenness
of its walls. Imitation cupboard
doors, some open or half-open, line
the bottom part of the wall.

▲ Baccio Pontelli, to drawings by Botticelli
and Francesco di Giorgio Martini, intarsia
in Federico da Montefeltro's study,
ca. 1470. Urbino, Ducal Palace.

The wonderful coffered ceiling in the classical style precisely defines the depth of space and displays the passionate attention paid to the effect of light.

Viewing the Flagellation scene is someone dressed to look exactly like the Byzantine emperor John VIII Palaeologus, whom the Turks deposed in 1454 when they took Constantinople—not long before this painting was made.

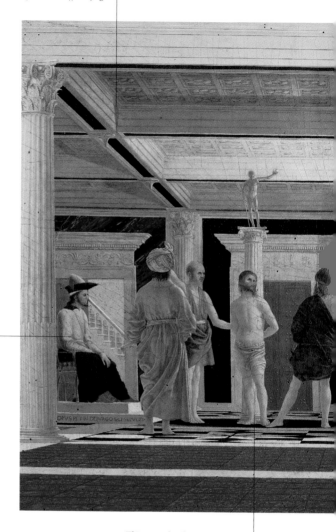

This unusual and intriguing painting seems to be divided neatly into two: in the foreground, on the right, are three very large figures, whereas the scene of the Flagellation, with Christ bound to the column, takes up the middle ground on the left.

▶ Piero della Francesca, *The Flagellation*, ca. 1460. Urbino, Galleria Nazionale delle Marche.

No one knows who these three main figures are or what they signify, despite the best efforts of many experts.

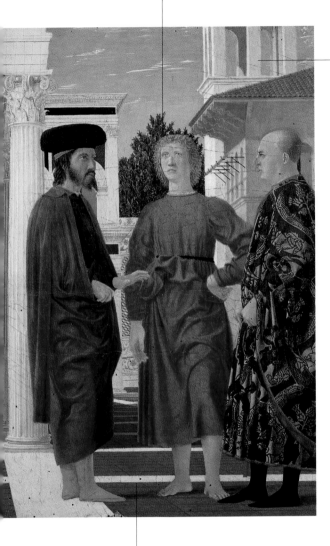

The clear sky on the right announces a sunny spring day and enhances the broadly diffused light that makes the painting so memorable.

The regular pattern of the flooring, which brings together the two parts of the painting, is evidence of the artist's perfect control of architectural and urban space.

On the banks of the river Arno, a group of young artists laid the foundations for a renewal of the figurative arts, putting into practice or even anticipating the aspirations of the humanists.

Florence

The dome of Santa Maria del Fiore—the Duomo—is a monumental symbol of the early Renaissance. With it, architect Brunelleschi built on what had been achieved a century earlier by Arnolfo di Cambio. He erected a structure that, though immense, is still graceful thanks to its slightly ogival section, which was made possible by a revolutionary building technique. Beside Brunelleschi we find Donatello, who from his earliest monumental statues offers us solid, powerful figures infused with symbolism. Though younger than Brunelleschi and Donatello, Masaccio proved to be extraordinarily precocious and receptive, and during these same years he radically changed the course of painting. He abandoned the gold and ornamentation of the late Gothic and experimented with perspective in sober, severe compositions that have a weighty power. Masaccio's achievements were developed by artists such as Fra Angelico, Paolo Uccello, and Filippo Lippi; there was a movement away from polyptychs toward unitary altarpieces, where all the figures are involved in a single scene.

Halfway through the century, investigations into the rules of perspective found scientific support and geometrical proof in the writings of Piero della Francesca. Once the conspiracy of the rival Pazzi family was defeated in 1478, the Medici consolidated their control over Florence under Lorenzo the Magnificent. Botticelli depicted a kind of rediscovered "golden age" during this period. But Lorenzo died before his time in 1492, and the preaching of a Dominican friar, Gerolamo Savonarola, touched off a period of crisis and art-burning in the city. After Piero de' Medici's expulsion and the creation of a republic, the excommunication and execution of Savonarola on May 23, 1498 was a tragic epilogue.

*These panels are the artists' entries for a competition
to design a pair of monumental bronze doors for the
baptistery of Florence. Ghiberti seems at ease with
the complicated quatrefoil outline of the panel and
can concentrate on a meticulous attention to detail.*

*Isaac's classical torso
shines like an antique
jewel that has been
smoothed and pol-
ished to perfection.
Such care is more
typical of a goldsmith
than a sculptor, and it
was to win Ghiberti
the commission,
though only by a
small margin.*

*Despite the
explosion of violence
in the principal
group of figures,
Brunelleschi carefully
follows the outline of
the lobes as required
by the competition.
This control over
space foreshadows
his future career as a
great architect.*

*Brunelleschi was
passionately
interested in classical
antiquity, and so he
skillfully includes in
his composition a
reference to the
famous Hellenistic
bronze of a boy
removing a thorn
from his foot.*

◀ Giovanni di Ser Giovanni
(known as Lo Scheggia), *The
Triumph of Fame*, 1449, birth tray
of Lorenzo the Magnificent. New
York, Metropolitan Museum.

▲ Above: Lorenzo Ghiberti, *The
Sacrifice of Isaac*, 1401. Florence,
Museo Nazionale del Bargello.

▲ Below: Filippo Brunelleschi, *The
Sacrifice of Isaac*, 1401. Florence,
Museo Nazionale del Bargello.

Masolino has modeled the figures of Adam and Eve in a refined, luminous classical style, and their stance and expressions are noble and relaxed. The serpent has a woman's head, a fairly common motif in art of the time.

In Masaccio's fresco, Adam and Eve no longer have the sunlit grace of Masolino's figures. In despair and weeping, they are peremptorily expelled from the Garden of Eden and an angel with a sword points the way out. Despite the drama of the scene, however, Masaccio gives his figures a new and intense physicality, restoring to humanity an independent and powerful dignity.

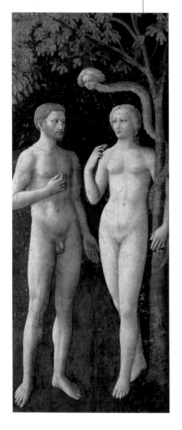

▲ Masolino, *Adam and Eve*, 1424. Florence, Santa Maria del Carmine, Brancacci chapel.

▲ Masaccio, *The Expulsion from Eden*, 1424. Florence, Santa Maria del Carmine, Brancacci chapel.

In Florence, patrons commissioned two great artists to work together or even in competition with each other: in the case of the cathedral choir lofts, Luca Della Robbia and Donatello each made one to his own design. Della Robbia's is pictured on page 267.

Donatello does not divide the choir-loft balustrade into rectangular sections, as does Della Robbia. His genius is to sculpt a continuous frieze with putti who dance, sing, laugh, and chase one another.

Donatello ornaments the choir loft with an exuberant variety of motifs, involving a series of chiaroscuro and polychrome effects. The dynamic force of the figures and ornamentation is utterly different from the clarity and formal precision of his rival.

▲ Donatello, choir loft, 1433. Florence, Museo dell'Opera del Duomo.

At a high point in the age of Lorenzo the Magnificent, Botticelli painted four great allegories on mythical subjects. It was not exactly a painting cycle, in spite of the stylistic and cultural similarities, but taken as a whole these works are the most striking example of mythological and allegorical themes in humanist art.

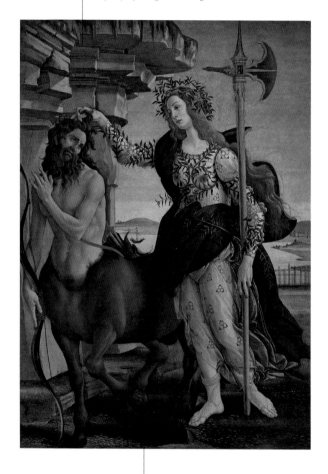

▲ Sandro Botticelli, *Pallas and the Centaur*, ca. 1482. Florence, Uffizi.

It is not difficult to interpret the symbols here: Pallas Athene, the Greek goddess of wisdom, reins in and controls the semibestial instincts of the centaur, directing them toward human ideals. Florence was at that time the capital of a comparatively small state, which certainly could not have stood up to the great powers in military terms. But paintings like this enabled the city to celebrate the supremacy of intellectual power over brute force.

The background is highly elaborate, with its complicated architectural ruins (or construction site?) and an encounter between knights.

While the Virgin naturally occupies the center of the composition, Leonardo's originality lies in the animated surrounding scene, with its wealth of gestures and expressions.

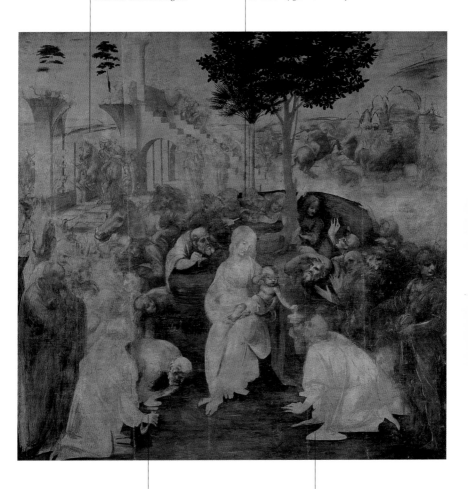

▲ Leonardo da Vinci, *The Adoration of the Magi*, 1481. Florence, Uffizi.

The painting is unfinished, and it may be little more than a preparatory drawing. Leonardo began it for a small church at the gates of Florence, at a time when his fellow artists were called to Rome to fresco the Sistine Chapel, but he left for Milan before it was completed.

The Adoration of the Magi is a favorite subject in Florentine painting. Leonardo introduces a number of his own ideas into the iconography of this very popular theme: the three kings, for example, are not easily identified.

Perugino likes
simple, solid
architectural
structures, with
square columns
and elegant
round arches.

The soft, luminous
landscape is very typical
of late-fifteenth-century
painting in Umbria
and Tuscany.

Once again, two Florentine artists are
tackling the same subject (see page
199): Perugino and Filippino Lippi are
both depicting the appearance of the
Virgin to Saint Bernard of Clairvaux,
who reinvigorated the Cistercian order.

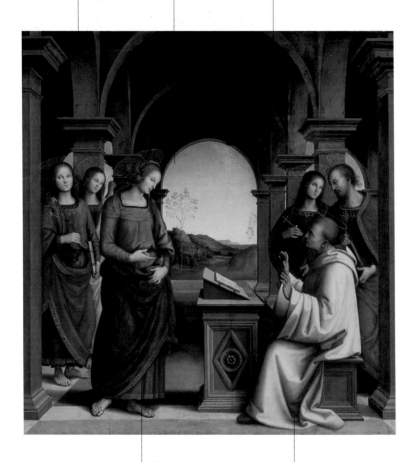

All the gestures and expressions of
Perugino's figures have a serene,
calm sweetness. The altarpiece
was intended for the basilica of
Santo Spirito in Florence.

Saint Bernard, seated
at his desk, reacts with
measured surprise to
the appearance of
the Virgin.

▲ Perugino, *The Vision of
Saint Bernard*, 1488–89.
Munich, Alte Pinakothek.

The center of the landscape is dominated by a jagged hunk of rock.

While the atmosphere of Perugino's painting is serene, here we get a sense of animated movement that spreads from foreground to background.

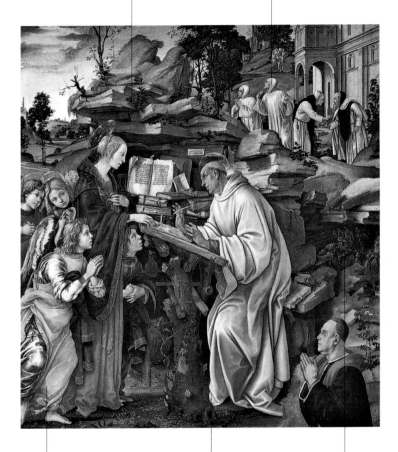

The bright colors and animated expressions of the angels are effective in introducing the feeling of religious fervor and emotion that Filippino wishes to convey.

The devil appears in a cleft in the rocks. According to tradition, he was defeated and chained by Saint Bernard.

▲ Filippino Lippi, *The Vision of Saint Bernard*, 1486. Florence, church of the Badia.

Saint Bernard is seated at a rustic lectern (very different from Perugino's refined and inlaid piece of furniture), and he leans attentively toward the Virgin.

Fouquet, Van der Weyden, Fra Angelico, and Piero della Francesca all converged on Rome in 1450, the Jubilee Year. The Eternal City was now rediscovering its role as "capital of the world."

Rome

▼ Melozzo da Forlì, *An Angel Playing the Lute*, ca. 1480. Vatican City, Pinacoteca Vaticana, formerly in the Santi Apostoli church.

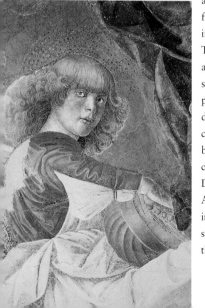

When they returned to Rome from Avignon, the popes first consolidated the doctrinal and political aspects of their role. Only then did they turn their attention to restoring the city, whose population was at a very low ebb. They concentrated on two sites: the church of Saint John Lateran (where Gentile da Fabriano and Pisanello were working around 1425–30) and the Vatican, on the opposite bank of the Tiber. The Vatican became the papal residence, and the area surrounding the basilica of Saint Peter turned into an enormous building site. The frescoes that Fra Angelico painted around 1450, under Pope Nicholas V, were the first important expression of an artistic culture based on monumental figures, perspective, and the careful organization of light. Of major importance were the projects initiated by Pope Sixtus IV. He founded the Vatican Library, entrusting its management to famous humanists, and then, around 1480, he had the Sistine Chapel built for the Church's most august religious ceremonies. The artists he called on to fresco the chapel walls were the best of those then working in Florence: Botticelli, Perugino, and Ghirlandaio. Their frescoes are broad and monumental in conception and include many references to classical architecture, such as triumphal arches and buildings with a central plan, and the sequence of scenes has a measured, confident rhythm. This collective undertaking established the characteristics of late-fifteenth-century style and, long before the contributions of Michelangelo, made the chapel a basic point of reference for Renaissance art. During the controversial reign of the Borgia pope Alexander VI, in the last decade of the century, the leading artist was Bernardino Pinturicchio, who was responsible for the fanciful frescoes in the papal apartments in the Vatican, full of classical ornamental motifs.

A basic characteristic of
Fra Angelico's painting is
the clear, diffuse light.

When Fra Angelico was called to
the Vatican by Pope Nicholas V, he
brought to the art of Rome both
central perspective and the characteris-
tics of humanist architecture, in a form
adapted to the classical past of the city.

▲ Fra Angelico, *Saint Lawrence Distributing
Alms*, 1453. Vatican City, Vatican palaces,
chapel of Nicholas V.

Although the fresco has elements of
realism in the depiction of the poor
and sick receiving alms, the prevailing
tone is one of harmony and order.

The chapel was built for the most important ceremonies of the papal curia. Its shape is a simple rectangle. Before Michelangelo painted the ceiling, it was pale blue with gold stars, and on the rear wall was a fresco by Perugino depicting the Assumption of the Virgin.

The frescoes along the left-hand wall depict scenes from the life of Moses. The principal artist involved was Botticelli.

The right-hand wall has scenes from the life of Christ. The most important episode (Christ Handing the Keys to Saint Peter) was painted by Perugino.

▲ Interior of the Sistine Chapel. The frescoes along the sides (1481–82) are the work of various masters, including Botticelli, Perugino, Ghirlandaio, Cosimo Rosselli, and Piero di Cosimo.

The ornamental details, the friezes, and some of the architectural features are painted in relief, using gilded plaster: we are reminded that the tastes of Pope Alexander VI, a Spaniard named Rodrigo Borgia, tended toward a nostalgia for the late Gothic.

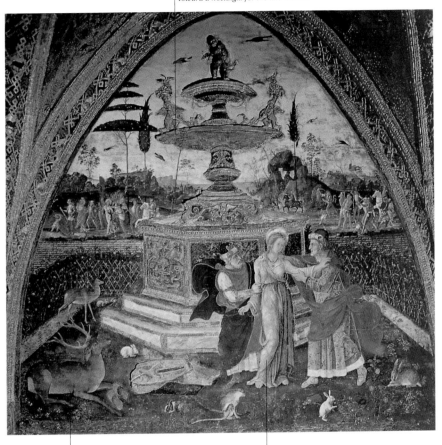

Pinturicchio has filled his painting with animals, plants, and naturalistic details, but there are also classical references.

The painting represents a biblical episode—Susannah and the Elders—but the superabundance of ornamentation gives the impression that it is primarily a fanciful piece of courtly decoration.

▲ Pinturicchio, frescoes in the Borgia apartments, 1492–95. Vatican City, Vatican palaces.

The wealthy kingdom of Naples was disputed between the Angevins and the Aragonese, and its capital was an important center for the culture of Mediterranean Europe.

Naples

Related entries
International Gothic,
Humanism, Fresco, Oil
Painting, Miniature,
Intarsia

Antonello da Messina,
Baço, Fouquet, Pisanello

▼ Unknown Neapolitan
painter, *View of Naples*
(*Return of the Aragonese
Fleet*), known as the *Tavola
Strozzi*, detail showing the
Castel Nuovo, 1472–73.
Naples, Museum of the
Carthusian Monastery of
San Martino.

Dominating the city is the Castel Nuovo, the castle by the sea, and scattered across its heart are large, imposing Gothic churches displaying strong French influence in their architecture. They help to provide visual evidence of the international nature of fifteenth-century Neapolitan culture: Flemish panels stand out in the collections of King René of Anjou, and a whole series of master artists came to the city from Catalonia, Provence, and France, as well as from Lombardy and Florence. This is the cosmopolitan atmosphere in which Antonello da Messina developed. Antonello is vital to understanding the Mediterranean crosscurrents that affected painting internationally in the mid-fifteenth century, for his personal and artistic development typifies his times: he communicated with the great Flemish and Provençal artists, he was in contact with Piero della Francesca, and he also had a decisive influence on the development of the Venetian school. Many important sculptors (Donatello, Michelozzo, Laurana, and Guido Mazzoni) also worked in Naples. If we examine the sequence of their work in the city, we can successfully follow the development of monumental sculpture from the classical (the triumphal arch that forms the entrance to the Castel Nuovo, for example) to the striking realism of the Lombards. In the last decade of the century, Naples became the first place to experience the collapse of the political and territorial equilibrium that the Italian states had worked so hard to achieve at the Peace of Lodi (1454). The armies of Charles VIII of France invaded Italy: the kingdom of Naples fell, the duchy of Milan capitulated in 1499, Florence went through the critical Savonarola period, and in subsequent years Venice and Rome also experienced humiliating defeats.

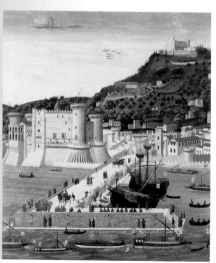

The most fascinating aspect of this panel is the extraordinary still life of books and other objects along the shelves in Saint Jerome's study. The Neapolitan painter responsible (traditionally held to be Antonello da Messina's teacher) is evidently echoing Flemish painting, which was well known in Naples thanks to King René of Anjou's interest in collecting.

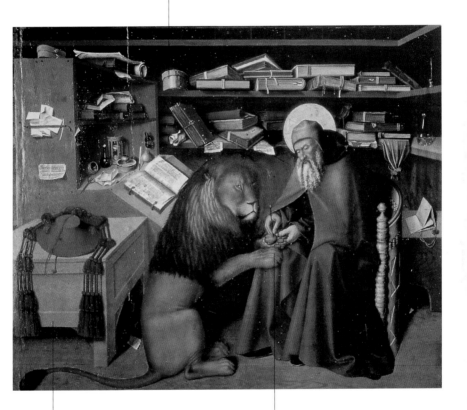

In spite of the apparent realism of this painting and the wonderful details, there is still some uncertainty in the use of perspective.

The painting illustrates the legendary episode in the life of Saint Jerome in which he removes a painful thorn from a lion's paw. From that moment onward the fearsome animal became his inseparable companion.

▲ Colantonio, *Saint Jerome and the Lion*, ca. 1450. Naples, Capodimonte.

During the fifteenth century, the five chief Italian states, whose capitals were Milan, Venice, Florence, Rome, and Naples, become closely linked to a whole constellation of small independent courts.

Other Italian Towns

No other European country had anywhere near as many art centers as Italy in the fifteenth century. In many cases, the lords of lesser cities and the dynasties that had established themselves in the large cities enhanced their prestige by undertaking grandiose artistic and cultural projects. Until the midcentury, the newly acquired knowledge of perspective and the rules of humanist art were applied almost solely in Florence. In the rest of Italy, late-Gothic taste still prevailed: the rigorous, severe quality of Florentine art was rejected in favor of a final flowering of ornamentation and ostentatious luxury that went right down to the choice of materials; hence gold grounds and the even more expensive "ultramarine," obtained from lapis lazuli, continued to be used. When great Florentine artists visited various other cities, sometimes for extended periods of time, their presence encouraged

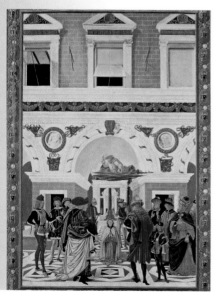

aged a general acceptance of humanist taste, but these Tuscan influences became grafted onto strong local traditions, giving rise to a great variety of original productions in the early Renaissance. The view that there is an intrinsic equilibrium and dignity in man led to the idea and representation of a harmonious space based on the laws of mathematics, in which human figures fit perfectly. Fifteenth-century Italian painting lived above all by carefully calculated proportions. No single aspect of a painting took clear precedence over any other; each part was related to the whole. Even feelings and facial expressions seem for the most part to have been rendered with controlled composure. In this way, the "autumn of the Middle Ages" was almost imperceptibly becoming the dawn of modern man.

A number of elderly people, their bodies bent with fatigue, wearily make their way to the fountain. After immersion they will be miraculously rejuvenated.

The pivot of the whole composition is the elaborate Gothic fountain, whose miraculous waters rejuvenate all those who bathe in it.

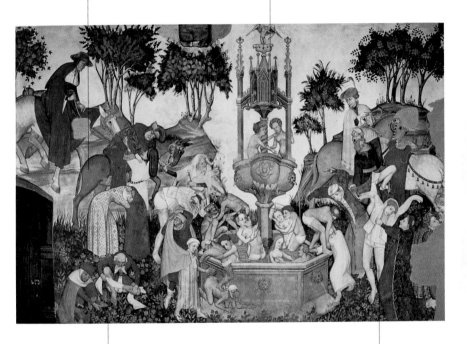

The fresco provides an interpretation on a grand scale of the typically fanciful world found in late–International Gothic miniatures.

There is a striking linearity about the way the Piedmontese painter has presented the figures.

◄ Pinturicchio, *Miracle of Saint Bernardino*, 1473. Perugia, Galleria Nazionale dell'Umbria.

▲ Giacomo Jaquerio, *The Fountain of Youth*, ca. 1420. Saluzzo, Castello della Manta, Sala Grande.

The scene in the lunette is the Lamentation. The classical sarcophagus and the splendid arch in perspective reveal that this painter from the Marches was exceptionally up-to-date in his knowledge of humanism.

The series of buildings in perspective, brightly lit by the sun, revives the theme of the "ideal city."

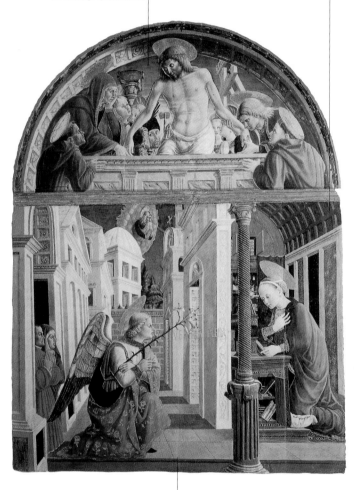

▲ Angelo da Camerino, *The Annunciation*, ca. 1455. Camerino, Pinacoteca e Museo Civici.

The local school of painting in the little town of Camerino in the Marches shows what can happen in fifteenth-century Italian painting when the rules of humanism become widely known. Here, in a mere provincial town, the development of art is outstanding, thanks to contact with Piero della Francesca.

The brightly lit sky is characteristic of this and the other panels from this polyptych, which is now dismantled but was once at Sansepolcro, the town where Piero della Francesca was born. The polyptych is an important precursor of Piero's painting.

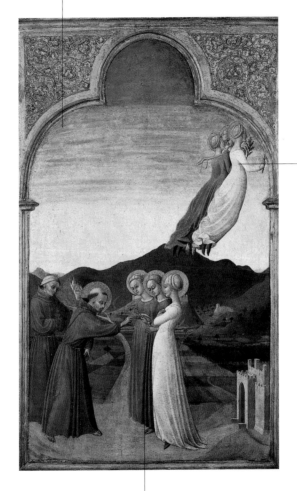

Sassetta was born in Siena and brought up in the wonderful local Gothic tradition. He gives his figures a characteristic elongated silhouette.

The painting shows the mystic and symbolic marriage of Saint Francis and "Lady Poverty." This subject, popular in Franciscan iconography, is treated by Sassetta with a graceful, light touch.

▲ Sassetta (Stefano di Giovanni di Consolo), *The Mystic Marriage of Saint Francis*, ca. 1440. Chantilly, Musée Condé.

The artist responsible for this fresco has painted his own portrait at the top of the group on the left. In all probability he is the Burgundian master Guillaume Spicre. His presence in Palermo underscores once again how far ideas and artists traveled in fifteenth-century Europe.

Even the power of the fountain of youth—immediately recognizable as a late-Gothic image—fails before the onslaught of Death.

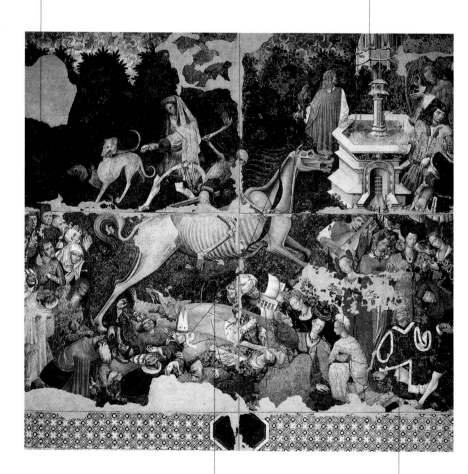

▲ Attributed to Guillaume Spicre, *The Triumph of Death*, ca. 1440. Palermo, Galleria Regionale della Sicilia, formerly in Palazzo Scláfani.

The macabre scene is dominated by the galloping skeletal horse on which Death is mounted.

In subject and style, the painting belongs to the cultural milieu known as the "autumn of the Middle Ages."

The form and stylistic qualities of this retable, which has survived intact, are clearly linked to those of contemporary Catalan art.

Certain details place the painter of this polyptych—probably a Sardinian—in direct contact with Spanish art. Note, for example, the bands used to protect against dust, found almost exclusively in Spanish retables, and also the figure of Saint James the Great, who was venerated at Compostela.

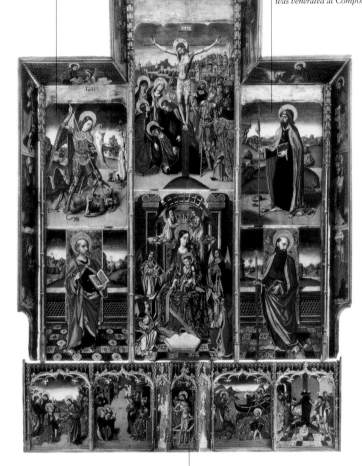

▲ Master of Castelsardo, retable, 1492–1500. Tuili (Sardinia), San Pietro.

As is often the case, the predella contains narrative scenes. In this instance they treat the life of Saint Peter, in whose church in Tuili the polyptych still hangs.

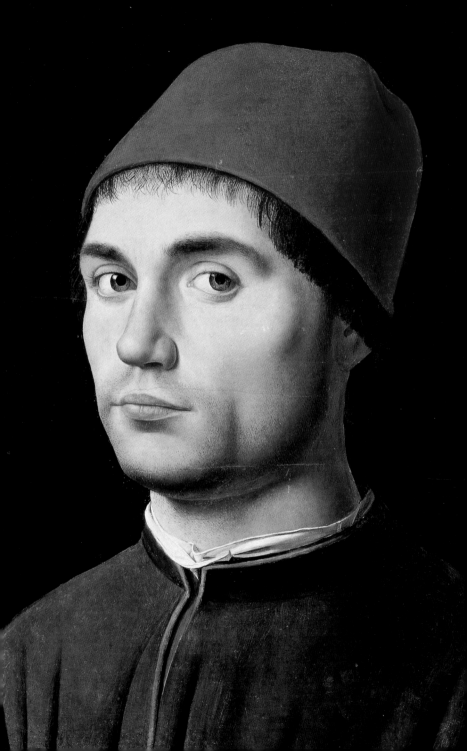

LEADING ARTISTS

Leon Battista Alberti
Andrea del Castagno
Fra Angelico
Antonello da Messina
Jaime Baço
Giovanni Bellini
Bartolomé Bermejo
Pedro Berruguete
Sandro Botticelli
Dirck Bouts
Bramante
Filippo Brunelleschi
Robert Campin
Vittore Carpaccio
Enguerrand Charonton
Petrus Christus
Carlo Crivelli
Gerard David
Jacopo Della Quercia
Luca Della Robbia
Donatello

Michel and Gregor
 Erhart
Barthélemy d'Eyck
Vincenzo Foppa
Jean Fouquet
Nicolas Froment
Geertgen tot Sint Jans
Gentile da Fabriano
Lorenzo Ghiberti
Domenico Ghirlandaio
Benozzo Gozzoli
Jaume Huguet
Juan de Flandes
Justus of Ghent
Leonardo da Vinci
The Limbourg Brothers
Filippino Lippi
Filippo Lippi
Stephan Lochner
Andrea Mantegna
Masaccio

Masolino da Panicale
Hans Memling
Hans Multscher
Michael Pacher
Pietro Perugino
Piero della Francesca
Piero di Cosimo
Pisanello
Antonio del Pollaiolo
Martin Schongauer
Luca Signorelli
Veit Stoss
Cosmè Tura
Paolo Uccello
Hugo van der Goes
Rogier van der Weyden
Jan van Eyck
Andrea del Verrocchio
Konrad Witz

Alberti's eclecticism as an architect, scholar, and writer of treatises makes him an example of the humanist artist-intellectual.

Leon Battista Alberti

Genoa 1406 – Rome 1472

School
Florentine

Principal place of residence
Florence from 1434,
Mantua from 1459

Travels
Rome (1432),
Rimini (1450)

Principal works
Palazzo Rucellai and the
facade of Santa Maria
Novella in Florence; the
Tempio Malatestiano in
Rimini; the churches of
San Sebastiano and
Sant'Andrea in Mantua

Links with other artists
Donatello and Brunelleschi
in Florence; Piero della
Francesca in Rimini;
Mantegna in Mantua

Alberti was the son of a political exile from Florence. After early studies at the universities of Padua and Bologna, he moved to Rome in 1432. There he became a keen student of the antique, planned a pioneering reconstruction of the imperial city, and studied the characteristics of classical architecture with the intent of modernizing them. He did so not only by writing treatises but also by drawing up specific projects and restoring and renovating ancient monuments in Rome and Florence, where he was allowed to return from exile after 1434. Here he drew up plans for the Palazzo Rucellai—the archetype of the palatial Renaissance residence—and also designed the little chapel of Santo Sepolcro, a beautifully proportioned and decorated jewel in marble, formerly annexed to the palace. There followed his refined completion of the Gothic facade of Santa Maria Novella, which involved applying the fifteenth-century rules of geometry to a splendid vestment in polychrome marble. His project (unfinished) for the Tempio Malatestiano in Rimini (1450) was even more complex; here he applied classical architectural motifs to a church building in an innovative but effective way. His intellectual discoveries and observations taken from antiquity are described in his treatises on painting (1435), architecture (ca. 1445), and sculpture (1464); each one of these is a classic in its field and led to the recognition that artistic creation has an intellectual component. In 1459, Alberti moved to Mantua, where he built the churches of San Sebastiano and Sant'Andrea and steered the culture of the Gonzaga court toward a classical sense of nobility that was fully embraced by Andrea Mantegna.

The upper part has never been completed. The original plans involved a huge arch that would have completely hidden the old church of San Francesco within the Tempio. As it is, the simple structure of the old church can be seen at the top center of the facade.

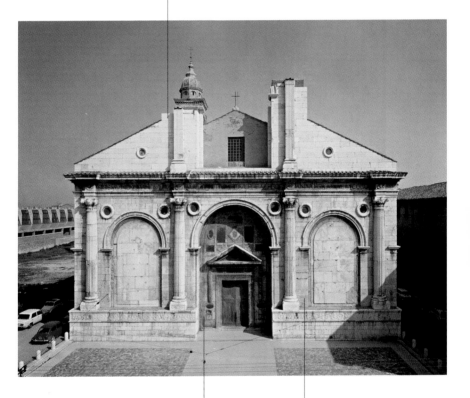

The area around the central portal is the richest in ornamental detail, including inlaid slabs of red and green marble. The monogram SI— the initials of Sigismondo Malatesta and his wife Isotta—appears frequently.

This marble facade, exemplifying the revival of classical architecture, was inspired by the Arch of Augustus in Rimini: the town's principal Roman monument and the terminus of the Via Emilia.

◄ Leon Battista Alberti, facade of Santa Maria Novella (completed in 1470). Florence.

▲ Leon Battista Alberti, facade of the Tempio Malatestiano, 1447–50. Rimini.

The tall, brick, late-Gothic bell tower belonged to the previous church, and it contrasts strikingly with the pure classicism of the facade.

A characteristic feature is the tall central arch with its splendid coffered vault. Inside, the church has a single nave with side chapels and a large barrel-vaulted ceiling.

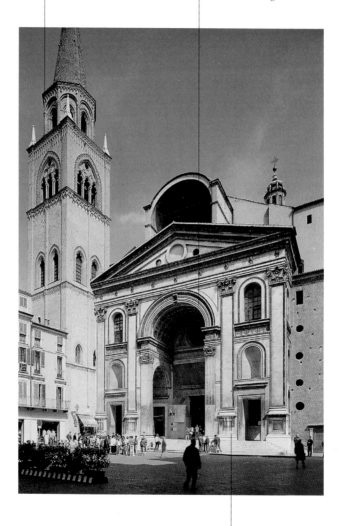

▲ Leon Battista Alberti, basilica of Sant'Andrea, completed after Alberti's death in 1472 by his pupil Luca Fancelli. Mantua.

The facade is conceived as the front of an ancient building, with a monumental arch in the middle and a triangular tympanum at the top. The openings and other architectural features create strong chiaroscuro effects.

Andrea del Castagno is an austere and rather prickly representative of Florentine humanist art, who stands out for the expressive force of his drawing and his powerful plasticity and realism.

Andrea del Castagno

His early death (partly offset by his precociousness) does not prevent Andrea del Castagno from occupying a significant place in the history of Tuscan art, especially as regards fresco technique and the incisive use of drawing. In 1439, he and Piero della Francesca were working with Domenico Veneziano on the decoration of Sant'Egidio, which was completed in subsequent years but has now almost entirely disappeared. Shortly afterward, in 1442, he went to Venice. Here he painted frescoes in the apse of the chapel of San Tarasio in the church of San Zaccaria. The outlines of his figures are still austere and linear but he courageously adopts a humanist perspectival style that is quite different from that of contemporary Venetian painting. When he returned to Florence, he collaborated on the stained-glass cycle in Santa Maria del Fiore, and soon showed that he was one of the most brilliant artists of his generation. His most complex masterpiece is the vast and impressive *Last Supper* (1445–50) in the refectory of Sant'Apollonia. The sculptural figures are shown in a splendid room seen in perspective and are given an intensely expressive form. Similar qualities of austerity and powerful expressiveness can also be seen in his paintings for the Santissima Annunziata church. Also important, particularly from an iconographical point of view, are the frescoes on historical subjects that he painted immediately after 1450, such as the *Illustrious Men and Women* cycle for Villa Pandolfini at Legnaia (now in the Uffizi), and the *Equestrian Monument of Niccolò da Tolentino*, painted in monochrome in Santa Maria del Fiore close to a similar fresco by Paolo Uccello.

Castagno nel Mugello
(Florence) 1421 –
Florence 1457

School
Florentine

Principal place of residence
Florence

Travels
Venice (1442)

Principal works
All in Florence: frescoes
in the refectory of
Sant'Apollonia (1445–50)
and in Santissima
Annunziata (after 1451);
*Equestrian Monument of
Niccolò da Tolentino* in
Santa Maria del Fiore
(1456)

Links with other artists
Domenico Veneziano
(his teacher) and other
Florentine artists, such as
Donatello, Paolo Uccello,
Piero della Francesca, and
Antonio del Pollaiolo

◀ Andrea del Castagno,
Esther, ca. 1450, fresco
detached from the *Illustrious
Men and Women* cycle at
Villa Pandolfini.
Florence, Uffizi.

217

Andrea del Castagno

The scene is set inside a perfect "box" in perspective, defined in accordance with geometric rules. The most surprising aspect of the painting is the back of the "box," which has large rectangles painted to look like veined marble slabs.

The figures are delineated with clear, sharp drawing, which emphasizes their features and expressions.

The scene is basically static and contemplative. The principal group of figures at the center of the composition consists of four men: Christ is gazing at John, who is dozing at the table, while Judas, in accordance with tradition, sits on the other side of the table, across from Peter.

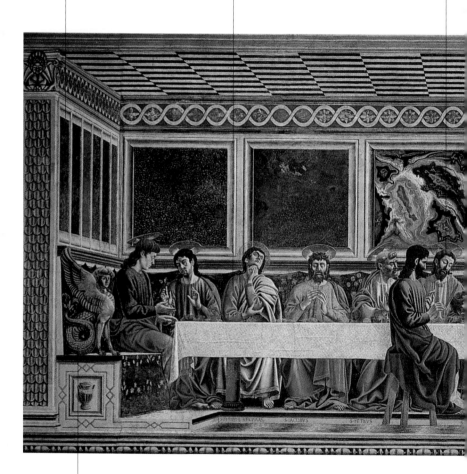

Gilded sphinxes mark the ends of the long banquette on which the figures are seated. The room as a whole gives an impression of luxurious and refined elegance.

▲ Andrea del Castagno, *The Last Supper*, 1445–50. Florence, refectory of Sant'Apollonia.

The Last Supper *is the lower and better-preserved part of a grandiose composition that covers the whole refectory wall, ending with* The Resurrection.

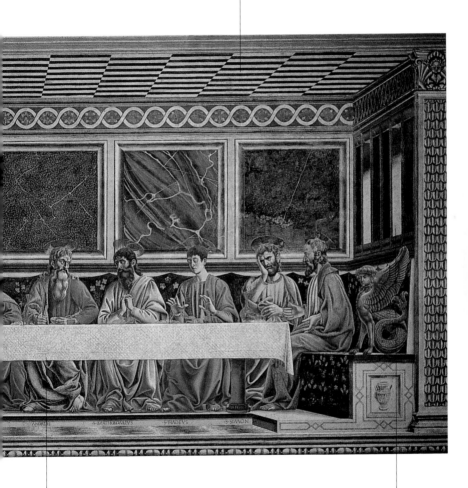

The long white tablecloth emphasizes the horizontal arrangement of the composition.

Andrea del Castagno has painted two rectangular windows on the right-hand side in order to make the source of light explicit and identifiable.

Fra Angelico is known and loved for the delicate sensitivity of paintings that are so mystical as to seem outside time; but he was in fact deeply involved in the early humanist debate.

Fra Angelico

His name as a Dominican friar was Giovanni da Fiesole, but he was born Guido di Pietro; Vicchio di Mugello (Florence) ca. 1395 – Rome 1455

School
Florentine

Principal place of residence
Florence

Travels
Rome (1446 and 1453–55), Orvieto (1447)

Principal works
Frescoes and panels in the convent of San Marco in Florence (1439–42); frescoes in the chapel of Nicholas V in the Vatican (1446)

Links with other artists
Masaccio, Gentile da Fabriano, and Lorenzo Monaco (when Fra Angelico was young); Lorenzo Ghiberti (with whom he collaborated); Benozzo Gozzoli (his pupil)

He trained as a painter and miniaturist in Florence in the 1420s, where the prevailing style was still that of Gentile da Fabriano. He never lost his affection for gold, limpid colors, refined details, and graceful gestures and expressions. After the death of Masaccio, he became a leading figure on the Florentine art scene, partly thanks to his collaboration with the sculptor Lorenzo Ghiberti, and produced works such as the *Linaioli Tabernacle* (1433, Florence, Museo di San Marco). He developed a series of variations on the theme of the Madonna Enthroned or the Annunciation, placing the figures in a web of light and in rooms rendered in perspective. During the 1430s, he was the leading light of a sort of humanist "avant-garde," of which Piero della Francesca, just beginning his career, took due note. Between 1439 and 1442, he painted the frescoes in the convent of San Marco, with the help of assistants, among whom Benozzo Gozzoli stands out. He frescoed the hall of the chapter house, the cloister galleries, and the cells of his fellow monks. In 1446 he was summoned to Rome by Pope Nicholas V to fresco the Vatican chapel of Saint Stephen and Saint Lawrence. The following year, he began

decorating the chapel of Saint Brice in Orvieto cathedral (the work was resumed by Luca Signorelli fifty years later). He then returned to Florence, and around 1450 we find him once more engaged on various works for the Dominican convent of San Marco. Finally, in 1453, he was called to Rome for a final time; he died there in 1455. He is buried in the church of Santa Maria sopra Minerva.

▶ Fra Angelico, *The Naming of John the Baptist*, ca. 1436. Florence, Museo di San Marco.

The divine ray of light that cuts across the scene provides a visual link between heaven and earth, but, as is always the case in Fra Angelico's paintings, even the most intensely mystical episodes take place in an atmosphere of calm and serene contemplation.

The principal scene takes place beneath a sharply defined portico in beautiful fifteenth-century style. The central bas-relief provides a symbolic reminder of the presence of God the Father.

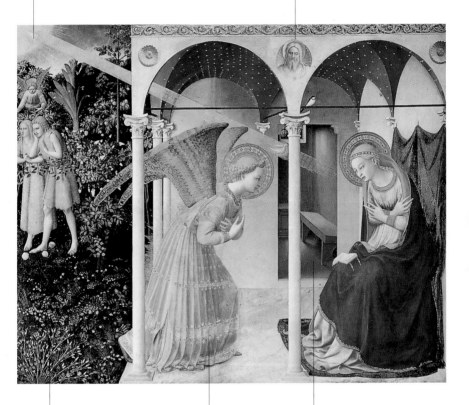

The scene on the left shows Adam and Eve being expelled from the Garden of Eden. It tells us why the incarnation of Christ and the redemption of man are necessary.

▲ Fra Angelico, *The Annunciation*, ca. 1440. Madrid, Prado.

The limpid, luminous colors of the angel's robe and wings remind us of Fra Angelico's early work as a miniaturist.

The Annunciation is one of Fra Angelico's favorite subjects. The Virgin's humility is emphasized not only by her pious gesture but also by the chaste simplicity of the room's furnishings.

Fra Angelico

This fresco forms part of a substantial cycle of Gospel scenes that Fra Angelico painted in the cells of his Dominican brothers at the convent of San Marco. Their delicate beauty makes them one of the most moving examples of fifteenth-century art.

The predominantly bright colors in the San Marco frescoes give the scenes a broad luminosity. But one should also note that the correct rules of perspective are applied, giving us an impression of considerable depth.

The colors also have symbolic meaning: the little red flowers near the feet of the risen Christ represent the blood from his wounds. In this way Fra Angelico alludes to the "new life" produced by Christ's sacrifice.

▲ Fra Angelico, *Noli Me Tangere*, 1439–42. Florence, convent of San Marco.

He establishes a poetic blend of Flemish analysis and Italian monumentality, creating realistic portraits in lively backgrounds.

Antonello da Messina

Throughout an eventful career, Antonello da Messina displayed a constant capacity for absorbing every artistic innovation in the cities he visited. At the same time he passed on contributions of his own, which led to new developments in local schools. He completed his training around 1450 in Naples, where he was able to see the important royal collections of Flemish and Provençal art. In his own work, Antonello concentrated mainly on two subjects: the Crucifixion and half-bust male portraits against a dark ground. His dialogue with northern painting, particularly with the art of Petrus Christus, Memling, and Fouquet, was carried on at various stages of his personal development and travels, which included a gradual ascent of the Italian peninsula, punctuated by periods spent in Sicily. Thanks to his early adoption of the technique of oil painting, Antonello was able to use superimposed paint layers to obtain effects of atmospheric transparency that were hitherto unknown. After a visit to Rome, Antonello studied the works of Piero della Francesca in Tuscany and the Marches, learning from him to give his groups of figures a solid monumentality and to organize his compositions according to the rules of perspectival geometry. Of vital importance was his subsequent visit to Venice (1474–76), where he painted *The San Cassiano Altarpiece* (its surviving parts are in Vienna) and the *Saint Sebastian*, which is now in Dresden. His interest in color and light is apparent here, and it was to lead to Giovanni Bellini's mastery of color tones. He spent the last years of his life in Sicily, leaving behind a lasting artistic inheritance when he died.

Messina ca. 1435 – 1479

School
Italian

Principal place of residence
Sicily

Travels
Naples (ca. 1450), Rome (ca. 1460), Venice (ca. 1470 and 1474–76); perhaps Milan and Bruges

Principal works
Saint Jerome in His Study (London, National Gallery, ca. 1475); *Saint Sebastian* (Dresden, Gemäldegalerie, 1475–76); *The Annunciation* (Palermo, Galleria Regionale, ca. 1478)

Links with other artists
Colantonio and Jean Fouquet in Naples; the works of Piero della Francesca and Fra Angelico in Rome and central Italy; Giovanni Bellini in Venice

◀ Antonello da Messina,
The Annunciation (detail),
ca. 1478. Palermo, Galleria
Regionale della Sicilia.

223

Saint Jerome's study is situated inside a vast Gothic room. It is a perfectly organized "cell," with desk, chairs, plenty of shelves, and even two vases of aromatic herbs.

The light that penetrates the painting from a variety of sources is extraordinarily well defined: the influence of Flemish painting is obvious here, but Antonello enhances it with a new awareness of space. The painting has been attributed to Memling in the past.

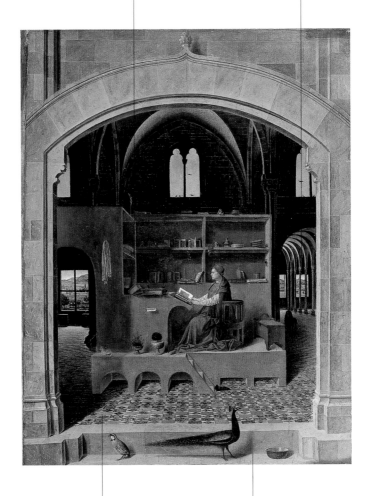

▲ Antonello da Messina, *Saint Jerome in His Study*, ca. 1475. London, National Gallery.

The rendering of perspective in the geometric pattern of tiles on the floor is a tour de force.

The scene is framed in a large arched window, a device often used by Flemish painters, but also mentioned in Leon Battista Alberti's treatises.

The painting was intended for a Venetian church and is one of very few works by Antonello with large figures. Saint Sebastian is tied to a tree and his body is slightly rotated in order to emphasize the effect of light on his smooth skin.

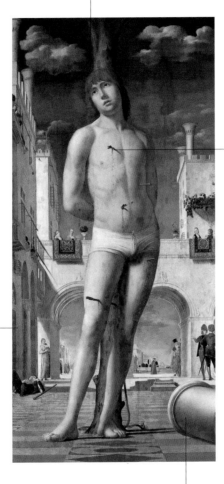

The shadows of the very few arrows in the saint's body serve to indicate the direction of the sun's rays.

The serene urban setting in full sunlight and perfect perspective is one of the many examples of an "ideal city" in humanist painting.

The base of a cylindrical column serves to guide our eye into the painting, and it echoes the other curved shapes that dominate the whole composition.

▲ Antonello da Messina, *Saint Sebastian*, 1475–76. Dresden, Gemäldegalerie.

Baço, also called Jacomart, is the chief representative of fifteenth-century Catalan art. He combines the latest Flemish techniques with a liberal use of gold, conveying intense piety.

Jaime Baço

Called Jacomart; Valencia
ca. 1410 – 1461

School
Catalan

Principal place of residence
Valencia and Catalonia

Travels
Naples (1442),
Rome (1446)

Principal works
The Borgia Triptych
(Játiva cathedral, ca. 1447);
*The Saint Ildefonsus
Retable* (Valencia
cathedral, ca. 1460)

Links with other artists
Juan Reixach (his pupil);
Colantonio and other
mid-fifteenth-century
Neapolitan masters

Baço was the favorite painter of King Alfonso of Aragon, who called him *el nostro leal maestro Jacomart* (our loyal master Jacomart). He worked in Valencia until 1442, when he left for Naples, where he had a considerable influence on the painters of the time, including Colantonio. In 1445 he was back in Valencia, but in 1446 he was called to Italy again by the king, and this time he went to Rome and Tivoli, where he encountered Cardinal Alfonso Borgia (who later became Pope Calixtus III). Despite his Italian contacts, his style remained linked to the Flemish tradition, as was generally the case in Catalonia and other Mediterranean outposts. Flourishing trade links between Valencia and both central and northern Europe had promoted the diffusion of Flemish taste, which was then adapted to local devotional needs. The scarcity of documentation makes it difficult to trace Baço's life and track down his works. Since his altar painting for Santa Maria della Pace in Naples is lost, his only documented work is the Catì retable, a work commissioned in 1460, only

▶ Jaime Baço, *Saint Benedict*, ca. 1460. Valencia cathedral.

a year before he died; it was probably painted largely by his follower, Juan Reixach. Those works that are unanimously attributed to Baço, such as *The Borgia Triptych* (*The Saint Anne Retable*) in the collegiate church at Játiva, and the panels in Valencia cathedral depicting Saint Benedict and Saint Ildefonsus, display a subtle sensitivity and a very personal interpretation of Flemish ideas. The sumptuous decoration and abundant use of gold in these paintings make it clear that the hand of Reixach was involved as well.

The frame of the polyptych, bearing the Borgia coat of arms with a bull, is not original: the polyptych was reassembled in 1924 with the addition of a later predella.

The central panel contains the strongly drawn, sober, and composed image of Saint Anne with the Virgin and Child on her knee. The minor figures are Joachim (Anne's husband) and the archangel Gabriel.

RETABLO DE LA CAPILLA LLAMADA DEL PAPA LEVAN TADA POR CALIXTO III EN EL SOLAR DE LA NAVE CONTIGUA DISPERSOS SUS ELEMENTOS POR LUENGOS AÑOS REUNIERONSE EN 1924 PARA PERPETUA MEMORIA

▲ Jaime Baço, *The Borgia Triptych* (*The Saint Anne Retable*), ca. 1447. Játiva, cathedral.

In the right-hand panel we see Saint Ildefonsus and the donor, Cardinal Alfonso Borgia, who was subsequently elected pope as Calixtus III. The shell-shaped niche at the top of the saint's throne is the only humanist and Italianate feature in the polyptych.

*Bellini's long career spans the entire development of Venetian paint-
ing in the fifteenth and early sixteenth centuries, from late-Gothic
drawing to the mastery of color and atmospheric effects.*

Giovanni Bellini

Venice ca. 1430 – 1516

School
Venetian

Principal place of residence
Venice

Travels
None of importance,
except for brief visits to
the Marches

Principal works
*The Coronation of the
Virgin* (Pesaro, Museo
Civico, 1474); *The Frari
Triptych* (Venice, Frari
church, 1488); *Feast of
the Gods* (Washington,
National Gallery, 1514)

Links to other artists
His father, Jacopo, and his
brother Gentile; Andrea
Mantegna (his brother-
in-law); Antonello da
Messina and Albrecht
Dürer during their visits to
Venice; Giorgione, Lotto,
and Titian (his pupils)

▶ Giovanni Bellini,
Virgin and Child
(detail), ca. 1480.
Bergamo,
Accademia
Carrara.

For the first thirty years of his life, he and his brother Gentile worked
industriously with their father, Jacopo, producing paintings that were
still late Gothic in style, but suggestions of humanist influence appear
in his work after a period spent working in Padua and after his sister
Nicolosia's marriage to Andrea Mantegna in 1451. Compared with
his brother-in-law, Bellini shows a greater interest in color than in
drawing, and in his first independent works of the 1460s he begins
a search for ways of using light to give landscapes a natural
atmosphere. His monumental *Coronation of the Virgin* in Pesaro
(1471–74) shows that he has studied Piero della Francesca's rules of
geometry and has harmonized them with his own rapid absorption
of the innovations offered by Antonello da Messina, who arrived in
Venice in 1474. His works in the 1480s, such as *The San Giobbe
Altarpiece* (Gallerie dell'Accademia) and *The Frari Triptych*, show
that he knows how to render perspective as well as how to harmo-
nize it with a diffused light that is much softer and warmer
than that found in the art of the time in central Italy.
In 1483, he was appointed official painter to the
Venetian Republic, and he retained that
position until his death. Painters such as
Lotto, Giorgione, and Titian trained in
his workshop. In the early years of the
sixteenth century, when Bellini was
over seventy, he was still trying to
perfect his rendering of atmosphere,
producing some grand altarpieces
among other works. And one final
surprise—secular paintings—
confirms that his exceptional creative
abilities persisted into the closing
years of his life.

228

The inlaid and gilded frame is original. The altarpiece is wonderfully intact, except for the top panel, depicting the Lamentation, which is now in the Pinacoteca Vaticana.

Bellini has made an unusual iconographical choice in setting the scene on earth rather than in heaven. At the center of the composition is a large marble throne; its back is an open frame. This allows a realistic background view of the castle of Gradara, on the boundary between Romagna and the Marches.

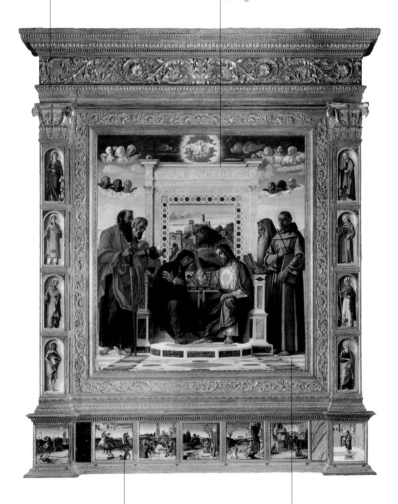

▲ Giovanni Bellini, *The Coronation of the Virgin*, 1474. Pesaro, Museo Civico.

The ritual solemnity of the central scene contrasts with the lively episodes depicted in the predella.

The colors have a wonderful diffused luminosity, but the composition remains firmly anchored to precise rules of geometrical perspective.

Giovanni Bellini

Although Giovanni Bellini adopts the traditional triptych arrangement, he unifies the whole by setting it within a single architectural unit, and above all by his handling of light.

Once again, Bellini uses an apse lined with gilded mosaics as a backdrop. The soft, diffuse light is clearly reminiscent of candlelight reflected on gold.

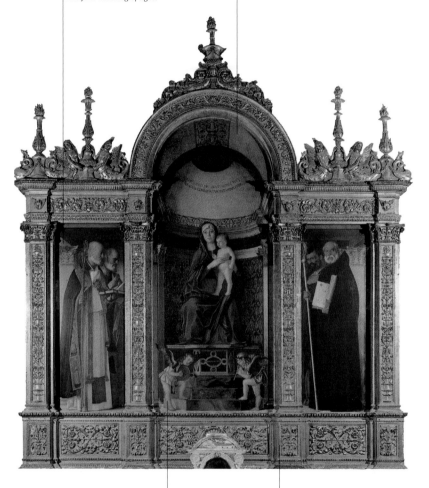

▲ Giovanni Bellini, *The Frari Triptych*, 1488. Venice, Frari church.

In arranging the central scene, Bellini has accentuated its vertical component without disrupting the sense of harmonic relationship with the rest of the triptych.

The frame is an integral part of the composition and was probably designed by Bellini himself. Although he holds to the traditional division into three parts, the whole is imbued with humanist taste, affecting both the piece's overall shape and the individual decorative elements.

Bermejo typifies the artists working in the fifteenth-century Mediterranean cultural milieu. He initially adheres to the late Gothic but then adopts a broad humanist vision.

Bartolomé Bermejo

Bermejo was a genial, restless, wandering painter who trained either in the Low Countries or, more likely, with the flourishing Neapolitan school, where Flemish and Provençal influences were strong. From 1474 to 1476 he was in Daroca, Spain, where he painted the *Saint Dominic of Silos Altarpiece*; it was completed by his pupil Martín Bernat in 1477. In Daroca he also painted the *Santa Engracia Altarpiece*, which has since been dismantled, but one of its finest parts, a *Crucifixion*, is still in the collegiate church there. He then moved to Saragossa for the period 1477–81, and on to Valencia, where he stayed until 1486. He may also have visited Italy, which would explain the presence of his important work *The Madonna of Montserrat Triptych* in the cathedral at Acqui Terme. Finally we find him in Barcelona, where he painted one of the most important works in the whole of Spanish painting: the *Pietà with Saint Jerome and a Donor*, now in the cathedral museum. It was commissioned by Canon Desplá in 1490 and displays an original and intense synthesis of many influences, in addition to the preponderant Flemish one. We have no reliable information about his activities after 1498.

Also called Bartolomé de Cárdenas; Cordoba ca. 1440 – Barcelona ca. 1500

School
Spanish

Principal place of residence
The kingdoms of Aragon and Catalonia

Travels
Daroca, Saragossa, Valencia, Italy, Barcelona

Principal works
The Saint Dominic of Silos Altarpiece (Madrid, Prado, 1474); The Madonna of Montserrat Triptych (Acqui Terme cathedral, ca. 1480); The Pietà of Canon Desplá (Barcelona, cathedral museum, 1490)

Links with other artists
He was the head of a busy workshop and had an important influence on Catalan painting

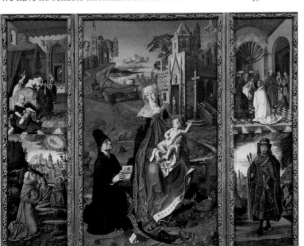

◄ Bartolomé Bermejo, *The Madonna of Montserrat Triptych*, ca. 1480. Acqui Terme, cathedral.

231

Bartolomé Bermejo

The painting might justifiably be titled "meditation on the Pietà." In addition to the donor we see Saint Jerome, who appears intent on comparing the scene of mourning with the account in Holy Scripture.

At the center of the composition is the Pietà group, in the widely diffused Vesperbild form, with the dead Christ on the lap of the seated Madonna. The modes of Spanish piety are responsible for the river of blood issuing from Christ's side.

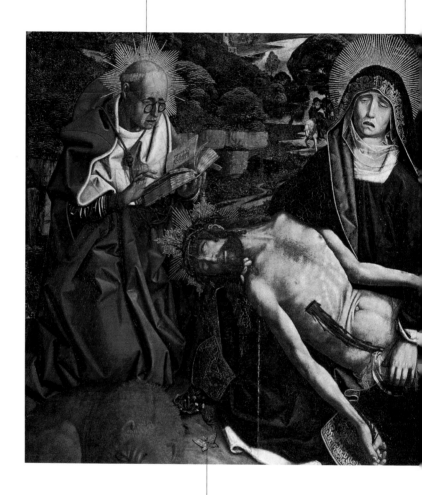

▲ Bartolomé Bermejo, *Pietà with Saint Jerome and a Donor* (*The Pietà of Canon Desplá*), 1490. Barcelona, cathedral museum.

Contrasting with the tragic atmosphere of death, the background is enlivened by flowering shrubs and a number of small animals or insects, all of which have symbolic meaning: the lizard, for example, symbolizes the salvation of the soul, and the butterflies allude to the resurrection of Christ, while symbols of evil—the mouse and the snake—flee the pious scene.

This painting was commissioned by the learned canon and archdeacon Lluís Desplá, and Bermejo has included an unforgettable, highly realistic portrait of him.

The whole painting is pervaded by gloomy symbols of death. It is common in such scenes to depict the bones of Adam at the foot of the cross, but here they are given unusual prominence. The clarity and detail obviously reflect Flemish taste, and they draw our attention to small items such as the tail of a snake disappearing into the rocks near the skull.

Pedro Berruguete brings a note of lively realism to the refined and rather intellectual atmosphere of Urbino, making his presence felt at the highest level of society.

Pedro Berruguete

Paredes de Nava
(northern Spain)
ca. 1450 – Avila ca. 1504

School
Spanish

Principal place of residence
Castile

Travels
Long residence at Urbino
(1474–83)

Principal works
Portrait of Federico da Montefeltro (Urbino, Galleria Nazionale delle Marche, ca. 1475); *Scenes from the Life of Saint Dominic*, (Madrid, Prado, ca. 1490)

Links with other artists
Justus of Ghent, Piero della Francesca, and the other artists working at Urbino; his pupil Juan de Borgoña and his son Alonso Berruguet

▶ Pedro
Berruguete,
Hezekiah (detail),
ca. 1482. Paredes
de Nava, Saint
Eulalia, parish
museum.

Berruguete learned to paint in the circle of Fernando Gallegos, but from his earliest works he displays clear allegiance to the Flemish style, and especially to Van Eyck. In 1474 he moved to Italy, spending most of his time at Urbino, where he collaborated with Justus of Ghent in decorating Federico da Montefeltro's palace. In the duke's private study he and Justus painted a gallery of half-bust portraits of famous characters from the past and present (some are still in Urbino; the rest are in the Louvre), and Berruguete himself painted a full-length portrait of the duke, which is still at Urbino: the duke is seen in profile, with his young son Guidobaldo. Another renowned work—allegorical representations of the Liberal Arts seated on splendid thrones decorated with precious stones—is of less certain attribution: it was painted for the ducal library and is now in the National Gallery in London. In 1483, Berruguete returned to Spain and reverted to gold grounds and an extremely decorative style, as one can see in works such as the retable with scenes from the life of the Virgin, which he painted for the church of Saint Eulalia in Paredes de Nava between 1490 and 1500. His last commission was the Dominican retable for the high altar in Avila cathedral, in which we see echoes of his Italian residence in the use of perspective and light. The unfinished painting was completed by Juan de Borgoña. Pedro Berruguete's son Alonso trained in both sculpture and painting in Florence at the time of Pontormo and Michelangelo. He became one of the leading figures in the precocious mannerism found in Spanish art in the the early sixteenth century.

The portrait is full of carefully articulated symbols of the sitter's ducal status and is intended to emphasize his international standing. The pearl-encrusted miter was a personal gift from the sultan of Constantinople.

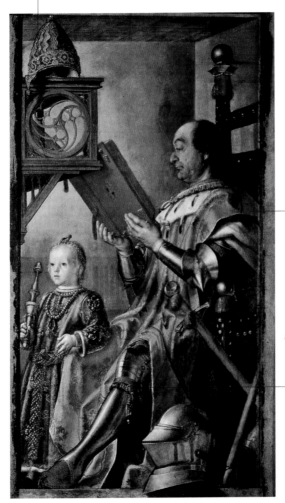

The duke is wearing royal ermine as well as the Order of the Golden Fleece collar. He is portrayed as an intellectual absorbed in reading, but under his robe he is clad in armor, a sword hangs at his side, and his commander's baton rests against his chair.

Berruguete draws attention to the duke's garter, symbol of the Order of the Garter, conferred on him by the king of England.

▲ Pedro Berruguete, *Portrait of Federico da Montefeltro*, ca. 1475. Urbino, Galleria Nazionale delle Marche.

In Botticelli's mythological paintings we find indelible evidence of a new epoch of the spirit, marked by artistic innovation and freedom of thought: the age of Lorenzo the Magnificent.

Sandro Botticelli

Born Alessandro di
Mariano Filipepi;
Florence 1445 – 1510

School
Florentine

Principal place of residence
Florence

Travels
Rome (1481–83)

Principal works
The Adoration of the Magi
(Florence, Uffizi, 1475);
frescoes in the Sistine
Chapel (Vatican City,
1481–83); secular
allegories for the Medici
(Florence, ca. 1485)

Links with other artists
Filippo Lippi and
Verrocchio (his
teachers); Pollaiolo,
Filippino Lippi,
Leonardo, and Perugino
(fellow pupils and
companions in his
early years)

Botticelli's dazzling secular allegories, which came to symbolize the Florence of Lorenzo the Magnificent, made him the outstanding representative of a high point in the history of art and culture. But we would fail to do him justice if we were to take into account only his mature masterpieces for the Medici, because his long artistic career took him from the heart of humanism to the threshold of mannerism. As a young man, he studied under Filippo Lippi in 1474 and then worked with Verrocchio, practicing his skills with a series of paintings of the Virgin and Child. In 1470, his *Fortitude* completed a group of allegorical figures by Piero Pollaiolo (Florence, Uffizi), and two years later he and his pupil Filippino Lippi joined the guild of Florentine painters. Once he gained access to the Medici circle, he painted a number of portraits of members of the family, as well as increasingly important works such as *The Adoration of the Magi* (1475, Uffizi) and *Primavera* (1478–82), which in turn led to an exceptional group of works, including *The Birth of Venus* and *Pallas and the Centaur*. Now at the height of his fame, he was called to Rome in 1481 to paint three frescoes in the Sistine Chapel, and in fact to coordinate the whole enterprise. After returning to Florence, he painted a series of altarpieces and specialized in the difficult art of painting tondi. The death of Lorenzo the Magnificent and the iconoclastic preaching of Savonarola led Botticelli to radically reassess his art. His last masterpieces belong to this period of spiritual turmoil and almost foreshadow mannerism.

▶ Sandro Botticelli, *The Madonna of the Magnificat*, 1483–85. Florence, Uffizi.

In painting as in wood intarsia, an armillary sphere allows Botticelli to demonstrate his skill in rendering objects in perspective.

The architectural details reflect later-fifteenth-century Florentine taste.

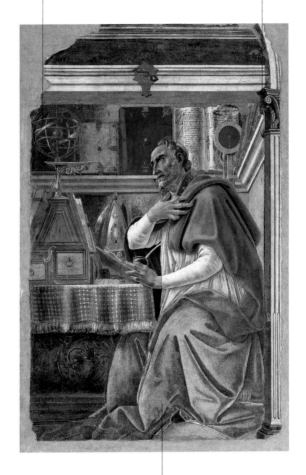

▲ Sandro Botticelli, *Saint Augustine in His Study*, 1480. Florence, Ognissanti.

Thanks to the intensely expressive portrayal of Saint Augustine, the saint remains the pivot of the composition despite the presence of numerous descriptive details in his study, including scientific instruments and treatises.

Sandro Botticelli

The trees form a thick, dark screen behind the figures, which are arranged in a row, almost on the same plane. Botticelli is deliberately using a "flat" presentation, similar to that found in tapestry, without using perspective to emphasize depth.

The figure of Mercury moving the clouds with his rod seems oddly extraneous to the rest of the composition.

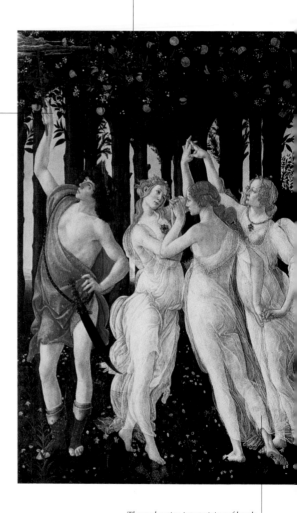

The enchanting intertwining of hands, gestures, glances, and transparent draperies enlivens and unites the group of the three Graces.

▶ Sandro Botticelli, *Primavera*, 1478–82. Florence, Uffizi.

This very famous painting came down to us with no direct documentary evidence, and scholars continue to debate its iconographical language. The pivot of the action is clearly the central figure of Venus, whose body appears luminous against the dark shrubbery behind her. Cupid flies above her head, ready to dispatch one of his arrows.

Zephyr, the impetuous wind, chases the nymph Chloris among the trees.

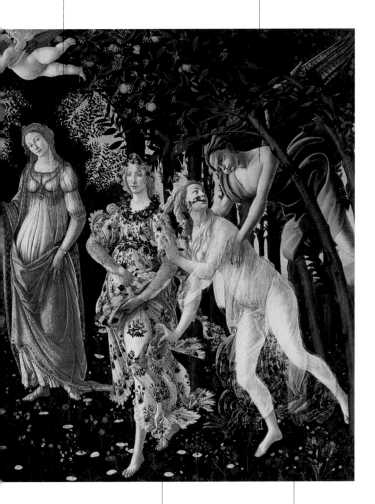

Flora, the flower-scattering nymph of spring, is seen here advancing toward the spectator.

Inspired by Flemish masterpieces that had arrived in Florence, Botticelli paints the flowery meadow with careful attention to botanical detail.

Sandro Botticelli

The two allegorical personifications of winds fly over the waves. Their breath barely ruffles the surface of the sea but manages to propel Venus toward landfall on the island of Cyprus.

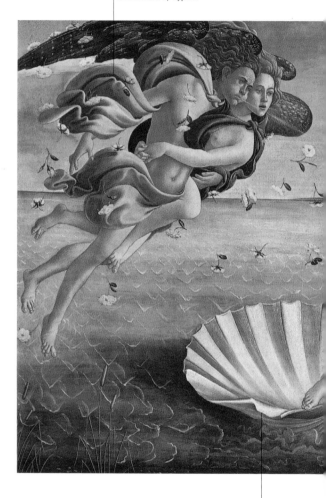

The large shell is the natural womb from which Venus emerges. It was a favorite shape in humanist art, though it was usually tipped up to form a niche, as in Piero della Francesca's Brera Altarpiece.

▶ Sandro Botticelli, *The Birth of Venus*, 1484–86. Florence, Uffizi.

Slim, sophisticated, and modest, with long blonde hair flying in the wind, the figure of Venus is the very image of Florentine glamour in the second half of the fifteenth century.

A nymph welcomes Venus onto the shore, holding out a voluminous robe with a beautiful embroidered floral pattern.

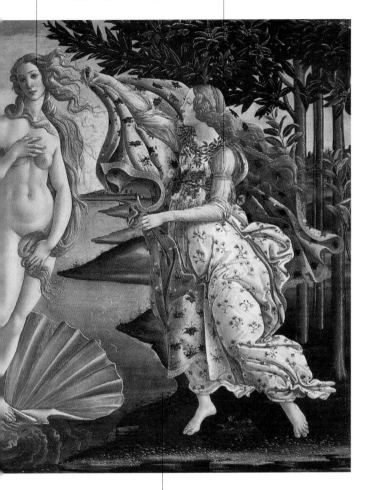

The shore is given a rather nondescript appearance, with very little perspective. Leonardo was harshly critical of Botticelli's landscapes, describing them as "very forlorn."

Sandro Botticelli

The upper part of the painting depicts an unusual ring of angels dancing in the air beneath a gilded Empyrean. A Greek inscription alludes to the end of a long period of disturbances: a direct reference to the tumultuous political and spiritual situation in Florence in the last decade of the fifteenth century, between the death of Lorenzo the Magnificent and the rise of Savonarola.

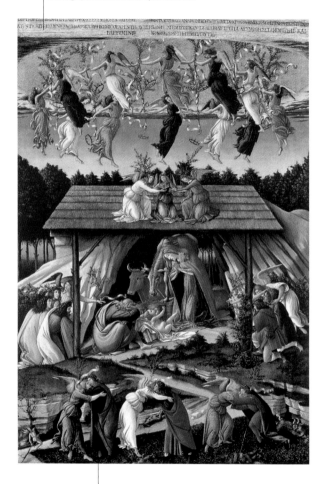

▲ Sandro Botticelli, *The Mystic Nativity*, 1500. London, National Gallery.

This painting is Botticelli's last important work. It seems to be pervaded with a feeling of deep trepidation, which is reminiscent of the contemporary works of Filippino Lippi. At the bottom, three angels wearing the traditional colors of the theological virtues (Faith, Hope, and Charity) passionately embrace three figures who represent rediscovered concord.

Bouts belongs to the second generation of Flemish masters. He brings together the innovations of the "primitive" first generation and the self-glorifying needs of the ambitious mercantile towns.

Dirck Bouts

The years of Bouts's youth are shrouded in mystery, but the influence of Van der Weyden is clear in the works he painted around the 1450s. There is documentary evidence that Bouts was in Louvain—a rapidly growing city—from 1457 onward, and in 1468 he was appointed official painter there. Among his most significant works are the *Altarpiece of the Holy Sacrament* (this work, which is extremely interesting iconographically, has survived intact) and the *Altarpiece of the Last Judgment* (now broken up), which was commissioned by the Louvain city council to compete with the majestic *Last Judgment Polyptych* by Rogier van der Weyden at Beaune. Bouts painted large official works, such as the two panels of *The Justice of Emperor Otto*, now in Brussels. But he also painted many calm, intimate pictures of the Virgin and Child, which were intended for private devotional purposes; these are pleasing both for their clear-cut drawing and their refinement of detail. His lucid, controlled use of space allows him to set scenes in very precise, cohesive rooms and landscapes, into which his figures seem to fit perfectly. In so doing, he was not only anticipating the compositional ideas of Gerard David but also giving visible form to the "conservative" ideals, rich in emblematic civil and bourgeois values, of the wealthy and harmonious society of mid-fifteenth-century Flanders.

Haarlem ca. 1415 – Louvain 1475

School
Flemish

Principal place of residence
Louvain

Travels
Visit to Haarlem

Principal works
Altarpiece of the Holy Sacrament (Louvain, Saint-Pierre, 1464–67)

Links with other artists
Echoes of Memling and Van der Weyden

◄ Dirck Bouts, *The Dream of Elijah*, 1464–67, lower panel of the right shutter of the *Altarpiece of the Holy Sacrament*. Louvain, Saint-Pierre.

243

Dirck Bouts

Water gushes from the fountain of grace in the earthly paradise.

The blessed are traveling toward the light from the highest heavens, which can be glimpsed through the clouds.

The celestial space that Bouts depicts is a "transitional" area: an intermediate stage between earth and the Empyrean, corresponding to Eden.

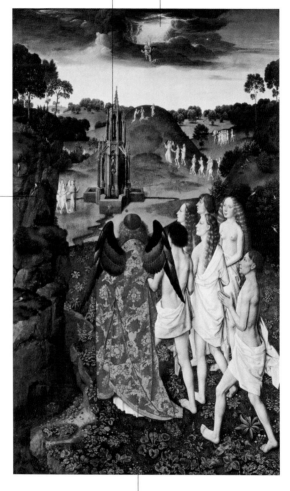

▲ Dirck Bouts, *The Road to Heaven*, 1450, left panel of the *Altarpiece of the Last Judgment*. Lille, Musée des Beaux-Arts.

An angel in a luxurious brocade robe is conducting the souls of the blessed toward paradise.

*Bramante is a splendid and original interpreter of classicism,
expressed in forms that become increasingly monumental and bold
in the Milan of the Sforza family and the Rome of Pope Julius II.*

Bramante

Bramante trained in the unique artistic hotbed of the Ducal Palace of
Urbino, where he learned the rules of perspective from Piero della
Francesca. Once he had completed his training, largely in painting,
he moved to Lombardy, producing in Bergamo and Milan works
whose rigorously monumental figures in grandiose spatial settings
were powerful enough to influence the Lombard school. However,
his most unusual and fascinating *Prevedari Engraving*, which shows
the interior of an imposing church, foreshadows his decisive move
toward architecture. From 1478 onward he was working for
Ludovico il Moro in Milan, where he not only produced some spec-
tacular buildings (Santa Maria presso San Satiro, Santa Maria delle
Grazie, and the cloisters of Sant'Ambrogio) but also designed Pavia
cathedral and the harmonious Piazza Ducale in Vigevano. After the
fall of Ludovico il Moro, he left Milan, arriving in Rome in 1499.
There he embarked on an extraordinary reinterpretation of the
antique: his Tempietto next to San Pietro in Montorio made a lasting
impression on contemporary artists, including Raphael. Within a few
years he became the most
important architect at the
courts of Popes Alexander
VI and Julius II, for whom
he designed a total reorga-
nization of the Vatican
palaces around the Belve-
dere courtyard. In 1506 he
began to lay the founda-
tions for the rebuilding of
Saint Peter's—a project
that was subsequently
taken up by Michelangelo.

Born Donato d'Agnolo
or d'Angelo; Fermignano
(Pesaro) 1444 –
Rome 1514

School
Italian

Principal place of residence
Milan and Rome

Travels
Urbino, Mantua, and
Florence

Principal works
The church of Santa Maria
presso San Satiro in Milan
(1478); the tribune of
the church of Santa
Maria delle Grazie in
Milan (1490);
the Tempietto at San
Pietro in Montorio
in Rome (1502)

Links with other artists
Piero della Francesca in
Urbino; Leon Battista
Alberti in Mantua;
Leonardo in Milan;
Raphael and Michelangelo
in Rome

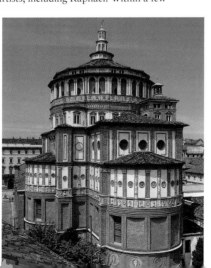

◄ Donato Bramante, tribune
and apse area of the church
of Santa Maria delle Grazie,
1490. Milan.

*The lovely "Lombard" landscape
in the background and the careful
rendering of light in Christ's hair
may be linked to Leonardo's
early period in Milan.*

*Christ is bound not to the traditional
round column but to a rectangular
pilaster decorated with humanistic
ornamental reliefs.*

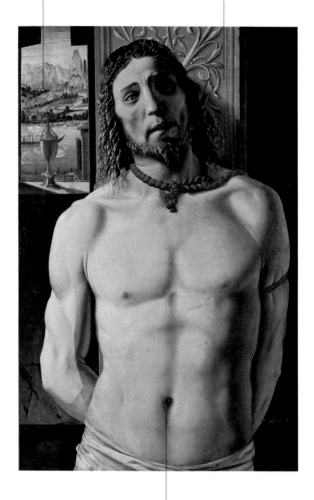

*This important work was probably painted
for the abbey of Chiaravalle. It illustrates
Bramante's interest in perspective and the
volumes of the human body, which in this
case has a perfectly smooth surface.*

▲ Donato Bramante, *Christ at
the Column*, ca. 1485. Milan,
Pinacoteca di Brera.

Brunelleschi is a new kind of architect: an intellectual who designs and constructs buildings with a breadth of vision that is both serene and grandiose, rational and yet poetic.

Filippo Brunelleschi

Brunelleschi trained as a goldsmith and produced both metalwork (*Altar of San Jacopo*, Pistoia cathedral) and wood sculpture (*Crucifix*, Santa Maria Novella, Florence). He discovered his vocation as an architect during a series of visits to Rome, the first and most memorable of which was made in the company of Donatello (1402). Florentine workshops were traditionally eclectic in their activities, so Brunelleschi continued to produce occasional works of sculpture and even painting. He combined the study of applied mathematics with a keen interest in humanism and formulated the principles of linear perspective, which would make it possible to plan and construct rationally measured spaces. He was undoubtedly a leading figure in the Florentine cultural scene in the first half of the fifteenth century, and in 1409 he became involved in the construction of Santa Maria del Fiore. In 1418 he started the great dome, to a design that used quite new aesthetic and technical criteria. Brunelleschi's designs in Florence provided a series of archetypes for vastly different buildings, from grandiose basilicas to private chapels on a central plan, from private palaces to public welfare buildings, and from town-planning projects to mechanical and military devices. Brunelleschi preferred a "graphic" linearity in architectural features and sections of *pietra serena* (the local Florentine stone) set against a bright plaster background, though he also used richly decorative elements made by masters such as Donatello and Della Robbia. But the whole is always dominated by a calculated sense of rhythm based on simple geometrical rules, so that each part of a building enjoys a harmonious relationship with the whole.

Florence 1377 – 1446

School
Florentine

Principal place of residence
Florence

Travels
Numerous visits to Rome, sometimes in the company of Donatello

Principal works
All in Florence: the dome of Santa Maria del Fiore (1418–34); San Lorenzo, including the old sacristy (1420–30); the Pazzi chapel (ca. 1430); Santo Spirito (1436–44)

Links with other artists
He influenced the entire history of Renaissance architecture, but specific mention must be made of Donatello (the companion of his youthful years), Ghiberti (frequently his rival), and Luca Della Robbia (who decorated the Pazzi chapel)

◄ Filippo Brunelleschi, the dome of Santa Maria del Fiore, 1418–34. Florence.

247

Filippo Brunelleschi

The delightful glazed terra-cotta medallions representing newborn babies in swaddling clothes are the work of Giovanni Della Robbia. The hospital was founded in 1419 to shelter and bring up orphaned or abandoned children.

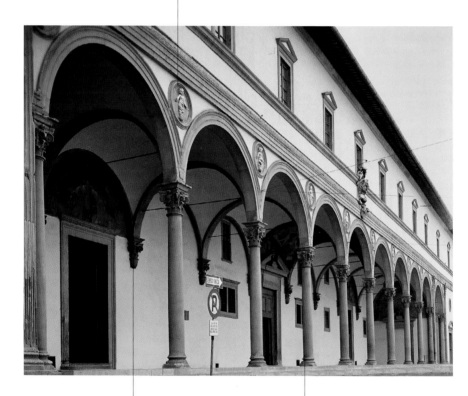

The structural elements (columns, moldings, and corbels) are made of pietra serena, the local stone, and the contrast between their dark gray color and the white plaster is characteristic of Tuscan architecture.

The magnificent portico with arches supported on slender columns is an example of perfectly calculated proportions. It is strictly functional and at the same time a splendid addition to the urban scene.

▲ Filippo Brunelleschi, portico at the Spedale degli Innocenti, inaugurated in 1445 (the facade was completed in 1439). Florence.

The chapel is adjacent to the right transept of the great Franciscan church of Santa Croce. The upper part of its facade is incomplete.

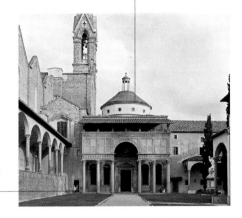

The facade has an open portico on Corinthian columns with a tall arch at the center. The upper part is divided into squares, and a simple little dome rises at the top.

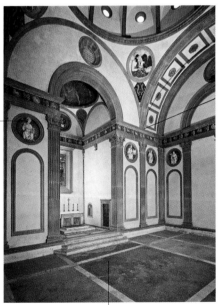

The decorative details were entrusted to masters such as Desiderio da Settignano (sculpted decoration), Luca Della Robbia (tondi with glazed terra-cottas), and Giuliano da Maiano (inlaid doors).

▲ Filippo Brunelleschi, facade and interior of the Pazzi chapel, begun in 1429. Florence, convent of Santa Croce.

The interior is one of the purest examples of humanist architecture, thanks to the perfect rhythm in the use of space.

Robert Campin is one of the most outstanding painters of the early fifteenth century. His intense realism places him alongside Van Eyck at the pinnacle of Flemish painting.

Robert Campin

Also known as Master of Flémalle (or Master of Mérode); Valenciennes 1378/79 – Tournai 1444

School
Flemish

Principal place of residence
Tournai

Travels
Probable visits to Burgundy

Principal works
The Mérode Triptych (New York, Metropolitan Museum, 1427); *The Virgin and Child before a Firescreen* (London, National Gallery, ca. 1430); panels of *The Flémalle Triptych* (Frankfurt, Städelsches Kunstinstitut, 1430–32)

Links with other artists
Van der Weyden and Jacques Daret (his pupils)

Though in the past there were many doubts about Campin's life and work, today we have formed a clearer picture of him, one that confirms his fundamental role in the birth of the Flemish school. It is known that he spent a good deal of his life at Tournai, in the present-day Walloon region of Belgium, where a rebellion headed by representatives of the craft organizations led to a more broadly based local government. Within this bourgeois society, Campin held prestigious positions as dean of the goldsmiths' guild and deacon of the painters' guild. He ran a well-organized workshop, in which Rogier van der Weyden and Jacques Daret served their apprenticeships. He painted some portraits but specialized in large triptychs (not all of which have survived intact) in which grandiose religious subjects are translated into strikingly realistic images. Campin's fortunes seem to have suffered when the nobility returned to power toward the end of the 1430s, for we find him enmeshed in a series of lawsuits and trials. His robust realism was to have great influence on the next generation of artists. Although a contemporary of Van Eyck, he expressed himself in a different and less detached artistic language. Under the influence of Burgundian sculpture and painting, he developed a style made up of appealing everyday images, and his figures have a strong and very human physical presence that is quite original.

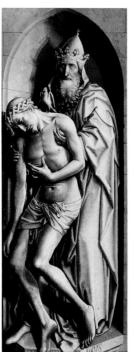

▶ Robert Campin, *The Trinity*, 1430–32. Frankfurt, Städelsches Kunstinstitut.

Through a window at the back, we get
a hint of the bustling life of a Flemish
town in the early fifteenth century.

The painting's title derives from the
wicker firescreen. It shields the flames in
the hearth and at the same time creates
a kind of secular, domestic halo around
the Virgin's head.

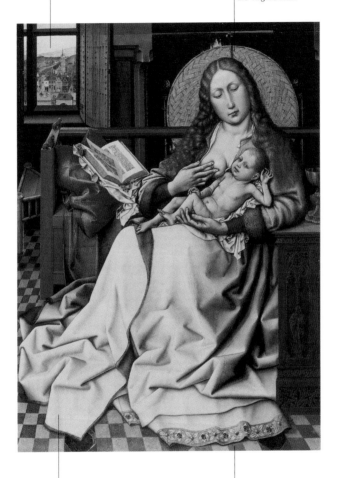

The ample, sculpted form of the Virgin's
robe derives from stone statues by the
Burgundian artist Claus Sluter—a
comparison also suggested by the
fact that the robe is monochrome.

The perspective in the flooring, though
intentional, still seems rather too steep.

▲ Robert Campin, *The Virgin and
Child before a Firescreen*, ca. 1430.
London, National Gallery.

The small round table in front of the angel draws attention to the sloping perspective—a technique that Campin has evidently not yet mastered.

The careful and poetic depiction of realistic details encourages one to examine the painting slowly. Every fresh look brings more of them to light.

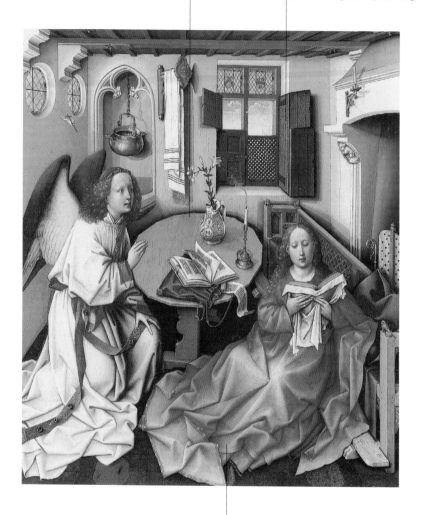

The Virgin is immersed in her book and has not yet noticed the silent, cautious arrival of the angel, who seems to be searching for the right words with which to reveal his presence.

▲ Robert Campin, *The Annunciation*, 1427, central panel of *The Mérode Triptych*. New York, Metropolitan Museum, The Cloisters.

Some of the best-known images of Venice are to be found in the large canvases of Carpaccio's Saint George and Saint Ursula cycles. His narrative scenes evoke the fascination of the Venetian Republic.

Vittore Carpaccio

Carpaccio's early career is obscure, but he seems to have had contact with a variety of artistic schools, since Flemish and Ferrarese influences can be detected over a definitely Venetian substratum. In 1490, having acquired his own mature, independent style, he embarked on the cycle *Scenes from the Life of Saint Ursula* (Venice, Accademia). He spent years on these paintings, gradually achieving a perfect equilibrium between drama, soft lighting, bright colors, and a wealth of descriptive detail. The canvases he painted between 1502 and 1507 for the Scuola di San Giorgio degli Schiavoni (still in situ) reach the same high standard, but his later cycles for the Scuola degli Albanesi and the Scuola di Santo Stefano, now broken up and housed in various museums, are less intense. Although his specialty was narrative scenes for the Scuole, the rare portraits and altar paintings that he produced in the first decade of the sixteenth century have great expressive power, almost as though in opposition to the color tones of Giovanni Bellini and Giorgione (*The Presentation in the Temple*, Venice, Accademia; *Meditation on the Dead Christ*, Berlin, Gemälde-galerie). Carpaccio also obtained some public commissions (*The Lion of Saint Mark*, Ducal Palace), but his altarpiece for the church of San Vitale (1514) seems to mark the end of his Venetian career, partly because Titian's star was rising. Carpaccio ended his career in the provinces (Bergamo, Cadore, and Istria), where his now-outdated style still found admirers.

Venice 1460/ca.1465 – 1525/26

School
Venetian

Principal place of residence
Venice

Travels
He moved to Istria in the last years of his life

Principal works
Scenes from the Life of Saint Ursula (Venice, Gallerie dell'Accademia, 1490–97); large canvases for the Scuola di San Giorgio in Venice (1502–7); *Portrait of a Young Knight* (Madrid, Thyssen-Bornemisza Museum, 1510)

Links with other artists
The Venetian art scene, from Antonello da Messina and the Bellini brothers to Giorgione and Titian

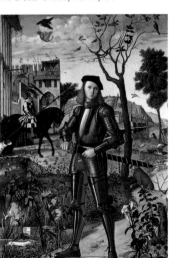

◀ Vittore Carpaccio, *Portrait of a Young Knight*, 1510. Madrid, Thyssen-Bornemisza Museum.

Vittore Carpaccio

This painting still hangs in what was originally the headquarters of the Dalmatian confraternity in Venice. It offers a clear representation of a humanist's study, with books, small collector's items, and Christ the Redeemer in the background.

The seated figure of Saint Augustine at his desk is a typical representation of a senior prelate in the age of humanism: he is shown to be a man capable of reconciling classical culture and Christianity.

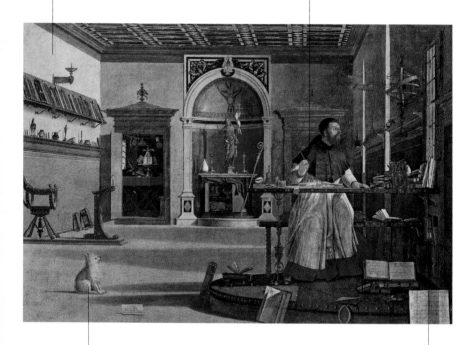

The presence of the little dog in such an elevated, intellectual scene adds a note of delightful realism.

It is not easy to establish the meaning of the painting: Carpaccio depicts Saint Augustine's vision of Saint Jerome, who takes the form of light that "illuminates" and helps him to understand the scriptures.

▲ Vittore Carpaccio, *The Vision of Saint Augustine*, ca. 1502. Venice, Scuola di San Giorgio degli Schiavoni.

His noble and luminous paintings stand at the meeting point between refined Flemish elegance and grandiose Italian monumentality.

Enguerrand Charonton

Enguerrand Charonton worked in the south of France—in Aix, Arles, and Avignon—in the years around 1450 and played a decisive role in the rebirth of Provençal art, together – with Barthélemy d'Eyck and Nicolas Froment. We have very little information about his life and work, but we do know that his productive period was concentrated between 1444 and 1466. Even his surname is spelled in various ways. He was definitely responsible for *The Coronation of the Virgin* and *The Virgin of Mercy* (Chantilly, Musée Condé), but the attribution of the Avignon *Pietà* (now in the Louvre) has long been debated: it is perhaps the most intense work in French fifteenth-century painting and scholars now generally attribute it to Charonton. The particular characteristics of his work are his rigorously formal organization based on a regular rhythm (usually tripartite), his sober style, and a monumental treatment of the figures—a quality that ties him to the great Italian models from Fra Angelico to Piero della Francesca. The styliza-
tion of shapes and their reduction to essential volumes; the balance of masses; and the clear, cold light that emphasizes the geometrical structure of figures and objects—these qualities iden-tify Charonton as a creative genius who reaches so far beyond his own time that he can even be considered a precursor of another great Provençal painter: Cézanne.

Also referred to as Quarton Enguerrand; Laon ca. 1415 – last known to be alive in 1466

School
Provençal

Principal place of residence
Various towns in Provence

Travels
He may well have trained in Flanders

Principal works
The Virgin of Mercy (Chantilly, Musée Condé, 1452); *The Coronation of the Virgin* (Villeneuve-lès-Avignon, Municipal Museum, 1453–54; (?)*Avignon Pietà* (Paris, Louvre, ca. 1455)

Links with other artists
There are stylistic echoes of Domenico Veneziano and Piero della Francesca

◄ Enguerrand Charonton, *David at Prayer*, ca. 1445, illuminated page from a book of hours. New York, Pierpoint Morgan Library.

John is given an unusual gesture: he very delicately removes the crown of thorns from Christ's head.

This large panel is one of French painting's greatest achievements and an impressive example of Provençal style, which combines a Flemish attention to detail with a monumentality reminiscent of Italian painting.

The portrait of the donor, a canon of Villeneuve-lès-Avignon, is most impressive. Above the voluminous drapery, his well-lit, lean, tense face has a firm and exceptionally intense gaze.

▶ Enguerrand Charonton (?),
Avignon Pietà, ca. 1455. Paris, Louvre.

The central group of the Madonna with the dead Christ partly echoes the elements one usually finds in a Vesperbild, *but* instead of the ostentatiously devotional rendering of the blood, wounds, and anguish, Charonton prefers a noble expression of deep, intimate emotion.

The large figures stand out sharply against the gold ground. The haloes and inner frame are decorated with elegant stamped patterns and inscriptions.

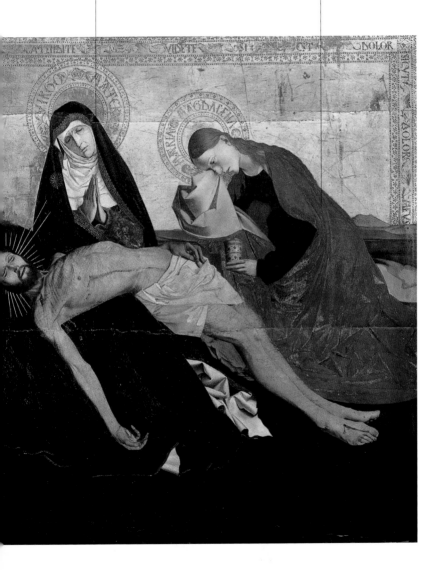

His figures cross the divide between the painted space and that of the spectator, giving life to scenes that have an intimate but intense feeling of realism.

Petrus Christus

Baerle ca. 1410 – Bruges
1475/76

School
Flemish

Principal place of residence
Bruges

Travels
Brief visits to Flanders;
perhaps also a journey
to Milan in 1456

Principal works
Portrait of a Lady (Berlin,
Gemäldegalerie, ca. 1445);
*A Goldsmith in His Shop,
Possibly Saint Eligius*
(New York, Metropolitan
Museum, 1449)

Links with other artists
He may have had contacts
with Antonello da Messina
in addition to the Flemish
masters (Van Eyck and
Van der Weyden

Petrus Christus belongs to what is commonly called the second generation of fifteenth-century Flemish artists, the one that followed on from the "founding fathers," Van Eyck, Campin, and Van der Weyden. We know little of his early life, but it is likely that he made a careful study of the works of the best-established artists, especially Van Eyck. One interesting hypothesis is that he may have completed a *Madonna* left unfinished by Van Eyck (New York, Frick Collection). In 1444, Christus moved to Bruges, where he remained for the rest of his life. He soon gained entry to the circles that mattered in the city. He and his wife became members of two confraternities of Mary that counted nobles and members of the royal family—including the duke and duchess of Burgundy—among their followers, as well as members of the rising middle class. Christus's very personal pictorial language was based in the meticulous realism of Van Eyck, but he went on to concentrate on the depiction of space. Ultimately he

became the first northern painter to structure space in a rational way, using a single vanishing point, and after the midcentury his paintings take on a monumental tone under the influence of Van der Weyden. As a painter in the employ of the city, he was also responsible for grandiose ephemeral decorations and ceremonial displays for special occasions, such as the wedding of Charles the Bold and Margaret of York in 1468.

► Petrus Christus,
*The Madonna of the
Dry Tree*, 1465. Madrid,
Thyssen-Bornemisza
Museum.

An engaged couple are choosing a wedding ring. As usual, Flemish painting likes to project its scenes into contemporary reality.

The meticulous representation of the precious objects on display in the workshop means that we are effectively looking at a very early still life.

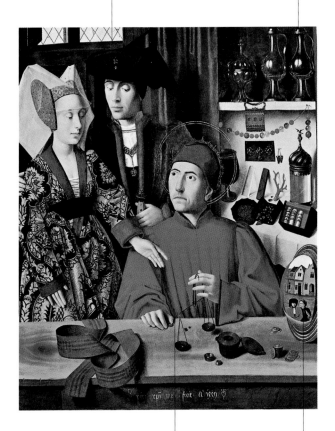

Only a slender halo reveals that Eligius is a saint, for he is painted as an ordinary goldsmith, weighing rings in order to calculate their price.

▲ Petrus Christus, *A Goldsmith in His Shop, Possibly Saint Eligius*, 1449. New York, Metropolitan Museum.

A convex mirror reflects the street outside with people passing by.

Crivelli is poised between the latest understanding of perspective and memories of the late Gothic. His works display sumptuous decoration and incisive, vigorous drawing.

Carlo Crivelli

Venice, ca. 1430/35
–Marches 1494/95

School
Venetian and the Marches

Principal place of residence
The Marches

Travels
Padua (ca. 1455),
Zara (Dalmatia) (ca. 1460)

Principal works
The Saint Lucy Altarpiece
(divided between various
museums, ca. 1475);
The Annunciation
(London, National
Gallery, 1486);
*The Madonna della
Candeletta* (Milan,
Pinacoteca di Brera,
ca. 1490)

Links with other artists
In his formative years he
was in contact with the
Vivarini, Jacopo Bellini,
and Paduan circles
(Mantegna, Tura,
and Pacher)

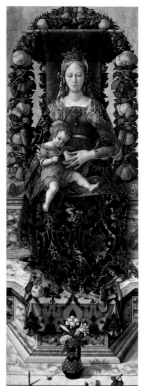

▶ Carlo Crivelli, *The Madonna
della Candeletta*, ca. 1490.
Milan, Pinacoteca di Brera.

Crivelli was born in Venice and trained first in the Vivarini work-shop and then in the lively humanist circles of mid-century Padua. A series of youthful misadventures, however, led to his being exiled from Venice. He moved first to Istria (1459) and then on a more per-manent basis to the Marches, where he lived from 1468 until his death. Here he found himself more in his element, and he became one of the most extraordinary artists of the later fifteenth century. He was evidently aware of the latest rules of perspective and of classical monumentality, but he envelops this knowledge in rich, exuberant decoration, even returning to the old-fashioned gold ground. His figures are wrapped in arabesque-covered draperies with festoons of flowers and fruit and motifs in relief, but they are still strongly characterized. With the help of a well-equipped workshop, including his brother Vittore, he produced polyptychs and other altarpieces for large, small, and even tiny towns in the Marches. Many of these works have been broken up, and some of his polyptychs are divided among Italian and foreign museums. Some of the paintings are still in their original positions, though few of them are intact: some panels of the *Saint Lucy Altarpiece* remain at Montefiore del-l'Aso, and the grandiose high altar is still in Ascoli Piceno cathedral (1473). Crivelli became increasingly isolated from humanist developments, shutting himself up in a sort of precious, narcissistic isolation of a decid-edly nostalgic variety.

This is an enchanting view of an "ideal city," and it includes a number of its inhabitants.

This elaborate and splendid humanistic building has a colonnade in perspective that is very similar to one painted by Mantegna in his early frescoes at Padua—the city where Mantegna and Crivelli trained together.

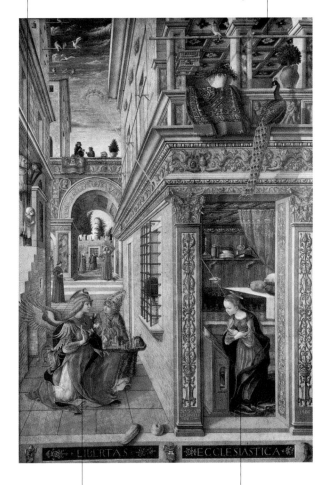

▲ Carlo Crivelli, *The Annunciation*, 1486. London, National Gallery.

Next to the angel, Crivelli has painted Saint Emidius, the patron saint of Ascoli Piceno, the city for which this Annunciation was intended. By doing so, Crivelli brings the Gospel episode into a more contemporary context.

The Virgin is struck by a divine ray of light (which passes through a specially provided hole in the palace wall) as she kneels in a tidy, elegant chamber, which the painter has depicted in great detail.

Gerard David stands at the intersection of the great Flemish tradition and the artistic innovations in the opening years of the sixteenth century. He is one of the greatest precursors of landscape painting.

Gerard David

Oudewater ca. 1460 –
Bruges 1523

School
Flemish

Principal place of residence
Bruges

Travels
Haarlem as a young man;
Antwerp (1515)

Principal works
*The Justice of
Cambyses* (Bruges,
Groeningemuseum, 1498);
*The Mystic Marriage of
Saint Catherine* (London,
National Gallery, 1505);
*The Baptism of Christ
Triptych* (Bruges,
Groeningemuseum, 1508)

Links with other artists
He had direct or stylistic
links with all the major
fifteenth-century
Flemish artists

David was born in the province of Holland, in the north of the Low Countries, and was to become the last great artist working in fifteenth-century Bruges. He probably trained in his father's workshop and then embarked on a journey that took him first to Haarlem and then to the south. In 1484 he settled permanently in Bruges, where his style underwent considerable modification under the influence of Memling's sober, detached artistic language. His broadly conceived, grandiose paintings soon made him the most important painter in Bruges at the turn of the century, and he shrewdly kept control of his own success by foreseeing social and economic changes. He realized that Bruges was slowly declining in importance (its port was silting up), and that the center of Flemish politics and wealth was moving toward Antwerp, at the mouth of the Schelde. Toward the end of the century, when there were increased contacts between Flanders and Italy, he was one of the first artists to give his works a

Renaissance character. Although he remained faithful to the traditional themes of Flemish painting, he introduced a poetic, atmospheric treatment of light into his works, and his compositions became increasingly simple and monumental. But David's greatest original contribution to Flemish art was to immerse his figures in a landscape whose essence was vibrant and tangible, a captivating place in which to abandon oneself to meditation. In this he anticipated the extraordinary work of Joachim Patinier.

▶ Gerard David, *Landscapes*,
ca. 1510, outer panels of *The
Nativity Altarpiece*. The
Hague, Mauritshuis.

Although the composition adheres to a traditional form, David introduces fanciful landscapes that anticipate later Flemish developments from Patinier to Bruegel.

In the middle ground is a secondary scene of Saint John preaching to the masses.

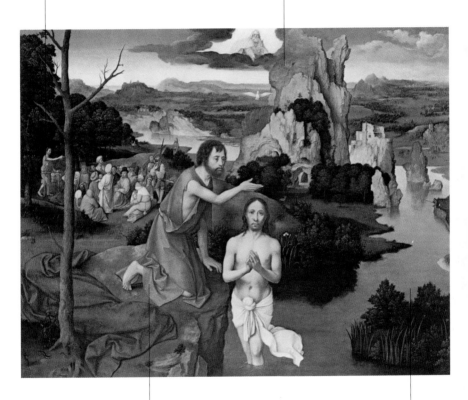

In the principal group of figures, David displays his predilection for calm, solemn gestures.

The river Jordan meanders between rocky banks in the distance, but in the foreground it becomes slower and more placid.

▲ Gerard David, *The Baptism of Christ*, ca. 1510. Vienna, Kunsthistorisches Museum.

A sculptor with a rebellious temperament, he elegantly blends late-Gothic drapery-filled surfaces with a humanist sense of monumentality.

Jacopo Della Quercia

Siena ca. 1371 – 1438

School
Tuscan

Principal place of residence
Siena and Lucca

Travels
Florence, Ferrara, Bologna

Principal works
Tomb of Ilaria del Carretto (Lucca, cathedral, 1406); *Fonte Gaia* (Siena, Piazza del Campo, 1409–19); central portal of San Petronio (Bologna, 1425–38)

Links with other artists
Donatello, Ghiberti, and Brunelleschi in Florence; echoes of Sluter

▶ Jacopo Della Quercia, *The Creation of Eve* and *Original Sin*, panels from the central portal. Bologna, basilica of San Petronio.

Jacopo Della Quercia was the son of a goldsmith who lived in a district called Quercia Grossa near the gates of Siena, and in the history of early-fifteenth-century sculpture he counts as a "dissident." He entered the 1401 competition for the baptistery door in Florence, but after being defeated by Ghiberti and Brunelleschi, he kept his distance from Florentine artistic circles. He branched out and worked in a number of places that are of some historical and artistic importance without being at the very center of events. His works in Lucca, Siena, Ferrara, and San Gimignano and as far away as Bologna avoid being too sweet or, at the other extreme, too cerebral. His sculpture is virile and substantial, and any classical echoes encounter a realism that is sometimes almost coarse. He is as much at ease with monumental marble sculpture as with polychrome wood sculpture or bronze panels. In his very personal interpretation of classicism, large, solid, and muscular figures are often wrapped in insistent drapery folds that hark back to Gothic taste. Under the influence of the Tuscan tradition of Nicola and Giovanni Pisano, Jacopo sculpted both figures in the round and elaborate bas-reliefs in which he displayed his training as a goldsmith and his love of detail. He spent a great deal of time on his last work: the powerful panels with biblical scenes that frame the portal of San Petronio in Bologna. They have often been seen as foreshadowing Michelangelo.

*The very elegant figure of Ilaria
has become famous for the
painful contrast it presents
between beauty and death.*

*There is a touch of moving realism in the
faithful little dog that crouches at the feet
of its dead mistress.*

*While the draperies still follow late-
Gothic models, the row of putti bearing
festoons is an explicit classical quotation,
and a declaration that the artist is open to
humanist ideas.*

▲ Jacopo Della Quercia, *The Tomb of
Ilaria del Carretto*, 1406. Lucca, cathedral.

In the midst of a lively artistic debate in Florence, Luca Della Robbia chooses a calm, noble classicism and initiates the new and very successful genre of glazed polychrome terra-cottas.

Luca Della Robbia

Florence ca. 1400 – 1482

School
Florentine

Principal place of residence
Florence

Travels
None known outside
Tuscany

Principal works
Choir loft (Florence,
Museo dell'Opera del
Duomo, 1431–38);
The Federighi Tomb
(Florence, Santa Trìnita,
1454–57); ceiling of the
chapel of Cardinal Jacopo
of Portugal (Florence,
San Miniato, 1461–66)

Links with other artists
Brunelleschi, Donatello,
Nanni di Banco, Ghiberti,
Michelozzo, and the other
early-fifteenth-century
Florentine masters

▶ Luca Della Robbia,
Madonna and Child,
ca. 1450, Florence, Museo
Nazionale del Bargello.

Let us not be misled by the image of a terra-cotta production line in the Della Robbia workshop in Florence for three generations, including the popular and rather conventional blue-and-white Madonnas designed for private devotional purposes. Luca Della Robbia was in fact a powerful, up-to-date sculptor, in constant contact with Ghiberti and Donatello but able to produce his own version of classical motifs and compositional balance. His marble choir loft for Florence cathedral, begun in 1431, displays his search for a sensitive and balanced elegance. It was also for the cathedral site that he made reliefs for the bell tower and glazed terra-cottas for the lunettes over the bronze doors of the sacristy, using a very refined and original technique that he devised around 1440, which Brunelleschi adopted to decorate the Pazzi chapel. The glazed ceramic technique had been developed in the Della Robbia workshop in Florence by members of his family and collaborators for over a century. It was used to produce not only a series of splendid Madonnas but also very elaborate polychrome items for architectural decoration (festoons, cornices, coats of arms, pilasters, canopies, and so on), not to mention monumental sculptural groups such as the powerful *Visitation* in the church of San Giovanni Fuoricivitas at Pistoia.

The long, elegant Latin inscriptions are in perfect proportion to the whole. They can also be found on various other humanistic buildings, such as the facade of Santa Maria Novella in Florence or the courtyard of the Ducal Palace in Urbino.

The large corbels are decorated with motifs from antiquity.

This choir loft, or cantoria, was made to rival the one by Donatello (see page 195), and displays Della Robbia's predilection for calm, rhythmic scenes set in squares.

▲ Luca Della Robbia, choir loft, 1431–38. Florence, Museo dell'Opera del Duomo.

Donatello celebrates man in the full range of his emotions, from the most tender sweetness to the agony of suffering. No artist expresses the intensely human spirit of the fifteenth century better than he.

Donatello

Born Niccolò di Betto
Bardi; Florence ca.
1386 – 1466

School
Florentine

Principal place of residence
Florence

Travels
Repeated visits to Rome
and various Tuscan cities
(Siena, Prato); long stay
in Padua

Principal works
Saint George (Florence,
Bargello, 1416);
*Equestrian Monument of
Gattamelata* (Padua,
1447–53); choir loft for the
basilica of San Lorenzo
(Florence, 1460–66)

Links with other artists
Donatello influenced the
entire humanist movement,
both in Italy and elsewhere
in Europe

Donatello's long career (he was still very active when he died in his eighties) is a milestone in the history of art. He spent almost all his career in Florence, with one long and important visit to Padua. During that time he expressed himself in works of very different dimensions, ranging from an enormous equestrian statue to little table bronzes, and he had no difficulty in handling the most varied materials (marble, bronze, terra-cotta, and mixed techniques) in an inexhaustible variety of works. He began his career when he was barely twenty at the Santa Maria del Fiore site, along with Nanni di Banco, and he soon became known for powerful large-scale sculptures. In 1416 he was commissioned to make the *Saint George* for Orsanmichele. Later on, during the 1420s, he was working with Michelozzo, making powerful blended works of sculpture and architecture in Florence, Prato, Rome, and Naples. In that same period he was also jointly involved in the decoration of a gilded-bronze baptismal font for Siena, and in 1433 he was Luca Della Robbia's rival in the two marble choir lofts for Florence cathedral.

Beginning in 1443 he spent almost ten years in Padua, where he made the *Equestrian Statue of Gattamelata* as well as the grandiose figures for the *Altar of Saint Anthony*. His experience in casting large bronze statues proved useful for later works in Florence, such as the *Judith* now in the Palazzo Vecchio, and the dramatic pulpits in San Lorenzo. Even Giorgio Vasari, who was keen to claim that Michelangelo was greater than any other artist in history, had to conclude: "Either the spirit of Donatello entered into Michelangelo, or that of Michelangelo found earlier expression in Donatello."

▶ Donatello, *Judith and
Holofernes*, 1455–60.
Florence, Palazzo Vecchio.

The perfect bronze-casting and chasing technique makes the surface very smooth and so emphasizes the modeling.

The statue was commissioned by the Medici family to be placed in a garden. David represents the ideal of republican freedom. His thoughtful expression adds a note of gravitas to his splendidly youthful form.

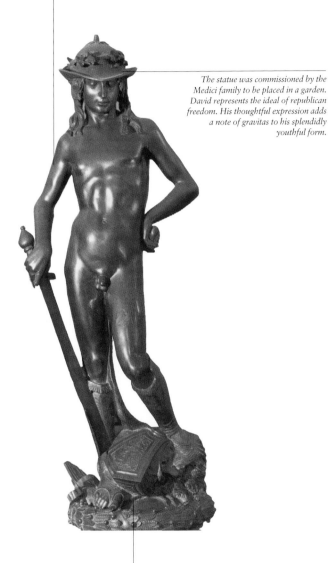

▲ Donatello, *David*, 1433. Florence, Museo Nazionale del Bargello.

The head of the defeated giant Goliath has been severed by David and lies on a laurel wreath, the symbol of victory.

Donatello

The background of the relief is decorated with gilded motifs inspired by classical art.

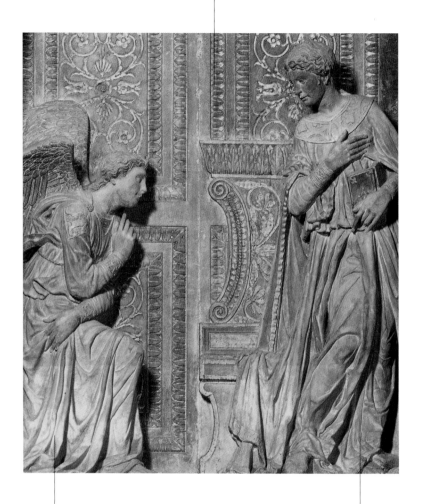

This Annunciation scene was commissioned by the Cavalcanti family and placed in a splendid niche made of pietra serena, *the local Florentine stone.*

The wonderful relationship of gestures, glances, and emotions between the figures has been very carefully worked out.

▲ Donatello, *The Annunciation*,
1435. Florence, Santa Croce.

Donatello shows great mastery of very different materials. In this case, he has used wood, partially gilded, and has taken the opportunity to create an unusually rough and dramatic surface.

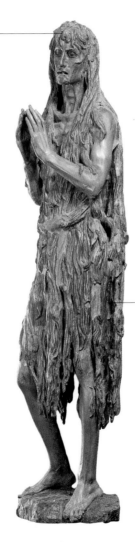

This figure of the penitent Magdalene was originally intended for the cathedral baptistery. She seems totally steeped in penitence: her face is drawn, emaciated, and devoid of beauty, while her body is almost entirely hidden by her ascetic dress of rough skins.

▲ Donatello, *The Penitent Magdalene*, ca. 1460. Florence, Museo dell'Opera del Duomo.

The two Erharts are among the most refined late-Gothic wood sculptors, and their work on monumental winged altars initiated a period of intense, almost romantic sensibility.

Michel and Gregor Erhart

Michel (father): Ulm, known to be active between 1469 and 1494; Gregor (son): Ulm ca. 1460 – Augsburg 1540

School
German

Principal place of residence
Ulm and Augsburg (Gregor)

Travels
Various places in Bavaria and in central and southern Germany

Principal works
Altar of the Virgin (Blaubeuren, 1493–94), with outer wings, polychromy and backgrounds painted by Bartholomäus Zeitblom and Bernhard Striegel

Links with other artists
Hans Multscher and Jörg Syrlin in Ulm; later on, the Holbein workshop at Augsburg

► Gregor Erhart (polychromy by Hans Holbein the Elder), *Allegory of Vanity*, ca. 1500. Vienna, Kunsthistorisches Museum.

In this survey of leading fifteenth-century artists, there are numerous examples of brothers or sons in the same family of artists, but only here, with the Erhart father and son, do we treat such a group as a single unit. This is because it was their collaboration on one masterpiece that established their reputation: the splendid *Altar of the Virgin* at Blaubeuren, one of the best-preserved and most spectacular winged altars in southern Germany. Michel trained in Ulm as a pupil and assistant of Jörg Syrlin, and he soon became the outstanding exponent of a characteristic Swabian style. His figures have thoughtful expressions and elongated bodies, slightly flexed at the hips—a style that can be seen in the *Virgin of Mercy*, now in Berlin but formerly in Ravensburg (ca. 1480). His first signed and dated work, the *Crucifix* for the church of Saint Michael in Schwäbisch-Hall, was made in 1490. The altar for Blaubeuren abbey, already mentioned, was made in 1493–94. Fortunately, the whole abbey church has survived, complete with its contemporary furnishings; this altar also marks the first time that father Michel handed a commission over to his son Gregor. In the last decade of the century, Gregor moved to Augsburg, a dynamic and ascendant city both commercially and culturally. There he was involved in the decoration of the Fugger chapel and soon became a leading figure in the brilliant local Renaissance scene. He also tried his hand at the nude in the *Allegory of Vanity* (Vienna, Kunsthistorisches Museum).

As often happens with German
altars, the elaborate open-work Gothic
superstructure reaches the ceiling.

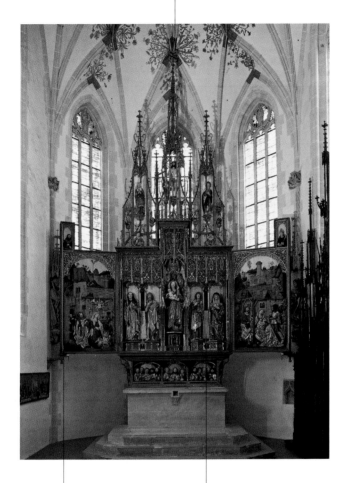

The inner shutters were painted
by Bartholomäus Zeitblom and
Bernhard Striegel with scenes
from the life of the Virgin.

Before Stoss and Riemenschneider
created their innovative models, the
shrines of German altars displayed
a regular row of figures rather than
a dynamic scene.

▲ Michel and Gregor Erhart,
Altar of the Virgin, 1493–94.
Blaubeuren (Germany), former
Benedictine monastery.

Patient documentary and critical reconstruction has revealed d'Eyck as a profoundly interesting painter and miniaturist—a figure of importance in Angevin art.

Barthélemy d'Eyck

Also known as the Master of the Aix Annunciation, and sometimes identified as the Master of the Coeur d'Amour épris, he was in France from 1447 to 1470

School
Flemish – Provençal

Principal place of residence
Provence, probably Aix

Travels
Some changes of residence, to Angers and Naples among other places

Principal works
The Annunciation Triptych (divided between Aix-en-Provence, Rotterdam, and Brussels, 1443–45)

Links with other artists
Possibly a relative of the Van Eycks; many contacts in southern France and French Naples (including Fouquet and Colantonio)

Archival documents relating to the period 1447–70 tell us that a master called Barthélemy d'Eyck was active in Angers and Naples, and then for a long period in Provence at the court of René of Anjou (count of Provence and king of Sicily). According to contemporary biographers he was one of the greatest artists of his time. However, we have no direct evidence that would allow us to identify the works of this mysterious master. A consequent debate has failed to produce unanimous agreement among critics, but the present tendency is to identify Barthélemy d'Eyck as the man responsible for some splendid anonymous paintings by artists hitherto named after their greatest works: the Master of the Aix Annunciation (this splendid triptych has been dismantled); and the Master of the Coeur d'Amour épris, responsible for the *Livre du Coeur d'Amour épris*—one of the wonders of fifteenth-century miniature painting. He may have been a relative (but probably not a brother) of Jan and Hubert van Eyck.

Characteristic of his work are the vigorous plasticity of his modeling, indicative of the influence of Claus Sluter's sculpture, and the role of

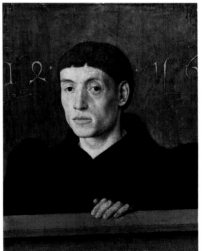

light, which unifies space and figures in a way that was to become an attribute of the Avignon school. A good example is the complex Gothic perspective into which he has inserted the *Annunciation* scene, which was originally the central part of the triptych. It remains at Aix-en-Provence.

God the Father appears on a sort of choir loft with an open-work rose window.

This is the work that defined the personality of the Master of the Aix Annunciation, who was subsequently identified as Barthélemy d'Eyck. There were originally side panels depicting the prophets Isaiah and Jeremiah, but they are now at museums in Rotterdam and Brussels, respectively.

The architectural structure is very unusual. It is rather out of proportion, but the diagonally arranged aisles of the Gothic cathedral are certainly effective.

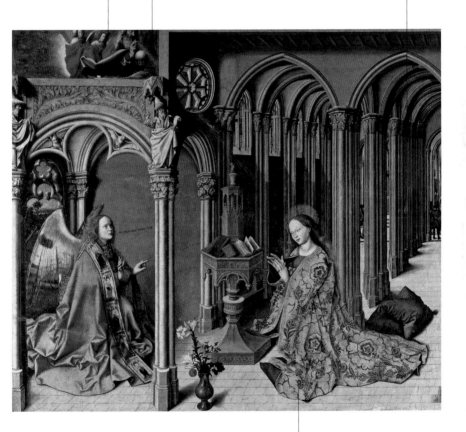

◄ Barthélemy d'Eyck, *Portrait of a Man*, 1456. Vaduz, Princes of Lichtenstein Collections.

▲ Barthélemy d'Eyck, *The Annunciation*, 1443–45. central panel of *The Annunciation Triptych*. Aix-en-Provence, church of Sainte-Marie-Madeleine.

The ample, spreading forms of the figures enable large areas of precious fabrics to be displayed, without too many folds.

Foppa is the leading Lombard artist of the late fifteenth century.
His independent style can be seen in the balance he achieves between
elements of precocious classicism and strong links with tradition.

Vincenzo Foppa

Orzinuovi (Brescia)
1427/30 – Brescia 1515/16

School
Lombard

Principal place of residence
Milan and then Brescia

Travels
Trained at Padua; various
visits to Pavia, Genoa,
Savona, and other northern
Italian towns

Principal works
Frescoes in the Portinari
chapel (Milan, Sant'
Eustorgio, 1468);
*The Martyrdom of
Saint Sebastian* (Milan,
Musei del Castello
Sforzesco, 1481)

Links with other artists
Paduan circles in his youth;
Milanese circles, including
Leonardo, Bramante, and
Bergognone

Foppa and Mantegna were fellow students in Padua. Foppa subsequently settled in Milan, where his work reflects the whole range of styles over the Sforza period. He became established as the most significant early-Renaissance painter in Lombardy. At a time when the late-Gothic taste of the court held sway in Milan, Foppa painted some very modern frescoes in the Portinari chapel in Sant'Eustorgio (1468), in which scenes of nature are skillfully arranged around complex architecture in perspective. His panel paintings and altarpieces display not only Flemish influences on the Lombard tradition but also a certain amount of humanist culture, enriched by the arrival of Bramante in Milan. However, Foppa's paintings are often suffused with pensive melancholy, which is expressed through the delicate use of chiaroscuro in faces and a range of colors that tend to be soft in tone. Foppa was also active in Pavia and Liguria, dictating style in northwest Lombardy with his gentle gracefulness and firm adherence to reality. Another characteristic of Lombard art was the subtle interpretation of emotion, always in tones of reserved yet poetic human sympathy. He was one of the few Lombard artists not to be influenced by Leonardo, and he spent the concluding part of his career in seclusion in Brescia, where he long continued to influence the local school of painting.

▶ Vincenzo Foppa, polyptych,
ca. 1480. Savona, Pinacoteca
Civica.

These chapel frescoes, commissioned by the Florentine banker Pigello Portinari, are the high point of Lombard humanist painting before the arrival of Leonardo. One of their characteristics is the careful realism of the backgrounds and landscapes.

Dramatic expressions and adherence to reality will from now on be typical features of Lombard painting.

▲ Vincenzo Foppa, *The Murder of Saint Peter Martyr*, 1468. Milan, Sant'Eustorgio, Portinari chapel.

Foppa's large, powerful figures show that he has firmly distanced himself from the detailed and ornate late-Gothic manner.

Fouquet develops a visual language that is fresh and poetic. In it he brings together the new understanding of perspective then current in Italy and the naturalistic discoveries of Flemish artists.

Jean Fouquet

Tours ca. 1420 – 1481

School
French

Principal place of residence
Tours and Paris

Travels
Visit to Italy, including residence at Florence, Naples, and Rome (1444–47)

Principal works
The Melun Diptych
(divided between Berlin and Antwerp, ca. 1450);
The Book of Hours of Étienne Chevalier
(Chantilly, Musée Condé, ca. 1455)

Links with other artists
Contact in Italy with Domenico Veneziano and Fra Angelico; links with d'Eyck

Fouquet is the most outstanding figure in fifteenth-century French painting. He trained in miniaturist circles in Paris, and throughout his career we find both panel paintings and extraordinary miniatures. Lacking documentation and works of certain attribution, it is difficult to trace his life, but we can learn something about him from the evolution of his style. A journey to Italy lasting from 1445 to 1447 culminated in a visit to Rome, where he was able to meet various artists, learn the latest rules of perspective, and also put together a repertory of classical architecture for use in his works. Works we know to have been executed before his visit to Italy are the *Portrait of King Charles VII* and the Nouans-les-Fontaines *Pietà* in central France, both of which owe a debt to Jan van Eyck's teaching and the Burgundian sculptures of Claus Sluter. During his visit to Rome he met Fra Angelico, who was then working at the Vatican: the latter's influence can be seen in Fouquet's miniatures in the *Book of Hours of Étienne Chevalier*. After his return to France, Fouquet was active in 1448 at the court of Charles VII and then at that of Louis XI, whose court painter he became in 1475. Senior state officials were among those who commissioned paintings from him, including the chancellor of France, Guillaume Jouvenel des Ursins, and the treasurer, Étienne Chevalier. Around 1450, he was commissioned by Chevalier to paint *Étienne Chevalier and His Patron Saint Stephen* (together with a *Madonna and Child*, it formed the *Melun Diptych*), and he subsequently painted some wonderful miniatures in a book of hours now at Chantilly. More splendid miniatures followed in the period 1465–70, illustrating the *Jewish Antiquities* of Josephus and the *Grandes Chroniques de France*.

The pallor of the Virgin's and the Child's ivory flesh contrasts with the bright blue and red of the angels and the decorative features of throne and crown.

This Virgin has been recognized as a portrait of Agnès Sorel, the mistress of Charles VII. Her figure has been formed in accordance with the geometric rules of humanism: her face is a perfect oval and her breast a perfect sphere.

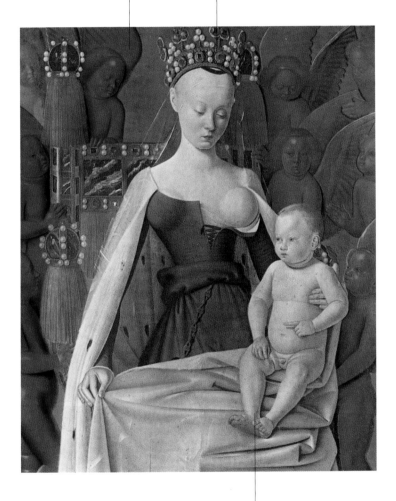

The pose and the robust plasticity of the Child show that Fouquet has been in contact with Italian art.

◄ Jean Fouquet, *Étienne Chevalier and His Patron Saint Stephen*, ca. 1450. Berlin, Gemäldegalerie.

▲ Jean Fouquet, *Madonna and Child*, ca. 1450. Antwerp, Musées Royaux des Beaux-Arts.

Today we can see that Froment's stylistic development is typical of mid-fifteenth-century art, moving from meticulous Flemish beginnings to a final stage of Provençal radiance.

Nicolas Froment

Probably Uzès ca. 1435 – Avignon 1483

School
Franco-Provençal

Principal place of residence
Avignon

Travels
Probably trained in Flanders

Principal works
The Raising of Lazarus Triptych (Florence, Uffizi, 1461); *The Burning Bush Triptych* (Aix-en-Provence, cathedral of Saint-Sauveur, 1475–76)

Links with other artists
Contacts with Bouts and Van der Weyden in his youth; links with Provençal artists

Froment served his apprenticeship in northern France, and sometime after 1468 he was called to the court of Anjou, where King René had created a cultural center of considerable vitality. Froment stood out among the artists of the Avignon school, who collectively helped invent a new language in fifteenth-century French painting. The fact that Froment's first work (*The Raising of Lazarus Triptych*, signed and dated 1461) is in the Uffizi in Florence suggests that he may have visited the city, but the style of the winged triptych suggests otherwise: its hard, tense drawing and crowds of figures with contorted faces betray strong Flemish influence. The most recent view is that he painted this triptych when traveling through Flanders with Francesco Coppini, bishop of Terni. During his residence in Provence, he often made cartoons for tapestries and stained-glass windows. *The Burning Bush Triptych*, now in Aix, is the only other large painting that can be safely attributed to him. It was commissioned by King René, perhaps along with the striking little diptych *René of Anjou and Jeanne de Laval*, now in the Louvre. Although the triptych has links with the Flemish tradition, its compositional arrangement is new and more expansive. Compared with the crowded triptych in Florence, it has a much grander setting; space has depth as well as breadth; and the figures have a more imposing presence.

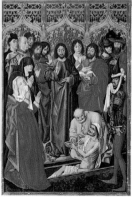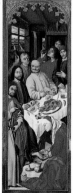

◄ Nicolas Froment, *The Raising of Lazarus Triptych*, 1461. Florence, Uffizi.

The bush burns without being consumed by the fire. Froment's interpretation accepts the Christian tradition that the burning bush foreshadows the birth of the Virgin. Hence the appearance of the Virgin and Child in the center of the bush.

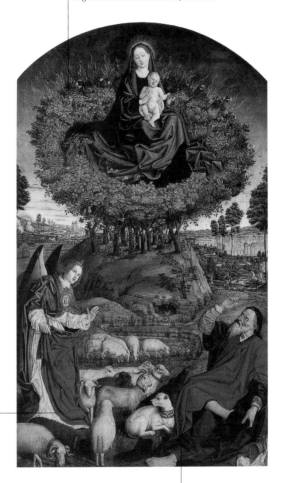

The red and white robe of the angel stands out against the green landscape and the unsuspecting sheep, and his reassuring gesture contrasts with Moses' excited wave of the hand.

The figure of Moses is dynamic and self-assured: he is shown in the act of removing his shoes before the burning bush, a symbol of divine power.

▲ Nicolas Froment, *The Burning Bush Triptych*, 1475–76. central panel. Aix-en-Provence, cathedral of Saint-Sauveur.

He is the first great painter who can really be called "Dutch," and his bequests to the late fifteenth century are his appealing warm light and a surprising smile.

Geertgen tot Sint Jans

Leiden? ca. 1460 –
Haarlem ca. 1490

School
Flemish/Dutch

Principal place of residence
Haarlem

Travels
He probably visited Bruges
and Ghent

Principal works
*The Knights of Saint John
Polyptych* at Haarlem
(dismantled and partly lost;
some panels in Vienna,
1485); *The Nativity*
(London, National
Gallery, ca. 1490)

Links with other artists
Stylistic echoes of
Van der Goe

Geertgen is an important representative of painting in the northern Low Countries. We know for certain that he trained at Haarlem in the workshop of Albert van Ouwater, but an early visit to Flanders brought him into contact with art circles in Ghent and perhaps Bruges as well. He was given the nickname "tot Sint Jans" ("of Saint John") because he lived with the order of Saint John when he was in Haarlem, working as general helper and painter. It was in 1485 that he painted his most significant work for the order: a polyptych, of which the only surviving panels are *The Lamentation* and *The Burning of the Bones of Saint John the Baptist*. Early works such as these seem to have a somewhat static arrangement, with bright colors and sharp outlines, but as time goes on one finds echoes of Hugo van der Goes, whose work Geertgen studied carefully. His

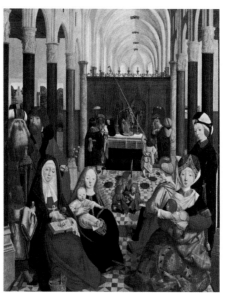

later paintings are enhanced by a more complete sense of space and movement, which accentuates his dramatic as well as his narrative effect. In particular, he becomes more emotionally involved in his paintings: his late works convey an intense sense of poetry and affection.

▶ Geertgen tot Sint Jans,
The Holy Family, ca. 1490.
Amsterdam, Rijksmuseum.

Although almost all his paintings are fairly small, Geertgen often succeeds in producing tones of pure poetry, especially in his magical manipulation of light.

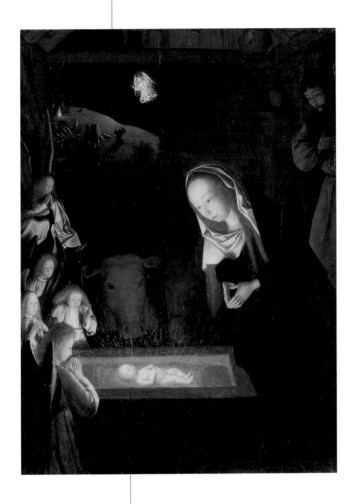

▲ Geertgen tot Sint Jans, *The Nativity*, ca. 1490. London, National Gallery.

The Child in the manger emits rays of light that reflect off the faces of the Madonna and the astonished little angels, as well as on the heads of the ox and donkey. In setting the scene in the enchanted silence of night, Geertgen provides a novel and charming interpretation of the Nativity theme.

Gentile da Fabriano's profound, poetic paintings are a fascinating and conscious expression of the transition from the late-Gothic decorative style to early humanism.

Gentile da Fabriano

Born Niccolò di Massio, also called Gentile di Niccolò; Fabriano 1370/80 – Rome 1427

School
Italian

Principal place of residence
An itinerant artist

Travels
Frequent travels to the Marches, Venice, Brescia, Florence, Siena, Orvieto, and Rome

Principal works
The Valle Romita Polyptych (Milan, Pinacoteca di Brera, ca. 1410); *The Adoration of the Magi* (Florence, Uffizi, 1423); *The Quaratesi Polyptych* (parts in various museums, 1425)

Links with other artists
He decisively influenced many local late-Gothic schools over his lifetime; his favorite pupil was Pisanello

Gentile's early training as an artist was in Umbria and the Marches, under the joint influence of Rimini and Lombardy, and he made his debut on the art scene with a masterpiece: *The Valle Romita Polyptych* (Milan, Pinacoteca di Brera). In 1408 he painted some frescoes in the Doge's Palace in Venice; now lost, they exerted an influence on mid-fifteenth-century Venetian art. He returned to the Marches after spending some time in Lombardy. Many of his principal frescoes are unfortunately now lost, but from the surviving fragments, and especially from his panel paintings, we can see that he scaled the heights of Italian painting by virtue of his exquisite taste in the use of line and his unequaled use of decorative features. In 1419 he moved his workshop to Florence. Without abandoning his personal style, and while accentuating the fabulous aspect of his figures—described with sinuous lines and clothed in dazzling costumes—he began a dialogue with early humanism. One can also

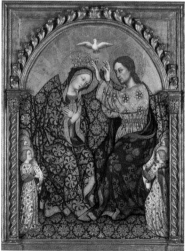

see the careful observation of antique sculpture reflected in his works. In 1423 he painted his most famous panel: *The Adoration of the Magi* for the Strozzi chapel in Santa Trìnita, now in the Uffizi. After visits to Siena and Orvieto, Gentile went to Rome in 1427 to begin decorating the church of Saint John Lateran. His death in August of that same year brought the grandiose project to a halt, but it was completed five years later by Pisanello.

▶ Gentile da Fabriano, *The Coronation of the Virgin*, ca. 1430. Los Angeles, J. Paul Getty Museum.

This sumptuous painting was commissioned
by Palla Strozzi, a wealthy Florentine banker,
for the church of Santa Trinita. It exemplifies
the extreme evolution of the gold-ground
triptych during the fifteenth century. While it
retains some general characteristics of this
type, the scene is unitary.

The chaotic and joyful
superimposition of the
figures in the entourage
of the Magi has no
regard for perspective,
though the composition
does have depth.

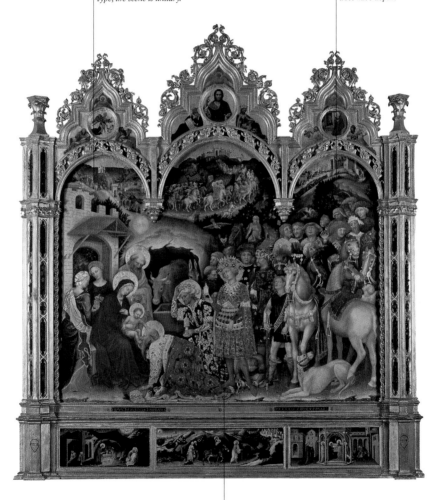

▲ Gentile da Fabriano, *The Adoration
of the Magi*, 1423. Florence, Uffizi.

The principal scene obeys the rules of late-
Gothic decoration: the Magi, for example,
are wearing luxurious clothes, and the
atmosphere of luxury reflects the taste of
the courtly world.

Ghiberti greatly expands the field of early humanist art, applying the new rules of perspective to bronze reliefs.

Lorenzo Ghiberti

Florence 1378 – 1455

School
Florentine

Principal place of residence
Florence

Travels
A visit to Pesaro in his youth, and a brief visit to Venice in 1424

Principal works
Panels for a baptismal font (Siena, baptistery, 1417–27); The "Gate of Paradise" (Florence, Museo dell'Opera del Duomo, 1425–52)

Links with other artists
He was at the center of Florentine artistic debates; a rival of Brunelleschi, he collaborated with Fra Angelico; Benozzo Gozzoli was his pupil

Ghiberti was an outstanding personality in early-fifteenth-century Florence. He excelled particularly in goldwork and bronze sculpture but also tackled monumental sculpture and cartoons for stained glass. One insufficiently stressed aspect of his output is his important treatises: the *Commentarii*, which he began in 1447, are considered the first real investigation into the history of Florentine art, a century before Vasari's *Lives of the Artists*. Thanks to his skills as a goldsmith, Ghiberti bested Brunelleschi in the competition for the second door of the Florence baptistery in 1401. He spent many years on these bronze panels, completing them only in 1423. Meanwhile, he also made statues for Orsanmichele and began the important and complex baptismal font for Siena, with gilded bronze panels in relief (the work was later completed by Donatello and Verrocchio). After a visit to Venice, he began work on the third door of the Florence baptistery (the one known as the "Gate of Paradise") in 1425, a

great masterpiece that took thirty years of dedication to complete. The ten panels were completed and mounted in 1452, and they illustrate the definitive transition from late Gothic to full, conscious humanism: he has used complex structures in perspective, and the monumentality of his images is now thoroughly classical.

▶ Sculpting by Lorenzo Ghiberti, painting by Fra Angelico, *The Linaioli Tabernacle*, 1432. Florence, Museo di San Marco.

The ten large panels on the door that Michelangelo called the "Gate of Paradise" display spectacularly original scenes in perspective. In this case, we see a grandiose circular portico stretching right into the background.

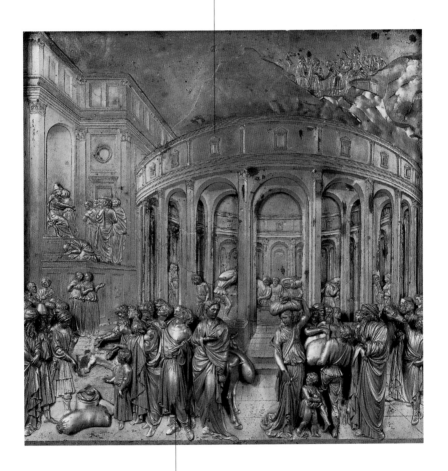

▲ Lorenzo Ghiberti, *Scene from the Life of Joseph*, panel from the "Gate of Paradise" Florence, Museo dell'Opera del Duomo.

The figures in the foreground are in such high relief that they are almost in the round. Ghiberti explores all the possibilities offered by bronze reliefs: he indulges in a great deal of gilding and detail but never loses sight of the grandeur of the whole.

Ghirlandaio is at his best when painting broadly conceived fresco cycles, and he certainly merits Vasari's description of him as "pronto, presto e facile" (ready, quick, and fluent).

Domenico Ghirlandaio

Born Domenico di
Tommaso Bigordi;
Florence 1449 – 1494

School
Florentine

Principal place of residence
Florence

Travels
To various places in
Tuscany, and to Rome
(1481–82)

Principal works
Frescoes in the chapel of
Saint Fina (San Gimignano,
collegiate church, 1475);
frescoes in the Sassetti
chapel (Florence, Santa
Trìnita, 1485); frescoes in
the Tornabuoni chapel
(Florence, Santa Maria
Novella, 1486–90)

Links with other artists
He was involved in the
Florentine school at the
highest level, together with
Perugino and Botticelli;
he was Michelangelo's
first teacher

With Ghirlandaio, fifteenth-century Florentine painting gained a pleasantly narrative dimension that was destined to become widespread, thanks partly to his efficient workshop. The nickname Ghirlandaio derives from the fact that his father specialized in *ghirlande*: the complicated garlandlike headgear worn by Florentine ladies. Ghirlandaio studied in Verrocchio's workshop, along with Perugino and Botticelli. He set up on his own in the early 1470s, under the patronage of the Vespucci family, for whom he painted a number of works in the Ognissanti church in Florence. In 1475 he was in San Gimignano to paint *Scenes from the Life of Saint Fina* in the collegiate church. In 1481 he went to Rome to paint two frescoes in the Sistine Chapel. The prestige that this commission led to other important commissions when he returned to Florence: the decoration of the Sala dei Gigli in the Palazzo Vecchio (1483), the frescoes and altarpiece in the Sassetti chapel in Santa Trìnita (1485), some sumptuous and luminous altarpieces, and a number of elegant portraits displaying almost Flemish clarity. Finally, he began work on the frescoes in the great Tornabuoni chapel that forms the main apse in Santa Maria Novella. Among the other artists working with him on this project, which was completed in 1490, was Michelangelo, just starting his career.

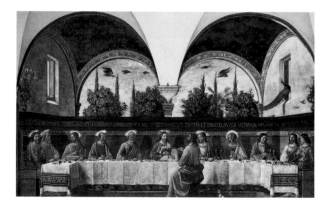

▶ Domenico Ghirlandaio, *The
Last Supper*, ca. 1480. Florence,
Ognissanti refectory.

The architectural structure is rather complicated: a richly sculpted pilaster separates the bedroom proper from a sort of atrium, from which a staircase rises to a gallery with a barrel-vaulted ceiling.

It has often been noted that Ghirlandaio has a particular skill in painting individual figures of great elegance; but by concentrating on the effect of each individual figure, the painter often risked compromising the vigor and coherence of the composition as a whole.

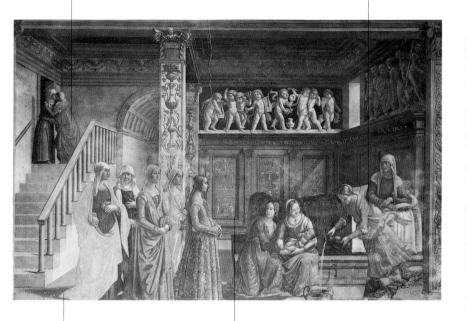

Among the group of ladies who come to visit Saint Anne, it has been possible to identify several members of the Tornabuoni family, one of the principal families in the Florentine oligarchy. The family commissioned this vast fresco cycle, on which Ghirlandaio was assisted by a number of pupils, including a very young Michelangelo.

The rich decoration of the bedroom allows Ghirlandaio to depict a luxurious domestic interior. The artist's signature is hidden in the intarsia that covers the walls.

▲ Domenico Ghirlandaio, *The Birth of the Virgin*, 1486–90. Florence, Santa Maria Novella, Tornabuoni chapel.

Benozzo Gozzoli, a successful painter of fresco cycles, does not seek to achieve innovative forms of expression, choosing a narrative and pleasantly decorative style.

Benozzo Gozzoli

Benozzo di Lese;
Florence ca. 1421 –
Pistoia 1497

School
Florentine

Principal place of residence
Florence

Travels
A great many, both to small towns in Tuscany and Umbria and to more important cities such as Rome, Orvieto, and Siena

Principal works
Montefalco frescoes (1450); frescoes in the chapel of Palazzo Medici-Riccardi (Florence, 1458); frescoes in the church of Sant'Agostino (San Gimignano, 1464–66)

Links with other artists
Collaborated with Fra Angelico

He served his apprenticeship in Ghiberti's workshop and helped him with the finishing process on the "Gate of Paradise" for the Florence baptistery, but during the 1440s he chose the career of painter in Florence, assisting Fra Angelico in San Marco and later in Rome and Orvieto. In 1450 he was at Montefalco in Umbria, where he painted important frescoes in the churches of San Fortunato and San Francesco. After visiting Rome and painting other works in Lazio and Umbria, he was commissioned by the Medici in 1458 to decorate their private chapel in the Medici palace in Florence. The result was the magnificent *Procession of the Magi,* in which various members of the Medici family are portrayed. There is a clear difference in quality between Benozzo's panel paintings and his vivacious frescoes—the technique he preferred. From 1464 to 1466 he was at San Gimignano, where he painted splendid frescoes in the collegiate church and that of Sant'Agostino. His *Stories from the Old Testament* in the Camposanto at Pisa (1468–84) were unfortunately largely lost to bombing. After carrying out a series of works in Florence and elsewhere in Tuscany, he died in the 1497 plague epidemic.

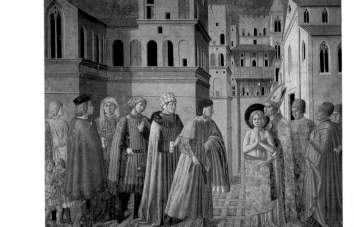

▶ Benozzo Gozzoli, *Saint Francis Returns His Clothes to His Father,* 1450. Montefalco (Perugia), Pinacoteca Comunale, former church of San Francesco.

*The frescoes cover the side walls of the chapel.
At the time there was a Nativity by Filippo
Lippi on the altar (now in Berlin). In the upper
part of the scenes, the figures in the splendid
entourage of the Magi wind their way through
fairy-tale landscapes, with castles, villages,
rocks, trees, and animals, against a background
of blue skies and passing clouds.*

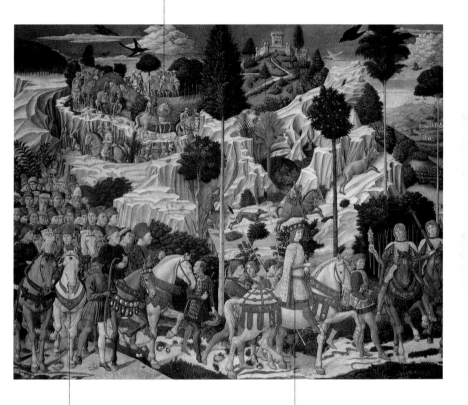

*In some parts of the painting Benozzo
crowds a great many figures into a small
space, creating an effect similar to that in
the late-Gothic Adoration of the Magi
painted in Florence a quarter of a century
earlier by Gentile da Fabriano.*

*The dazzling colors emphasize the
rich costumes and refined details.
Many of the principal figures are
members of the Medici family.*

▲ Benozzo Gozzoli, *The Procession
of the Magi* (detail), 1458. Florence,
Palazzo Medici-Riccardi, chapel.

Although an acute observer of real life, this Catalan master persists in using the spectacular old-fashioned technique of tempera painting on a gold ground.

Jaume Huguet

Valls (Tarragona) 1414 –
Barcelona 1492

School
Catalan-Aragonese

Principal place of residence
Barcelona

Travels
None known

Principal works
The Saint Abdon and Saint Sennen Retable (Tarrasa, Santa Maria, 1458–61)

Links with other artists
Bartolomé Bermejo and other Catalan artists

After training at Barcelona under the influence of French art, Huguet spent his early active years in the provinces of Aragon, and especially at Saragossa. In 1448 he returned to Catalonia and settled in Barcelona, where he married in 1454 and was active as an artist until 1487. *The Saint Abdon and Saint Sennen Retable* (Tarrasa, Santa Maria), painted between 1458 and 1461, is the best of many polyptychs produced by Huguet and his prolific workshop, especially because of its delicate melancholy and the intensely expressive figures of the two saints. His later works involved a greater contribution from his assistants, outstanding among whom were several members of the Vergós family. The glittering brocades and jewels, the heavy gold grounds, the scintillating ribbons of scrolls, and the jeweled borders intensify the emphatically decorative element in a typically Aragonese way. Huguet's style spread widely in the vast Aragon region, in Catalonia, and even in Corsica and Sardinia, where the use of gilded retables continued well into the sixteenth century. After these achievements, however, the Barcelona school lacked a second generation of artists to carry forward its work. On the threshold of the Renaissance it went into a long period of obscurity and silence.

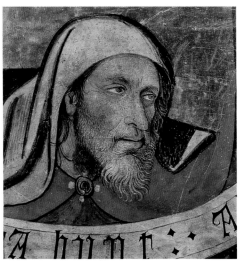

▶ Jaume Huguet, *Head of a Prophet* (detail), 1457. Madrid, Prado.

This panel is one of the masterpieces of late-fifteenth-century Spanish painting. It is the central and most refined part of an enormous retable painted for the Augustinians by Huguet and his workshop assistants over a number of years.

The intensity and concentration of the figures has suggested possible contact with the great and still rather obscure Portuguese portraitist Nuño Gonçalves.

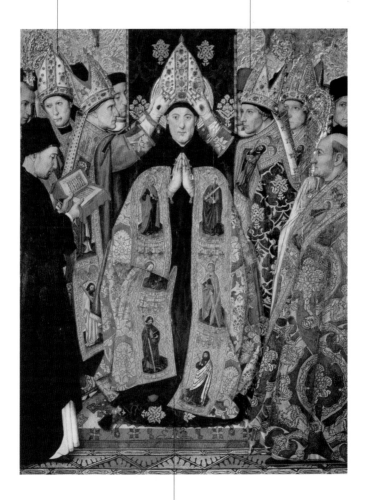

▲ Jaume Huguet, *The Consecration of Saint Augustine*, 1465–80. Barcelona, Museo Nacional de Arte de Catalunya.

The figure of Augustine—Huguet has given him a slight smile—has a wonderful frontality that reminds us of Bermejo's Saint Dominic *at the Prado.*

In the late fifteenth century, Juan de Flandes acted as a perfect link between the cultures of Flanders and Spain.

Juan de Flandes

Ghent? ca. 1450 –
Palencia 1519

School
Flemish-Spanish

Principal place of residence
Spain, and especially
Castile

Travels
There is documentary
evidence of various
journeys within Spain

Principal works
Polyptych for the
Carthusian monastery
at Miraflores (now
divided among various
museums, 1496)

Links with other artists
He was probably a pupil
of Justus of Ghent

Juan de Flandes was of Flemish origin. He came to Spain via Italy, where he had presumably gone in the entourage of Justus of Ghent. In 1496 he entered the service of Queen Isabella the Catholic, who very much supported the spread of Flemish art. He painted *Scenes from the Life of Christ* on a retable for her. This polyptych originally consisted of forty-six panels, but it has been dismantled and only twenty-seven panels survive. As court painter he made portraits of Joanna the Mad and Philip the Handsome at the time of their marriage agreement, which was intended to unify the crowns of Spain and Austria in a single Habsburg empire. When Isabella died in 1504, Juan de Flandes made a brief visit to Salamanca, where he painted the *Altar of Saint Michael* in the cloister of the old cathedral and also the high altar in the university chapel. Thereafter he moved to Palencia, where he worked until 1519. Characteristic of his work is the meticulous attention to detail, typical of the Flemish tradition, together with a delicate sensitivity to light and color. These qualities are particularly noticeable in his religious iconography and led to the creation of a delightful series of episodes from the Gospels, in which he shows considerable compositional inventiveness as well as a poetic quality.

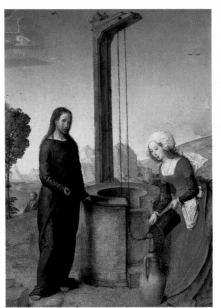

► Juan de Flandes, *Christ and the Woman of Samaria*, ca. 1496. Madrid, Prado.

Like the frame, the painting itself reflects the taste for the ornate that persisted in Spain until the end of the fifteenth century.

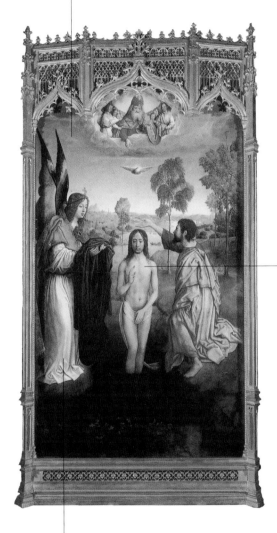

The slender, elegant nude figure is reminiscent of Memling, but the artist's concise narrative is what is most striking.

▲ Juan de Flandes, *The Baptism of Christ*, 1496–99. Madrid, Juan Abelló Collection.

The scene is arranged in a simple, effective way, with large, monumental figures standing out against the landscape. The angel in particular echoes Flemish models, while the luminosity of the natural environment shows that the artist is aware of the latest trends.

The importance of Justus is not diminished by the fact that few of his works are documented. He acts as a link between the Flemish school, the international art circle of Urbino, and Spain.

Justus of Ghent

Also called Joost van Wassenhove; known from 1460 to 1475

School
Flemish

Principal place of residence
Ghent

Travels
Long visit to Urbino

Principal works
Triptych of the Crucifixion (Ghent, cathedral of Saint-Bavon, ca. 1470); *The Communion of the Apostles* (Urbino, Ducal Palace, Galleria Nazionale delle Marche, 1473–74)

Links with other artists
Van der Goes at Ghent; Piero della Francesca, Pedro Berruguete, and Paolo Uccello at Urbino

We have little information about Justus, though he perfectly exemplifies the synthesis of ideas from the two principal fifteenth-century schools of painting: the Flemish and the Italian. He came from the Antwerp area and spent the years of his training and early activity at Ghent, working with Hugo van der Goes and deriving from the city the nickname by which he is usually identified. His early paintings display a broad-based artistic culture, including a sound knowledge of the Flemish masters of the first half of the century. The city of Ghent still has his chief work from before his move to Italy: the *Triptych of the Crucifixion* in the cathedral of Saint-Bavon, which fortunately escaped destruction during the late-sixteenth-century iconoclasm. In 1471, Justus went to Italy, where he was engaged by Duke Federico da Montefeltro on the decoration of the Ducal Palace at Urbino. He applied the rules of perspective, as set out by Alberti and Piero della Francesca, in an experimental way in his large panel *The Communion of the Apostles* (the predella was painted by Paolo Uccello) and collaborated with Berruguete on the *Illustrious Men* busts for the duke's study. These paintings were to have an interesting effect on Urbano artist Donato Bramante, whose works seem to reflect both Spanish and Flemish precedents.

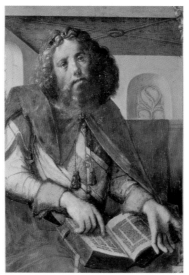

▶ Justus of Ghent, *Plato*, ca. 1475. Paris, Louvre.

An architectural setting like this—an ambulatory with tall columns—is more commonly found in Flanders than in Italy, and the draperies of the flying angels also accord with northern convention. But the overall composition of the scene obeys the rules of humanist perspective.

Duke Federico da Montefeltro observes the scene and discusses it with some of his counselors.

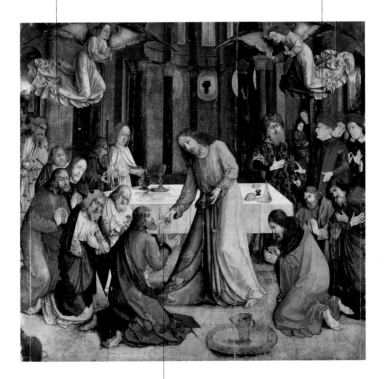

▲ Justus of Ghent, *The Institution of the Eucharist* (or *The Communion of the Apostles*), 1473–74. Urbino, Galleria Nazionale delle Marche.

Of the various moments in the Last Supper, Justus chooses to depict the one that has the greatest religious import, namely Christ distributing the broken bread to the apostles and so instituting the sacrament of the Eucharist ("Take, eat"). The panel originally had a predella painted by Paolo Uccello, now preserved separately at Urbino, which depicts the profanation of the Host by a Jewish family.

Though often seen as an unsurpassable master, endowed with almost superhuman qualities, Leonardo is in fact an artist and thinker rooted in the historical and cultural reality of his time.

Leonardo da Vinci

Vinci (Florence) 1452 –
Cloux (Amboise) 1519

School
Florentine, then
substantially independent

Principal place of residence
Florence, Milan, and
finally Amboise

Travels
In addition to the cities
where he took up
residence, brief visits to
Mantua, Venice, and Rome

Principal works
Virgin of the Rocks
(Paris, Louvre, 1483);
The Last Supper (Milan,
Santa Marie delle
Grazie, 1494–98);
Mona Lisa (Paris,
Louvre, 1504–13)

Links with other artists
Verrocchio, Botticelli, and
Perugino in Florence;
Foppa and Bramante in
Milan; Raphael and
Michelangelo during his
second period in Florence

Leonardo was a uniquely polyvalent artist. He reached the highest levels in contemporary painting but was also an inventor and engineer, a designer of machines and installations, and at the same time a precursor in many fields of speculation and scientific research. Thanks to his supreme intellectual control, all these activities were carried on without internal contradictions: indeed, they enriched one another. At the pinnacle of his achievements is his painting. His artistic training took place in Florence in the multifarious workshop of Verrocchio, where he acquired all the essential artistic techniques, especially through the medium of drawing. From the beginning of his career, he showed a predilection for portraiture and the study of nature. In 1482, at the age of thirty, he left Florence for the court of Ludovico il Moro in Milan, where he was to spend much of his career. During his early Milanese period he painted, among other things, the *Virgin of the Rocks* (Paris, Louvre, begun in 1483) and *The Last Supper* (1494–98). He fled Milan on the arrival of French soldiers, visiting Mantua and Venice. Then he returned to Florence, where he began painting the *Mona Lisa* and continued his technological, geographical, and scientific studies. He returned to Milan in 1506, where he completed his *Madonna and Saint Anne*, now in the Louvre. In 1513, he accepted an invitation from Francis I of France and moved to Amboise.

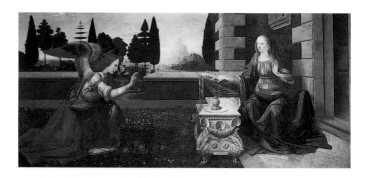

► Leonardo da Vinci, *The Annunciation*, ca. 1474. Florence, Uffizi.

The paint is applied in strikingly different ways: some parts, such as the costume, are barely sketched, whereas others, such as the extraordinary curly hair, display a meticulous attention to the most subtle effects of light.

The portrait corresponds exactly to suggestions written by Leonardo himself: the figure is placed in a dark room and invited to turn his head and eyes toward a source of light on the right.

▲ Leonardo da Vinci, *Portrait of a Musician*, 1485–90. Milan, Pinacoteca Ambrosiana.

The musical score has made it possible to identify the sitter as a musician, at a time when Milan was one of the most important musical centers in Europe. He is probably either Franchino Gaffurio, a composer, writer of treatises, and conductor of the cathedral choir, or else Josquin des Prez, the Flemish musician who was chapel-master to the Sforza dukes.

Leonardo da Vinci

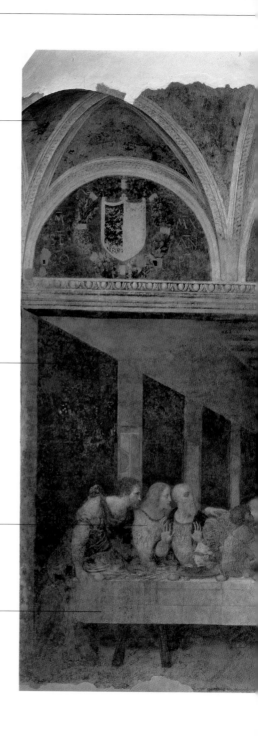

This painting is on the north wall of the refectory. Leonardo did not use the usual fresco technique, but attempted to paint on dry plaster in an experimental—and unsuccessful—method. He has painted the coats of arms of the Sforza family in the lunettes at the top.

By means of an astonishing perspectival device, Leonardo has apparently doubled the size of the room. In placing all the figures on the far side of the table, he is abandoning the normal Florentine convention of isolating Judas on the near side (see the corresponding paintings by Andrea del Castagno and Ghirlandaio).

At the center of the composition is the melancholy but calm figure of Christ, with a brightly lit window in the background behind him. The apostles are arranged symmetrically around him in four groups of three. The figures are larger than life size.

Thanks to a lengthy and very careful restoration carried out a few years ago, it is now possible to appreciate the details of the still life on the table: dishes, food, and an embroidered tablecloth.

▶ Leonardo da Vinci, *The Last Supper*, 1494–98. Milan, refectory of Santa Maria delle Grazie.

The wonderful miniatures by the Limbourg brothers are typical examples of the enchanted world of the late-Gothic courts, with turreted castles rising out of busy farming landscapes.

The Limbourg Brothers

Pol, Jehannequin, and
Herman Malouel;
Nijmegen, late fourteenth
century – Dijon 1416

School
Flemish-Burgundian

Principal place of residence
Dijon and Berry

Travels
They trained in Paris

Principal works
Cycle of miniatures for the
*Très Riches Heures du duc
de Berry* (Chantilly, Musée
Condé, 1413–16)

Links with other artists
Jean Malouel (their uncle);
links with Burgundian art,
and influence on the
principal miniaturists of
the early fifteenth century,
including d'Eyck

The work of the three Limbourg brothers in France in the early fifteenth century brought about a revolution in the art of the miniature. They trained in Paris in the workshop of a goldsmith under the care of their uncle, Jean Malouel, an established painter. Around 1402 they were in the service of Philip the Bold, duke of Burgundy, and after his death they were active at the court of Jean de Berry. It is likely that the most skillful of the three was Pol, who became close to the duke and was appointed valet de chambre. The earliest works of the Limbourgs were a Bible (now in Paris), which they illuminated in 1402 for Philip the Bold, and the *Belles Heures* (in New York). Although they remain tied to the French calligraphic tradition, they display a sound knowledge of the latest Flemish and Italian artistic ideas. But it is in the great, full-page miniatures of the *Très Riches Heures*, begun in 1413 for the duc de Berry, that their extraordinary talent is best seen—especially in the pages of the months, where peasants busy at their work and noblemen standing stiffly in attitudes of courtly abstraction enliven the largest landscapes ever painted in miniature. In this way, the repertory of images they created was to remain an established reference point for Franco-Flemish illuminated books of hours throughout the fifteenth century. All three brothers probably died in the plague epidemic that struck Dijon in 1416.

▶ Herman de Limbourg,
The Raising of Lazarus,
1413–16, illuminated page
from the *Très Riches Heures
du duc de Berry*. Chantilly,
Musée Condé.

The most famous miniatures in the codex are the twelve large illustrations of the months. The codex was commissioned by Jean de Berry and made by the three Limbourg brothers, with Pol, the most skillful of the three, rather more productive than the others. In the tympanum is a semicircular astrological band showing the appropriate signs of the zodiac and the constellations of each month.

In the background of each miniature we see one of the duke's residences— in this case, Poitiers castle.

In accordance with late-medieval tradition, each month is represented by the corresponding agricultural tasks, all depicted with lively realism. July is the month for reaping grain and shearing sheep.

▲ Pol de Limbourg, *July*, 1413–16, illuminated page from the *Très Riches Heures du duc de Berry*. Chantilly, Musée Condé.

Filippino provides us with a perfect cross section of late-fifteenth-century Florentine art: from the age of equilibrium and pure line to passionate tensions at the threshold of the new century.

Filippino Lippi

Prato ca. 1457 –
Florence 1504

School
Tuscan

Principal place of residence
Florence

Travels
To Spoleto with his father
(1467–69); residence in
Rome (1488–93)

Principal works
*The Vision of Saint
Bernard* (Florence, Badia,
1486); frescoes in the
Caraffa chapel (Rome,
Santa Maria sopra
Minerva, ca. 1490);
frescoes in the Strozzi
chapel (Florence,
Santa Maria Novella,
1497–1502)

Links with other artists
He was a pupil of his
father, Filippo Lippi, and
subsequently collaborated
closely with Botticelli

Being the child of Brother Filippo Lippi and Sister Lucrezia Buti, Filippino was something of an embarrassment, but he was also a child prodigy and helped his father from a very young age. He was scarcely twelve when his father died, but he was already able to complete his father's frescoes in Spoleto cathedral and to assist Botticelli immediately afterward in what proved to be a long period of fruitful collaboration. In those early works of certain attribution, we find a restless sweetness, developed in parallel with the sinuous rhythms of thoroughly controlled drawing. His career as an independent artist developed substantially in Florence in the early 1480s, when he completed the frescoes begun by Masaccio and Masolino in the Brancacci chapel (ca. 1485) and also painted portraits and memorable altarpieces. Thanks to the influence of Lorenzo the Magnificent, he was called to Rome in 1488 to paint frescoes in the Caraffa chapel in Santa Maria sopra Minerva. Filippino now found himself in the midst of a classical revival linked to new discoveries of Roman remains. He developed a very personal style that was eccentric and substantially anticlassical, as he made intellectual play of his eclectic and encyclopedic knowledge of ancient sculpture and ornamentation. When he returned to Florence, his paintings reflected the crisis of humanism resulting from the death of Lorenzo (1492) and the sermons of Savonarola. His painting became bizarre and fantastical, foreshadowing the birth of mannerism.

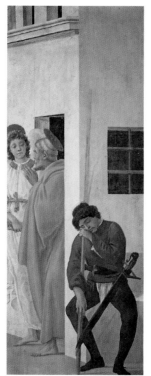

▶ Filippino Lippi, *The Freeing of Saint Peter*, ca. 1485. Florence, Santa Maria del Carmine, Brancacci chapel.

Filippino uses strongly
expressive effects in
the figures of the
onlookers poisoned by
the dragon's breath.

The temple altar is an amazing product
of Filippino's imagination: inanimate
objects—the ornamentation, statues,
and votive offerings—seem to possess
an independent and restless vitality.

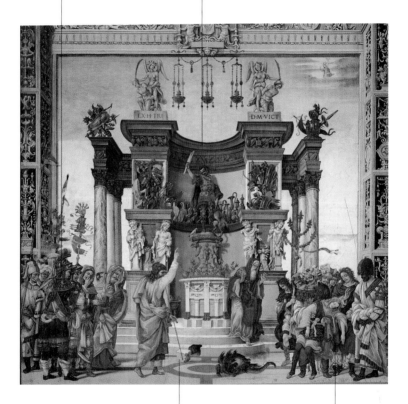

The broken temple step where the
dragon was hiding can almost be
read as a symbol of the breakdown
of religious confidence at the
threshold of the sixteenth century.

▲ Filippino Lippi, *Saint Philip
Defeating the Dragon of Hierapolis*,
1497–1502. Florence, Santa Maria
Novella, Strozzi chapel.

The fresco illustrates a little-known
episode in the life of the apostle Philip,
set down in the Golden Legend, *in
which he defeated and rendered
harmless a dragon that had been hiding
inside a temple. The stench of its breath
was so poisonous that it stupefied and
even killed a number of people,
including the son of a priest.*

In mid-fifteenth-century Florence, Filippo Lippi gives his paintings substantial realism, placing his figures in real, recognizable architectural and urban settings.

Filippo Lippi

Florence ca. 1406 –
Spoleto 1469

School
Florentine

Principal place of residence
Florence

Travels
Padua (1434), Prato during
the 1450s, and Spoleto
(1467–69)

Principal works
*The Coronation of the
Virgin* (Florence, Uffizi,
1441–47); frescoes in the
cathedrals of Prato (from
1442 onward) and
Spoleto (1467–69)

Links with other artists
Masaccio and then
Fra Angelico in his youth;
Florentine art circles in
general; during his last
years he supervised the
development of his son,
Filippino, and Sandro
Botticelli

Filippo Lippi appeared on the Florentine art scene at the beginning of the 1430s, and his work provides a link between Masaccio and Botticelli. His earliest paintings were his frescoes in the Carmine convent, where he had taken vows some years before. During a visit to Padua in 1434, and perhaps to Flanders, Filippo broadened and softened his style. He became an artist of moment on the Florentine scene and in 1441 began his monumental *Coronation of the Virgin* (now in the Uffizi), followed by numerous altarpieces. These follow the rules of perspective as adopted by Domenico Veneziano, but always with a delicate realism of detail and expression that impressed even Leonardo. He painted certain subjects, such as the Madonna and Child and the Nativity, a number of times, and these works were a constant source of inspiration to a whole generation of Florentine artists. Now that he was supported by a well-organized workshop, Filippo Lippi moved to Prato, where he painted the spectacular frescoes in the cathedral choir and other works. It was during his long residence in Prato that his affair with Lucrezia Buti, a nun, caused a scandal and led to the birth of his son, Filippino. When he returned to Florence, Filippo obtained some very prestigious commissions, such as the *Nativity* for the chapel of the Magi in Palazzo Medici (now in Berlin). And it was also a Medici commission that led to his beginning his last work, the frescoes in the choir of Spoleto cathedral.

▶ Filippo Lippi, *The
Coronation of the
Virgin*, 1466–69.
Spoleto, cathedral.

Plain walls run along the sides of the painting to emphasize the central perspective.

Since the painting was intended for a convent of cloistered nuns, Filippo Lippi has painted a series of rooms surrounding an enclosed garden— an allusion to the special purity of the Virgin's life.

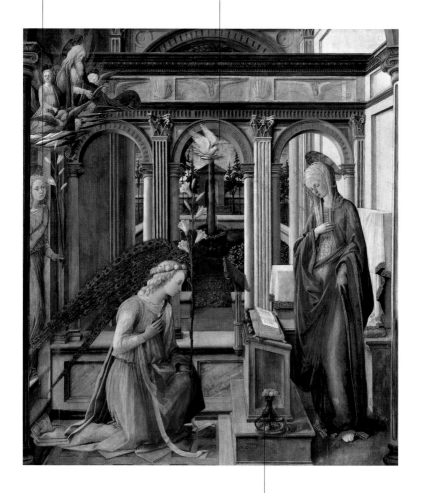

▲ Filippo Lippi, *The Annunciation,* ca. 1450. Munich, Alte Pinakothek.

Although this is a grandiose and synthetic composition, Filippo has included some lovely descriptive details.

Lochner is the most representative figure of the Cologne art scene. He was open to new ideas from both Flanders and Italy and adopted what is known as the "soft style."

Stephan Lochner

Meersburg ca. 1400 –
Cologne 1451

School
German

Principal place of residence
Cologne

Travels
None documented, but he
may well have trained in
Flanders

Principal works
The Last Judgment
(Cologne, Wallraf-Richartz
Museum, ca. 1440);
*The Patron Saints of
Cologne Altarpiece*
(Cologne cathedral,
1440–45)

Links with other artists
Influenced by Flemish
masters; contacts with all
the principal artists in the
Rhineland

He was born and grew up near Lake Constance. In his youth he very probably journeyed to the Low Countries, where he must have seen the works of Jan van Eyck and Robert Campin. That makes him one of the first German painters to undertake the *Wanderjähre* ("years of travel"), whose purpose was to gain personal knowledge of the most advanced art circles. He moved to Cologne around 1437 and became a figure of importance in the flourishing local school of painting. In 1447 he became a member of the city council, the most prestigious and broadly representative body in Cologne. Lochner is the most typical exponent of the "soft style" in the Rhineland, as one can see from the way he paints Virgins with thin, oval faces and elegant, measured gestures. While the history of German art reveals a constant search for intensity of expression, Lochner always manages to avoid unnatural or grotesque exaggeration, preferring a smooth and sweetly poetic style. In his masterly *Patron Saints of Cologne Altarpiece* in Cologne cathedral, the use of a gold ground and the detailed depiction of fabrics and jewels reflect the aristocratic tastes of its patron, but Lochner blends these traditional features with Flemish qualities: a careful description of his figures and an attention to natural reality. In this way he creates a harmonious and personal style that was to be admired by Albrecht Dürer himself.

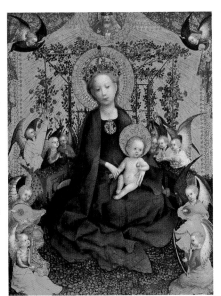

▶ Stephan Lochner, *Madonna of the Rose Bower*, ca. 1440. Cologne, Wallraf-Richartz Museum.

At the center of the composition is the gesture of Christ separating the souls, but he also seems to be turning to listen to Mary's intercession. In a way that is characteristic of Rhineland art, Lochner is trying not to stress evil, sin, and the demonic, but rather to emphasize divine benevolence, as Fra Angelico was doing in Italy in these same years.

The souls of the blessed swarm toward the gates of paradise, where a busy Saint Peter greets them.

In the struggle between the angel and the devil, it is the angel who prevails, and so the soul is saved.

One can easily identify the fat bodies of the gluttonous among the damned souls being dragged away to hell.

▲ Stephan Lochner, *The Last Judgment*, ca. 1440. Cologne, Wallraf-Richartz Museum.

Mantegna is a leading proponent of humanist culture in northern Italy. He brings about profound stylistic changes in both religious and secular painting, thanks to his thorough reappraisal of classical art.

Andrea Mantegna

Isola di Carturo (Padua)
1431 – Mantua 1506

School
Veneto-Lombard

Principal place of residence
Padua, and then Mantua

Travels
Visits to Tuscany
(1466–67) and Rome
(1488–90)

Principal works
The San Zeno Triptych
(Verona, San Zeno, 1458);
frescoes in the Camera
degli Sposi (Mantua, Ducal
Palace, 1465–74); *The
Madonna of Victory* (Paris,
Louvre, 1495); *The Dead
Christ* (Milan, Pinacoteca
di Brera, ca. 1500)

Links with other artists
Paduan art circles,
including Donatello,
as a young man;
brother-in-law of
Giovanni Bellini

▶ Andrea Mantegna, *Saint
George*, 1467. Venice,
Gallerie dell'Accademia.

Mantegna was a pupil of Francesco Squarcione in Padua, but he was aware of the work of Donatello and the other great Tuscan artists who were active there. He began his career as a very young man by painting frescoes in the Eremitani church in Padua shortly after the midcentury. His triptych (1458) for the high altar in the church of San Zeno in Verona clearly establishes the characteristics of his art: figures of monumental plasticity in an architectural setting to which he has applied the latest rules of perspective. His relationship with Giovanni Bellini dates to about this time. In 1460 Mantegna became court painter to the Gonzaga family and thereafter left Mantua only for a few visits to Tuscany and Rome. The masterpiece that defines his long period of activity in Mantua is the famous Camera degli Sposi in the Ducal Palace (1465–74). In its conception and virtuoso execution it is a revolutionary work. As a keen collector and student of antiquities, Mantegna persisted in seeking a form of expression comparable to that of classical art, and he sometimes chose classical subjects, such as the great tempera paintings of the *Triumphs of Caesar* (Hampton Court, Royal Collections, 1480). The elevated tone of these compositions recurs in his altarpieces, such as the *Madonna of Victory*. In 1497 he began the extremely refined decoration of Isabella Gonzaga's study, adopting a complex humanist program and he was also responsible for two mythological compositions, both of which are now in the Louvre. In the final stage of his career, he also experimented with engraving.

In the top left-hand corner are three faces bathed in tears. Their expressively contorted features derive from the masks of classical tragedy.

This is a highly experimental work, both technically (it is one of the rare paintings of the period on canvas) and in terms of its composition, which depends on an invasive, obsessive, steeply angled perspectival arrangement.

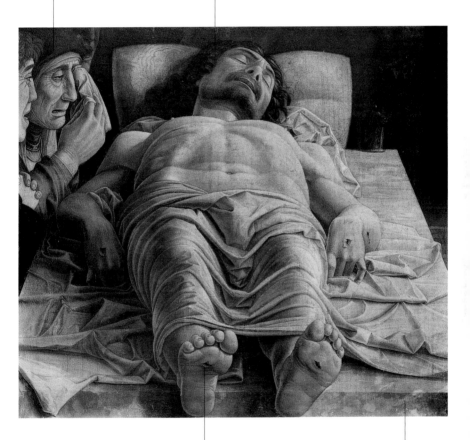

Christ's wounds are vividly portrayed, while the painting as a whole is done almost entirely in earthy, pinkish gray monochrome.

Christ's body is laid out on a stark marble table in a dark mortuary. The cold immobility of death is rendered with a pitiless attention to detail. Mantegna insists on intense, harsh, implacable drawing, with no concession to the soft tones that were becoming widespread in early-fifteenth-century painting in the Veneto.

▲ Andrea Mantegna, *The Dead Christ*, ca. 1500. Milan, Pinacoteca di Brera.

Masaccio is the first to apply to painting the new understanding of perspective, thereby giving the Florentine school a bridge between Giotto and the High Renaissance.

Masaccio

Born Tommaso di ser Giovanni di Mone Cassai; San Giovanni Valdarno (Arezzo) 1401 – Rome 1428

School
Florentine

Principal place of residence
Florence

Travels
A few short visits in Tuscany; final journey to Rome

Principal works
Frescoes in the Brancacci chapel (Florence, Santa Maria del Carmine, 1424–25); *The Trinity* (Florence, Santa Maria Novella, ca. 1427)

Links with other artists
Collaboration with Masolino da Panicale; constant contact with Brunelleschi and Donatello; influenced all the Tuscan Renaissance artists up to Michelangelo

In the history of art no other painter has died so young (age 27) and yet left so profound a heritage of innovation as Masaccio. He began his career in the provinces, painting a triptych in the church of San Giovenale at Cascia di Reggello (1422) and then developed as an artist in Florence in close collaboration with Masolino. Together they painted the *Madonna and Child with Saint Anne* in the Uffizi (1424) and began a fresco cycle in the Brancacci chapel in Santa Maria del Carmine, which was destined to change the course of the history of painting. Masaccio concentrated on the expressive power of his figures, which are solidly placed in urban or landscape settings. These qualities were confirmed when he worked on his own, as in the great polyptych with a gold ground in the Carmelite church in Pisa (1426; the panels are now divided among various museums) and the impressive fresco of the *Trinity* in Santa Maria Novella in Florence (ca. 1427). It is thought that Brunelleschi was directly involved in the spectacular architectural perspective seen in the latter work. It becomes increasingly clear in these works that Masaccio wanted to abandon the seductively decorative features of late Gothic once and for all and to substitute close concentration on human figures and their role in time and space. In late 1427, Masolino and Masaccio collaborated again on a series of commissions in Rome. Masaccio died shortly afterward, in circumstances that are unclear.

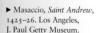

▶ Masaccio, *Saint Andrew*, 1425–26. Los Angeles, J. Paul Getty Museum.

The polyptych retains the traditional gold ground, but Masaccio's development of the solid volumes of the figures is modern.

Like the painting on page 312, this panel was part of a polyptych intended for Pisa but now divided among various museums around the world. The Crucifixion was at the top, which explains why the body of Christ is foreshortened.

The most impressive figure is Mary Magdalene, who is kneeling at the foot of the cross. The intense red mass of her robe conveys her powerful emotion, even though we do not see her face.

▲ Masaccio, *The Crucifixion*, 1425–26. Naples, Capodimonte.

Masaccio

On Christ's instructions, Peter lands a fish. Inside it he finds a coin to pay the tribute (Matthew 17:27). The landscape is rough and bare, so that attention is concentrated on the figures.

The rough, bulky, rudimentary volumes of the apostles are arranged around Christ to form what has been described as "a Colosseum of men."

▲ Masaccio, *The Tribute Money*, 1424–25. Florence, Santa Maria del Carmine, Brancacci chapel.

The figure of Christ stands at the center of the composition. The fresco illustrates three different moments in the story: in the center the apostles are asking Christ how they are to pay the tribute; on the left Peter lands a fish from the lake; and on the right Peter is paying the tribute with the coin found in the fish.

Using a fair measure of imagination,
scholars have tried in the past to find
Masaccio's own features among those
of the apostles, but the identification
is far from certain.

Landscape, figures, and architecture are
all subjected to a process of geometrical
simplification, which draws attention to
volume and renounces the dispersive
effects of decoration.

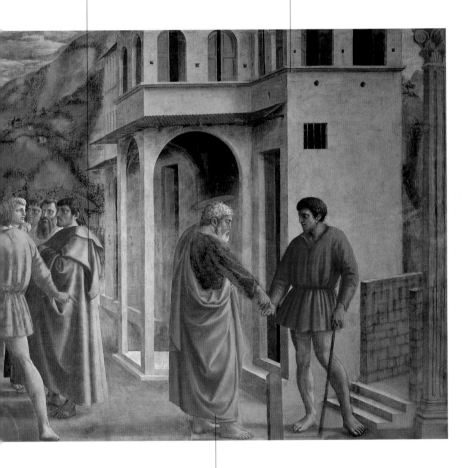

Saint Peter, seen here in the act of handing
the tax to the collector, is the protagonist of
the whole fresco cycle in the Brancacci
chapel. In this scene, which is thematically
the most important of all, he appears three
times, at three different moments in the story.

Masolino is Ghiberti's pupil and Masaccio's teacher, with important works in Florence, Lombardy, Umbria, and Rome. He is an artist of central importance in the early fifteenth century.

Masolino da Panicale

Also called Tommaso di Cristofano Fini; Panicale in Valdelsa 1383 – Florence 1440

School
Florentine

Principal place of residence
Florence, but with long visits elsewhere

Travels
Hungary (1425); Rome (between 1425 and 1428); Umbria (1432); Castiglione Olona (1435)

Principal works
Frescoes in the chapel of Santa Caterina (Rome, San Clemente, 1428); frescoes in the collegiate church and baptistery at Castiglione Olona (1435)

Links with other artists
Although he collaborated closely with Masaccio, his work really belongs in the Florentine artistic current from Ghiberti to Domenico Veneziano

With his subtle sensitivity and innate classical grace, Masolino succeeded in marrying the narrative and naturalistic qualities of late Gothic with the conquest of perspective, bathing his scenes in warm light and delicate colors. He appeared on the Tuscan art scene in the early 1420s with works in Florence and Empoli. The 1424 *Madonna and Child with Saint Anne* marks the beginning of his collaboration with Masaccio, which reached its peak in the Brancacci chapel in Santa Maria del Carmine. In 1425 he interrupted his work in Florence in order to go to Hungary in the entourage of Cardinal Branda Castiglioni. The cardinal invited him to Rome in 1428 to paint his private chapel in San Clemente with the fresco *Scenes from the Life of Saint Catherine of Alexandria*. Masolino was responsible for some important panels during these years in Rome, and in 1432 he painted a delightful fresco of the Madonna and Child for the church of San Fortunato at Todi. In 1435, he was called upon again by Cardinal Castiglioni and so moved to Castiglione Olona in Lombardy. He and other important Tuscan artists painted frescoes in the choir of the collegiate church there, as well as in some rooms in the cardinal's palace and, above all, in the spectacular interior of the baptistery. Masolino died in Florence on October 18, 1440.

The typical tilt of the Madonna's head is reminiscent of late-Gothic wood sculptures. In fact, the painting as a whole harks back to the late fourteenth century, but its luminosity and choice of colors are new.

The Christ child's very human gesture as he takes milk at Mary's breast is typical of Tuscan piety. Note also the realistic detail of the Madonna squeezing her breast with her right hand.

The title of the painting derives from the fact that Mary is seated on a cushion on the floor rather than on a throne.

◄ Masolino, *Imaginary View of Hungary* (detail), 1435. Castiglione Olona (Varese), Museo di Palazzo Brandi Castiglioni.

▲ Masolino, *The Madonna of Humility*, 1415–20. Florence, Uffizi.

Memling's sophisticated, melancholy elegance is a fascinating page in the history of European painting. It provides a poetic image of the ephemeral success enjoyed by the merchants and artists of Bruges.

Hans Memling

Seligenstadt 1435/40 –
Bruges 1494

School
Flemish

Principal place of residence
Bruges

Travels
Training and early work in
Cologne and Brussels

Principal works
*Triptych of the Last
Judgment* (Gdansk,
Muzeum Narodowe,
1466–73); *The Saint
John Polyptych* with *The
Mystic Marriage of
Saint Catherine* (Bruges,
Memlingmuseum,
1474–79)

Links with other artists
Pupil of Van der Weyden,
subsequently in contact
with all the later
fifteenth-century Flemish
artists, such as Petrus
Christus, Bouts, and
David; indirect influence
on Italian art as well

▶ Hans Memling, *Vase of
Flowers*, ca. 1485. Madrid,
Thyssen-Bornemisza
Museum.

The artist who was destined to become the most typical representative of Flemish painting in the second half of the fifteenth century was in fact of German origin, born in a small town near Mainz. As a young man, Memling was influenced by the works of the Cologne school and quickly developed a tasteful, elegant interpretation of reality. He moved to Flanders, where he trained for a time in Rogier van der Weyden's workshop in Brussels. After Van der Weyden's death in 1464, he moved again, this time to the wealthy city of Bruges. With the career of Petrus Christus winding down, Memling's arrival filled a large gap. Assisted by a reliable workshop, and above all by an indomitable will to work, Memling set about producing a great number of devotional paintings, some of them extremely large and complex; in the intervals he painted some forceful portraits. His reputation spread rapidly across Europe, and his works traveled along the trade routes between the Hanseatic towns and Florence. His paintings are the product of a refined culture that today we tend to idealize, almost as if these flowing pictorial microcosms had crystallized into a kind of perfection. Memling perceived that the great season of Flemish commerce and art was starting to wane, and he seems rather deliberately to have ceased developing his style. But his legacy—reworking the great Flemish tradition to create a harmonious and measured pictorial language—was already assured.

Here once again a Flemish painter uses a semicircular ambulatory with supporting columns as a background.

The spectacularly sumptuous effect of setting and costumes is enhanced by the rich damask fabrics.

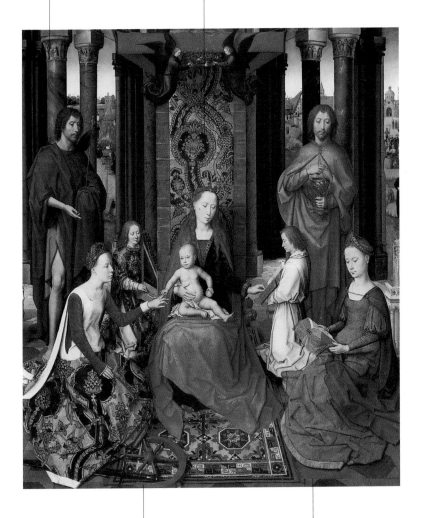

▲ Hans Memling, *The Mystic Marriage of Saint Catherine*, 1474–79, central panel of *The Saint John Polyptych*. Bruges, Memlingmuseum.

The principal character in this scene is in fact Saint Catherine (easily recognized by the wheel of her martyrdom in the foreground), who is in the act of symbolically "marrying" the Christ child. He is placing a wedding ring on her finger.

A glance at the use of perspective in the floor reveals a continuing tendency toward verticality.

The expression of the maid holding out the towel, with lowered glance and perfectly smooth face, is one of the most common in Memling's repertory.

This part of the painting is not original, but a sixteenth-century addition. A fragment with the figure of King David, which Memling did paint, has been in the same museum for a few years but has not been reattached.

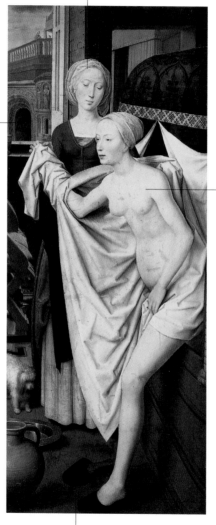

On the vague pretext of the Bible story, Memling has produced one of the first great female nudes in Flemish painting.

▲ Hans Memling, *Bathsheba Emerging from the Bath*, 1485. Stuttgart, Staatsgalerie.

The everyday details, such as the slippers, the jug, and the wooden frame of the bath, are depicted with touching realism.

Multscher acts as a link between the age of Burgundian sculpture and that of the great German wooden altarpieces. His depiction of intense emotion makes him a typical exponent of northern art.

Hans Multscher

Multscher was a many-sided and influential artist who enjoyed a long and varied career. He began with the customary *Wanderjähre*—educational travel of several years' duration. His first sojourn was to Flanders, where he focused on painting, followed by a period in Burgundy, where he paid particular attention to sculpture. His first important work in stone was his *Christ as Man of Sorrows* (or *Schmerzensmann*) for Ulm cathedral, which is influenced by Sluter but imbued with a new realistic pathos. He has other works in Ulm, many of which unfortunately suffered during the period of Protestant iconoclasm. Nonetheless, one can still observe the intensity of emotion in figures that are characterized by expressive gestures and line, which endow them with devotional intensity. A significant painting from the mid-1430s is the Wurzach altar, now in Berlin. But the high point of Multscher's achievement—a work enriched by its combination of painting and sculpture—must be the Vipiteno winged altar (1458), now broken up and dispersed. The painted shutters are still at Vipiteno/Sterzing, and other parts are housed in German and Austrian museums. This great altar in the South Tirol was a direct precedent for the splendid achievements of Michael Pacher.

Reichenhofen ca. 1400 – Ulm 1467

School
German

Principal place of residence
Ulm

Travels
Educational visit to Flanders and Burgundy; visits to the Tirol (Vipiteno/Sterzing)

Principal works
Christ as Man of Sorrows (Ulm cathedral, 1429); the Vipiteno altar (divided between various museums, 1458)

Links with other artists
Stylistic influences from France and Flanders

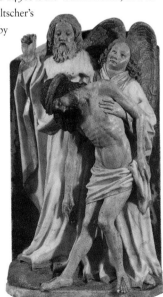

◀ Hans Multscher, *The Holy Trinity*, ca. 1430. Frankfurt, Liebighaus.

Painter or sculptor? Italian or German? Humanist or Gothic? Within this play of alternatives, Michael Pacher takes his place in European art as an outright master.

Michael Pacher

Brunico/Bruneck ca.
1430/35 – Salzburg 1498

School
Tyrolean

Principal place of residence
Brunico/Bruneck and Val
Pusteria/Pustertal

Travels
Early training in Padua;
apart from various visits to
Austria and the Rhineland,
he is thought to have
visited Florence briefly

Principal works
*The Coronation of the
Virgin Altar* (Sankt
Wolfgang [Austria], parish
church, 1471–80); *The
Fathers of the Church Altar*
(Munich, Alte Pinakothek,
ca. 1480)

Links with other artists
Apart from Tyrolean art
circles (Multscher), he had
direct contacts with
humanist circles in Padua
(Donatello and Mantegna)

He is the most original figure in late-fifteenth-century German art. He was born in the Tirol and his twin talents as sculptor and painter found full expression in winged altars. His painting was initially inspired by Rhenish and Flemish works, and it is likely that his early educational travels took him as far as Flanders. Around 1460 he visited Padua, where he was able to study the works of Donatello, Mantegna, and Paolo Uccello. In this way his northern qualities became infused with a very Italian feeling for perspective and volumes. After he spent ten years working in Tyrolean churches, his career took off in 1470. First he made the altar in the parish church at San Lorenzo di Sebato near Brunico/Bruneck, where only the gilded wood carving of the *Madonna and Child* remains; the sur-viving painted panels are now in Vienna. There followed the great altar at Gries, on the outskirts of Bolzano/Bozen, whose carved and gilded shrine represents *The Coronation of the Virgin*. The same subject appears on the altar at Sankt Wolfgang on Mondsee (Austria), the only painted and sculpted work by Pacher to survive in its entirety. Then he executed the *Fathers of the Church Altar* for the Augustinian abbey of Novacella/Neustift. In 1497, he moved to Salzburg to work on his last altar. He died there in August 1498.

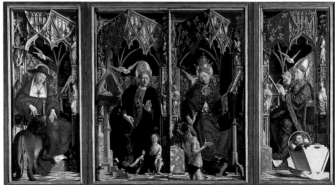

▶ Michael Pacher, *Altarpiece of the Church Fathers*, ca. 1480. Munich, Alte Pinakothek.

The alpine Gothic structure of the
canopy over the altar clearly belongs
to the Tyrolean architectural tradition.

As with all his other works, Pacher grafts
Italian compositional features onto his
northern visual and devotional culture.

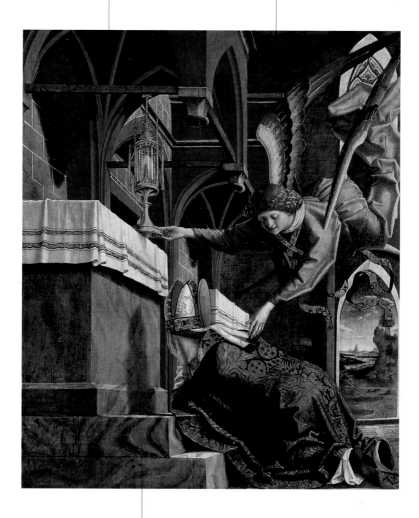

The shadows, volumes, and surfaces
reflect the Italian humanist approach
that Pacher learned in Padua.

▲ Michael Pacher, *Saint Wolfgang
at Prayer*, ca. 1480. Munich,
Alte Pinakothek.

Pietro Perugino manages one workshop in Florence and another at Perugia at the same time. For many years he is the best known and most influential painter in Italy.

Pietro Perugino

Born Pietro Vannucci;
Città della Pieve (Perugia)
ca. 1450 – Fontignano
(Perugia) 1523

School
Umbrian

Principal place of residence
Perugia and Florence

Travels
Extensive travel in the
Marches, Umbria, and
Tuscany; visits to Rome
and northern Italy as well

Principal works
*Christ Handing the Keys
to Saint Peter* (Vatican City,
Sistine Chapel, 1482); *The
Lamentation* (Florence,
Palazzo Pitti, 1494);
frescoes at the Collegio
del Cambio (Perugia,
1498–1500)

Links with other artists
A pupil of Verrocchio
along with Botticelli and
Leonardo; an influential
figure for the Umbro-
Tuscan school in the
late fifteenth century;
taught Raphael

Perugino was a companion of Botticelli's in Verrocchio's workshop and soon achieved widespread fame. In 1481 he was summoned to Rome by Pope Sixtus IV to supervise the decoration of the Sistine Chapel walls, and for about twenty years he was undoubtedly the most sought-after Italian painter. He was able to satisfy multiple commissions thanks to a vast workshop, which employed Raphael among others. Around 1490 he painted *The Vision of Saint Bernard* (Munich, Alte Pinakothek) and *The Lamentation* (Florence, Palazzo Pitti). While he had prestigious contacts with the duchy of Milan, the republic of Venice, and the Gonzaga family, he worked increasingly at Perugia, where he began a grandiose altarpiece for the church of

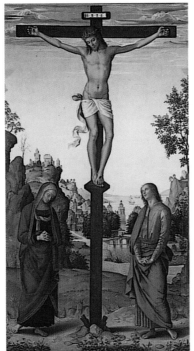

San Pietro and decorated the Collegio del Cambio between 1496 and 1502. This masterpiece nevertheless reveals Perugino's limitations: he tends to use repertory compositions and is ill at ease in creating dynamic narrative scenes. When Leonardo arrived on the scene, Perugino's style was no longer acceptable in Florence and Rome. Nevertheless, he continued producing paintings for Umbria, reserving his last flashes of grace and harmony for his native region.

324

Perugino painted few portraits, but they are always noteworthy, and this one is a masterpiece. The landscape may be a view of Lake Trasimeno, outside Perugia.

The sitter's bust, hands, and face stand out for their unusual vigor, whereas the hair is light and downy.

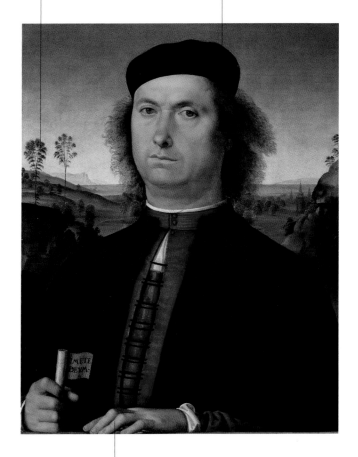

The vigorous presentation of the figure harks back to the old lessons about volumes he learned as a young man from Piero della Francesca. But here it is combined with a new, fresh sensitivity to light.

◄ Perugino, *The Crucifixion,* 1481–84, central panel of *The Galitzin Triptych.* Washington, National Gallery.

▲ Perugino, *Portrait of Francesco Delle Opere,* 1494. Florence, Uffizi.

Pietro Perugino

From a compositional point of view, this scene is quite innovative. It is a broadly conceived view of architecture and landscape from the edge of a church courtyard, whose paving forms a central perspectival grid. Classical elements, such as the two triumphal arches, combine with a very modern-looking little church on a central plan.

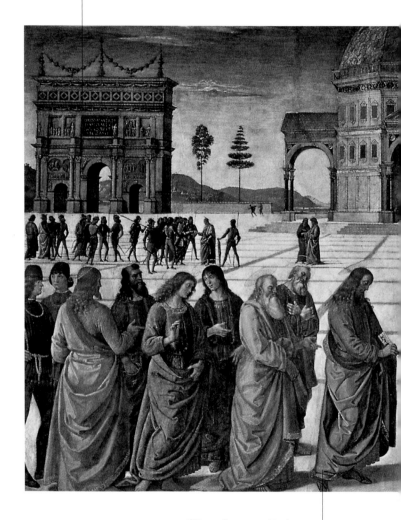

▲ Perugino, *Christ Handing the Keys to Saint Peter*, 1482. Vatican City, Sistine Chapel.

This grandiose composition has a very powerful symbolic meaning: the investiture of the first pope (Saint Peter) by Christ ratifies the role of the pope and reiterates his authority as vicar of Christ at the very spot where conclaves are held.

Along with Ghirlandaio and Botticelli, Perugino was summoned by Pope Sixtus IV to decorate the Sistine Chapel. Perugino painted three large scenes on the side walls, the composition on the back wall (later destroyed by Michelangelo to make way for his Last Judgment*), and some figures of early popes on the upper part of the walls.*

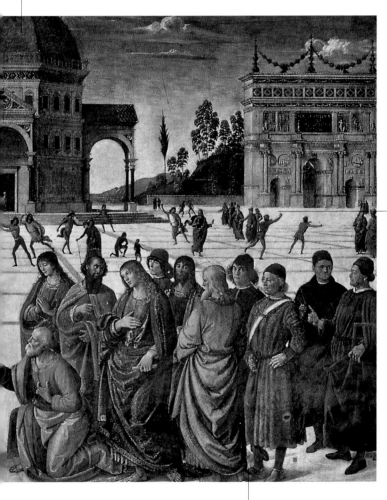

As often happens with the side frescoes in the Sistine Chapel, the principal scene is accompanied by minor ones: here we see Christ's fellow citizens in a failed attempt to stone him.

The characters from the scriptures mingle with contemporary figures, such as dignitaries from the papal curia, humanists, and intellectuals.

*He is a leading figure in the second generation of humanist painters.
He brings about a marriage between art and geometry, between the
highly calculated use of perspective and poetic expression.*

Piero della Francesca

Sansepolcro (Arezzo)
1416/17 – 1492

School
Tuscan

Principal place of residence
Sansepolcro and Urbino

Travels
Early studies in Florence,
then visits to Rome,
Ferrara, Rimini, Arezzo,
and Perugia

Principal works
*The Legend of the True
Cross* (Arezzo, San
Francesco, 1452–62);
*The Resurrection of
Christ* (San Sepolcro,
Museo Civico, ca. 1463);
The Brera Altarpiece
(Milan, Pinacoteca
di Brera, 1472–74)

Links with other artists
A pupil of Domenico
Veneziano in Florence at
the time of Paolo Uccello
and Fra Angelico;
widespread influence on
European art in the
mid-fifteenth century,
partly thanks to contacts
with Berruguete and
Justus of Ghent

Piero trained in Florence, and we know that in 1439 he was working
with Domenico Veneziano on a fresco cycle that is now almost com-
pletely lost. Apart from this youthful period in Florence, he worked
entirely in the provinces (Sansepolcro, Arezzo, Rimini, Ferrara,
Urbino, and Perugia). During the 1440s he worked partly in
Sansepolcro and partly in other cities, including Rome. At Ferrara
he was in contact with Leon Battista Alberti and perhaps with the
Flemish painter Van der Weyden. From 1452 onward he was work-
ing on the most important undertaking of his career: the frescoes of
The Legend of the True Cross in the church of San Francesco in
Arezzo. In the 1460s he worked mostly at the court of Duke Fed-
erico da Montefeltro in Urbino. In addition to producing some mem-
orable masterpieces during that period, he also met with many
foreign artists and pursued his study of geometry, perspective, and
algebra, setting out his results in important
treatises. In the mid-1470s his fail-
ing eyesight obliged him to give
up painting. He returned to
Sansepolcro, devoting
himself to the study of
mathematics and the
completion of his trea-
tises. He is an artist who
symbolizes the fifteenth-
century intellectual
world and, by a strange
coincidence, he died on
the very day the New
World was discovered:
October 12, 1492.

▶ Piero della Francesca,
The Madonna del Parto,
ca. 1450. Monterchi
(Arezzo), Museo Civico.

The position of Christ exactly on the vertical axis of the painting is emphasized by the motionless, mystic, open-winged dove, as well as by the pale, smooth tree trunk. Piero also stresses the intrinsic nobility and beauty of the human figure but at the same time places it in a natural environment.

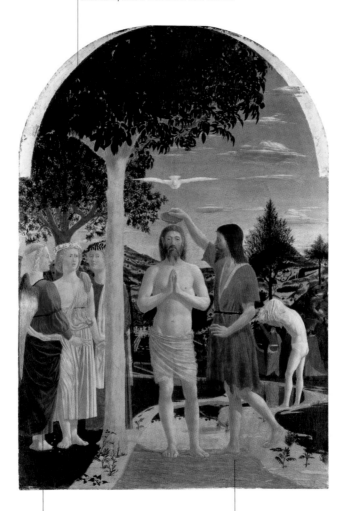

The three angels holding hands are a symbol of concord: a sort of Christian alternative to the classical three Graces.

The landscape closely resembles the hills of the Casentino, east of Florence, which Piero knew well. Notice also the limpid stream reflecting plants and figures. The high, thin clouds seem to emphasize the clarity of the spring sky.

▲ Piero della Francesca, *The Baptism of Christ*, ca. 1450. London, National Gallery.

Piero della Francesca

Piero does not scrupulously follow a chronological sequence, preferring a rhythmical arrangement that creates clear symmetries between the two walls. In this way, elevated ritual solemnities (seen here) alternate with confused battle scenes, and areas of lyrical contemplation with lively narrative episodes.

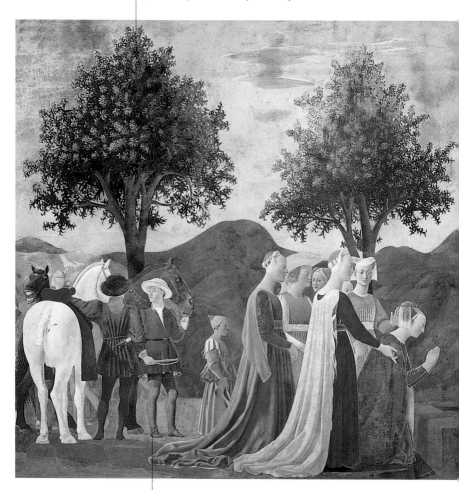

The frescoes that Piero painted in the choir of the church in Arezzo are one of the greatest masterpieces of Italian painting: an outstanding example of balanced relationships governing proportions, order, and calm composure.

▲ Piero della Francesca, *The Adoration of the Holy Wood* and *The Meeting of Solomon and the Queen of Sheba*, frescoes from the cycle *The Legend of the True Cross*, 1452–62. Arezzo, San Francesco.

The controlled, masterly mind of the artist adjusts gestures and pauses in accordance with strict mathematical logic.

Within the intellectual rigor there burns a spark of emotion and tenderness. The world of feeling does not undermine the geometric purity of the artist's invention but rather enhances it.

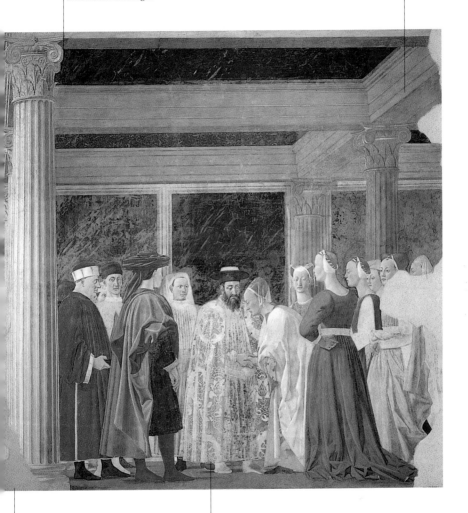

The source of this episode is the Golden Legend *by Jacobus de Voragine. Piero tells the complicated history of the wood of the cross, from the death of Adam to the time of Emperor Constantine. Here, the Queen of Sheba kneels as she recognizes the wood from which the cross will be made.*

The scene of the Queen of Sheba and Solomon embracing obviously echoes the group of apostles in Masaccio's The Tribute Money, *but here it is given even greater monumentality and is placed within an architectural structure of strictly classical proportions.*

Piero della Francesca

Piero pays attention to the tiniest, delicate details, such as the transparent light entering through the glass window and even its reflection on the characters' fingernails, jewels, veils, and collars.

It is clear in the Madonna's perfectly oval face that the artist is using simple geometric volumes (a pyramid for the Madonna and two cylinders placed between the doorposts for the angels).

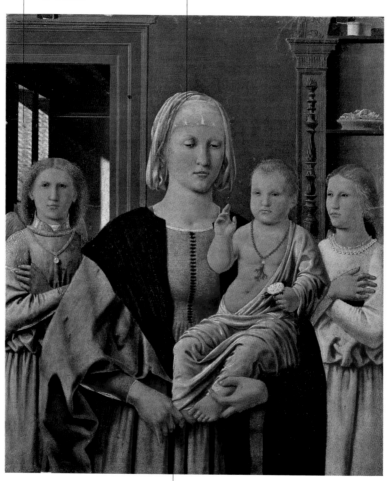

▲ Piero della Francesca, *Madonna and Child with Two Angels* (*Madonna of Senigallia*), ca. 1470. Urbino, Galleria Nazionale delle Marche.

This highly refined panel is the fruit of Piero's long contact with the court of Urbino. It displays a synthesis of the particular qualities of Flemish painting (careful attention to detail, the meticulous rendering of light, and a concern with describing real life) and those of Italian humanism (calm symmetry and logical control of the image).

An ostrich egg hangs on a slender chain from the shell in the apse. This famous detail unites a symbolic element (it alludes to both the birth of Jesus and the Montefeltro coat of arms) with an impressive demonstration of the depiction of depth.

The scene is set inside a Renaissance building whose proportions are carefully scaled to those of the figures. The light models the figures with silent clarity, giving the group all the nobility of heavenly courtiers, arranged according to strict rules of hierarchy.

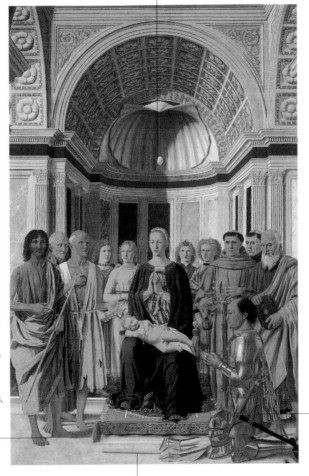

Kneeling in the foreground, in armor, is Federico da Montefeltro, one of the greatest patrons of fifteenth-century art.

The two sides of the artist meet here: on the one hand we find the geometrical theoretician and author of important treatises on perspective, and on the other is the creative artist, deeply concerned with achieving an ideal image.

▲ Piero della Francesca, *The Brera Altarpiece*, 1472–74. Milan, Pinacoteca di Brera.

Extraordinary, refined, mercurial: Piero di Cosimo is an artist whose restlessness and imaginative capacity are amazing. He strikes a discordant note but remains fascinating for that very reason.

Piero di Cosimo

Born Piero di Lorenzo;
Florence 1461/62 – 1521

School
Florentine

Principal place of residence
Florence

Travels
To Rome in 1482 to
work on frescoes in the
Sistine Chapel

Principal works
*Portrait of Simonetta
Vespucci as Cleopatra*
(Chantilly, Musée Condé,
ca. 1490); *Scenes from the
Life of Primitive Man*
(New York and Oxford,
1490–95)

Links with other artists
A pupil of Cosimo Rosselli;
in contact with the
whole spectrum of late-
fifteenth-century Florentine
art from Filippino Lippi
to Leonardo

▶ Piero di Cosimo, *Portrait
of Simonetta Vespucci as
Cleopatra* (detail), ca. 1490.
Chantilly, Musée Condé.

This strange personality from the Florentine school, working at a time of transition between the fifteenth and sixteenth centuries, takes his nickname from Cosimo Rosselli, whom he studied under and who involved him at an early age in the decoration of the Sistine Chapel. Such a prestigious beginning led to a substantial career and the production of many significant works, including some compelling portraits. Behind his painting one can see a variety of different cultural influences: a Flemish clarity in the handling of light, the expressive power of Leonardo, and the nervous restlessness of Filippino Lippi. This cultural eclecticism makes Piero di Cosimo an "outsider," capable of suddenly reverting to an older style or urgently looking forward to mannerism. It may in part be due to this eccentricity (Vasari said he had "an abstracted and eccentric mind") that his works are now very scattered: few of his paintings have remained in their original positions, and a substantial proportion are now in British and American museums. One example is the interesting cycle of historical and mythological scenes about the life of primitive man, which he painted for the Dal Pugliese family in the last decade of the fifteenth century. In the early sixteenth century, his style became even more extraordinary, and he increasingly withdrew from the artistic debate, producing some fascinating and timeless compositions, concerned on the one hand with a severe and powerful religious iconography, and on the other with complex symbolism.

Piero di Cosimo's imagination even transforms his subject matter: the little angels on the top of the throne are just like the sculpted head in the middle.

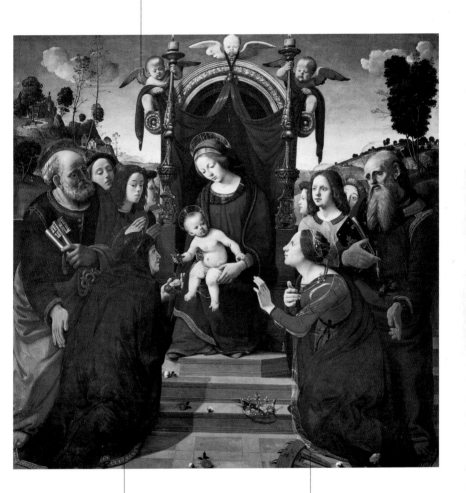

The figures are given a feverish, passionate, emotional intensity that is characteristic of Florentine painting in the closing years of the fifteenth century.

The objects in the foreground are keenly observed.

▲ Piero di Cosimo, *Sacra Conversazione*, 1493. Florence, Museo dello Spedale degli Innocenti.

*Like his medals, Pisanello's art has two sides: one is turned toward
the fabulous, decorative, and noble world of the late-Gothic courts,
and the other looks toward humanist experimentation.*

Pisanello

Also called Antonio Pisano;
Verona ca. 1395 –
Mantua 1455

School
Italian

Principal place of residence
Verona and then Mantua,
but he traveled a great deal

Travels
Many visits to Venice,
Florence, and Rome,
and to the courts of
Milan, Ferrara, Rimini,
and Naples

Principal works
*Saint George and the
Princess of Trebizond*
(Verona, Sant'Anastasia,
1437–38); *Scenes of War
and Chivalry* (Mantua,
Ducal Palace, ca. 1435)

Links with other artists
He collaborated with
Gentile da Fabriano and
had wide-ranging cultural
links with many Italian art
centers and, indirectly, with
foreign ones

Pisanello was the son of a merchant from Pisa (hence his nickname)
and was almost certainly born in Verona. He trained in Verona and
then in Venice, and he soon came into contact with Gentile da
Fabriano. He collaborated directly with Gentile during the period
1418–20 and by 1423 had arrived in Florence in Gentile's wake. His
first known works, in Verona, reflect his experience to date but
always adopt the late-Gothic style. When Gentile da Fabriano died
(1427), Pisanello was called to Rome to complete his master's unfin-
ished frescoes in the church of Saint John Lateran. When he returned
to northern Italy, he embarked on a successful career at various
courts, producing painting cycles and medals and carrying out the
full range of court painter's duties. In addition to his frescoes on
chivalrous subjects in the Ducal Palace in Mantua, he also painted
some noteworthy portraits in Ferrara. The most important of his
surviving works is the great scene *Saint George and the Princess of
Trebizond* (1437–38) in the church of Sant'Anastasia in Verona.
After this work, Pisanello largely abandoned painting, specializing in
wonderful commemorative medals for the court of Naples. After the
midcentury, his fame rapidly declined
as painting in perspective soared
in popularity. He probably
died in Mantua, where his
position as court painter
was taken up, a few
years later, by Andrea
Mantegna.

▶ Pisanello, *Medal of Cecilia
Gonzaga*, 1447. Mantua,
Ducal Palace.

This initial from a "gradual," a book of music sung at mass, illustrated the mass for the conversion of Saint Paul.

The initial seems to honor less the saint than the rider wearing a fancy red hat and tunic trimmed in green, white, and red—the colors of the Gonzaga rulers of Mantua and the Este of Ferrara, both of whom Pisanello served. The model for the rider probably belonged to one of these families and perhaps commissioned this book.

The landscape was painted by another artist, whose style differs from that of Pisanello.

Pisanello, working for courts throughout Italy, excelled in and relished the depiction of fancy dress and armor. He used silver and gold in this miniature to convey the luster of armor and bridle adornments.

▲ Attributed to Pisanello, *Initial S: The Conversion of Saint Paul,* ca. 1440–50. Los Angeles, J. Paul Getty Museum.

Saint Paul was born a Jew named Saul and in his youth persecuted Christians. One day he was traveling to Damascus when he experienced a light from heaven that engulfed him. He fell off his horse and heard the voice of Jesus calling him to become a Christian evangelist. Saul converted, took the name Paul, and went on to preach Christianity.

Pisanello

This painting is almost a résumé of the qualities and themes typical of Pisanello's painting: real life takes on the hues of the fabulous, details acquire monumentality, and life throbs within a kind of pantheism of nature.

In the depths of a dark forest, a huntsman (Saint Eustace) dressed in extravagant luxury, riding a richly caparisoned horse, draws to a halt before a miraculous stag with a crucifix between its horns.

The flower-strewn forest swarms with animals: a pack of dogs sniffing, pointing, pawing, and barking; a hare in flight; stags, fawns, and bears hidden in crevices; cranes and swans in the pool; and birds feeding in the bushes.

▲ Pisanello, *The Vision of Saint Eustace*, ca. 1440. London, National Gallery.

Pollaiolo, with his eclectic style and technique, likes to convey intense emotion and drama. His activities include bronze sculpting and goldsmithing as well as painting and engraving.

Antonio del Pollaiolo

In spite of his nickname, which derives from the fact that his father was a modest poultry merchant, Antonio del Pollaiolo is one of the most refined and expressive artists in later-fifteenth-century Florence. In accordance with standard practice in workshops at that time, he learned an extraordinary variety of skills. In his early maturity he stood out for designing goldwork and cartoons for luxury embroidered work for the baptistery (now in the Museo dell'Opera del Duomo). He soon became known in particular for his forceful painting and his willingness to undertake what were then unusual commissions: secular and mythological subjects. However, he still continued to switch from terra-cotta and bronze sculpture to painting, including portraits, altarpieces, and frescoes. The only technique he did not attempt was marble sculpture. The outstanding characteristic of all his work is dramatic tension, conveyed in a strongly linear way. The particular brilliance of his colors and the forcefulness of his drawing are to be linked to the arrival of Flemish paintings in Florence and their success in Tuscan circles. After he moved to Rome, his preference was for monumental bronze sculptures, such as the sarcophagi for Pope Sixtus IV (r. 1484–92) and Innocent VIII (r. 1492–98) in Saint Peter's. They are laden with complex intellectual allusions and were part of the artistic and cultural revival of the Vatican.

◀ Antonio del Pollaiolo, *Hercules and Antaeus*, ca. 1470. Florence, Uffizi.

Born Antonio Benci; Florence ca. 1431 – Rome 1498

School
Florentine

Principal place of residence
Florence

Travels
Numerous visits to Rome

Principal works
The Martyrdom of Saint Sebastian (London, National Gallery, ca. 1475); *The Tomb of Pope Sixtus IV* (Vatican City, San Pietro, 1484–92)

Links with other artists
He often worked with his brother and was in contact with late-fifteenth-century art circles in Florence (Andrea del Castagno, Verrocchio, and Botticelli)

Antonio del Pollaiolo

The young woman's bust is outlined against a sky with a few clouds, but there are no environmental or architectural references to give the viewer a sense of scale.

Such a sharply defined and idealized profile was to remain the preferred pose in Tuscany for a long time. The flowing outlines of the young noblewoman's head and her complicated hairdo are intensified by details of current fashion, such as shaving the forehead to make it appear higher, and the choice of pearls against her pale flesh.

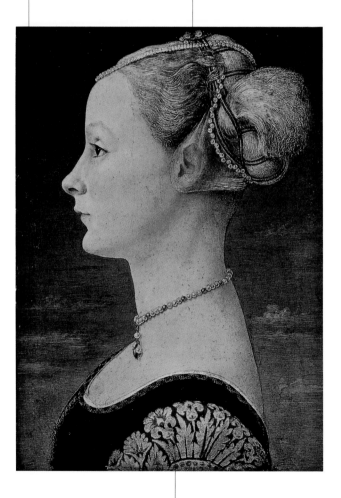

▲ Antonio del Pollaiolo, *Profile Portrait of a Lady*, ca. 1480. Milan, Museo Poldi Pezzoli.

The rendering of the velvet on her sleeve is a tour de force of tactile illusion.

Schongauer is a pivotal figure in German art. He abandons the angular gestures of late Gothic in favor of soft, calmly serene lines, which bring out poetic and human qualities.

Martin Schongauer

Schongauer was born into an Alsatian family of goldsmiths and artists. He completed his artistic education in contact with the art of the Low Countries: during a visit to Cologne he had occasion to study Rogier van der Weyden's *Saint Columba Triptych*, and after studying at Leipzig University he traveled to Burgundy. These experiences led him to develop a style in which he reveals an outstanding sensitivity to line along with a controlled, rhythmic use of perspective for both space and figures. He interpreted his favorite subject, the Madonna and Child, in a succession of different ways, ranging from realistic Nativity scenes to complex allegories. But what made Schongauer's reputation was his work as an engraver. His virtuoso craft skills and his extraordinarily sure hand led to the production of works in which the broken and agitated lines convey a strong sense of solidity. His engravings enjoyed rapid and widespread diffusion, providing a whole reper-tory of motifs that were to inspire numerous artists, including Michelangelo. Even Albrecht Dürer, who took the technique of engraving to its highest peak, felt that he owed a debt to the older man. In 1492, Dürer visited Alsace, but by the time he reached Colmar, Schongauer had already died, leaving behind an unfinished fresco cycle, *The Last Judgment*, in Breisach cathedral.

Colmar ca. 1450 – Breisach 1491

School
German

Principal place of residence
Colmar

Travels
He studied in Germany and probably visited Burgundy and Flanders

Principal works
The Madonna of the Rose Garden (Colmar, church of Saint Martin, 1473)

Links with other artists
Flemish masters such as Van der Weyden, Bouts, and Van der Goes; he influenced Rhineland painters and the young Dürer

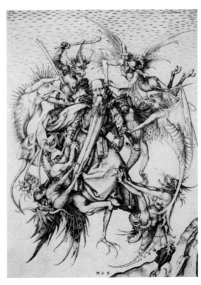

◄ Martin Schongauer, *The Temptation of Saint Anthony Abbot*, ca. 1480, engraving.

It is normal in fifteenth-century painting for Saint Joseph to be placed in the middle or background.

This is a typical Schongauer devotional work: the format and subject are his favorites. He is perfectly at ease with small dimensions and with the intimate interpretation of the theme.

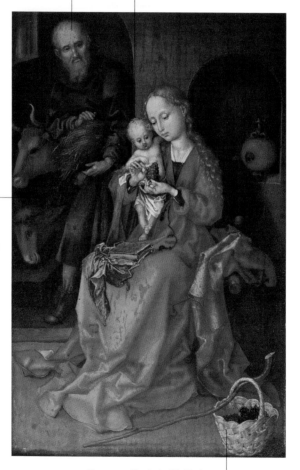

The domestic setting is bare and unassuming but, as though through some silent agency, we feel the strong presence of the divine.

▲ Martin Schongauer, *The Holy Family*, 1475–80. Vienna, Kunsthistorisches Museum.

The composition is simplified by having few elements in the setting: attention is concentrated on the Holy Family and the everyday objects that glint in the semidarkness.

Luca Signorelli absorbs and interprets the latest ideas in Tuscan painting and acts as an important link between the great art centers and the provinces.

Luca Signorelli

Signorelli is a difficult artist to place in context, because he spent some periods working in the most productive and liveliest art centers (the Florence of Lorenzo the Magnificent and the Urbino of Federico da Montefeltro) and others on lengthy visits to smaller towns. He was a pupil of Piero della Francesca at Arezzo, assisted the Pollaiolo brothers in Florence, and completed his artistic education in Urbino, where he painted, among other things, *The Flagellation* that is now in the Pinacoteca di Brera in Milan. In 1482 he was in Rome, assisting Perugino on the Sistine Chapel frescoes, and his contact with Perugino softened his style, as one can see in the frescoes in the sacristy of the church of the Holy House at Loreto, and the *Saint Onuphrius Altarpiece* in Perugia cathedral (1484). Moving to Florence, Signorelli became a leading figure in the cultural circles around Lorenzo the Magnificent. Some panels painted during this period are now in the Uffizi, including the vigorous *Madonna and Child* tondo. After Lorenzo's death, Signorelli left Florence and embarked on two large, memorable fresco cycles: *Scenes from the Life of Saint Benedict* in the abbey cloister at Monte Oliveto Maggiore (1496–98), and the terrifying series *The End of the World* and *The Last Judgment* in the chapel of San Brizio in Orvieto cathedral (1499–1502). The last twenty years of his life were spent almost entirely in the provinces, at Cortona and Città di Castello.

Cortona (Arezzo)
ca. 1445 – 1523

School
Tuscan

Principal place of residence
Cortona and various other towns in Tuscany, Umbria, and the Marches

Travels
Always ready to move: he visited Florence and Rome and many other central Italian towns

Principal works
Frescoes in the abbey of Monte Oliveto Maggiore (1496–98) and Orvieto cathedral (1499–1502)

Links with other artists
A pupil of Piero della Francesca and Pollaiolo; he worked with Perugino

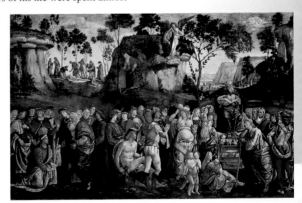

▶ Luca Signorelli and Bartolomeo della Gatta, *Scenes from the Life of Moses*, 1482. Vatican City, Sistine Chapel.

Luca Signorelli

The decoration of the chapel ceiling was begun by Fra Angelico fifty years before Luca Signorelli worked there.

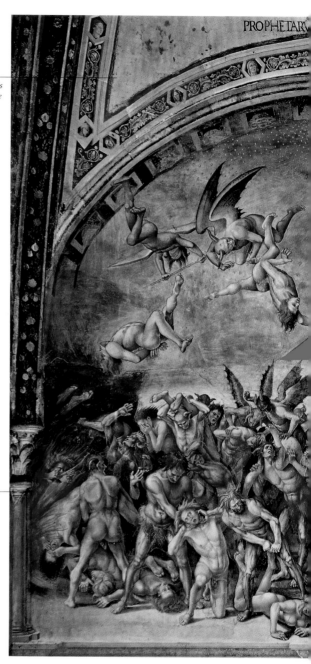

The large lunettes in the chapel at Orvieto contain a striking fresco cycle. The paintings are inspired by the book of Revelation, and chronologically as well as stylistically they mark the arrival of the sixteenth century.

▶ Luca Signorelli, *The Last Judgment*, 1499–1502. Orvieto, cathedral, chapel of San Brizio.

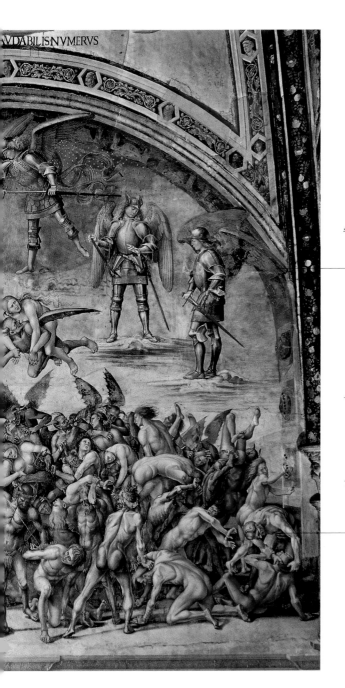

VDABILIS NVMERVS

In contrast to the chaotic scene of hell and the fall of the damned, the angels in armor have the calm composure of the victorious.

The contorted and powerfully muscular figures of the devils and naked souls have been convincingly linked to the early work of Michelangelo.

Stoss is a virtuoso artist with a vivid and inexhaustible imagination, but also capable of forceful representations of reality. He typifies the German wood sculptor.

Veit Stoss

Horb am Neckar
1437/47 – Nuremburg
1533

School
German

Principal place of residence
Nuremburg and a long
period of exile in Krakow

Travels
Possibly a brief visit to
Florence

Principal works
*Altar of the Death of the
Virgin* (Krakow, church of
Saint Mary, 1477–89);
The Annunciation
(Nuremburg, church of
Saint Lawrence, 1518)

Links with other artists
Dürer and the Nuremburg
artists; Stoss, Pacher, and
Riemenschneider are the
three great creators of
wooden altars in Germany

Stoss was a multitalented artist who worked as a painter and engraver, but above all he was a great wood sculptor, specializing in spectacular winged altars. He was active in the brilliant art circles of Nuremburg, but while still a young man he was accused of forgery, branded on both cheeks, and expelled from the city. In 1477, Stoss was in Krakow, where he began work on the enormous *Altar of the Death of the Virgin* for the church of Saint Mary in the market square. There, using his favorite limewood, he created the most colossal *theatrum sacrum* of fifteenth-century central and northern Europe. After completing other works in wood and marble in Krakow (including the tomb of King Casimir IV Jagiello in the cathedral), he was pardoned in 1496 and allowed to return to Nuremburg, where he produced some important sculptures in an animated and expressive style. In an artistic climate now affected by the presence of Dürer, Stoss toned down his usual capriciousness, but his manner of rendering the flowing folds of draperies and grandiose figures remained his alone. He began to receive commissions from Italy, sent two splendid wood sculptures to Florence, and may even have visited Tuscany himself. In his last winged altar (1518), now in Bamberg cathedral, Stoss abandoned his usual polychromy, leaving the warm color of the dark wood in evidence.

► Veit Stoss, *Christ as the Man of Sorrows*, ca. 1500. Nuremburg, church of Saint Sebald.

Stoss has fitted the Coronation
of the Virgin into the delicate
architectural tracery.

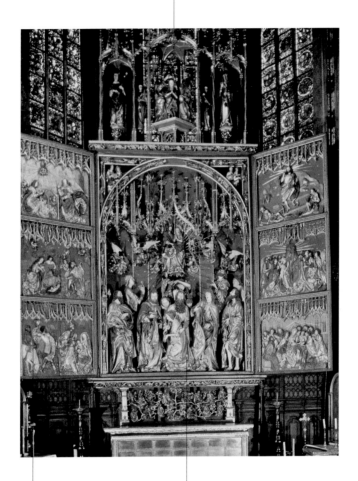

In the side panels Stoss revives
his training as a painter, making
abundant use of color.

▲ Veit Stoss, *Altar of the Death
of the Virgin*, 1477–89. Krakow,
church of Saint Mary, high altar.

The huge Altar of the Death of the Virgin
*would be more appropriately titled "Altar
of the Virgin Fainting," since that is what
one mostly sees in the principal scene. The
portrayal of intense feeling, the careful and
almost theatrical arrangement of the figures,
and the untiringly dynamic effect of
costumes, beards, arms, and hair make
the work irresistibly lively and enthralling.*

As he reaches the heights of inventiveness in the treatment of drapery's folds and waves, Stoss is in the process of abandoning color and gilding.

The subject of the sculpture and the style of Tobias's costume suggest that the work was commissioned by a Florentine merchant. Stoss in fact sent two important wood sculptures to Florence.

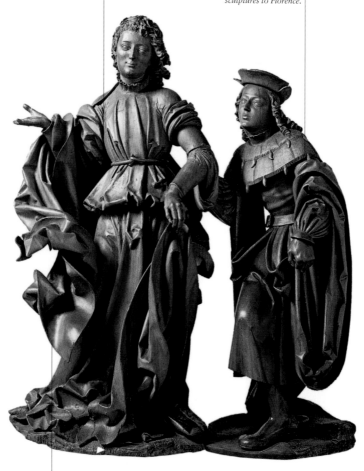

This little carved group exemplifies his virtuoso skill in handling limewood. The angel's upwelling draperies even seem to foreshadow the baroque.

▲ Veit Stoss, *Tobias and the Angel*, ca. 1516. Nuremburg, Germanisches Nationalmuseum.

Tura initiates and develops an enigmatic and fascinating school of painting in which the latest modernity is found alongside Gothic memories, and real life is juxtaposed with the magic of horoscopes.

Cosmè Tura

Tura is closely associated with the Este dukes. His style is almost indecipherable and totally original, combining his knowledge of late Gothic with the need to celebrate courtly ideals, but referencing the visual clarity of Flemish painting and the monumental qualities of Piero della Francesca and Leon Battista Alberti. As a young man in the 1450s, Tura spent time in Padua, where he was in contact with Squarcione, Crivelli, Pacher, and especially Mantegna. What Tura particularly acquired during this period was a taste for sharp, clear-cut, and almost exaggeratedly expressive drawing. After his return to Ferrara, he became court painter to Ercole and Borso d'Este, and he never left the city again. The fall and ruin of the Este dukes at the end of the sixteenth century and subsequent historical events led to the loss of many of Tura's works. However, the Ferrara cathedral organ shutters, which he painted in 1469, have survived intact and are now in the adjacent museum; sadly, his grandiose *Roverella Polyptych* has been dismantled and its parts are widely scattered in various museums. Tura was put in charge of the frescoes in the Salone dei Mesi (Hall of the Months) in Palazzo Schifanoia, one of numerous projects for decorating Este residences. The work, one of the most extraordinary fresco cycles in fifteenth-century Europe, was actually executed by several local artists, including Francesco del Cossa and Ercole de' Roberti.

Ferrara ca. 1430 – 1495

School
Ferrarese

Principal place of residence
Ferrara

Travels
Early formative visits to Venice and Padua

Principal works
Organ shutters (Ferrara, Museo del Duomo, 1469); *The Roverella Polyptych* (now broken up and divided among various museums, 1470–74)

Links with other artists
With Paduan circles as a young man; contacts with Pisanello, Alberti, Piero della Francesca, and Van der Weyden when they visited Ferrara

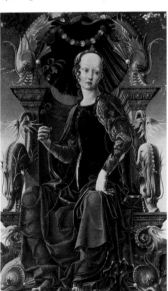

◀ Cosmè Tura, *An Allegorical Figure*, ca. 1460. London, National Gallery.

Cosmè Tura

The strange landscape is bathed in an
unreal atmosphere projected from the
golden sky above. In the background lies
a strange fortified mountain, below which
some mysterious bearded sages stand idle.

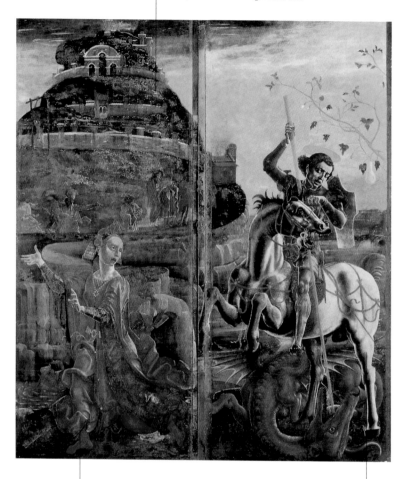

The princess flees
in terror.

▲▶ Cosmè Tura, *Saint George and the
Dragon* and *The Annunciation*, 1469,
organ shutters from Ferrara cathedral.
Ferrara, Museo del Duomo.

The dramatically frozen gestures and
the grimaces of all the principal figures
(the animals as well as the human
beings) make this work one of the
most original in Italian Renaissance
painting. In this case, the results are
particularly harsh and violent.

There is an echo of Tura's early training in Padua in the festoons of leaves and fruit at the top of the painting.

There are numerous delightful details, such as the squirrel on the tie-rod of the arch.

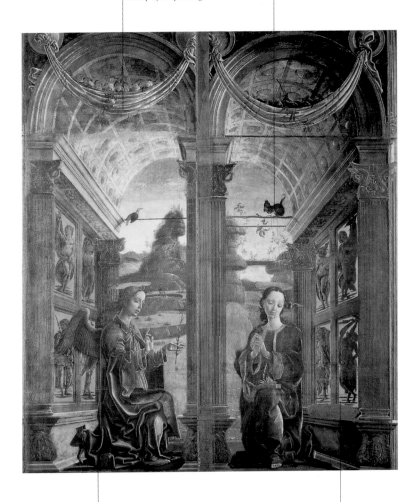

Tura's draperies always seem stiff and metallic, as though they had been hammered out of sheet metal.

The perspective view is enclosed at the sides by walls decorated with reliefs on a gold ground.

Paolo Uccello seems to stand at the crossroads between the old and the new: fascinated by theories about perspective and also deeply involved in the fabulous world of International Gothic.

Paolo Uccello

Born Paolo di Dono;
Pratovecchio (Arezzo)
1397 – Florence 1475

School
Florentine

Principal place of residence
Florence

Travels
Venice (1425), Padua
(1445), Urbino (1465–69)

Principal works
Frescoes in the Chiostro
Verde at Santa Maria
Novella in Florence (ca.
1430); *The Battle of San
Romano*, three scenes
painted for the Medici
(now in Florence, Paris,
and London, ca. 1456)

Links with other artists
Lorenzo Ghiberti,
Masaccio, Donatello, and
other early-fifteenth-
century Florentine masters;
Piero della Francesca,
Justus of Ghent, and Pedro
Berruguete in Urbin

Paolo Uccello belonged to the same generation as Masaccio and Fra Angelico. Like them, he began his career in the 1420s in Florentine art circles that were on the one hand dominated by Gentile da Fabriano, and on the other open to the new humanist ideas of Brunelleschi, Donatello, and Ghiberti. After completing some early works in Florence, Uccello paid an important visit to Venice in 1425. After brief stops in Padua and Bologna, he returned to Florence, where he became a leading figure on the painting scene. He was particularly involved at the Santa Maria del Fiore site (Brunelleschi, Donatello, and Luca Della Robbia were also working there), where he painted the fresco *Monument to Sir John Hawkwood* in 1436, followed by those around the clock, and cartoons for the stained-glass windows. Along with the almost monochrome lunettes in the cloister of Santa Maria Novella, his most famous work is the decoration intended for a room in Palazzo Medici: three panels depicting episodes from the battle of San Romano between Siena and Florence (1432). They are now divided between the Uffizi, the Louvre, and the National Gallery in London. In his old age, around 1465, he was working for Federico da Montefeltro at the Ducal Palace in Urbino. His long panel *The Profanation of the Host*, painted as the predella for Justus of Ghent's large altarpiece, is still there.

▶ Paolo Uccello, *The Flood*, ca. 1430. Florence, Santa Maria Novella, Chiostro Verde.

The cave and jagged rock closely resemble those in an earlier work by Fra Angelico.

An interesting detail is the vortex of a cyclone whose storm clouds seem to foreshadow Leonardo's studies.

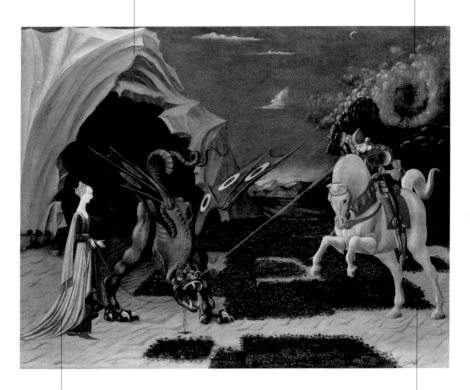

This delightful interpretation of the subject is deliberately fantastical and strange. Note how the princess has the outlandish dragon on a lead, and how fragile Saint George's very thin lance seems to be.

In spite of his attractively narrative interpretation of the subject, Paolo Uccello still manages to include some perspective, arranging the hedges in a regular pattern in depth.

▲ Paolo Uccello, *Saint George and the Dragon*, ca. 1455. London, National Gallery.

Paolo Uccello

This is one of three famous panels commissioned as a prestigious decoration for a room in Palazzo Medici.

▲ Paolo Uccello, *Battle of San Romano*, ca. 1456. Florence, Uffizi.

The perspectival effects (the broken red and white lances form a kind of grid) and the dramatic nature of the clash between the knights combine to create an almost magical feeling in a scene where the colors and light seem as unreal as in a chivalrous romance.

The use of perspective in depicting the dead horses is a tour de force.

While individual details are depicted in
strict perspective, the composition as a
whole does not have a single viewpoint.

In all three
scenes there are
"mazzocchi"—
a type of large,
many-sided
headgear. Paolo
Uccello used
them on a
number of
occasions
because of the
peculiar
difficulty of
correctly
rendering them
in perspective.

The story of the battle, in which the
Florentine militia defeated the Sienese
in 1432, is presented at three separate
moments, even though the three episodes
effectively form a single spectacular
narrative. The other two panels are in the
Louvre and the National Gallery in London.

Van der Goes is a strange, tormented figure, whose life and works reflect the religious turmoil that spread through Europe in the fifteenth century. He eventually succumbs to mental illness.

Hugo van der Goes

Ghent ca. 1440 –
Rode Klooster (Audergem, Brussels) 1482

School
Flemish

Principal place of residence
Ghent, and then the convent of Rode Klooster, not far from Brussels

Travels
Visits to Bruges

Principal works
The Portinari Triptych (Florence, Uffizi, 1475–77); *The Death of the Virgin* (Bruges, Groeningemuseum, ca. 1480)

Links with other artists
Van Eyck and Van der Weyden (his models); Justus of Ghent; various Tuscan artists, especially Ghirlandaio, were influenced after the *Portinari Triptych* arrived in Florence

Van der Goes was active in Ghent beginning in 1467, the year he enrolled in the guild of painters. Most of his works are on religious subjects, and around 1475 his deep faith led him to become a lay friar at the Augustinian convent of Rode Klooster, where he spent the rest of his life. His monastic life did not prevent him from working; indeed, his fame attracted so many illustrious figures to the convent that he was granted special privileges in order to entertain them in proper style. The high point of his career came in 1477 when he painted *The Portinari Triptych*, which was sent to Florence; but at the same time he began to show symptoms of mental illness. The convent chronicles reveal that he had increasing emotional difficulties, leading to severe depression. It is not clear whether his personal difficulties directly influenced his artistic attitudes, but he certainly developed an agitated and emotional style. His close and very personal dialogue with tradition gradually led him to subvert the canons of refined realism as they were then understood. Thus, in the works of his maturity, his treatment of space tends to be discontinuous and artificial, with stress placed on the dichotomy between reality and the painted image. To that extent, Van der Goes stands apart from the Flemish artists of his time.

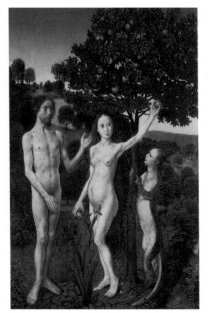

▶ Hugo van der Goes,
The Fall of Man, 1473–75.
Vienna, Kunsthistorisches
Museum.

Van der Goes's image is dominated by distorted proportions and expressions in a highly dramatic and emotional vision of the Virgin's death.

In a cramped, claustrophobic room, the apostles crowd around the bed of the dying Virgin.

The taut expressions, cold colors, subdued lighting, and anxious, doleful gestures seem to transmit a feeling of anguish to the viewer. The attractive realism, concern for the real world, and descriptive enjoyment that had up until now characterized Flemish art give way here to an unexpected, dramatic, and introspective interpretation of the subject.

▲ Hugo van der Goes, *The Death of the Virgin*, ca. 1480. Bruges, Groeningemuseum.

Hugo van der Goes

The central panel depicts the Adoration of the Shepherds. The side panels contain portraits of various family members of Tommaso Portinari, the Medici bank's representative in Bruges and an active patron of art. Behind them are monumental figures of saints.

This is one of the greatest masterpieces of late-fifteenth-century Flemish painting. When it arrived in Florence, to be set up in the church of Sant'Egidio, it became an important influence on the stylistic development of the Tuscan masters of the age of Lorenzo the Magnificent.

▲ Hugo van der Goes, *The Portinari Triptych*, 1475–77. Florence, Uffizi.

In the foreground, at the center of the composition, is a wonderful still life, consisting of a bundle of hay and two vases of flowers—symbols of the future suffering of the Virgin.

The Child, lying by himself on a bare bed of straw, is shown in all his fragility. The faces of the Madonna and the angels are pensive and disturbed; only the three shepherds on the right look on in wonderment.

Two episodes can be made out in the background: on the left, Joseph and Mary are about to arrive at the place where Jesus will be born; and on the right, the Magi, on their journey to Bethlehem, stop to ask the way.

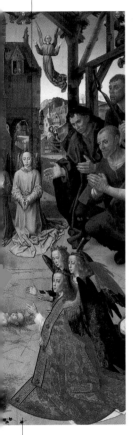

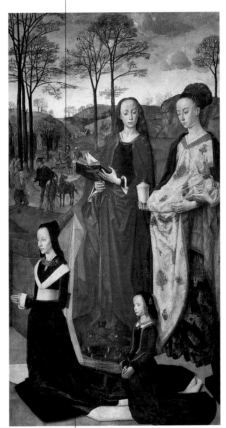

It is characteristic of Van der Goes's tormented sensitivity that the central panel does not describe the joy of the Nativity. On the contrary, it seems to foreshadow the sorrow of Christ's Passion.

The differing proportions of the figures, the insistence on describing countless details, the warm reds and cold blues add to the tension that pervades the scene.

There is something very human and communicative about
Van der Weyden's works. He can convey a wide range of feelings,
but they are always restrained by a certain dignified composure.

Rogier van der Weyden

**Tournai ca. 1399 –
Brussels 1464**

School
Flemish

Principal place of residence
Tournai and Brussels

Travels
Pilgrimage to Rome in
the Jubilee year, 1450,
including visits to other
Italian cities

Principal works
The Deposition of Christ
(Madrid, Prado, 1435);
*The Last Judgment
Polyptych* (Beaune,
Hôtel-Dieu, 1443–51);
*The Saint Columba
Triptych* (Munich, Alte
Pinakothek, 1455)

Links with other artists
Robert Campin (his
teacher); Van Eyck; various
Italian artists encountered
in 1450, including
Fra Angelico

▶ Rogier van der Weyden,
The Magdalene
(detail), 1452–53,
panel from *The
Jean de Bracque
Triptych*. Paris,
Louvre.

His real name was Rogelet de la Pasture and he was born in Tournai, where he trained in the flourishing workshop of Robert Campin. All his early activity was carried on in that workshop, and it was not until 1432, when he was over thirty, that he became an independent artist. In 1435 he moved to Brussels, where he was appointed official painter to the city and became known for grandiose works commissioned by the city. He also became an outstandingly wealthy and generous citizen. His early style was influenced by his two illustrious contemporaries, Jan van Eyck and Robert Campin. He admired the former's extraordinary technique and analytical treatment of detail, and from the latter he gained a full understanding of volume and space. Nevertheless, he interpreted what he learned from them in an independent way, arriving at a very personal compositional and chromatic language, which he adapted to a wide variety of works: miniatures, portraits, altarpieces, grand polyptychs, cartoons for tapestries, and panels for private devotions. A particular achievement was to transfer Van Eyck's visual subtlety and use of light to works of great monumentality and pathos, extending considerably the dramatic range of his expression of feeling, as one can see in his penetrating portraits. In 1450, the year of the Jubilee, his journey to Rome (passing through Milan, Ferrara, and Florence) became famous, partly because of its profound effect on Italian art.

In this youthful work, Van der Weyden reworked ideas absorbed from the more mature vision of Robert Campin and Jan van Eyck. The balance of the composition is based on the monumentality of the figures, which are well placed within the physical space of the room and characterized by their sinuous outlines.

The light reveals surprisingly realistic details.

The scene is set in the Virgin's bedroom, which has a bourgeois appearance, but Van der Weyden has arranged the domestic space to ensure that objects do not interfere with the figures.

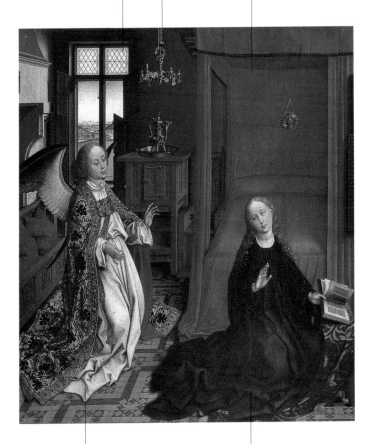

The archangel is wearing a magnificent brocade cloak and seems to float over the floor, as though the artist wanted to emphasize his divine nature.

▲ Rogier van der Weyden, *The Annunciation*, ca. 1434, central panel of *The Annunciation Triptych*. Paris, Louvre.

The Virgin interrupts her reading and seems to be turning toward the angel with a natural, spontaneous gesture.

Rogier van der Weyden

This grandiose altarpiece in nine compartments is Van der Weyden's largest work, and his total dedication to its compositional structure, together with the care he devotes to every detail, puts it on a level with Jan van Eyck's Adoration of the Lamb Altarpiece.

Paradise is simply represented by an ornate gilded door, and hell is just a precipice licked by flames. Van der Weyden's intellectual attitude is typical of early humanism in that he does not indulge in macabre details or the depiction of physical torment, preferring to emphasize inner feelings and the mental state of the figures.

The polyptych has remained where the donor, Chancellor Nicolas Rolin, wanted it to be: in the hospital chapel at Beaune.

At the center of the principal scene, the archangel Michael is weighing souls, while the men and women who have been resurrected hover at his feet, waiting to be judged.

▲ Rogier van der Weyden, *The Last Judgment Polyptych*, 1443–51. Beaune, Hôtel-Dieu.

The heavenly court seems to float on the incandescent cloud leading up to the figure of Christ in Judgment.

Although he is painting a polyptych divided into separate panels, Van der Weyden has tried to give the whole a strong unity. Thus the rainbow of God's alliance with man curves across the three main panels.

In spite of a few crudely realistic details, this composition is quite different from the overcrowded nightmare visions seen in late-medieval interpretations of the same subject.

Van Eyck's painting reveals a new universe: every work is a self-contained microcosm, the image of a perfect world.

Jan van Eyck

Maastricht? 1390/95 –
Bruges 1441

School
Flemish

Principal place of residence
The Hague, Tournai,
and Bruges

Travels
Apart from changing his
own place of residence, he
visited Spain and Portugal
(1428–30)

Principal works
*The Adoration of the
Lamb Altarpiece* (Ghent,
cathedral of Saint-Bavon,
1426–32); *Portrait of
Giovanni Arnolfini and
His Wife* (London,
National Gallery, 1434);
*The Van der Paele
Altarpiece* (Bruges,
Groeningemuseum, 1436)

Links with other artists
He influenced all the other
Flemish artists and had
contacts with Robert
Campin and Rogier van
der Weyden; one of the
most influential artists in
fifteenth-century Europe

▶ Jan van Eyck, *Portrait
of a Man (Self-Portrait?)*,
1433. London, National
Gallery.

The artistic education of Flemish painting's great innovator was very traditional. At an early stage he worked on miniatures. This skill affected his other paintings: they display both a constant concern to achieve a refined technique and a love of those tiny details that are typical of illuminated manuscripts. From 1422 to 1424 he worked at the court of John of Bavaria at The Hague. His career was closely linked to the Flemish authorities: in 1425 he was appointed court painter to Philip the Good, duke of Burgundy, a position he was to hold for the rest of his life. He also acted as counselor and diplomat for the court of Burgundy, making various journeys abroad, including a long diplomatic visit to Spain and Portugal. On his return, he settled in Bruges, which thus became Flanders's artistic capital. Van Eyck soon acquired an international reputation. As his fame spread, so did the influence of his style, which centered on the analytical

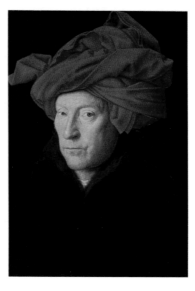

depiction of reality and the new technique of oil painting. The pivotal work of Van Eyck's career is *The Adoration of the Lamb Altarpiece*, for the cathedral of Saint-Bavon in Ghent (1426–32), left unfinished by his brother Hubert. There followed a prestigious series of masterpieces in the fields of both religious painting and portraiture.

Details are not just revealed but transfigured by the light. Note, for example, the little carved lions on the arms of the throne.

The iconography is a combination of the Madonna del Latte *and the* Maestà *(Madonna in Majesty), where Mary sits on a throne.*

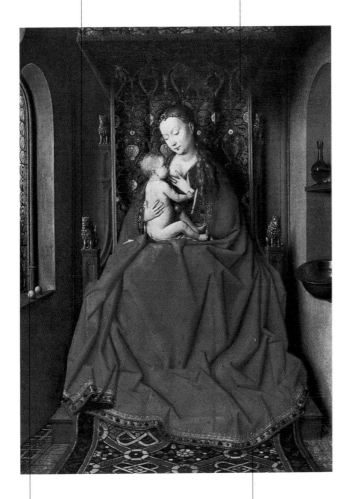

The painting is small but executed with amazing skill: it seems to foreshadow some of the light effects developed by Vermeer. Note, for example, the fruit on the windowsill.

The fine Turkish carpet gives Van Eyck an opportunity to demonstrate a perfect mastery of perspective.

▲ Jan van Eyck, *The Lucca Madonna,*
ca. 1433. Frankfurt, Städelsches Kunstinstitut.

Jan van Eyck

Diffused sunlight enters through the three-arched loggia in the middle, but Van Eyck adds the refinement of two additional closed windows at the edges of the painting, both with clear roundels of glass.

Rolin was a wealthy and influential counselor to the duke of Burgundy. Here he assumes the usual pose of devout prayer before the Virgin, but his sumptuous fur-trimmed robe glittering with gold brocade, the luxurious velvet covering of his prie-dieu, and especially the way he looks at the Virgin all indicate his personal and social self-confidence.

There are some refined and illuminating "contacts" between different materials, such as the floor tiles meeting the fur-trimmed brocade. Van Eyck's microcosm of figures and objects provides a poetic but precise and detailed image of reality, and there is also a wealth of symbols, some of whose meanings we can no longer decode.

▶ Jan van Eyck, *Virgin and Child with Chancellor Rolin*, ca. 1435. Paris, Louvre.

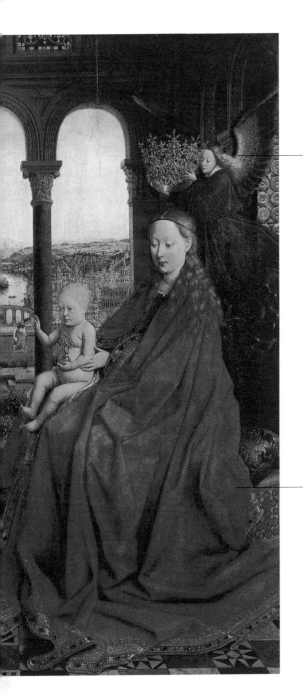

Van Eyck's paintings depend on very acute visual perception: Every minute detail is analyzed and conveyed in terms of material, light, and compositional relationship to the setting.

As is typical in paintings with portraits of donors, there is a striking difference between the studied realism of the counselor and the deliberate idealization of the Virgin.

The rocky, mountainous landscape is
an attractive invention by Van Eyck,
and the color tones of the rocks and
trees are harmonized with the
browns of the two friars' habits.

Saint Francis's wounds are visible but not
accentuated. Even in a scene of intense
mysticism, Van Eyck remains faithful to
his ideal of truthfulness to human life.

The figure of Francis's companion,
Brother Leo, is reduced to a single mass,
in a way that is reminiscent of Giotto.

▲ Jan van Eyck, *Saint Francis Receiving the
Stigmata*, 1432. Turin, Galleria Sabauda.

Into the complex play of light, Van Eyck introduces
a stained-glass window with God the Father, an
important presence in the Annunciation scene. The
three windows below are symbols of the Trinity.

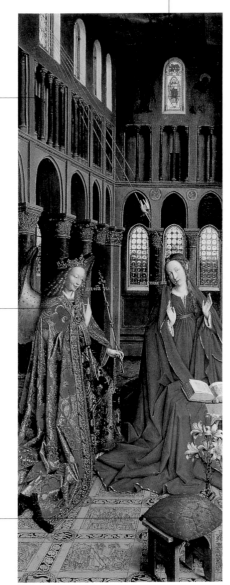

The scene is set in a cathedral that is
partly Romanesque and partly Gothic.

The two principal figures are richly
colored and solidly portrayed. The angel
speaks the words recorded in the Gospel,
and those uttered by Mary are written
backward, being addressed to the angel.

The setting contains a wealth of
wonderfully described details: the
occasional table with the vase of lilies,
for example, stands on a floor decorated
with scenes from the Old Testament.

▶ Jan van Eyck, *The Annunciation*, 1434–36.
Washington, D.C., National Gallery.

Verrocchio is the most multitalented artist of his time, equally skilled as goldsmith, painter, and sculptor. When called upon, he can be an architect, an armorer, or a furniture decorator.

Andrea del Verrocchio

Born Andrea di Michele di Francesco Cione; Florence 1435 – Venice 1488

School
Florentine

Principal place of residence
Florence

Travels
To Venice, for the Colleoni statue

Principal works
The Medici Tomb
(Florence, Old Sacristy of San Lorenzo, 1472); *The Incredulity of Saint Thomas* (Florence, Orsanmichele, 1467–83); *Equestrian Statue of Bartolomeo Colleoni* (Venice, 1488)

Links with other artists
Leonardo, Perugino, Botticelli, and other Tuscan masters trained or specialized in his workshop

Verrocchio's fame is perhaps more closely linked to the work of his pupils than to his own very fine artistic output. In his busy Florentine workshop, pupils such as Leonardo, Perugino, and Lorenzo di Credi were encouraged to practice and become proficient in a variety of arts, techniques, and styles, thus getting an artistic training that was unparalleled in breadth and eclecticism. Verrocchio's workshop was in fact a small but prestigious manufactory producing not only paintings and sculptures (of widely varying dimensions and in many different materials) but also furnishings, furniture, stage scenery, gifts, coats of arms, temporary structures for festivities, and various kinds of decorations. One famous "group" painting, designed by Verrocchio and completed by Leonardo, is *The Baptism of Christ* (1474), now in the Uffizi. In spite of his substantial efforts in painting, Verrocchio is now appreciated primarily for his sculptures, such as *The Medici Tomb* in porphyry and bronze in the Old Sacristy of San Lorenzo in Florence. He produced some extremely refined works in marble and bronze, including portraits and statuettes for fountains, and was involved in making the silver *Altar of Saint John* (Florence,

Museo dell'Opera del Duomo). He also tackled large groups, such as *The Incredulity of Saint Thomas* for Orsanmichele (completed in 1483) and the dashing *Equestrian Statue of Bartolomeo Colleoni* in Campo San Zanipolo in Venice (1488).

▶ Andrea del Verrocchio and Alessandro Leopardi, *Equestrian Statue of Bartolomeo Colleoni*, 1488. Venice, Campo San Zanipolo.

This group is one of Verrocchio's most famous sculptures. It stands in a splendid niche made earlier by Donatello and Michelozzo for Donatello's Saint Louis of Toulouse, which is now in the Museo di Santa Croce.

Orsanmichele is a vast Gothic church in the center of Florence. It is unique in that the exterior has a series of niches dedicated to the sixteen guilds into which Florence's productive workforce was divided. Each niche contains a statue of the patron saint of one particular guild (this one is for the Merchant's Tribunal); in many cases they are absolute masterpieces of Renaissance sculpture.

▲ Andrea del Verrocchio, *The Incredulity of Saint Thomas*, 1467–83. Florence, Orsanmichele.

The two figures are elegantly wrapped in soft draperies, and Verrocchio has linked them in a way that creates a sense of dynamic narrative.

One can detect various influences and contacts in Witz's style, but he always reworks them in an attractive and unique way, often with touches of humor and wit.

Konrad Witz

Rottweil am Neckar
ca. 1400 – Geneva or
Basel 1445/46

School
German

Principal place of residence
Basel

Travels
He may have made a
study visit to Flanders
or Burgundy

Principal works
Saint Christopher (Basel,
Kunstmuseum, ca. 1440);
panels from *The Saint Peter
Altarpiece* (Geneva, Musée
d'Art et d'Histoire, 1444)

Links with other artists
Sluter and Burgundian
circles

Konrad Witz was one of the great artistic innovators north of the Alps. His paintings have solid and compact volumes, and his robust figures often have attractive smiles on their faces—quite different from the languid and lyrical qualities of the preceding generation of German painters of the Rhenish school, with their "soft style." He came from a small town in southwest Germany and in 1434 joined the guild of painters in Basel, where he was granted citizenship in the following year. In the cosmopolitan atmosphere of the city— a church council was in progress at the time, trying to heal the wounds of the religious schism—Witz asserted his own particular personality, supported by both a vigorous talent and a very earthy view of life. Although he was influenced by the works of his Flemish contemporaries (he may have trained in Flanders or at least visited the region), the powerful solidity of his figures reveals that he was acquainted with Burgundian sculpture, particularly the work of Claus Sluter. His two most important works are *The Mirror of Salvation Altarpiece*, which he made for the abbey of Saint Leonard at Basel, and *The Saint Peter Altarpiece* for Geneva cathedral. The four large main panels of the latter have survived, but the former was dismantled in 1529 during the wave of Protestant iconoclasm, and only fragments remain. It was inspired by the widely circulating *Speculum humanae salvationis*, in which episodes from the Old Testament are shown to foreshadow the events of the Gospel.

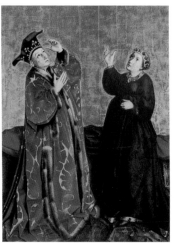

▶ Konrad Witz, *Augustus and the Tiburtine Sibyl*, 1435.
Dijon, Musée des Beaux-Arts.

*The apostles, including the struggling
and expressive Saint Peter, have the
appearance and manner of ordinary,
clumsy, and slightly uncouth people,
busy with their fishing equipment or
trying to keep the boat steady.*

*For the first time in the panorama of
European painting, we see a real, identifiable
landscape, rendered all the more appealing by
the substantial nature of all its elements
(fields, houses, rocks, water, bushes, and
pebbles), and also by the limpid water and
the reflections on its surface. The glaciers on
Mont Blanc can be made out in the distance.*

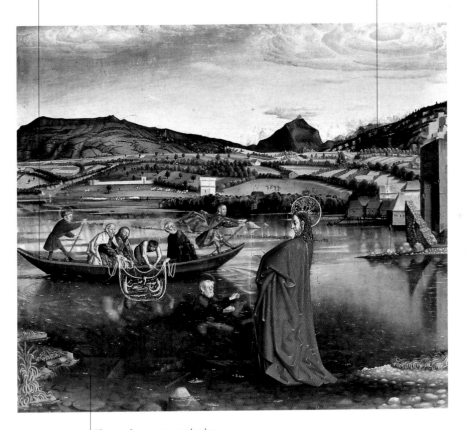

*The most famous scene on the altar
dedicated to Saint Peter at Geneva is
undoubtedly the miraculous draft of
fishes. By situating the episode on the
banks of Lake Geneva, Witz provides
the faithful with a familiar setting.*

▲ Konrad Witz, *The Miraculous Draft of Fishes*,
1444, panel from *The Saint Peter Altarpiece*.
Geneva. Musée d'Art et d'Histoire.

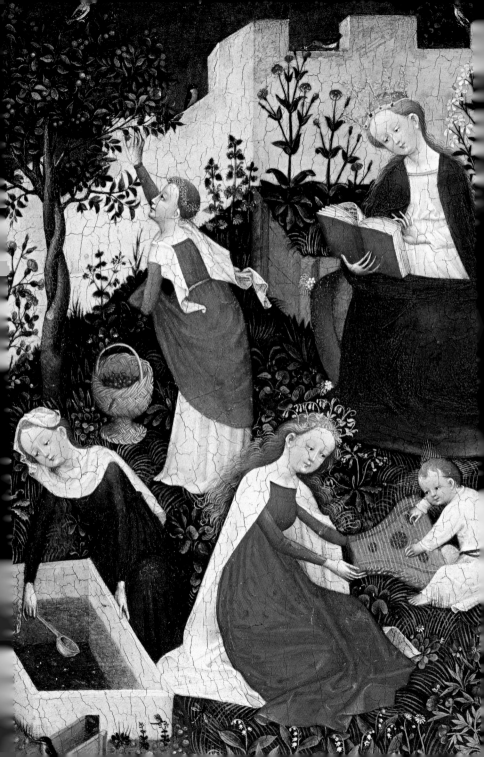

APPENDIXES

Chronology

1400

An anonymous Parisian miniaturist begins the *Boucicaut Book of Hours*.

1401

Competition in Florence for the second baptistery door: victory of Lorenzo Ghiberti over Brunelleschi.

1402

The Burgundian sculptor Claus Sluter completes *The Well of Moses* at Dijon.
Brunelleschi and Donatello go to Rome to study classical antiquities. Their visit is to have a decisive effect on the launching of humanism.

1404

Death of Philip the Bold, the forceful duke of Burgundy.

1405

Death of Claus Sluter in Dijon, leaving *The Tomb of Philip the Bold* unfinished.

1406

Jacopo Della Quercia sculpts *The Tomb of Ilaria del Carretto* at Lucca. It becomes a model for fifteenth-century funerary sculpture.

1408

Nanni di Banco and Donatello make statues of the evangelists for Florence cathedral.

1413

The Limbourg brothers begin the miniatures for the *Très Riches Heures du duc de Berry.*

1414

Thomas à Kempis writes *The Imitation of Christ*, the most important and widely known fifteenth-century devotional text— a primary source for works of art.

1414–17

The Council of Constance. Thanks to Martin V, the Great Schism in the papacy comes to an end after the Avignon exile.

1415

The battle of Agincourt confirms English sway over a large part of France.
Jan Hus is burnt as a heretic in Prague.
Master Bertram von Minden dies at Hamburg.

1416

Donatello sculpts *Saint George* for the church of Orsanmichele in Florence.

1418

Approval given for Brunelleschi's planned dome for Florence cathedral.

1420

Birth of Jean Fouquet.

1423

Gentile da Fabriano paints *The Adoration of the Magi* in Florence.

1424

Masolino and Masaccio start painting the frescoes in the Brancacci chapel in Florence.

1426

Hubert van Eyck begins *The Adoration of the Lamb Altarpiece* in Ghent. It will be completed by his brother Jan in 1432.

1427

Robert Campin (also known as the Master of Flémalle) paints *The Mérode Triptych*, now in New York.
Hans Multscher sculpts the *Christ as Man of Sorrows* for Ulm cathedral.

1430

Fra Angelico paints the Cortona *Annunciation*.
At about this time Paolo Uccello begins painting the frescoes in the Chiostro Verde of Santa Maria Novella in Florence, emphasizing the use of perspective.

1431

Opening of the Council of Basel on the role of the pope and

schismatic tendencies.
Joan of Arc, the heroine of the
French war against the English,
is executed at Rouen.

1434
The Medici establish firm control
in Florence. Brunelleschi's
cathedral dome is completed.
Jan van Eyck paints the *Portrait
of Giovanni Arnolfini and His
Wife*, now in London.

1435
Leon Battista Alberti writes his
De pictura, in which he sets out a
scientific theory for the use of
perspective in art.
About this year, Rogier van der
Weyden paints *The Deposition of
Christ*, now in Madrid.

1436
Jan van Eyck paints *The Van der
Paele Altarpiece* in Bruges.

1437–38
Pisanello paints the fresco of *Saint
George and the Princess of
Trebizond* in Verona.

1441
Death of Jan van Eyck.

1442
Alfonso of Aragon conquers the
Kingdom of Naples.

ca. 1443
Barthélemy d'Eyck paints the
Aix-en-Provence *Annunciation*.
Rogier van der Weyden begins the
Beaune *Last Judgment Altarpiece*.

1444
Konrad Witz paints *The Saint
Peter Altarpiece* for Geneva.

ca. 1445
Leon Battista Alberti writes the
De re aedificatoria, the most
important fifteenth-century
treatise on architecture.

1446
Death of Filippo Brunelleschi.

1447
Johann Gutenberg invents printing
with movable characters at Mainz.
Donatello starts work on the
Equestrian Statue of Gattamelata
in Padua.

ca. 1448
Stained-glass window of
The Annunciation in Bourges
cathedral—probably the work
of Jacob de Littemont.

1449
Petrus Christus paints the
Goldsmith in His Shop, now
in New York.

1450
Artists from many nations con-
verge on Rome in this Jubilee year.
Jean Fouquet paints the *Melun
Diptych*.
Francesco Sforza gains
power in Milan.

1451
Death of Stephan Lochner, the
chief exponent of the Rhenish
school of painting.
Rogier van der Weyden completes
the Beaune *Last Judgment
Altarpiece*.

1452
Piero della Francesca starts
painting *The Legend of the True
Cross* at Arezzo.
Leonardo da Vinci is born.

1453
Constantinople is taken by
Mahomet II: fall of the Eastern
Roman Empire.
Enguerrand Charonton paints
The Coronation of the Virgin for
the Carthusian monastery at
Villeneuve-lès-Avignon.

1454
The Peace of Lodi brings
equilibrium to the Italian states.

1455
Death of Pisanello.
Rogier van der Weyden paints
The Saint Columba Triptych,

now in Munich, for a church
in Cologne.
Jean Fouquet begins the miniatures
for *The Book of Hours of
Étienne Chevalier.*

1456
At about this time Paolo Uccello
paints the three panels of *The
Battle of San Romano.*

1458
Mantegna paints *The San Zeno
Triptych* at Verona.
The humanist Enea Silvio
Piccolomini becomes pope as
Pius II. Benozzo Gozzoli paints
the fresco *The Procession of the
Magi* in the chapel of Palazzo
Medici in Florence.

ca. 1460
Nuño Gonçalves paints *The Saint
Vincent Polyptych,* a Portuguese
masterpiece, for Lisbon.

1465
Mantegna begins decorating the
Camera degli Sposi in Mantua.

1466
Death of Donatello.
Memling begins *The Last
Judgment Triptych,* now
in Gdansk.

1467
Dirck Bouts completes *The Altar
of the Holy Sacrament* at Louvain.

1469
The marriage of Ferdinand of
Aragon and Isabella of Castile
unites their kingdoms.
Lorenzo de' Medici, the
Magnificent, becomes effective
lord of Florence.

ca. 1470
The Ducal Palace in Urbino is
completed.

1471
Michael Pacher sculpts and paints
the *Altar of the Coronation of the
Virgin* at Sankt Wolfgang.
Albrecht Dürer is born in
Nuremburg.
Giovanni Bellini begins his
monumental *Coronation of the
Virgin* for Pesaro.

1472
Piero della Francesca paints *The
Brera Altarpiece,* now in Milan.

1473
Martin Schongauer paints *The
Madonna of the Rose Bower*
in Colmar.

1474
Bartolomé Bermejo paints the
Saint Dominic of Silos Altarpiece,
now in Madrid.
Leonardo paints his first important
independent work: the Florence
Annunciation.
Hans Memling begins the

Polyptych of Saint John with *The
Mystic Marriage of Saint Catherine*
in Bruges.

1475
Antonello da Messina moves to
Venice and paints his *Saint Jerome
in His Study,* now in London.
Pedro Berruguete paints his
Portrait of Federico da Montefeltro
in Urbino.
Michelangelo Buonarroti is born.

1476
Nicolas Froment paints the
Triptych of the Burning Bush in
Aix-en-Provence.

1477
Marriage of Maximilian of
Habsburg and Mary of Burgundy.
Botticelli begins painting his
secular allegories at about
this time.
Veit Stoss starts work on the
Altar of the Death of the Virgin
at Krakow (completed in 1489).
Hugo van der Goes finishes the
Portinari Triptych, now in
Florence.
On the death of Charles the Bold,
the duchy of Burgundy is divided
between France and the Habsburgs
(Mary of Burgundy is the wife of
Maximilian I).

1480
Pope Sixtus IV (Della Rovere)
summons the best painters from

central Italy (including Botticelli and Perugino) to Rome to fresco the walls of the Sistine Chapel.

1482
Leonardo leaves *The Adoration of the Magi* unfinished in Florence and moves to the court of Ludovico il Moro in Milan.

1483
Raphael (Raffaello Sanzio) is born in Urbino.
Pedro Berruguete returns to Spain.

1485
Beginning of the Tudor dynasty in England.

1488
Giovanni Bellini paints *The Frari Triptych* in Venice.

1490
Bartolomé Bermejo paints *The Pietà of Canon Desplá* at Barcelona.

1491
Martin Schongauer dies at Breisach, leaving his *Last Judgment* frescoes unfinished.

1492
Christopher Columbus discovers America.
Lorenzo the Magnificent dies in Florence and the Florentine Republic is proclaimed.

The Battle of Las Navas leads to the final expulsion of the Moors from Spain.
Pinturicchio decorates the Borgia apartments in the Vatican for Alexander VI.

1493
Maximilian I of Habsburg is elected Holy Roman Emperor.

1494
Sebastian Brandt's poem *The Ship of Fools* is published in Basel. Some of the engraved illustrations are early works by Dürer.
The Altar of the Virgin is sculpted by the Erharts at Blaubeuren. The outer shutters, polychromy, and gold grounds are painted by Bernhard Striegel and Bartholomäus Zeitblom.

1494–99
The states of Naples and Milan are conquered by French armies. A period of war begins between Spain and France for control of Italy.

1495
Venice acquires Cyprus and so reaches its maximum territorial expansion.
The printer Aldo Manuzio begins working in Venice.

1496
Mantegna paints *The Madonna of Victory*, now in Paris.
Juan de Flandes begins painting a huge polyptych for Queen Isabella of Castile.

1497
Michael Pacher moves to Salzburg, where he dies the following year.

1498
Leonardo finishes *The Last Supper* in Milan.
Fra Girolamo Savonarola is hanged and burned in a square in Florence.
The Portuguese navigator Vasco de Gama rounds the Cape of Good Hope.
Gerard David paints the panels of *The Justice of Cambyses* in Bruges.

1499
Luca Signorelli begins a series of frescoes, *The End of the World*, in Orvieto cathedral.

1500
Michelangelo finishes his *Pietà* for Saint Peter's in Rome.
Dürer celebrates his own social success with his *Self-Portrait in a Fur-Collared Robe*, now in Munich.
The future emperor Charles V is born in Ghent.

Index of Artists

The numbers in italics refer to the entries in the "Leading Artists" section

Bibliography

Ainsworth, M. W. 1988. *Gerard David: Purity of Vision in an Age of Transition.* New York.

Baxandall, M. 1980. *The Limewood Sculptors of Renaissance Germany.* New Haven.

———. 1988. *Painting and Experience in Fifteenth-Century Italy: A Primer in the Social History of Pictorial Style.* 2nd ed. Oxford.

Belozerskaya, M. 2002. *Rethinking the Renaissance: Burgundian Arts across Europe.* Cambridge.

———. 2005. *Luxury Arts of the Renaissance.* Los Angeles.

Blum, S. 1989. *Early Netherlandish Triptychs: A Study in Patronage.* Berkeley.

Borsi, F. 1989. *Leon Battista Alberti: The Complete Works.* London.

Brown, P. F. 1988. *Venetian Narrative Painting in the Age of Carpaccio.* New Haven.

Cadogan, J. K. 2000. *Domenico Ghirlandaio: Artist and Artisan.* New Haven.

Campbell, L. 1990. *Renaissance Portraits: European Portrait Painting in the 14th, 15th, and 16th Centuries.* New Haven.

———. 1998. *Cosmè Tura of Ferrara: Style, Politics, and the Renaissance City, 1450–1495.* New Haven.

Campbell, T. P., et al. 2002. *Tapestry in the Renaissance: Art and Magnificence.* New York.

Chapuis, J. 2004. *Stephan Lochner: Image Making in Fifteenth-Century Cologne.* Turnhout.

Chapuis, J., et al. 1999. *Tilman Riemenschneider, Master Sculptor of the Late Middle Ages.* Washington, New York.

Chastel, A. 1995. *French Art: Renaissance, 1430–1620.* Paris.

Clark, K. 1988. *Leonardo da Vinci.* Rev. ed. Harmondsworth.

Cole, A. 1995. *Virtue and Magnificence: Art of the Italian Renaissance Courts.* London.

Cole, B. 1983. *The Renaissance Artist at Work: From Pisano to Titian.* New York.

Corley, B. 2000. *Painting and Patronage in Cologne, 1300–1500.* Turnhout.

Dhanens, E. 1980. *Hubert and Jan van Eyck.* New York.

Edgerton, S. Y. 1975. *The Renaissance Rediscovery of Linear Perspective.* New York.

Gilbert, C. E. 1980. *Italian Art, 1400–1500: Sources and Documents.* Englewood Cliffs, NJ.

Goffen, R. 1989. *Giovanni Bellini.* New Haven.

Gothic and Renaissance Art in Nuremberg 1300–1500. 1986. Munich, New York.

Grafton, A. 2002. *Leon Battista Alberti: Master Builder of the Italian Renaissance.* Cambridge, MA.

Hartt, F., and Wilkins, D.G. 2003. *History of Italian Renaissance Art: Painting, Sculpture, Architecture.* 5th ed. New York.

Hollingsworth, M. 1994. *Patronage in Renaissance Italy: From 1400 to the Early Sixteenth Century.* London.

Humfrey, P., and Kemp, M., eds. 1990. *The Altarpiece in the Renaissance.* Cambridge.

Huse, N., and Wolters, W. 1990. *The Art of Renaissance Venice: Architecture, Sculpture, and Painting, 1460–1590.* Chicago.

Jacobs, L. F. 1998. *Early Netherlandish Carved Altarpieces, 1380–1550: Medieval Tastes and Mass Marketing.* New York.

Janson, H. W. 1957. *The Sculpture of Donatello.* Princeton.

Kren, T., and McKendrick, S. 2003. *Illuminating the Renaissance: The Triumph of Flemish Manuscript Painting in Europe.* Los Angeles.

Lavin, M. A. 2002. *Piero della Francesca.* New York.

Lightbown, R.W. 1986.
*Mantegna: With a
Complete Catalogue of the
Paintings, Drawings, and
Prints.* Oxford.
———. 1989. *Sandro Botticelli:
Life and Work.* New York.
———. 2004. *Carlo Crivelli.* New
Haven.
Meiss, M. 1974. *French Painting
in the Time of Jean de
Berry: The Limbourgs and
Their Contemporaries.*
New York.
Müller, T. 1966. *Sculpture in the
Netherlands, Germany,
France, and Spain:
1400–1500.*
Harmondsworth.
*National Gallery Technical
Bulletin* 18 (1997): *Early
Northern European
Painting.* London.
Pope-Hennessy, J. W. 1966.
*The Portrait in the
Renaissance.* New York.
———. 1974. *Fra Angelico.* 2nd
ed. Ithaca, NY.
Post, C. R. 1930–66. *A History of
Spanish Painting.*
Cambridge, MA.
Prevenier, W., and Blockmans, W.
1986. *The Burgundian
Netherlands.* Cambridge.
Roettgen, S. 1996. *Italian
Frescoes: The Early
Renaissance, 1400–1470.*
New York.

Saalman, H. 1993. *Filippo
Brunelleschi: The Buildings.*
University Park, PA.
Smith, J. C. 2004. *The Northern
Renaissance.* London.
Snyder, J. 2005. *Northern
Renaissance Art: Painting,
Sculpture, the Graphic Arts
from 1350 to 1575.* 2nd
ed. Upper Saddle River, NJ.
Sobré, J. B. 1996. *The Artistic
Splendor of the Spanish
Kingdoms: The Art of
Fifteenth-Century Spain.*
Boston.
Stechow, W. 1966. *Northern
Renaissance Art,
1400–1600: Sources and
Documents.* Englewood
Cliffs, NJ.
Strange, A. 1950. *German
Painting, XIV–XVI
Centuries.* New York.
Syson, L., and Gordon, D. 2001.
*Pisanello: Painter to the
Renaissance Court.* London.
Thomas, A. 1995. *The Painter's
Practice in Renaissance
Tuscany.* Cambridge.
Thürlemann, F. 2002. *Robert
Campin: A Monographic
Study with Critical
Catalogue.* Munich.
Turner, R. A. 1997. *Renaissance
Florence: The Invention of a
New Art.* New York.
Vigni, G. 1963. *All the Paintings
of Antonello da Messina.*
New York.

Vos, D. de. 1994. *Hans
Memling: The Complete
Works.* Ghent.
———. 1999. *Rogier van der
Weyden: The Complete
Works.* New York.
Wackernagel, M. 1981.
*The World of the
Florentine Renaissance
Artist: Projects and Patrons,
Workshops, and Art
Market.* Princeton.
Warnke, M. 1993. *Court Artist:
On the Ancestry of the
Modern Artist.* Cambridge.
Weiss, R. 1988. *The
Renaissance Discovery
of Classical Antiquity.*
2nd ed. Oxford.
Welch, E. S. 1995. *Art and
Authority in Renaissance
Milan.* New Haven.
———. 1997. *Art and Society in
Italy, 1350–1500.* Oxford.
Wieck, R. S. 1997. *Painted
Prayers: The Book of Hours
in Medieval and Renaissance
Art.* New York.
Wilson, J. C. 1998. *Painting in
Bruges at the Close of the
Middle Ages: Studies in
Society and Visual Culture.*
University Park, PA.

Photograph Credits

Archivio Mondadori Electa,
Milan

By permission of the Ministero per
i Beni e le Attività Culturali:
Soprintendenza per il Patrimonio
storico, artistico e demoet-
noantropologico for Piedmont /
Galleria Sabauda, Turin
Soprintendenza per il Patrimonio
storico, artistico e demoet-
noantropologico for Milan and
western Lombardy / Pinacoteca di
Brera / Cenacolo Vinciano, Milan
Soprintendenza per il Patrimonio
storico, artistico e demoet-
noantropologico for Brescia,
Cremona and Mantua / Museo
di Palazzo Ducale, Mantua
Soprintendenza Speciale per il Polo
Musicale Veneziano / Gallerie
dell'Accademia, Venice
Soprintendenza per il Patrimonio
storico, artistico e demoet-
noantropologico for Modena and
Reggio Emilia / Biblioteca Estense
Universitaria, Modena
Soprintendenza per il Patrimonio
storico, artistico e demoet-
noantropologico for Bologna,
Ferrara, Forlì, Ravenna, and
Rimini / Pinacoteca Nazionale,
Bologna / Pinacoteca Nazionale,
Palazzo dei Diamanti, Ferrara
Soprintendenza Speciale per il Polo
Musicale Fiorentino / Gabinetto
dei Disegni e delle Stampe degli
Uffizi / Galleria degli Uffizi /
Museo Nazionale del Bargello /
Museo di San Marco / Cenacolo
di Sant'Apollonia / Chiesa e
Museo di Orsanmichele /
Cenacolo di Ognissanti, Florence
Soprintendenza per il Patrimonio
storico, artistico e demoet-
noantropologico delle Marche /
Galleria Nazionale delle Marche,
Urbino
Soprintendenza per il Patrimonio
storico, artistico e demoet-
noantropologico dell'Umbria /
Galleria Nazionale dell'Umbria,
Perugia
Soprintendenza Speciale per il Polo
Musicale Napoletano / Museo di
Capodimonte / Museo di San
Martino, Naples
Soprintendenza per i Beni culturali
ed ambientali di Palermo / Galleria
Regionale della Sicilia, Palazzo
Abatellis, Palermo

Mondadori thanks all those Italian
and other archives, museums, and
dioceses that have allowed the use
of their photographic material,
and especially the Curia
Patriarcale of Venice
© Pinacoteca Ambrosiana, Milan

Mondadori is willing to provide
any unidentified iconographical
sources to all entitled.